Nikon® D7200™

DUMMIES A Wiley Brand

by Julie Adair King

Nikon® D7200™ For Dummies®

Published by: John Wiley & Sons, Inc., 111 River Street, Hoboken, NJ 07030-5774, www.wiley.com

Copyright © 2015 by John Wiley & Sons, Inc., Hoboken, New Jersey

Published simultaneously in Canada

No part of this publication may be reproduced, stored in a retrieval system or transmitted in any form or by any means, electronic, mechanical, photocopying, recording, scanning or otherwise, except as permitted under Sections 107 or 108 of the 1976 United States Copyright Act, without the prior written permission of the Publisher. Requests to the Publisher for permission should be addressed to the Permissions Department, John Wiley & Sons, Inc., 111 River Street, Hoboken, NJ 07030, (201) 748-6011, fax (201) 748-6008, or online at http://www.wiley.com/go/permissions.

Trademarks: Wiley, For Dummies, the Dummies Man logo, Dummies.com, Making Everything Easier, and related trade dress are trademarks or registered trademarks of John Wiley & Sons, Inc. and may not be used without written permission. Nikon and D7200 are trademarks or registered trademarks of Nikon Corporation. All other trademarks are the property of their respective owners. John Wiley & Sons, Inc. is not associated with any product or vendor mentioned in this book.

LIMIT OF LIABILITY/DISCLAIMER OF WARRANTY: THE PUBLISHER AND THE AUTHOR MAKE NO REPRESENTATIONS OR WARRANTIES WITH RESPECT TO THE ACCURACY OR COMPLETENESS OF THE CONTENTS OF THIS WORK AND SPECIFICALLY DISCLAIM ALL WARRANTIES, INCLUDING WITHOUT LIMITATION WARRANTIES OF FITNESS FOR A PARTICULAR PURPOSE. NO WARRANTY MAY BE CREATED OR EXTENDED BY SALES OR PROMOTIONAL MATERIALS. THE ADVICE AND STRATEGIES CONTAINED HEREIN MAY NOT BE SUITABLE FOR EVERY SITUATION. THIS WORK IS SOLD WITH THE UNDERSTANDING THAT THE PUBLISHER IS NOT ENGAGED IN RENDERING LEGAL, ACCOUNTING, OR OTHER PROFESSIONAL SERVICES. IF PROFESSIONAL ASSISTANCE IS REQUIRED. THE SERVICES OF A COMPETENT PROFESSIONAL PERSON SHOULD BE SOUGHT. NEITHER THE PUBLISHER NOR THE AUTHOR SHALL BE LIABLE FOR DAMAGES ARISING HEREFROM. THE FACT THAT AN ORGANIZATION OR WEBSITE IS REFERRED TO IN THIS WORK AS A CITATION AND/OR A POTENTIAL SOURCE OF FURTHER INFORMATION DOES NOT MEAN THAT THE AUTHOR OR THE PUBLISHER ENDORSES THE INFORMATION THE ORGANIZATION OR WEBSITE MAY PROVIDE OR RECOMMENDATIONS IT MAY MAKE. FURTHER, READERS SHOULD BE AWARE THAT INTERNET WEBSITES LISTED IN THIS WORK MAY HAVE CHANGED OR DISAPPEARED BETWEEN WHEN THIS WORK WAS WRITTEN AND WHEN IT IS READ.

For general information on our other products and services, please contact our Customer Care Department within the U.S. at 877-762-2974, outside the U.S. at 317-572-3993, or fax 317-572-4002. For technical support, please visit www.wiley.com/techsupport.

Wiley publishes in a variety of print and electronic formats and by print-on-demand. Some material included with standard print versions of this book may not be included in e-books or in print-on-demand. If this book refers to media such as a CD or DVD that is not included in the version you purchased, you may download this material at http://booksupport.wiley.com. For more information about Wiley products, visit www.wiley.com.

Library of Congress Control Number: 2015943335

ISBN 978-1-119-13415-2 (pbk); ISBN 978-1-119-13417-6 (ebk); ISBN 978-1-119-13416-9 (ebk)

Manufactured in the United States of America

V10002209 080318

Table of Contents

Introduction	1
A Quick Look at What's Ahead	
Part I: Fast Track to Super Snaps	5
Chapter 1: First Steps, First Shots	7
Preparing the Camera	7
Navigating Menus	
Decoding the Displays	
Exploring More External Controls	
Back-of-the-body controls	
Topside controls	
Left-front features	
Front-right controls	
Hidden connections	
Familiarizing Yourself with the Lens	
Working with Memory Cards	36
Taking advantage of the two-card system	36
Buying and maintaining memory cards	
Taking a Few Final Setup Steps	39
Cruising the Setup menu	
Exploring Custom Setting menu options	42
Restoring default settings	43
Shooting in Auto and Auto Flash Off Modes	44
Viewfinder photography in the Auto modes	44
Live View photography in Auto mode	47
Chantan C. Barrian in a Fire Francial Birth. Talling C. Carr	
Chapter 2: Reviewing Five Essential Picture-Taking Options	
Choosing an Exposure Mode	
Fully automatic exposure modes	
Semi-automatic modes (P, S, and A)	
Manual exposure mode (M)	56
U1 and U2	
Setting the Shutter-Release Mode	
Single Frame and Quiet modes	
Continuous (burst mode) shooting	58
Self-timer shooting	60
Mirror lockup (MUP)	

	Off-the-dial shutter release features	.62
	Selecting Image Size and Image Quality	.66
	Considering Image Size (resolution)	.66
	Understanding Image Quality options	
	(JPEG or Raw/NEF)	
	Adjusting the Image Size and Image Quality settings	
	Reducing the Image Area (DX versus 1.3x Crop)	
Chap	oter 3: Adding Flash	.81
	Understanding Flash Limitations	.82
	Turning the Built-In Flash On and Off	83
	Choosing a Flash Mode	84
	Investigating Flash modes	84
	Changing the Flash mode	88
	Adjusting Flash Strength	
	Applying Flash Compensation	
	Switching to manual flash-power control	
	Enabling High-Speed Flash (Auto FP)	
	Using Flash Value Lock (FV Lock)	
	Exploring Additional Flash Options	97
Part II.	Beyond the Basics	99
1 0110 111	organia the onsite illimitation illimitation in the second	,,
Chai	pter 4: Taking Charge of Exposure	101
0.1.4.	Meeting the Exposure Trio: Aperture,	
	Shutter Speed, and ISO	102
	Aperture affects depth of field	
	Shutter speed affects motion blur	
	ISO affects image noise	
	Doing the exposure balancing act	
	Stepping Up to Advanced Exposure	
	Modes (P, S, A, and M)	109
	Reading the Exposure Meter	
	Choosing an Exposure Metering Mode	
	Setting Aperture, Shutter Speed, and ISO	
	Adjusting aperture and shutter speed	118
	Controlling ISO	
	Solving Exposure Problems	125
	Applying Exposure Compensation	
	Expanding tonal range	
	Eliminating vignetting	
	Using autoexposure lock	
	Taking Advantage of Automatic Bracketing	140

Chapter 5: Controlling Focus and Depth of Field	145
Setting the Basic Focusing Method	
(Auto or Manual)	145
Exploring Standard Focusing Options	
(Viewfinder Photography)	147
Setting the Focus mode (AF lock or continuous AF)	147
Choosing an AF-area mode: One focus point or many?	149
Autofocusing for still subjects: AF-S + Single Point	153
Focusing on moving subjects: AF-C + Dynamic Area	155
Focusing manually	157
Mastering Live View Focusing	159
Choosing a Live View Focus mode	
Selecting the AF-area mode	161
Stepping through the Live View autofocusing process Manual focusing during Live View	
and movie shooting	166
Manipulating Depth of Field	166
Chapter 6: Mastering Color Controls	171
Understanding White Balance	
Changing the White Balance setting	173
Fine-tuning white balance	
Creating Custom White Balance Presets	180
Setting white balance with direct measurement	180
Matching white balance to an existing photo	182
Selecting the preset you want to use	183
Editing presets	
Bracketing White Balance	
Taking a Quick Look at Picture Controls	188
Chapter 7: Putting It All Together	193
Recapping Basic Picture Settings	193
Shooting Still Portraits	194
Capturing Action	200
Capturing Scenic Vistas	203
Capturing Dynamic Close-Ups	206
Chapter 8: Shooting, Viewing, and Trimming Movies	209
Shooting Movies Using Default Settings	210
Adjusting Basic Video Settings	215
Controlling Audio	218
Manipulating Movie Exposure	222
Exploring Other Recording Options	225
Screening Your Movies	227

	Trimming Movies	229
	Saving a Movie Frame As a Still Image	231
Part	III: After the Shot	233
C	hapter 9: Playback Mode: Viewing Your Pho	tos
	Picture Playback 101	
	Choosing Which Images to View	237
	Adjusting Playback Timing	239
	Enabling Automatic Picture Rotation	
	Shifting from Single-Image	
	to Thumbnails Display	241
	Displaying Photos in Calendar View	242
	Magnifying Photos During Playback	244
	Viewing Picture Data	245
	Enabling and changing playback display	
	File Information mode	
	Highlights display mode	
	RGB Histogram modeShooting Data display mode	
	Overview Data mode	
	Overview Bata mode	200
C	hapter 10: Working with Camera Files	
	Protecting Photos	258
	Hiding Photos During Playback	259
	Deleting Files	261
	Deleting files one at a time	
	Deleting all files	
	Deleting a batch of selected files	
	Taking a Look a Nikon's Free Photo Software.	263
	Downloading Pictures to Your Computer	
	Processing Raw (NEF) Files	269
	Processing Raw images in the camera	
	Processing Raw files in Capture NX-D Making Copies for Online Sharing	2 (3
	Copying Files from One Card to Another	970
	Taking Advantage of Wi-Fi Transfer	280
	Connecting the camera to your device	281
	Connecting the camera to your device Connecting via NFC (Android Only)	281 284
	Connecting the camera to your device	

Part IV: The Part of Tens	. 287
Chapter 11: Ten More Ways to Customize Your Camera	289
Creating Custom Exposure Modes	289
Creating Your Own Menu	291
Adding Hidden Comments and Copyright Notices	293
Customizing Filenames	
Customizing Folder Names	295
Changing the Purpose of the OK Button	297
Customizing the Command Dials	298
Assigning New Tasks to a Few Buttons	300
Customizing buttons for still photography	
Customizing buttons for movie recording	
Modifying the Role of the Shutter Button	303
Adjusting Automatic Shutdown Timing	304
Chapter 12: Ten Features to Explore on a Rainy Day	305
Investigating the Retouch Menu	
Straightening Crooked and Distorted Photos	
Manipulating Exposure and Color	
Cropping Your Photo	
Three Ways to Play with Special Effects	
Applying special effects via the Retouch menu	
Shooting in Effects mode	
Two roads to a multi-image exposure	
Using a Smart Device as a Wireless Shutter Release	
Connecting Your Camera to an HDTV	
Creating a Digital Slide Show	
0	
Inder	327

Introduction

ikon. The name has been associated with top-flight photography equipment for generations. And the introduction of the D7200 has only enriched Nikon's reputation, offering all the control that a diehard photography enthusiast could want while providing easy-to-use, point-and-shoot features for the beginner.

In fact, the D7200 offers so *many* features that sorting them all out can be more than a little confusing, especially if you're new to digital photography, SLR photography, or both. For starters, you may not even be sure what SLR means or how it affects your picture-taking, let alone have a clue about all the other techie terms you encounter in your camera manual — *resolution*, *aperture*, *white balance*, and so on. If you're like many people, you may be so overwhelmed that you haven't yet ventured beyond Auto-everything mode, which is a shame, sort of like treating yourself to a luxury sports car and then never driving faster than 30 mph.

Therein lies the point of *Nikon D7200 For Dummies*. Through this book, you can discover not just what each bell and whistle on your camera does but also when, where, why, and how to put it to best use. Unlike many photography books, this one doesn't require any previous knowledge of photography or digital imaging to make sense of things, either. In classic *For Dummies* style, everything is explained in easy-to-understand language, with lots of illustrations to clear up any confusion.

In short, what you have in your hands is the paperback version of an in-depth photography workshop tailored specifically to your Nikon picture-taking powerhouse.

A Quick Look at What's Ahead

This book is organized into four parts, each devoted to a different aspect of using your camera. Although chapters flow in a sequence that's designed to take you from absolute beginner to experienced user, I've also tried to make each chapter as self-standing as possible so that you can explore the topics that interest you in any order you please.

Here's a brief preview of what you can find in each part of the book:

- Part I: Fast Track to Super Snaps: Part I contains three chapters to help you get up and running. Chapter 1 guides you through initial camera setup, shows you how to adjust camera settings, and walks you through the process of taking your first pictures using Auto exposure mode. (Yes, I dissed Auto mode in the first part of this introduction, but with the tips provided in Chapter 1, you can take darned good pictures in Auto mode until you're ready to move on to more advanced options.) Chapter 2 introduces you to other exposure modes and also explains basic picture options such as Release mode, Image Size (resolution), Image Quality (JPEG or Raw), and Image Area (DX or 1.3x). Chapter 3 advances your skills another level by showing you how to use the built-in flash and how to modify flash lighting to get professional-looking results.
- Part II: Beyond the Basics: Chapters in this part help you unleash the full creative power of your camera by detailing advanced picture-taking features. Chapter 4 covers the critical topic of exposure; Chapter 5 explains how to manipulate focus and depth of field; and Chapter 6 discusses color controls. Chapter 7 summarizes techniques explained in earlier chapters, providing a quick-reference guide to settings and strategies that work well for portraits, action shots, landscape scenes, and close-ups. Chapter 8 shifts gears, moving from still photography to HD movie recording with your D7200.
- Part III: After the Shot: This part offers two chapters, both dedicated to tasks you do after you press the shutter button. Chapter 9 explains picture playback, providing details on such tricks as magnifying the onscreen image, changing the display to reveal shooting data, and choosing which pictures you want to view. Chapter 10 topics include hiding, deleting, and protecting photos, downloading images to your computer or to a tablet or smartphone, processing Raw files, and preparing pictures for online sharing.
- Part IV: The Part of Tens: In famous For Dummies tradition, the book concludes with two top-ten lists containing additional bits of information and advice. Chapter 11 details options for customizing your camera, including changing the function of some buttons and entering a copyright notice that the camera embeds into your files. Chapter 12 covers the photo-editing tools found on the camera's Retouch menu and also shows you how to use the Effects exposure mode to add effects to movies and photos as you record them. To close out the book, I show you how to use your smartphone or tablet as a wireless shutter-release unit, connect the camera to an HDTV so that you can view your work on a large screen, and create a slide show featuring your best work.

Icons and Other Stuff to Note

If this isn't your first *For Dummies* book, you may be familiar with the large, round icons that decorate its margins. If not, here's your very own icondecoder ring:

The Tip icon flags information that will save you time, effort, money, or some other valuable resource, including your sanity. Tips also point out techniques that help you get the best results from specific camera features.

When you see this icon, look alive. It indicates a potential danger zone that can result in much wailing and teeth-gnashing if ignored. In other words, this is stuff that you really don't want to learn the hard way.

Lots of information in this book is of a technical nature — digital photography is a technical animal, after all. But if I present a detail that is useful mainly for impressing your technology-geek friends, I mark it with this icon.

I apply this icon either to introduce information that is especially worth storing in your brain's long-term memory or to remind you of a fact that may have been displaced from that memory by another pressing fact.

Additionally, I need to point out these details:

- Other margin art: Replicas of some of your camera's buttons and onscreen symbols also appear in the margins of some paragraphs. I include these to provide a reminder of the appearance of the button or feature being discussed.
- Camera menu selections: Many camera functions require you to work your way through a series of menu screens. For example, to access the option that enables you to use your camera flash to trigger remote flash units, you have to display the Custom Setting menu, choose the Bracketing/Flash submenu, and then choose the option named Flash Cntrl for Built-In Flash. To conserve space, I sometimes present these menu sequences like so: Choose Custom Setting > Bracketing/Flash > Flash Cntrl for Built-in Flash.
- ✓ **Software menu commands:** In sections that cover software, a series of words connected by an arrow also indicates options that you choose from menus. For example, if a step tells you to "Choose File⇔Convert Files," click the File menu (at the top of the program window) to unfurl it and then click the Convert Files command on the menu.

Beyond the Book

If you have Internet access, you can find a bit of extra content online, including this book's Cheat Sheet.

The Cheat Sheet contains a quick-reference guide to critical camera functions. Log on, print it out, and tuck it in your camera bag for times when you don't want to carry this book with you. (As another option, you can also purchase this book in digital form so that you can access it from whatever device you use to read e-books.)

www.dummies.com/cheatsheet/nikond7200

In addition, a few articles offer additional advice about your camera and photography in general. For example, you can find an article about customizing Picture Control settings, which affect picture color, contrast, and sharpness.

www.dummies.com/extras/nikon

Practice, Be Patient, and Have Fun!

To wrap up this preamble, I want to stress that if you initially think that digital photography is too confusing or too technical for you, you're in very good company. *Everyone* finds this stuff mind-boggling at first. So take it slowly, experimenting with just one or two settings or techniques at first. Then, every time you go on a photo outing, make it a point to add one or two more shooting skills to your repertoire.

I know that it's hard to believe when you're just starting out, but it really won't be long before everything starts to come together. With some time, patience, and practice, you'll soon wield your camera like a pro, dialing in the necessary settings to capture your creative vision almost instinctively.

So without further ado, I invite you to grab your camera, a cup of whatever it is you prefer to sip while you read, and start exploring the rest of this book. Your D7200 is the perfect partner for your photographic journey, and I thank you for allowing me, through this book, to serve as your tour guide.

Part I Fast Track to Super Snaps

getting started with your Nikon

Visit www.dummies.com for more great For Dummies content online.

First Steps, First Shots

In This Chapter

- > Preparing the camera for its first outing
- Getting acquainted with basic camera features
- Viewing and adjusting camera settings
- Setting a few basic preferences
- Taking a picture in Auto and Auto Flash Off modes

hooting for the first time with a camera as sophisticated as the Nikon D7200 can produce a blend of excitement and anxiety. On one hand, you can't wait to start using your new equipment, but on the other, you're a little intimidated by all its buttons, dials, and menu options.

Well, fear not: This chapter provides the information you need to start getting comfortable with your D7200. The first section walks you through initial camera setup. Following that, I explain how to view and adjust picture settings and offer my take on some basic setup options. At the end of the chapter, I walk you step-by-step through taking your first pictures using Auto mode, which offers point-and-shoot simplicity until you're ready to step up to more advanced options.

Preparing the Camera

Before you can use your D7200, you need to install the battery, attach a lens, and insert at least one memory card. (Your camera can use two cards at a time, but you only need one to begin taking pictures or recording movies.) A few preliminary notes:

✓ Battery: Use only the MH-25 charger that came with your camera to charge the battery. When the light on the charger stops blinking, the battery is fully charged. See the list at the end of this section to find out how to monitor the current battery charge.

- Lens: You can mount a wide range of lenses on your D7200, but some lenses aren't compatible with all camera features. Your camera manual lists all the lens types that can be mounted on the camera and explains what features are supported with each type. For maximum compatibility, look for Type D or G AF Nikkor, AF-S Nikkor, or AF-I Nikkor.
- Memory card(s): Like all digital cameras, your D7200 stores picture and movie files on memory cards. It has two card slots, both of which accept only SD (Secure Digital) cards. Most SD cards sold today carry the designation SDHC (for *High Capacity*) or SDXC (for *eXtended Capacity*), depending on how many gigabytes (GB) of data they hold. SDHC cards hold from 4GB to 32GB of data; the SDXC moniker indicates a capacity greater than 32GB.

With a charged battery, lens, and memory card(s) at hand, take these steps to get the camera ready to go:

- 1. Turn the camera off.
- 2. Install the battery into the compartment on the bottom of the camera.
- 3. Attach a lens.

First, remove the caps that cover the front of the camera and the back of the lens. Then align the *mounting index* (white dot) on the lens with the one on the camera body, as shown in Figure 1-1. After placing the lens on

the camera mount, rotate the lens toward the shutter-button side of the camera. You should feel a solid click as the lens locks into place.

4. Insert a memory card (or two).

Open the card door on the right side of the camera to reveal the two memory card slots, labeled in Figure 1-2. If you're using a single card, install it into Slot 1. Orient the card with the label facing the back of the camera, as shown in the figure, and push it gently into the slot.

After you close the card door, the memory-card access light, labeled in the figure, illuminates briefly as the camera checks out the card. If the card

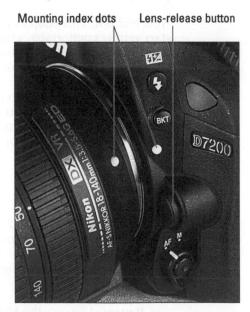

Figure 1-1: Align the white dot on the lens with the one on the camera body.

is damaged, full, or can't be used for some other reason, you see an error message in the Control panel (the LCD panel on top of the camera). You need to solve this issue before going forward; try a different card or visit the section "Working with Memory Cards," later in this chapter, for trouble-shooting tips.

5. Turn the camera on.

6. Set the language, time zone, and date.

When you power up the camera for the first time, a screen appears on the monitor asking you to select your language, time zone, date, and time. To adjust these settings, use the Multi Selector and OK button, both labeled in Figure 1-2. Press the edge of the Multi Selector up, down, right, or left to highlight a setting and then press OK to acti-

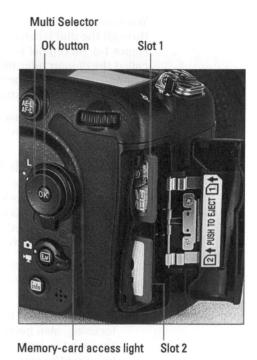

Figure 1-2: You can install one or two SD memory cards.

vate the option. Again, press the edges of the Multi Selector to adjust the active option, and then press the OK button to lock in your choice. (See the next section for more details about using camera menus.)

You don't need to take this step every time you use the camera; an internal battery separate from the main battery keeps the clock ticking for about three months. If you see a blinking clock symbol on the monitor, the clock battery is depleted. Simply charging the main camera battery and then putting that battery back in the camera restarts the clock, but you may need to reset the camera time and date.

7. Adjust the viewfinder to your eyesight.

This step is critical; if you don't set the viewfinder to your eyesight, subjects that appear out of focus in the viewfinder might actually be in focus, and vice versa. If you wear glasses while shooting, adjust the viewfinder with your glasses on — and don't forget to reset the viewfinder focus if you take off your glasses or your prescription changes.

You control viewfinder focus through the dial labeled in Figure 1-3. (In official lingo, it's called the *diopter adjustment dial.*) After taking off the front lens cap, follow these steps:

1. Look through the viewfinder and press the shutter button halfway.

In dim lighting, the flash may pop up. Ignore it for now and concentrate on the row of data that appears at the bottom of the viewfinder screen.

2. Rotate the viewfinder dial until that data appears sharpest.

Rotate dial to adjust viewfinder

Figure 1-3: Rotate this dial to set the viewfinder focus for your eyesight.

The markings in the center of the viewfinder, which relate to autofocusing, also become more or less sharp. Ignore the scene you see through the lens; that won't change because you're not actually focusing the camera.

3. When you finish, press down on the flash unit to close it if necessary.

8. Set the camera to normal (viewfinder) mode or Live View mode.

Live View is the feature that enables you to compose photos using the monitor, as you do with most point-and-shoot cameras. To record movies, you must use this option; you can't use the viewfinder to frame movie shots.

To shift to Live View photography, rotate the Live View switch to the still-camera icon, as shown in Figure 1-4; to set the camera to movie mode, set the switch to the movie-camera icon. Then press the center button (marked LV). The viewfinder goes dark, and the live preview appears on the monitor.

To exit Live View mode, press the LV button again. The Live View display turns off, and the viewfinder is once again available.

In addition to these initial setup steps, perform the following two preflight checks before each shoot:

Check the amount of free space on your memory card(s). Where you find this information varies depending on whether you're using the viewfinder, shooting stills in Live View mode, or recording movies, as follows:

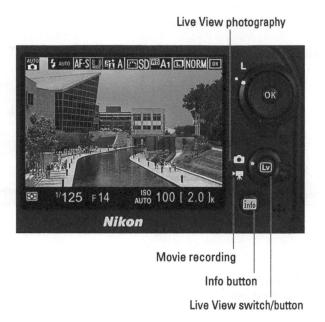

Figure 1-4: Press the LV button to toggle Live View on and off.

Viewfinder photography:

 A number indicating how many photos will fit in the available memory-card space appears in the Control panel on top of the camera, as well as in the Information display and viewfinder. Figure 1-5 shows you where to find the information in the Control panel; Figure 1-6 provides a guide to the Information display and viewfinder.

Battery status

Shots remaining

Figure 1-5: The Control panel displays the shots-remaining value and a symbol representing the battery status.

Turn the Information screen representing the battery status. on and off by pressing the Info button. To wake up the viewfinder, give the shutter button a half-press and then release it.

• Live View mode: For still photography, refer to the Control panel or the shots-remaining value in the lower-right corner of the Live View display, as shown on the left in Figure 1-6.

info

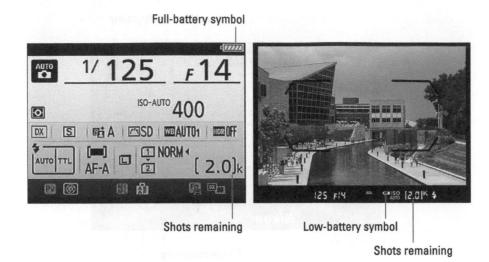

Figure 1-6: During viewfinder photography, you can verify the shots-remaining value and battery status in these displays.

In movie mode, you don't see a shots-remaining value in either display; instead, the maximum recording time appears on the monitor, in the area labeled on the right in Figure 1-7. Don't consider this value a full reflection of the amount of empty space on your memory card. The camera limits the maximum recording time per movie even if your card has oodles of free space remaining. After you reach the time limit for your first recording, the number resets to show you the maximum recording time for your next movie.

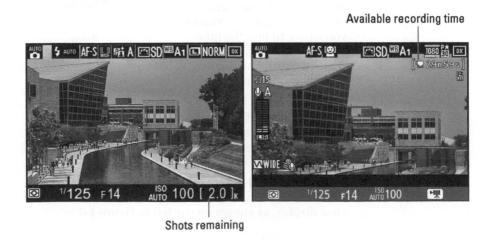

Figure 1-7: In Live View mode, the displays offer these hints about memory-card capacity.

If your displays look different from the ones in the figures, press the Info button to cycle through the various display modes available for Live View shooting. I explain more about each display later in the chapter, in the section "Decoding the Displays."

Keep in mind that certain picture- and movie-recording settings affect the size of the image/movie file, so the number of files that can fit in the available card space changes as you adjust those settings. Chapter 2 discusses the photo-related settings (Image Area, Image Size, and Image Quality); Chapter 8 clues you in on movie-recording options.

When two cards are installed, the shots-remaining number also depends on how you configure the camera to send image data to those cards. For still photography, the camera is set by default to fill the card in Slot 1 and then switch to the second card. For movie recording, files can be stored on only one of the two cards; by default, the card in Slot 1 gets the honors. I explain how to modify this setup in the section "Taking advantage of the two-card system," later in this chapter.

One final note: If the shots-remaining number is greater than 999, the initial K appears next to the value to indicate that the first number represents the picture count in thousands. (K being a universally accepted symbol indicating 1,000 units.) The number is rounded down to the nearest hundred. So if the number of shots remaining is, say, 2,004, the value reads as 2.0K, as shown in the figures here.

- Checking battery status: Also confirm the battery status before every outing with your camera. You can check the battery level as follows:
 - Viewfinder mode: Both the Control panel and Information screen display a battery-status symbol; look for it in the areas labeled in Figure 1-5 and on the left in Figure 1-6. When the battery is fully charged, the symbol looks as shown in the figure. As the battery loses power, the bars in the symbol disappear one by one to let you know that you need to find a battery charger or spare battery soon.

In the viewfinder, you see battery data only when you're running low on power. In that case, an empty-battery symbol appears at the bottom of the viewfinder, as shown on the right in Figure 1-6.

• *Live View mode:* When Live View is engaged, battery info appears only in the Control panel.

For more detailed battery data, choose Battery Info from the Setup menu, as shown in Figure 1-8. (See the next section for help with using menus.) The Charge data shows you the current power remaining as a percentage value, and the No. of Shots value tells you how many times you've pressed and released the shutter button since the last time you charged the battery. The final readout, Battery Age, lets you know how

much more life you can expect out of the battery before it can no longer be recharged. When the display moves toward the right end of the little meter, it's time to buy a new battery. (If you attach the optional battery pack, see its manual and the camera manual to find out how to interpret the data that's reported on this menu screen.)

That's all there is to it — the camera is now ready to go. From here, my recommendation is that you keep reading this chapter to familiarize yourself with the main camera features and basic operation. But if you're anxious to take a picture right away, I won't think any less of you if you skip to the very last section of the chapter, which guides you through the process of still photography. To start shooting movies, flip to Chapter 8. Just promise that at some point, you'll read the pages in between, because they actually do contain important information.

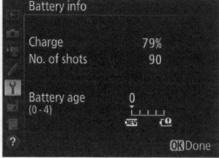

Figure 1-8: The Battery Info option on the Setup menu provides details about battery life.

What does [r 24] in the display mean?

In the viewfinder, the initial value in brackets at the right end of the display indicates the number of additional pictures that can fit on your memory card. This same value appears in the lower-right corner of the Control panel, Information display, and Live View still-photography display. (Refer to Figures 1-5 through 1-7.) When you press the shutter button halfway, the value changes to show you how many pictures can fit in the camera's memory buffer, which is

a temporary storage tank where the camera stores picture data until it has time to record that data to the memory card. For example, [r 24] tells you that the buffer can hold 24 pictures. This system exists so that you can take a continuous series of pictures without waiting between shots until each image is written to the card. When the buffer is full, you can't take another picture until the camera catches up with its recording work.

Navigating Menus

One of the first skills you need to learn to take full advantage of your D7200 is how to select options from camera menus. Table 1-1 offers a brief description of what controls live on the various menus.

Table 1-1		D7200 Menus
Symbol	Open This Menu	To Access These Functions
P	Playback	Viewing, deleting, and protecting pictures
Ω	Photo Shooting	Basic photography settings
素	Movie Shooting	Movie recording options, including settings for controlling audio and setting the frame size and frame rate
0	Custom Setting	Advanced photography options and some basic camera operations
Y	Setup	Additional basic camera operations
Ø	Retouch	Photo and movie editing options
	My Menu/Recent Settings	Your custom menu or the 20 most recently used menu options

Here's what you need to know to navigate the menu system:

- **✓ Display the main menus:** Press the Menu button, labeled in Figure 1-9.
- Select a menu: If the menu you want to see isn't visible, press the Multi Selector left to highlight the strip of menu icons, labeled in Figure 1-9. Press up or down to highlight a menu icon and then press the Multi Selector right or press the OK button to exit the icon strip and activate the menu itself.
- Adjust a menu option: Press the Multi Selector up or down to highlight the option you want to change and then press OK to display the settings available for that option. For example, if you select the Image Size option from the Photo Shooting menu, as shown on the left in

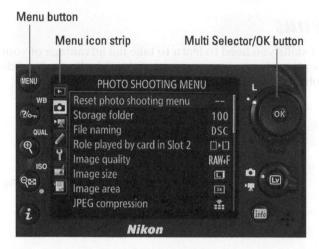

Figure 1-9: Press the Multi Selector left to activate the menu-icon strip; press right to activate the menu itself.

Figure 1-10, you see the settings shown on the right in the figure. Press the Multi Selector up or down to highlight your choice and then press OK to return to the main menu screen.

In some cases, a right-pointing triangle appears next to an option on the settings screen. That's your cue to press the Multi Selector right to display a submenu (although in many cases, you can press OK instead).

Items that are dimmed on a menu or settings screen aren't available in the current exposure mode. For access to all settings, set the Mode dial on top of the camera to P, S, A, or M.

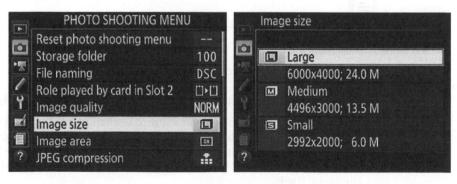

Figure 1-10: Use the Multi Selector to highlight a menu option (left) and then press OK to display the available settings (right).

Select items from the Custom Setting menu: The Custom Setting menu, represented by the Pencil icon, contains submenus that carry the labels A through G, as shown on the left in Figure 1-11. Each submenu holds clusters of options related to a specific aspect of the camera's operation. To get to those options, use the Multi Selector to highlight the submenu and then press OK. For example, if you choose the A (Autofocus) submenu, you see the options shown on the right in Figure 1-11.

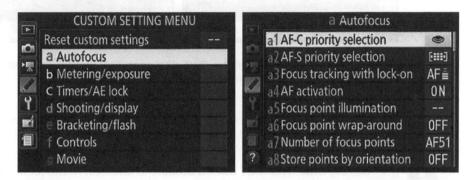

Figure 1-11: The Custom Setting menu contains submenus of advanced options.

In the Nikon manual, instructions reference the Custom Setting menu items by a menu letter and number. For example, "Custom Setting a1" refers to the first option on the a (Autofocus) submenu. I try to be more specific, however, so I use the actual setting names. (Really, we all have enough numbers to remember, don't you think?)

After you jump to the first submenu, you can simply scroll up and down the list to view options from other submenus. You don't have to keep going back to the initial menu screen and selecting a submenu.

Taking advantage of the My Menu and Recent Settings menus: These two menus, both shown in Figure 1-12, share the bottom slot in the strip of menu icons. You can display only one of the two at a time, however. Each menu contains a Choose Tab option as the last item on the menu; select this option to shift between the two menus.

Here's what the two menus offer:

Recent Settings: This screen lists the 20 menu items you ordered
most recently. To adjust those settings, you don't have to wade
through all the other menus to look for them — head to the Recent
Settings menu instead.

To remove an item from the Recent Settings menu, use the Multi Selector to highlight the item and press the Delete button. Press Delete again to confirm your decision.

Figure 1-12: The Recent Settings menu offers quick access to the last 20 menu options you selected; the My Menu feature enables you to design a custom menu.

- My Menu: From this screen, you can create a custom menu that contains up to 20 of your favorite menu items. Chapter 11 details the steps.
- ✓ **Saving time with the** *i* **button menus:** In addition to the menus listed in Table 1-1, you can press the *i* button, labeled in Figure 1-13, to display a menu screen that enables you to quickly access certain shooting or playback settings.

During shooting, which options the menu contains depends on your exposure mode and whether Live View is enabled. The screen shown in Figure 1-13 appears when you shoot in one of the advanced exposure modes (P, S, A, and M). Dimmed items can't be adjusted in your current exposure mode.

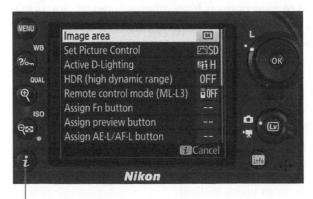

Press to display i button menu

Figure 1-13: Pressing the *i* button gives you fast access to the most frequently adjusted settings.

Things work a little differently in Live View mode: For still photography, pressing the \boldsymbol{i} button displays a column of options along the right side of the monitor, as shown on the left in Figure 1-14. When the Live View switch is set to the movie setting, options on the \boldsymbol{i} button menu relate to movie-recording options. Either way, use the Multi Selector to highlight an option and press OK to display the available settings for that option, as shown on the right in the figure. After you make your selection, press OK to return to the menu. To exit the menu, press the \boldsymbol{i} button or press the shutter button halfway and release it.

During playback, the i button menu offers items related to after-the-shot functions such as applying Retouch menu tools.

Figure 1-14: When Live View is enabled, the *i* button menu offers these settings during still photography.

Decoding the Displays

In addition to menus, your D7200 offers several displays to help you keep track of the most critical picture and camera settings. The following provides some details about using and customizing the displays. Note that the data that appears in each display depends on certain camera settings, including your exposure mode. The figures in this section show the screens as they appear in Auto exposure mode. (Don't worry if you haven't a clue as to what some symbols and numbers mean; most won't make any sense until you explore later chapters.)

Which displays are available depends on whether you're shooting still photos or movies and whether Live View is enabled. Here's the scoop:

✓ Control panel: The Control panel is the LCD display on top of the camera; Figure 1-15 offers a look. This display is a full-time worker. Its readout appears for viewfinder photography, Live View photography, and movie recording.

If you're shooting in dim lighting and find the readout hard to see, you can illuminate the panel by rotating the On/Off switch past the On position to the light bulb marker, labeled in Figure 1-15, and then releasing the switch. The backlight turns off automatically a few seconds after you release the switch.

Alternatively, you can set the camera to light up the Control panel any time the exposure meters are activated. If you prefer that arrangement, choose Custom Setting > Shooting/ Display > LCD Illumination and select On. Just keep in mind that this setting consumes more battery power than simply rotating the switch to light the display when needed.

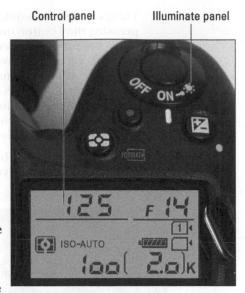

Figure 1-15: Rotate the On/Off switch to the light bulb position to illuminate the Control panel.

No matter which menu option you choose, the shots-remaining value and icons representing the installed memory cards remain visible even after you turn off the camera. The display only turns off fully if you remove the camera battery. (Don't worry that the display will run down your battery; it consumes very little power.)

Viewfinder: When Live View is not enabled, you can view a handful of settings in the data display at the bottom of the viewfinder, as shown on the left in Figure 1-16. (If you don't see the data strip, press the shutter button halfway and release it to bring the display to life.)

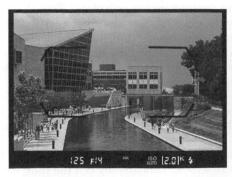

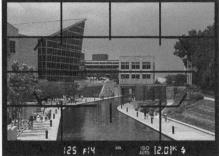

Figure 1-16: Picture settings also appear at the bottom of the viewfinder (left); enable the arid for help with aligning objects in the frame (right).

You can display gridlines in the viewfinder, as shown on the right in the figure, to help ensure the alignment of objects in your photo — for example, to make sure that the horizon is level in a landscape. To turn the feature on or off, choose Custom Setting > Shooting/Display > Viewfinder Grid Display.

✓ Information display (viewfinder photography only): Shown in Figure 1-17, this display offers a larger and more comprehensive look at camera settings than the Control panel. To display it, press the Info button. To turn off the display, press the button again or give

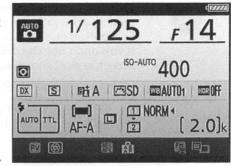

Figure 1-17: During viewfinder photography, press the Info button to view this screen, called the Information display.

By default, the camera tries to make the data easier to read by automatically shifting from black text on a light background to light text on a black background, depending on the ambient light. If you prefer one style over the other, choose Custom Setting > Shooting/Display > Information Display. Select Manual and then choose either Dark on Light or Light on Dark. In this book, I show the Dark on Light display because it reproduces better in print.

the shutter button a quick half-press and release it.

Live View and Movie displays: In Live View, camera settings appear superimposed over the live scene. The default still photography and movie-recording display modes, officially titled Information On, are shown side by side in Figure 1-18.

Live View Still Photography, Information On

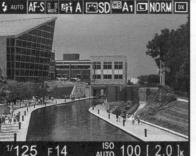

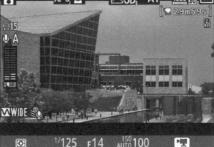

Movie Recording, Information On

Figure 1-18: These screens are the defaults for Live View still photography (left) and movie shooting (right).

You don't need to press the Info button to bring up these displays: they appear automatically when you turn on Live View. Instead, pressing the Info button enables you to vary the type and amount of data shown. If you don't like the default displays, choose from these alternative screen styles, shown in Figure 1-19:

- Information off: Shows only the major exposure settings.
- Framing guides: Displays a grid over the scene to help you ensure the vertical and horizontal alignment of objects in the scene with respect to the horizon.
- Virtual horizon: This display includes the circular level graphic shown in the lower-left screen in Figure 1-19. A green line through the middle of the display, as shown in Figure 1-19, indicates that the camera is level with the horizon.

You can access variations of this tool when the camera isn't in Live View mode: Go to the Setup menu and choose Virtual Horizon, You see the same leveling graphic shown in Figure 1-19, but on a blank menu screen. Although you can't see your subject in the monitor, the feature is still a handy option if you're using a tripod and want

Information Off

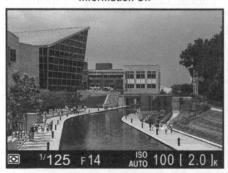

Framing Guides

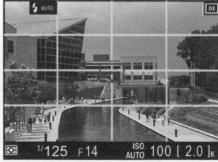

Virtual Horizon

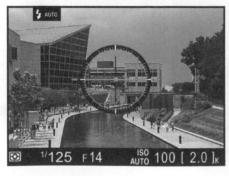

Histogram (movie recording only)

Figure 1-19: In Live View mode, pressing the Info button cycles through these alternative displays.

to make sure that the camera is level to the horizon. (Some tripods also have built-in levels.)

You also can enable an in-viewfinder guide, the Viewfinder Virtual Horizon, which displays a vertical or horizontal bar along the right and bottom of the framing area, depending on whether you're holding the camera in the horizontal or vertical position. You can access this feature only by assigning a camera button to it; see Chapter 11 for details on button customization. (In the meantime, the viewfinder's grid display, shown in Figure 1-16, should be enough to help you ensure that the camera is level.)

• Histogram (Movie mode only): The tiny chart shown in the lower-right area of the final screen in Figure 1-19 is a histogram, which offers some exposure information. The chart plots out the brightness values found in the scene, from black (left side) to white (right side). The vertical axis of the chart shows you how many pixels (the squares that make up a digital image) there are at a particular brightness value. A large spike at the right end of the chart indicates that the picture may be overexposed, with some highlight detail being lost. A concentration of pixels at the left end of the histogram indicates the opposite problem, with some shadow detail being lost due to underexposure.

You can also view histograms during playback mode; I provide more details about interpreting playback histograms in Chapter 9. Chapter 8 shows you how to adjust exposure during movie recording if needed.

All the displays except the Control panel shut off after a specific period of inactivity to preserve battery power. See Chapter 11 for details about altering these auto-shutdown times. (Hint: Start by choosing Custom Setting > Timers/AE Lock > Monitor Off Delay.)

Exploring More External Controls

Take a few minutes to acquaint yourself with the remaining bells and whistles found on the camera body, described in the next several sections. Don't worry about memorizing the purpose of each control; I provide specifics for using all of them in chapters to come. Consider this just a basic "what's this thing do" guide to get you started.

Back-of-the-body controls

One note before I dive into the smorgasbord of buttons and dials found on the back of the camera, shown in Figure 1-20: Three buttons on the left side of the monitor bear multiple labels to indicate that they play different roles depending on whether the camera is in shooting or playback mode. As Nikon

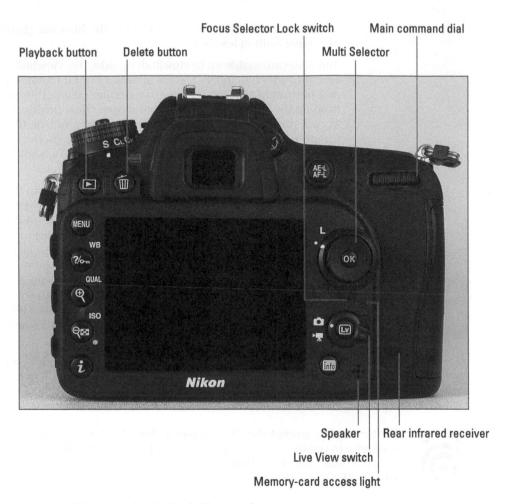

Figure 1-20: Here's a look at the backside controls.

does in the user manual, I refer to the button by the name that relates to the current operation. To avoid any confusion over which button I'm referencing, though, a picture of the button appears in the margin.

Starting in the upper-left corner and working clockwise around the camera back, you find these controls:

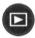

Playback button: Press this button to switch the camera to picture review mode; press it again to return to shooting. Chapter 9 details picture playback.

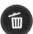

✓ Delete button: Sporting a trash can icon, the universal symbol for delete, this button enables you to erase pictures. Chapter 10 has specifics.

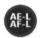

- AE-L/AF-L button: When taking pictures in some automatic modes, you can lock focus and exposure settings by holding down this button. Chapter 4 explains.
- Main command dial: You use this dial to adjust a variety of settings, often in combination with pressing a camera button.

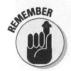

It's important to distinguish this dial from its sibling, the Sub-command dial, which is on the front of the camera below the On/Off button. In many cases, you rotate one dial to adjust one setting and rotate the other dial to adjust a related setting.

- Multi Selector/OK button: This dual-natured control plays a role in many camera functions. You press the outer edges of the Multi Selector left, right, up, or down to navigate camera menus and access certain other options. At the center of the control is the OK button, which you press to finalize a menu selection or other camera adjustment.
- Focus Selector Lock switch: Just beneath the Multi Selector, this switch relates to the camera's autofocusing system. When the switch is set to the position shown in Figure 1-20, you can use the Multi Selector to select the focusing point that you want to use. Setting the switch to the L position prevents you from choosing a different point. See Chapter 5 for details.
- Memory-card access light: When you insert a memory card, this light flashes briefly to indicate that the card is installed.

- Live View switch: Rotate the Live View switch to the camera symbol to use Live View for still photography; move the switch to the movie-camera symbol for movie recording. Either way, press the LV button at the center of the switch to actually turn on Live View; press it again to exit Live View.
- Rear infrared receiver: This sensor, labeled in Figure 1-20, picks up the signal from the optional ML-L3 wireless remote control. There's a second sensor on the front of the camera; see the next section for a look-see.
- ✓ Speaker: When you play movies that contain sound, the sound comes wafting through these little holes.

✓ **Info button:** During viewfinder photography, press this button to display the Information screen, which provides an overview of your current camera settings. In Live View mode, pressing the button changes the type of data that appears over the live preview. See "Decoding the Displays," earlier in this chapter, for details.

i button: Pressing this button during shooting or picture playback displays a special menu that gives you quick access to a handful of important settings. The earlier section "Navigating Menus" explains.

✓ ISO/Zoom Out button: In viewfinder picture-taking mode, this button provides access to the ISO setting, which controls the camera's sensitivity to light. Chapter 4 has details.

When you press this button or the next two buttons on the list, you see a screen similar to the one shown in Figure 1-21, offering two related options. While holding the button, you can adjust one setting by rotating the Main command dial and change the other setting by rotating the Sub-command dial. The icons labeled in the figure rep- Figure 1-21: The wheel symbols tell you resent the two dials. For the ISO dial turns Auto ISO Sensitivity on

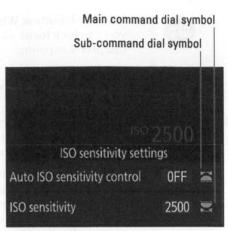

whether to rotate the Main command dial or button, rotating the Sub-command the Sub-command dial to adjust the setting.

and off, and rotating the Main command dial changes the ISO Sensitivity setting. When you release the button, the normal display reappears.

When Live View is engaged, the button doesn't play the ISO role. Instead, if you magnify the display (which you accomplish via the Zoom In button, described shortly), pressing the Zoom Out button reduces the magnification level.

In playback mode, pressing the button enables you to display multiple image thumbnails on the screen and to reduce the magnification of the current photo.

WB/Help/Protect button: This button serves three purposes:

- White Balance control: For picture-taking purposes, the button's main function is to access white balance options, a color-related topic you can explore in Chapter 6. (You can adjust the white balance options only in the P, S, A, and M exposure modes.) Rotate the Main command dial while holding down the button to select the White Balance setting; use the Sub-command dial to modify the selected setting by shifting colors along the blue-to-amber spectrum.
- Protect: In playback mode, pressing the button locks the picture file — hence the little key symbol that appears on the button face — so that it isn't erased if you use the picture-delete functions that I detail in Chapter 10. (The picture is erased if you format the memory card, however.)
- Help: When you see a question mark symbol in the lower-left corner of a menu or settings screen, press this button — also decorated with a question mark — to display information about the active option, as illustrated in Figure 1-22.

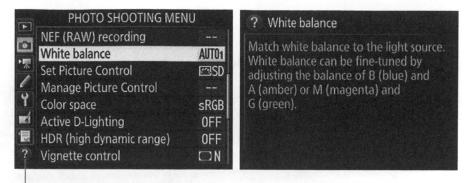

Help available symbol

Figure 1-22: If a screen sports a question mark symbol (left), press the WB button to display information about the current option (right).

Qual (Quality)/Zoom In button: In picture-taking mode, pressing the button gives you fast access to the Image Quality and Image Size options, both of which you can explore in Chapter 2. While the button is pressed, rotate the Main command dial to change the Image Quality setting, and rotate the Sub-command dial to change the Image Size setting. However, this function works only for viewfinder photography; in Live View mode, pressing the button magnifies the display so that you can check focus closely.

In playback mode, pressing this button magnifies the image and also reduces the number of thumbnails displayed at a time. Note the plus sign in the middle of the magnifying glass — plus for zoom in.

Menu button: Press this button to access menus of camera options. The section "Navigating Menus," earlier in this chapter, offers help with using menus.

Topside controls

Your virtual tour continues with the bird's-eye view shown in Figure 1-23. There are a number of features of note:

- On/Off switch and shutter button: Okay, I'm pretty sure you already figured out this combo button. But you may not be aware that you need to press the shutter button in two stages: Press and hold the button half-way and wait for the camera to initiate exposure metering and, if you're using autofocusing, to set the focusing distance. Then press the button the rest of the way to take the picture.
- Control panel: You can view many picture-taking settings on this LCD panel, detailed in the earlier section "Decoding the Displays." The data that appears depends on what action you're currently undertaking.

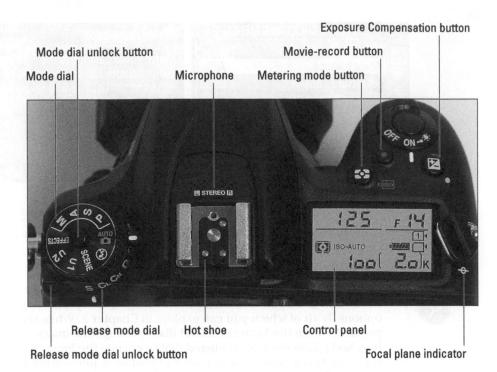

Figure 1-23: Press and hold the Mode dial unlock button before rotating the dial.

Exposure Compensation button: This button relates to an exposure correction you can apply when using some autoexposure modes. Press the button while rotating the Main command dial to set the amount of Exposure Compensation.

Metering Mode button: Press this button while rotating the Main command dial to select a metering mode, which determines what part of the frame the camera considers when calculating exposure. Look to Chapter 4 for details.

- Movie-record button: After setting the camera to movie mode, press this button to start and stop recording. (Engage movie mode by setting the Live View switch to the movie camera icon and then pressing the LV button.)
- Mode dial: The setting of this dial determines your exposure mode, which in turn determines how much control you have over exposure and certain other camera features. Your options range from fully automatic shooting to full manual mode; see Chapter 2 for an introduction to each. Also check out Chapter 11, which explains how to create your own exposure modes, named U1 and U2.

Before you can rotate the dial and change the setting, you must press and hold the Mode dial unlock button in the center of the dial, labeled in Figure 1-23.

- Release Mode dial: You use this dial, set directly under the Mode dial. to switch from normal shooting, where you take one picture with each press of the shutter button, to one of the camera's other Release modes. including Self-Timer mode. As with the Mode dial, you must press the dial's unlock button, labeled in Figure 1-23, to change the Release mode setting. A letter representing the selected mode appears at the bottom of the dial. For example, in the figure, the S (Single Frame) mode is selected. See Chapter 2 for a look at all your options.
- Microphone: The holes labeled Microphone in Figure 1-23 lead to the camera's built-in microphone. See Chapter 8 to find out how to adjust microphone sensitivity or disable audio recording altogether.
- Flash hot shoe: A hot shoe is a connection for attaching an external flash head such as a Nikon Speedlight. See Chapter 3 for information about a few flash features that work only with this type of flash.
- Focal plane indicator: Should you need to know the exact distance between your subject and the camera, the focal plane indicator labeled in Figure 1-23 is key. This mark indicates the plane at which light coming through the lens is focused onto the image sensor. Basing your measurement on this mark produces a more accurate camera-to-subject distance than using the end of the lens or some other external point on the camera body as your reference point.

Left-front features

The front-left side of the camera, shown in Figure 1-24, sports these features:

Flash/Flash Compensation: Pressing this button pops up the camera's built-in flash (except in automatic shooting modes, in which the camera decides whether the flash is needed). Depending on your exposure mode, you may be able to adjust the Flash mode (normal, red-eye reduction, and so on) and by holding the button down while rotating the Main command dial and change the flash power by rotating the Sub-command dial (the dial on the front of the camera).

- **BKT (Bracket) button:** Press this button to access settings related to automatic bracketing, a feature that simplifies the job of recording the same subject at various exposure, flash, and white balance settings. Chapter 4 details flash and exposure bracketing; Chapter 6 discusses white balance bracketing.
- Lens-release button: Press this button to disengage the lens from the camera body so you can remove the lens.

- Focus-mode selector: This switch sets the camera to manual (M) or autofocusing (AF). Chapter 5 gives you the lowdown on focusing.
- AF-mode button: This button accesses two autofocusing options. While pressing the button, rotate the Main command dial to adjust the Focus mode and rotate the Subcommand dial to adjust the AF-area mode. Chapter 5 explains how these settings affect the camera's autofocusing behavior.
- Front infrared receiver: Here's the second of two receivers that can pull in the signal from the optional ML-L3 wireless remote control unit. Figure 1-24 shows you where to aim the remote transmitter if you're standing in front of the camera.

Front-right controls

Figure 1-25 offers a look at the front-right side of the camera, which sports the following features:

Sub-command dial: This dial is the counterpart to the Main command dial on the back of the camera. As with the

Main command dial, you rotate this one to select certain settings, usually in conjunction with pressing a camera button.

✓ **AF-assist lamp:** In dim lighting, a beam of light shoots out from this lamp to help the camera's autofocus system find its target. In general, leaving the AF-assist option enabled is a good idea, but if you're shooting at an event where the light may be distracting, you can disable it by choosing Custom Setting > Autofocus > Built-In AF-Assist Illuminator and setting the option to Off.

The lamp also lights before the shutter is released in Self-Timer mode and before the flash fires in Red-Eye Reduction flash mode.

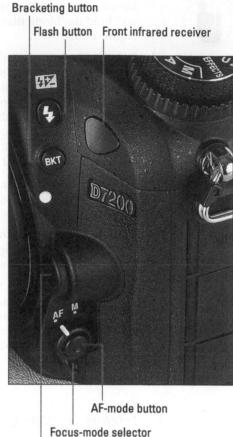

Lens-release button

Figure 1-24: Press the Flash button to use the built-in flash in P, S, A, or M mode.

ΔF-assist illuminator

Sub-command dial

✓ Depth-of-Field Preview button: By pressing this button, you can see how different aperture settings affect depth of field. or the distance over which focus appears sharp. Chapter 5 shows you how it works, and Chapter 11 explains how to assign a different function to the button if you don't care to preview depth of field.

If you stick with the default setting and flash is enabled, pressing the button also causes the flash to emit a pulse of light to help you see how your subject will be illuminated. You can disable that feature from the Custom Setting menu: Choose Bracketing/Flash > Modeling Flash to access the setting.

Function (Fn) button: By default, pressing this button while rotating either command dial switches the Image Area setting from the DX area mode. which captures your picture using the entire image sensor, to the 1.3 crop mode, which uses

Depth-of-Field Preview button

Function button

Figure 1-25: You can set the Function (Fn) and Depth-of-Field Preview buttons to perform a variety of operations.

a smaller area at the center of the sensor. For details on this setting, see Chapter 2. (In Live View mode, you must change the Image Area setting via the *i* button menu instead; the Fn button doesn't care to participate in Live View shooting.)

As with the Depth-of-Field Preview button, you can change the operation that's accomplished by pressing the button. Again, see Chapter 11 for help.

Hidden connections

Under the doors on the left side of the camera, you find the following connections, labeled in Figure 1-26:

Microphone jack: If you're not happy with the quality provided by the internal microphone, you can plug in an external microphone here. The jack accepts a 3.5mm microphone plug.

- USB port: One way to download images to your computer is to connect the camera and computer via the USB cable provided in the camera box. The small end of the cable goes into this port. Chapter 10 explains the downloading process.
- HDMI port: You can connect the camera to a high-def (HDMI) television via this port, but you need to buy a Type C mini-pin HDMI cable to do so. Chapter 12 has details about connecting your camera to a TV.
- Headphone jack: To enable you to monitor movie audio, you can attach headphones via this port. Your headphones need a 3.5mm plug.
- Accessory terminal: Here's where you attach the optional Nikon GP-1/GP-1A GPS (Global Positioning System) unit, the WR-1 and WR-R10/WR-T10 wireless remote controllers, and the MC-DC2 wired remote control. I don't cover these optional devices, so refer to the manuals that ship with them to find out more.

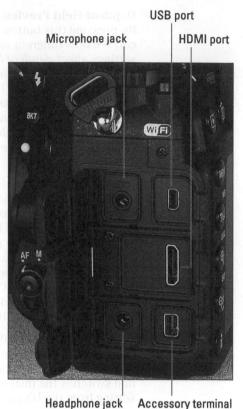

Figure 1-26: Connection ports for various cables and accessories are found under the covers on the left side of the camera.

If you turn the camera over, you find a tripod socket, which enables you to mount the camera on a tripod that uses a ¼" screw, plus the battery chamber. The other little rubber cover is related to the optional MB-D15 battery pack; you remove the cover when attaching the battery pack. Along the side of the battery cover, a little flap covers the connection through which you can attach the optional AC power adapter. The camera manual provides specifics on running the camera on AC power.

Familiarizing Yourself with the Lens

Because I don't know which lens you're using, I can't give you full instructions on its operation. But the following basics apply to most Nikon lenses as well as to certain third-party lenses. (You should explore the lens manual for specifics, of course.)

Focusing method (Auto or Manual): Assuming that your lens offers autofocusing as well as manual focusing, it has a switch that you use to choose between the two options. On the 18–140mm kit lens shown in Figure 1-27, choose M for Manual focus and A for Autofocus.

On the D7200, you also need to set the Focus-mode selector, labeled in the figure, to AF for autofocusing and M for manual focusing. For autofocusing, press the shutter button halfway to initiate autofocusing; to focus manually, rotate the focusing ring on the lens. The position of the focusing ring varies from lens to lens. Figure 1-27 shows its location on the 18–140mm kit lens.

By pressing the AF-mode button in the center of the Focus-mode selector, you access two settings that modify the default autofocusing behavior, a topic I save for Chapter 5.

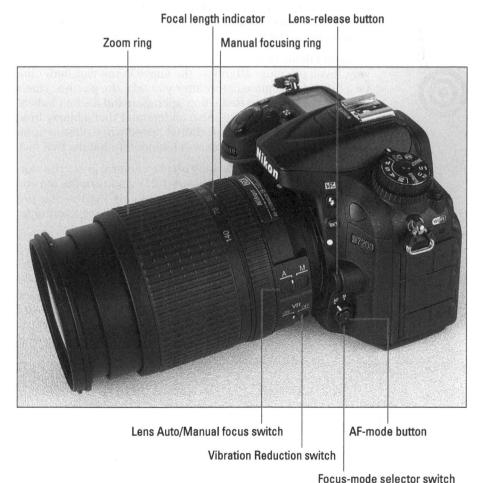

rocus-illoue selector switch

Figure 1-27: Set the focus mode both on the camera body and the lens.

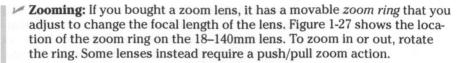

You can determine the current focal length of the lens by looking at the number that's aligned with the white dot labeled *focal-length indicator* in Figure 1-27. (If you're new to the term *focal length*, the nearby sidebar "Focal length and the crop factor," explains the subject.)

Enabling Vibration Reduction: Many Nikon lenses offer Vibration Reduction, which compensates for small amounts of camera shake that can occur when you handhold the camera. Camera movement during the exposure can produce blurry images, so turning on Vibration Reduction can help you get sharper handheld shots. When you use a tripod, however, turn the feature off so that the camera doesn't try to compensate for movement that isn't occurring. Turn Vibration Reduction on or off by using the VR switch (refer to Figure 1-27). The available settings vary depending on the lens, so again, see the lens manual for details.

Vibration Reduction is initiated when you depress the shutter button half-way. If you pay close attention, the image in the viewfinder may appear to be a little blurry immediately after you take the picture. That's a normal result of the Vibration Reduction operation and doesn't indicate a problem with your camera or focus. Also understand that a blurry image can be the result of using a too-slow shutter speed when photographing a moving subject; Vibration Reduction isn't intended to handle that focus issue.

Removing a lens: After turning off the camera, press the camera's lens-release button (refer to Figure 1-27), and turn the lens toward that button until it detaches from the lens mount. Put the rear protective cap onto the back of the lens and, if you aren't putting another lens on the camera, cover the lens mount with its cap, too.

Always switch lenses in a clean environment to reduce the risk of getting dust, dirt, and other contaminants inside the camera or lens. Changing lenses on a sandy beach, for example, isn't a good idea. For added safety, point the camera body slightly down when performing this maneuver; doing so helps prevent any flotsam in the air from being drawn into the camera by gravity.

Focal length and the crop factor

The angle of view that a lens can capture is determined by its *focal length*, or in the case of a zoom lens, the range of focal lengths it offers. Focal length is measured in millimeters.

According to photography tradition, a focal length of 50mm is described as a "normal" lens. Most point-and-shoot cameras feature this focal length, which is a medium-range lens that

works well for the type of snapshots that users of those kinds of cameras are likely to shoot.

A lens with a focal length under 35mm is characterized as a wide-angle lens because at that focal length, the camera has a wide angle of view, making it good for landscape photography. A short focal length also has the effect of making objects seem smaller and farther away. At the other end of the spectrum, a lens with a focal length longer than 80mm is considered a telephoto lens and is often referred to as a long lens. With a long lens, the angle of view narrows and faraway subjects appear closer and larger, which is ideal for wildlife and sports photographers.

Note, however, that the focal lengths stated here and elsewhere in the book are 35mm equivalent focal lengths. Here's the deal: For reasons that aren't really important, when you put a standard lens on most digital cameras, including the D7200, the available frame area is reduced, as if you took a picture on a camera that uses 35mm film negatives and cropped it. (Nikon refers to the image sensors used in this type of camera as a DX sensor.)

This *crop factor* varies depending on the camera, which is why the photo industry adopted the 35mm-equivalent measuring stick as a standard. With the D7200, the crop factor is roughly 1.5. In the figure here, the red line indicates the image area that results from the 1.5 crop factor.

When shopping for a lens, it's important to remember this crop factor to make sure that you get the focal length designed for the type of pictures you want to take. Just multiply the lens focal length by 1.5 to determine the actual angle of view. Not sure which focal length to choose? Point your web browser to http://imaging.nikon.com.click the link for Nikkor lenses, and then poke around until you find the link for the Nikkor Lens Simulator. (Sorry to be vaque, but Nikon seems to change the site layout as soon as I provide a complete link to a feature.) At any rate, this interactive tool enables you to see exactly how different focal-length lenses capture the same scene

Working with Memory Cards

To enable you to shoot oodles of pictures without having to swap out memory cards, the D7200 has two card slots. Open the cover on the right side of the camera to reveal them. The top slot is Slot 1; the bottom slot is Slot 2. The next section explains the options available to you when you install two cards; following that, I provide a few tips for buying and using SD cards.

Taking advantage of the two-card system

Here's what you need to know to make best use of the dual-card system:

- ✓ **Specifying how cards are used:** For still photography, you can specify how you want the camera to use the card in Slot 2. Open the Photo Shooting menu and choose Role Played by Card 2, as shown in Figure 1-28. You get three choices:
 - Overflow: This setting is the default. The camera fills the card in Slot 1 (the top slot) and then switches to the second card.
 - Backup: The camera records each picture to both cards. This
 option gives you some extra security should one card fail, you
 have a backup on the other card.
 - Raw Slot 1 JPEG Slot 2: This setting relates to the Image Quality option, which Chapter 2 explains. If you select one of the Raw (NEF)+JPEG settings, Raw files go on the card in Slot 1, and the JPEG files go on the card in Slot 2.

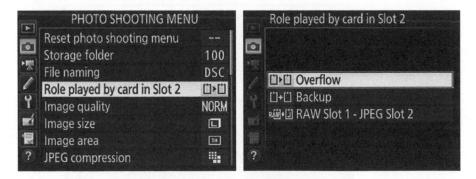

Figure 1-28: This option tells the camera how to use the card in Slot 2.

When you shoot movies, the camera automatically uses Card 1 to store the movie file. But if the card in Slot 2 has more empty space, you may want to put the movie file there. The option that enables you to do so lives on the Movie Shooting menu. From that menu, choose Destination,

as shown on the left in Figure 1-29. On the next screen, you can see the available recording time for each card. Select the card you want to use and press OK.

Monitoring card use in the Information display: You can tell which secondary slot function is in force by looking at the Image Quality readout of the Information screen, highlighted on the left in Figure 1-30. The card symbols tell you what's going where. In the figure, the symbols show that the camera is set up to send Raw files to Slot 1 and JPEG versions to Slot 2. (Fine represents one of three available settings for JPEG files.) If you see the same file type data for each card, the Backup option is selected. And if the file type label appears in only one card, with the other card appearing empty, the Overflow option is selected.

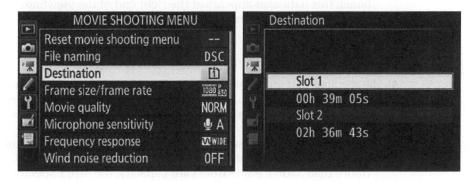

Figure 1-29: You can select which card you want to use to store your movie files.

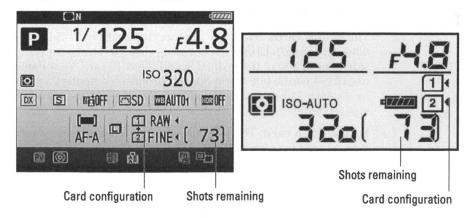

Figure 1-30: These symbols represent your memory cards.

- Monitoring card use in the Control panel: Symbols representing each card also appear in the Control panel, as shown on the right in Figure 1-30. If you set the slot function to Overflow, the number of the card currently in use appears (1 or 2). At the other settings, you see both a 1 and a 2, as in the figure, showing that both cards are in use.
- Determining how many more shots you can take: When you set the second card to the Backup or Raw/JPEG option, the number of shots depends on the card that contains the least amount of free space. When either card is out of space, you can't take any more pictures. For the Overflow option, the shots remaining value tells you how many pictures you can fit on the card in Slot 1 until you fill that card. Then it changes to indicate the space on the second card. Figure 1-30 reminds you where to find the shots-remaining value in the Information display and Control panel; this data also appears at the right end of the viewfinder and in the lower-right corner of the Live View still-photography display.

Buying and maintaining memory cards

As the medium that stores your picture files, the memory card is a critical component of your camera. See the steps at the start of this chapter for help installing a card; follow these tips for buying and maintaining cards:

- **Buying SD cards:** Again, you can use regular SD cards, which offer less than 4GB of storage space; SDHC cards (4GB−32GB); and SDXC cards (more than 32GB). Aside from card capacity, the other specification to note is *SD speed class*, which indicates how quickly data can be moved to and from the card (the *read/write speed*). For best performance, especially for movie recording, I recommend a speed class rating of 6 or 10 (currently the fastest SD speed class rating).
 - The newest cards also carry another designation, UHS-1, 2, or 3 (UHS for *ultra high speed*). UHS is a technology designed to boost data transmission speeds above the normal Speed Class 10 rate. Your camera can use UHS-1 cards, but Nikon doesn't promise compatibility with UHS-2 or -3 cards. The speed rating number appears on the card label inside a stylized letter U.
- Formatting a card: The first time you use a new memory card or insert a card that's been used in other devices, you need to *format* it to prepare it to record your pictures. You also need to format the card if you see the blinking letters *FOR* in the viewfinder or if the monitor displays a message requesting formatting.

Formatting erases everything on your memory card. So before you format a card, be sure that you've copied any data on it to your computer. After doing so, get the formatting job done by choosing Setup > Format Memory Card.

Removing a card: After making sure that the memory card access light on the back of the camera is off, indicating that the camera has finished recording your most recent photo, turn off the camera. Open the memory card door, depress the memory card slightly, and then let go. The card rises a little way out of the slot, enabling you to remove it.

If you turn on the camera when no card is installed, the symbol [-E-] appears in the lower-right corner of the viewfinder, and the image area of the viewfinder displays a blinking memory card symbol. A message on the monitor also nudges you to insert a memory card. If you have a card in the camera and you get these messages, try taking out the card and reinserting it. (Turn off the camera first.)

- When cards: Don't touch the gold contacts on the back of the card. When cards aren't in use, store them in the protective cases they came in or in a memory card wallet. Keep cards away from extreme heat and cold as well.
- Locking cards: The tiny switch on the top-left side of the card enables you to lock your card, which prevents any data from being erased or recorded to the card. If you insert a locked card into the camera, a message on the monitor alerts you, and the symbol [d blinks in the viewfinder. Slide the switch up to unlock the card.
- Using Eye-Fi memory cards: Your camera works with Eye-Fi memory cards, which are special cards that enable you to transmit your files wirelessly to your computer and other devices. That's a cool feature, but, unfortunately, the cards themselves are more expensive than regular cards and require some configuring that I don't have room to cover in this book. For more details, visit www.eye.fi.

If you use Eye-Fi cards, enable and disable wireless transmission via the Eye-Fi Upload option on the Setup menu. When no Eye-Fi card is installed in the camera, this menu option disappears.

Of course, for transferring files to a smartphone or tablet, you can instead use the camera's built-in Wi-Fi feature. Chapter 10 shows you how. This feature doesn't permit transferring files to a computer, however.

Taking a Few Final Setup Steps

Your camera offers scads of options for customizing its performance, some of which I discuss earlier in this chapter. Later chapters explain settings related to actual picture-taking, such as those that affect flash behavior and autofocusing, and Chapter 11 talks about some options that are better left at their default settings until you're fully familiar with your camera. That leaves just the handful of options covered in the next two sections that I recommend you consider at the get-go.

Cruising the Setup menu

The following options live on the Setup menu, which is the one marked with the little wrench icon and shown in Figure 1-31. The menu is a multiplepage affair (only Page 1 is visible in the figure); use the Multi Selector to scroll through the menu pages and access these settings:

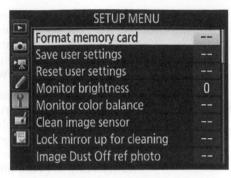

Figure 1-31: The Setup menu contains options related to the camera's general operation.

monitor may not be an accurate rendition of the picture exposure. I recommend that you keep the brightness at the default setting (0).

Clean Image Sensor: Your camera has an internal cleaning system designed to keep a filter that's fitted onto the image sensor free of dust and other debris, which can show up as small spots in your photos. To run the cleaner, choose Clean Image Sensor > Clean Now. Set the camera on a flat surface for best results. If you perform the cleaning sequence multiple times in a row, the camera may shut down briefly to give its circuitry a rest.

You can also tell the camera to perform automatic cleaning every time you turn the camera on or off, only at startup, only at shutdown, or never. To do so, select Clean at Startup/Shutdown instead of Clean Now. Then press the Multi Selector right and choose the cleaning option you prefer.

- Lock Mirror Up for Cleaning: This menu option moves the camera's internal mirror so that you can access the image sensor for manual cleaning. I don't recommend that you tackle this job yourself because you can easily damage the camera if you don't know what you're doing. If you are comfortable with the process, be sure that the camera battery is charged; the menu option disappears when the battery is low.
- ✓ Image Dust Off Ref Photo: This feature is related to an automated dust-spot remover found in Nikon Capture NX-D, a free program you can download from the Nikon website. You shoot a picture of a blank piece of paper and then load the image into the program. The program searches that image for dust spots and makes note of where in the frame they occur. When you open a real picture and run the dust-removal tool, the program targets those spots for cleanup.

I introduce this program in Chapter 10; check its Help system for information on using this feature. Bear in mind that it doesn't always work well. Areas where the dust spots appeared may simply look blurry after

- you run the tool. More importantly, it's available only for photos captured in the Raw (NEF) format. (Chapter 2 explains Raw images.)
- Monitor Color Balance: With this option, you can recalibrate the monitor if you think the screen is displaying colors incorrectly. I don't advise taking this step until you take the camera to a Nikon expert to make sure that it's your monitor, and not your picture or movie color settings, to blame. (Also be sure to calibrate your computer monitor to make sure that it displays pictures on a neutral canvas. Do an online search for monitor calibration tools to get tips on taking this step.)
- Non-CPU Lens Data: A CPU lens is equipped with technology that enables it to transmit certain data about the lens to the camera. When you use a non-CPU lens, you lose access to certain D7200 features. You can gain back a little of the lost functionality by registering your lens through this Setup menu option. You assign the lens a number you can register up to nine lenses and enter the maximum aperture and focal length of that lens.
- Location Data: If you purchase the optional Nikon GPS unit, this item holds settings related to its operation. This book doesn't cover this accessory, but the camera manual provides help to get you started.
- **Wi-Fi:** This option controls the built-in Wi-Fi transmitter, which enables you to link your camera to a smartphone or tablet. (See Chapter 10 for details.)

To save battery power, keep the Wi-Fi feature turned off, as it is by default, until you're ready to connect the camera to your smart device. When you do turn on the option, the nearby Network setting becomes available so that you can configure the wireless connection.

- ✓ NFC: Near Field Communication is a technology that enables the camera to communicate wirelessly with an NFC-enabled smartphone or tablet by simply bringing one device into contact with the other. At present, this feature works only with Android-based devices. If the camera senses an NFC device, it turns on the Wi-Fi system automatically. Set the NFC option to Off to disable this function.
- Conformity Marking: I bring this one up just so that you know you can ignore it. When you select the option, you see logos indicating that the camera conforms with certain camera-industry standards. I know you'll sleep better at night with that information.
- Firmware Version: Select this option to view which version of the camera *firmware*, or internal software, your camera runs. You see the firmware items C and L. At the time this book was written, C was version 1.00; L was 2.008.

Keeping your camera firmware up to date is important, so visit the Nikon website (www.nikon.com) regularly to find out whether your camera sports the latest version. You can find detailed instructions at the site on how to download and install any firmware updates.

Exploring Custom Setting menu options

A few options on the Custom Setting menu also warrant a quick look-see. In the following list, the first part of the option name points you to the submenu where you find the setting.

Shooting/display > Beep:
Through this option, shown in
Figure 1-32, you can tell the
camera to emit a beep to indicate
that focus is achieved when you
use certain autofocus settings.
The beep also sounds when
you use the Self-Timer Release
mode or certain Remote-Control
Release modes, if you try to take
a picture when the memory card
is locked, and when time-lapse
photography ends.

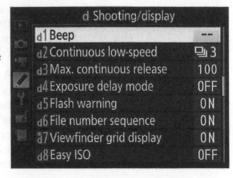

Figure 1-32: By default, the camera's beeper is disabled, enabling quieter shooting.

By default, the beep is disabled. If you want to hear the beep,

choose the Beep option and then set the volume and pitch of the beep. On the Information and Control panel displays, a little musical note icon appears when the beep is enabled.

Shooting/display > File Number Sequence: This option controls how the camera names your picture files. If you set this option to Off, the camera restarts file numbering at 0001 every time you format your memory card or insert a new memory card. Numbering is also restarted if you create custom folders (an advanced option covered in Chapter 11), or if the current folder is full and the camera automatically creates a new folder.

This setup can cause problems over time, creating a scenario where you wind up with multiple images that have the same filename — not on the current memory card, but when you download images to your computer. So, I strongly encourage you to stick with the default setting, On. At this setting, file numbering continues from the previous number used or from the largest file number in the current folder. Note that when you get to picture number 9999, file numbering is still reset to 0001, however. The camera automatically creates a new folder to hold your next images.

The Reset option tells the camera to look at the largest file number on the current card (or in the selected folder) and then assign the next-highest number to your next picture. If the card or selected folder is empty, numbering starts at 0001. Then the camera behaves as if you selected the On setting.

- Should you snap enough pictures to reach folder 999, and that folder contains either 9,999 pictures or a photo that has the file number 9999, the camera will refuse to take another photo until you choose that Reset option and either format the memory card or insert a brand-new one.
- Shooting/display > MB-D15 Battery Type and Battery Order: You don't need to worry about these two options unless you buy the optional MB-D15 battery adapter. If you use the battery pack, specify the type of battery you're using via the MB-D15 Battery Type menu option. Then use the Battery Order option to tell the camera whether you want it to draw power first from the battery pack or the regular camera battery when you have both installed. (See your camera manual for more details about using the battery pack.)
- Controls > Slot Empty Release Lock: This option determines whether the shutter release is disabled when no memory card is in the camera. At the default setting, OK, you can take a temporary picture, which appears in the monitor with the word *Demo* but isn't recorded anywhere. (The feature is provided mainly for use in camera stores, enabling salespeople to demonstrate the camera without having to keep a memory card installed.) I suggest that you change the setting to Release Locked. It's too easy to miss that *Demo* message and think you've recorded a picture when you really haven't.

Restoring default settings

Should you want to return your camera to its original, out-of-the-box state, the camera manual contains a complete list of all the default settings.

You can also partially restore default settings by taking these steps:

- Reset all Photo Shooting or Movie Shooting menu options: Choose Photo Shooting > Reset Photo Shooting Menu or Movie Shooting > Reset Movie Shooting Menu.
- Reset all Custom Setting Menu options: Choose Custom Setting > Reset Custom Settings.

ISO Q∷ Restore critical picture-taking settings without affecting options on the Custom Setting menu: Use the two-button reset method: Press and hold the Exposure Compensation button and the ISO button simultaneously for longer than two seconds. (The little green dots near the buttons are a reminder of this function.) See the camera manual for a list of exactly what settings are restored.

Shooting in Auto and Auto Flash Off Modes

Your camera is loaded with features for the advanced photographer, enabling you to exert precise control over options such as f-stop, shutter speed, ISO, flash power, and much more. But you don't have to wait until you master those topics to take great pictures, because your camera also offers point-and-shoot simplicity through its Auto exposure mode. Just for good measure, you also get Auto Flash Off mode, which works just like Auto mode but disables flash — a great option for shooting locations that don't permit flash.

The next two sections walk you through the process of taking a picture in both Auto modes using autofocusing and the default picture settings. The first section explains normal, through-the-viewfinder shooting; the second section shows you how to take a picture in Live View mode.

Viewfinder photography in the Auto modes

When you use the viewfinder to compose photos, follow these steps to take a picture:

1. Set the Mode dial to Auto or Auto Flash Off.

I labeled these settings in Figure 1-33. The two modes are identical except that Auto Flash Off disables the built-in flash. In Auto mode, the flash is set by default to fire if the camera thinks added light is needed. Remember to press and hold the Mode dial unlock button before rotating the Mode dial.

2. Set the Release Mode dial to the S position, as shown in Figure 1-33.

The S represents the Single Frame setting, which captures one photo each time you fully press the shutter button. Again, you can't rotate the Release Mode dial without holding down its unlock button.

3. Set the focus-method switches on the camera and lens to the autofocus position, as shown in Figure 1-34.

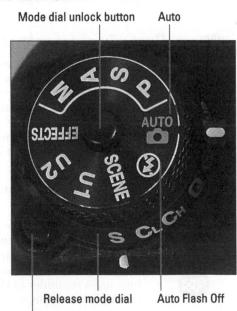

Release mode dial unlock button

Figure 1-33: Remember to press the unlock buttons before rotating the Mode and Release Mode dials.

If your lens offers Vibration Reduction, set the VR switch to On, as shown in the figure, if you're not using a tripod. Vibration Reduction helps compensate for camera shake that can blur a photo.

4. Looking through the viewfinder, compose the shot so that your subject is within the autofocus brackets, labeled in Figure 1-35.

The camera's autofocusing points are scattered throughout the area indicated by the brackets.

5. Press and hold the shutter button halfway down.

The following occurs:

• Exposure metering begins.

The autoexposure meter analyzes the light and selects the initial exposure settings. The camera continues monitoring the light up to the time you take the picture, however, and may adjust the exposure settings if lighting conditions change. In Auto mode, the built-in flash pops up if the camera thinks additional light is needed.

In Auto Flash Off mode, the camera may need to use a very high ISO setting or very slow shutter speed to expose the photo. A high ISO can create *noise*, a defect that makes your Lens Auto/Manual focus switch

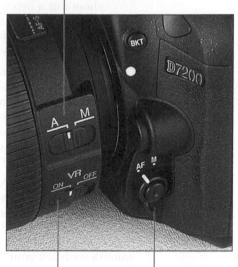

Focus-mode selector

Vibration Reduction switch

Figure 1-34: For autofocusing, be sure to set both the camera and lens to autofocus mode.

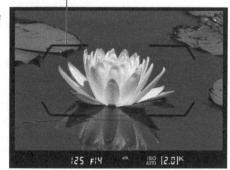

Figure 1-35: Position your subject within the area surrounded by the autofocus brackets.

picture look grainy, and a slow shutter speed can produce blur if either the camera or subject moves during the exposure. If you spot either problem, switch to Auto mode or add some other light source. (Chapter 4 explains ISO and shutter speed.)

- The autofocus system begins to do its thing. The AF-assist lamp may shoot out a beam of light to help the autofocusing system find a focusing target. One or more rectangles, representing focus points, flash red in the viewfinder to show you where the camera is trying to set focus — usually on the object closest to the lens.
- The shots remaining value changes to display the buffer capacity, as shown in Figure 1-36. Again, the buffer is a temporary storage tank where the camera stores picture data until it has time to record that data to the memory card. You don't need to worry about this number (21, in the figure) when using the Single Frame Release mode; the buffer comes into play only during continuous (burst) mode shooting, which you can read about in Chapter 2.

As for the tiny letters ADL in the viewfinder, they refer to Active D-Lighting, an exposure-adjustment feature that I explain in Chapter 4. The letters appear when the feature is enabled; you can't turn the option off in Auto mode. But don't fret: Active D-Lighting is applied to improve exposure when your scene contains both very light and dark areas. The camera analyzes your shot and chooses the best Active D-Lighting setting for the scene.

6. Check the focus indicators in the viewfinder.

When the camera has established focus, a single black focus point appears, as shown in Figure 1-36. At the bottom of the viewfinder, the focus indicator, labeled in the figure, lights to give you further notice that focus has been achieved.

If the subject isn't moving, autofocus remains locked as long
as you hold the shutter button
halfway down. But if the camera
detects subject motion, it adjusts
focus up to the time you press
the button fully to record the picture. As your subject moves, keep
it within the autofocus brackets
to ensure correct focusing.

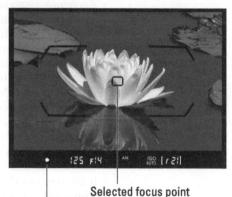

Focus indicator light

Figure 1-36: The white dot indicates that the camera locked focus on the object under the black focus point.

A triangle to the right or left of the spot where the focus dot should appear means that focus isn't yet spot on. If the triangle is pointing right, focus is set in front of the subject; if the triangle points left, focus is set behind the subject. And if both triangles blink, the autofocus system is stymied, so switch to manual focusing or release the shutter button and press halfway again to try refocusing.

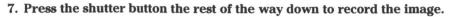

If the camera refuses to take the picture, don't panic: This error is likely related to autofocusing. By default, the camera insists on achieving focus before it releases the shutter to take a picture. You can press the shutter button all day, and the camera just ignores you if it can't set focus.

Try backing away from your subject a little — you may be exceeding the minimum focusing distance of the lens. If that doesn't work, the subject just may not be conducive to autofocusing. Highly reflective objects, scenes with very little contrast, and subjects behind fences are some of the troublemakers. The easiest solution? Switch to manual focusing and set focus yourself.

While the camera sends the image data to the memory card, the memory card access lamp lights. Don't turn off the camera or remove the memory card while the lamp is lit or else you may damage both camera and card.

To view the picture, press the Playback button. See Chapter 9 for playback details.

Live View photography in Auto mode

For still photography, I don't use Live View mode very often, for these reasons:

- When you shoot outdoors in bright light, the Live View display washes out, making it difficult to get a good look at your subject. If you do a lot of outdoor Live View shooting, you may want to invest in a monitor hood, which shades the display to make it easier to see. (Do an Internet search on "Nikon monitor hood" to investigate your options.)
- Live View autofocusing is slower than viewfinder autofocusing. This issue has to do with the fact that the camera uses a different autofocusing system when Live View is enabled than it does for viewfinder shooting.
- The risk of camera shake blurring your image increases. Any movement of the camera during the exposure can blur your photo. This is true for viewfinder photography, too, but when you use the viewfinder, you can brace the camera against your face. With Live View, you have to hold the camera out in front of you, making it more difficult to keep the camera steady during the shot. Long story short: Use a tripod for best Live View results.
- The monitor is one of the biggest drains on the camera battery. That means you have to stop shooting and recharge the battery more often than when using the viewfinder.

By default, the Live View display shuts down after ten minutes of inactivity. When shutdown is 30 seconds away, a countdown timer appears in the upper-left corner of the screen. You can adjust the shutdown timing via the Monitor Off Delay option, found on the Timers/AE Lock submenu of the Custom Setting menu; Chapter 11 has the details.

Using Live View for an extended period can harm your pictures and the camera. In Live View mode, the camera's innards heat up more than usual, and that extra heat can create the proper electronic conditions for noise, a defect that gives your pictures a speckled look. Perhaps more importantly, the increased temperatures can damage the camera. For that reason, Live View is automatically disabled if the camera detects a critical heat level. In extremely warm environments, you may not be able to use Live View mode for long before the system shuts down.

When the camera is 30 seconds or fewer from shutting down, the countdown timer appears to let you know how many seconds remain for shooting. The warning doesn't appear during picture playback or when menus are active, however.

I do find Live View helpful for shooting still-life photos, however. Being able to see the scene on the monitor saves me from having to repeatedly check the viewfinder while I'm arranging objects in the scene. (You can always use Live View while composing your shot and then exit Live View to actually take the picture, which is my normal course of action.)

Enough preamble: Here are the steps to take a Live View picture in Auto or Auto Flash Off mode using autofocusing and the default picture settings:

- 1. Set the Mode dial on top of the camera to Auto or Auto Flash Off.
- 2. Set the Live View switch to the Still Photo position, as shown in Figure 1-37, and then press the LV button to engage Live View.

The viewfinder goes dark, and the scene in front of the lens appears on the monitor, along with some shooting data.

Press the Info button to cycle through the available Live View displays.

- 3. Compose your shot.
- Check the position of the focusing frame.
 If necessary, adjust the frame so that it's over your subject.

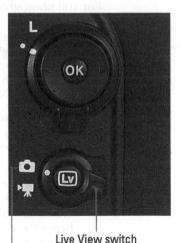

Still Photography mode

Figure 1-37: Set the Live View switch to the still-camera position and then press the LV button to turn on the Live View display.

The autofocus frame that appears depends on your subject:

- Portraits: By default, the camera uses an autofocusing option called Face Priority AF-area mode. If it detects a face, it displays a yellow focus box over it (refer to the left side of Figure 1-38). In a group portrait, you may see several boxes: The one that includes the interior corner marks (refer to the figure) indicates the face that will be used to set the focusing distance. To use a different face as the focus point, use the Multi Selector to move the focus box over it.
- Other subjects: Anytime the camera can't detect a face, it switches
 to Wide Area AF-area mode, with the focus area indicated by a
 red box in the center of the screen (refer to the right side of
 Figure 1-38). Again, use the Multi Selector to move the focus box
 over your subject. Press the OK button to move the focus box
 quickly back to the center of the frame.

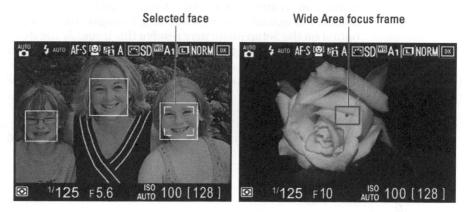

Figure 1-38: If the camera recognizes faces, you see yellow focus frames over each face (left); otherwise, the red, rectangular focus frame appears (right).

5. Press the shutter button halfway to set focus and initiate exposure metering.

When focus is set, the focus box turns green. In dim lighting, the built-in flash pops up if you selected the Auto exposure mode in Step 1.

In Live View mode, the camera always locks focus when you press the shutter button halfway, even if the subject is moving. To find out how to change this default autofocusing behavior, see Chapter 5.

6. Press the shutter button all the way down to record the picture.

The photo appears briefly on the monitor, and then the live preview reappears.

A few additional tips for getting the best Live View results:

- Cover the viewfinder to prevent light from seeping into the camera and affecting exposure. The camera ships with a cover designed for this purpose. Slide the rubber eye-cup that surrounds the viewfinder up and out of the groove that holds it in place; then slide the cover down into the groove. (Orient the cover so that the Nikon label faces the viewfinder.)
- Aiming the lens at the sun or another bright light can damage the camera. Of course, you can cause problems by doing this even during viewfinder shooting, but the possibilities increase when you use Live View. You can harm not only the camera's internal components but also the monitor (not to mention your eyes).
- Some lights may interfere with the Live View display. The operating frequency of some types of lights, including fluorescent and mercury-vapor lamps, can create electronic interference that causes the monitor display to flicker or exhibit odd color banding. Changing the Flicker Reduction option on the Setup menu may resolve this issue. At the default setting, Auto, the camera gauges the light and chooses the right setting for you. But you also can choose from two specific frequencies: 50 Hz and 60 Hz. (In the United States and Canada, the standard frequency is 60 Hz; in Europe, it's 50 Hz.)

Certain Live View features work differently when you're shooting movies; see Chapter 8 for the whole story on recording video with your D7200.

Reviewing Five Essential Picture-Taking Options

In This Chapter

- Selecting an exposure mode
- Changing the shutter-release mode
- Choosing the right Image Size setting
- ▶ Understanding the Image Quality setting: JPEG or Raw?
- Exploring the 1.3x crop option (Image Area setting)

very camera manufacturer strives to ensure that your initial encounter with the camera is a happy one. To that end, the D7200's default settings are designed to make it easy to take a good picture the first time you press the shutter button. The camera is set to the Auto exposure mode, which means that all you need to do is frame, focus, and shoot, as outlined at the end of Chapter 1.

Although the default settings deliver acceptable pictures in many cases, they don't produce optimal results in every situation. You may be able to take a decent portrait in Auto mode, for example, but by tweaking a few settings, you can turn that decent portrait into a stunning one.

This chapter helps you start fine-tuning the camera settings by explaining five basic picture-taking options: exposure mode, shutter-release mode, image size, image quality, and image area. They're not the most exciting features (don't think I didn't notice you stifling a yawn), but they make a big difference in how easily you can capture the photo you have in mind. You should review these settings before each photo outing.

Choosing an Exposure Mode

The first setting to consider is the exposure mode, which determines how much control you have over two critical exposure settings — aperture and shutter speed — as well as many other options. Select the exposure mode by pressing the Mode dial unlock button, labeled in Figure 2-1, and then rotating the dial until the symbol representing the mode you want to use aligns with the white bar to the right of the dial. In the figure, Auto mode is selected.

Exposure modes fall into three categories: fully automatic, semiautomatic, and manual. The next three sections provide the background you need to choose the right mode.

Mode dial unlock button Mode dial Auto Flash off AUTO AUT

Figure 2-1: The Mode setting determines how much input you have over exposure, color, and other picture options.

Fully automatic exposure modes

My guess is that you bought this book for help with using the camera's advanced exposure modes, so they receive the majority of the page space. But until you have time to digest that information — or if you just need a break from thinking about the advanced options — you can take advantage of point-and-shoot modes outlined in the next three sections.

Because these modes are designed to make picture-taking simple, they prevent you from accessing many of the camera's features. You can't use the White Balance control, for example, to tweak picture colors. Options that are off-limits appear dimmed in the camera menus.

Auto and Auto Flash Off modes

In both modes, the camera analyzes the scene and selects what it considers the most appropriate settings to capture the image. The only difference between the two modes is that Auto Flash Off (labeled in Figure 2-1) disables flash. In Auto mode, you can choose from a few Flash modes, which I detail in Chapter 3.

The last two sections in Chapter 1 show you how to take pictures using Auto and Auto Flash Off modes.

Effects mode

This mode works like Auto except that the camera applies one of seven special effects to the picture. Chapter 12 provides details on Effects mode and also explains how you can apply effects to existing pictures via the Retouch menu.

You can shoot movies as well as still photos in Effects mode. However, you must select the effect you want to use prior to switching the camera to movie-recording mode. Chapter 8 explains movie recording.

Scene modes

You also get a batch of automatic modes designed to capture specific subjects in ways deemed best according to photography tradition. For example, in Portrait mode, skin tones are manipulated to appear warmer and softer, and the background appears blurry to bring attention to your subject, as shown on the left in Figure 2-2. In Landscape mode, greens and blues are intensified, and the camera tries to maintain sharpness in both near and distant objects, as shown on the right in the figure.

Portrait mode

Figure 2-2: Portrait mode produces pleasant skin tones and a soft background; Landscape mode delivers vivid colors and keeps both foreground and background objects sharp.

To experiment with Scene modes, set the Mode dial to Scene and press the Info button to display the Information screen. An icon representing the current Scene mode appears in the upper-left corner of the screen, as shown on the left in Figure 2-3. Rotate the Main command dial to shift to the selection screen shown on the right; keep spinning the dial to cycle through the Scene types. To lock in your setting and return to shooting mode, press the shutter button halfway and release it.

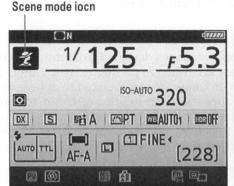

Figure 2-3: After setting the Mode dial to Scene, rotate the Main command dial to scroll through additional Scene types.

While either of the screens shown in Figure 2-3 is displayed, you can press the Help button to view information about the current Scene mode.

Figure 2-3 shows how things look for viewfinder photography, but you see the same Scene icon and scene-selection screen in Live View mode. However, when the camera is set to movie mode, you can't change the Scene mode. You must flip the switch to the still-camera symbol, change the Scene mode, and then return to movie-recording mode. You also can't display the scene-description Help screens in Live View mode.

For the most part, the process of taking pictures in the Scene modes is the same as for shooting in Auto mode. For a few Scene modes, however, some variations come into play:

Autofocusing: In most Scene modes, the camera bases focus on the nearest object. But in Close Up, Candlelight, Food, Sports, and Pet Portrait modes, focus is based on the center focus point. To choose a different focus point, look through the viewfinder and then use the Multi Selector to highlight the focus point you want to use. (You may need to give the shutter button a quick half-press to wake up the camera before

you can do so.) Also be sure that the Focus Selector Lock Switch (the switch that surrounds the OK button) is set to the white dot position. If you set the switch to L, you can't change the selected focus point.

In Sports and Pet Portrait modes, the camera sets the initial focus when you press the shutter button halfway, but then adjusts focus as necessary up to the time you press the button the rest of the way to take the shot. In the other modes, focus is locked as long as you keep the shutter button pressed halfway.

Release mode: Sports mode and Pet Portrait mode use the Continuous High shutter-release setting, which means that the camera records a burst of images as long as you hold down the shutter button. See the later section "Setting the Shutter-Release Mode" for more about this setting.

Flash: To use the built-in flash in Food mode, press the flash button to raise the flash. Close the flash unit to go flash free. In other Scene modes, the camera decides whether to use flash, but you may be able to choose from a few different flash settings. The next chapter outlines flash options.

Semi-automatic modes (P, S, and A)

To take more creative control but still get some exposure assistance from the camera, choose one of these modes:

- P (programmed autoexposure): The camera selects the aperture and shutter speed necessary to ensure a good exposure. But you can choose from different combinations of the two to vary the creative results. For example, shutter speed affects whether moving objects appear blurry or sharp. So you might use a fast shutter speed to freeze action, or you might go the other direction, choosing a shutter speed slow enough to blur the action, creating a heightened sense of motion. Because this mode gives you the option to choose different aperture/shutter speed combos, it's sometimes referred to as flexible programmed autoexposure.
- ✓ S (shutter-priority autoexposure): You select the shutter speed, and the camera selects the aperture. This mode is ideal for capturing sports or other moving subjects because it gives you direct control over shutter speed.
- A (aperture-priority autoexposure): In this mode, you choose the aperture, and the camera sets the shutter speed. Because aperture affects depth of field, or the distance over which objects in a scene appear sharply focused, this setting is great for portraits because you can select an aperture that results in a soft, blurry background, putting the emphasis on your subject. For landscape shots, on the other hand, you might choose an aperture that produces a large depth of field so that both near and distant objects appear sharp and therefore have equal visual weight in the scene.

All three modes give you access to all the camera's features. So even if you're not ready to explore aperture and shutter speed, go ahead and set the mode dial to P if you need to access a setting that's off-limits in the fully automated modes. The camera then operates pretty much as it does in Auto mode, but without limiting your ability to control picture settings if you need to do so.

When you're ready to make the leap to P, S, or A mode, look to Chapter 4 for assistance. In addition, check out Chapter 5 to find out ways beyond aperture to manipulate depth of field.

Manual exposure mode (M)

In Manual mode, you take the exposure reins completely, selecting both aperture and shutter speed as follows:

- ✓ To set the shutter speed: Rotate the Main command dial.
- ✓ To set the aperture: Rotate the Sub-command dial.

Even in Manual exposure mode, the camera offers an assist by displaying an exposure meter to help you dial in the right settings. (See Chapter 4 for details.) You have complete control over all other picture settings, too.

One important and often misunderstood aspect of Manual exposure mode: Setting the Mode dial to M has no bearing on focusing. You can still choose manual focusing or autofocusing, assuming that your lens offers autofocusing.

U1 and U2

These two settings represent the pair of custom exposure modes that you can create. (The U stands for user.) They give you a quick way to immediately switch to all the picture settings you prefer for a specific type of shot. For example, you might store the options you like to use for indoor portraits as U1 and store settings for sports shots as U2.

For step-by-step instructions, check out Chapter 11.

Setting the Shutter-Release Mode

By using the Release mode setting, you tell the camera whether to capture a single image each time you press the shutter button, record a burst of photos as long as you hold down the shutter button, or use Self-Timer mode, which delays the image capture until a few seconds after you press the shutter button. You also get two options related to wireless remote control shooting and Quiet Shutter mode, which dampens the normal shutter-release sounds.

Why *Release mode?* It's short for *shutter-release mode*. Pressing the shutter button tells the camera to release the *shutter* — an internal light-control mechanism — so that light can strike the image sensor and expose the image. Your choice of Release mode determines when and how that action occurs.

The primary point of control for shutter release is the Release mode dial, shown in Figure 2-4. To change the setting, press and hold the Release mode dial unlock button (labeled in the figure) while rotating the dial. The letter displayed next to the white marker represents the selected setting. For example, in Figure 2-4, the S is aligned with the marker, showing that the Single Frame mode is selected.

The Information display includes a symbol representing the current Release mode as well, as shown in Figure 2-5. (The S symbol represents the Single Frame mode.)

Upcoming sections explain the various Release modes (and their symbols) and introduce you to a few menu options that also affect the shutter release.

One note in advance: If you've worked with another Nikon dSLR with a Release mode dial, you may expect to find a dial setting designed for use with the wireless ML-L3 remote control unit. But on the D7200, you instead enable wireless remote shooting via the Remote Control Mode (ML-L3) option on the Photo Shooting menu. See "Wireless remote-control shooting with the Nikon ML-L3," later in the chapter, for details.

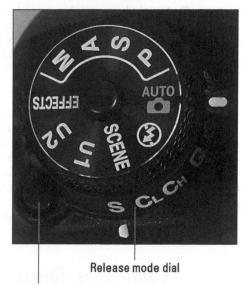

Release mode dial unlock button

Figure 2-4: You can choose from a variety of Release modes.

Release mode

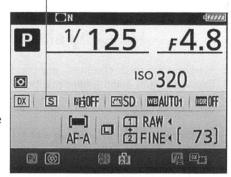

Figure 2-5: This symbol represents the current Release mode.

Single Frame and Quiet modes

- Single Frame mode produces one picture each time you press the shutter button. In other words, this is normal-photography mode.
- Quiet Shutter Release mode works just like Single Frame mode but makes less noise as it goes about its business. Designed for situations when you want the camera to be as silent as possible, this mode disables the beep that the autofocus system may sound when it achieves focus. (The beep sounds only if you enable it through the Beep setting on the Custom Setting menu; it's turned off by default.)

Additionally, Quiet Shutter Release mode affects the operation of the internal mirror that causes the scene coming through the lens to be visible in the viewfinder. Normally, the mirror flips up when you press the shutter button and then flips back down after the shutter opens and closes. This mirror movement makes some noise. In Quiet Shutter Release mode, you can prevent the mirror from flipping down by keeping the shutter button pressed after the shot. This feature enables you to delay the final mirror movement — and its accompanying sound — to a moment when the noise won't be objectionable.

Continuous (burst mode) shooting

Setting the Release mode dial to Continuous Low or Continuous High enables *burst mode* shooting. That is, the camera records a continuous burst of images for as long as you hold down the shutter button, making it easier to capture fast-paced action.

Hey, my shutter button isn't working!

You press the shutter button . . . and press it, and press it — and nothing happens. Don't panic: Your problem is likely related to one of these two menu options:

- Custom Setting > Autofocus > AF-S Priority Selection: By default, this setting is set to Focus, which tells the camera not to release the shutter if focus can't be achieved when you use autofocusing and the AF-S Focus mode. The same thing happens if you use the AF-A mode and the camera automatically selects the AF-S mode for you.
- (Chapter 5 details these Focus modes.) Change the setting to Release if you want the picture to be captured regardless of whether focus is achieved.
- Custom Setting > Controls > Slot Empty Release Lock: This option controls whether the shutter button is released if you don't have a memory card in the camera. If you took my advice at the end of Chapter 1 and set the option to Release Locked, the shutter button ignores you until you insert a card.

Here's how the two modes differ-

Continuous Low: In this mode. you can tell the camera to capture from 1 to 6 frames per second (fps). Set the maximum frame rate by choosing Custom Setting > Shooting/Display > Continuous Low-speed, as shown in Figure 2-6. The default is 3 fps.

Why would you want to capture fewer than the maximum number of shots? Well, frankly, unless you're shooting something that's moving at a really fast pace, not too much is going to change between frames when you shoot

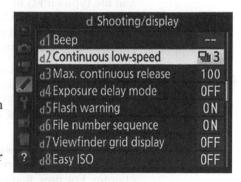

Figure 2-6: You can modify the maximum frame rate for Continuous Low Release mode.

at 6 frames per second. So when you set the burst rate that high, you typically wind up with lots of shots that show the exact same thing. wasting space on your memory card. I keep this value set to the default 3 fps and then, if I want a higher burst rate, I use the Continuous High setting, explained next.

The Release mode symbol in the Information display shows you the current frames-per-second setting. (Look for the Release mode symbol in the area highlighted in Figure 2-5.)

Continuous High: This mode works just like Continuous Low except that it records up to 6 frames per second. You can't adjust the maximum capture rate as you can for Continuous Low. However, you may be able to boost the rate to 7 frames per second by adjusting some other camera settings. (Keep reading for details.)

For both modes, you can limit the maximum number of shots taken with each press of the shutter button. Again, the idea behind this feature is to prevent lots of wasted frames. Make the adjustment by choosing Custom Setting > Shooting/Display > Max Continuous Release. (The option lives directly below the Continuous Low-Speed option shown in Figure 2-6.)

A few other critical details about these two release modes:

- ✓ You can't use flash. Continuous mode doesn't work with flash because the time that the flash needs to recycle between shots slows down the capture rate too much. So even if the Release mode dial is set to CL or CH, you get one shot for each press of the shutter button if the flash is raised.
- Images are stored temporarily in the memory buffer. The camera has some internal memory — a buffer — where it stores picture data until it has time to record it to the memory card. The number of pictures the

buffer can hold depends on certain camera settings, such as resolution and file type (JPEG or Raw). In the viewfinder, Information display, and Live View display, the buffer capacity appears in place of the shots-remaining value when you press the shutter button halfway. For example, if you see the value [r 21], the buffer can hold 21 frames.

After shooting a burst of images, wait for the memory card access light on the back of the camera to go out before turning off the camera. That's your signal that the camera has moved all data from the buffer to the memory card. Turning off the camera before that happens may corrupt the image file.

- The maximum frames-per-second (fps) rate depends on the Image Quality and Image Area settings. I detail both settings later in this chapter. For now, just be aware of their impact on the actual capture rate the camera delivers:
 - If the Image Area option is set to DX (the default) and the Image Quality option is set to 14-bit NEF (Raw): The maximum fps drops from 6 to 5 for both the Continuous Low and Continuous High Release modes. (Even if you select 6 fps as the Continuous Low-Speed option, the camera maxes out at 5 fps.) Why the slowdown? Because the 14-bit NEF (Raw) setting increases the image file size, and it takes more time for the camera to write the data to the memory card.
 - If the Image Area setting is 1.3x and the Image Quality setting is JPEG (the default) or 12-bit NEF (Raw): The maximum fps for Continuous High goes up to 7 fps. The camera can achieve this faster pace because the 1.3x Image Area setting captures a smaller image than normal, resulting in a smaller file size and faster data transfer. You just have to avoid setting the Image Quality setting to the 14-bit NEF (Raw) option, or you'll offset the reduction in file size.
- ✓ Your mileage may vary. The actual number of frames you can capture depends on a number of other factors, too, including your shutter speed. At a slow shutter speed, the camera may not be able to reach the maximum frame rate. Enabling Vibration Reduction also can reduce the frame rate, as can a weak battery. Additionally, although you can capture as many as 100 frames in a single burst, the frame rate can drop if the buffer gets full.

Self-timer shooting

You're no doubt familiar with Self-Timer mode, which delays the shutter release for a few seconds after you press the shutter button, giving you time to dash into the picture. Here's how it works on the D7200: After you press the shutter button, the AF-assist illuminator on the front of the camera starts to blink. If you enabled the camera's voice via the Beep option on the Custom Setting menu, you also hear a series of beeps. A few seconds later, the camera captures the image.

By default, the camera waits 10 seconds after you press the shutter button and then records a single image. But you can tweak the delay time, set the camera to capture as many as nine shots each time you press the shutter button, and specify how long you want the camera to wait between recording those successive shots. Set your preferences by choosing Custom Setting > Timers/AE Lock > Self-Timer, as shown in Figure 2-7.

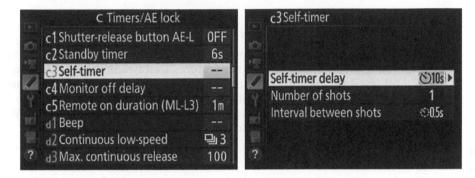

Figure 2-7: Set up self-timer shooting via this Custom Setting menu option.

Two more points to note about self-timer shooting:

- Using flash disables the multiple frames recording option. The camera records just a single image, regardless of the Number of Shots setting.
- Cover the viewfinder if possible. Otherwise, light may seep into the camera through the viewfinder and affect exposure. Your camera comes with a viewfinder cover made just for this purpose.

Mirror lockup (MUP)

One component of the optical system of your camera is a mirror that moves every time you press the shutter button. The small vibration caused by the action of the mirror can result in slight blurring of the image when you use a very slow shutter speed, shoot with a long telephoto lens, or take extreme close-up shots.

Mup To cope with that issue, the D7200 offers mirror-lockup shooting, which delays opening the shutter until after the mirror movement is complete. Enable the feature by setting the Release mode to Mirror Up (labeled MUP on the Release Mode dial).

Mirror-lockup shooting requires a two-step process. After framing and focusing, press the shutter button all the way down. This step locks the mirror up, and you can no longer see anything through the viewfinder. To record the

shot, let up on the shutter button and then press it all the way down again. (If you don't take the shot within about 30 seconds, the camera will record a picture for you automatically.)

Situations that call for mirror lockup also call for a tripod: Even with the mirror locked up, the slightest jostle of the camera can cause blurring. Using a remote control to trigger the shutter release is also a good idea.

Off-the-dial shutter release features

In addition to the Release modes you can select from the Release mode dial, you have access to three other features that tweak the way the shutter is released, all explained next. In addition, if you own a compatible smartphone or tablet, you can connect it to your camera via Wi-Fi and then use the device to trigger the shutter release. See Chapter 10 for help with initial Wi-Fi setup; Chapter 12 spells out how to use the shutter-release function.

Exposure Delay mode

As an alternative to mirror lockup, you can use the Exposure Delay feature when you want to ensure that the movement of the mirror doesn't cause enough vibration to blur the shot. Through this option, you can tell the camera to wait 1, 2, or 3 seconds after the mirror is raised to capture the image.

Choose Custom Setting > Shooting/Display > Exposure Delay Mode to turn on the feature. To help remind you that the feature is enabled, the letters DLY appear in the Information display and default Live View display. (Press the Info button to change the display during Live View shooting.)

Exposure Delay mode isn't compatible with Continuous High or Continuous Low shooting. If you enable it in those modes, you get one image for each press of the shutter button rather than a burst of frames.

At the end of your Exposure Delay series, always return to the menu and turn the feature off. Otherwise, I can pretty much guarantee that you'll forget that you asked for the delay and spend frustrating moments trying to figure out why the shutter isn't responding immediately to the shutter button. (Or maybe it's just me. . . .)

Wireless remote-control shooting with the Nikon ML-L3

To use the Nikon ML-L3 wireless remote to trigger the shutter release, select Remote Control Mode (ML-L3) from the Photo Shooting menu or *i* button menu. You have the following capture options:

- Delayed Remote: The shutter is released 2 seconds after you press the button on the remote control unit.
- Quick-Response Remote: The shutter opens immediately after you press the button.

- ✓ Remote Mirror-Up: Enables you to use the remote for mirror-up shooting, a technique explained earlier in the chapter.
- ✓ **Off (default):** The camera doesn't respond to the remote.

Interval Timer Shooting

Your D7200 offers automatic *time-lapse photography*, which enables you to record a series of shots over a specified period of time without having to stick around to the press the shutter button for each shot. You can space the shots minutes or even hours apart, and you can record as many images as your memory card can hold. Nikon calls this feature *Interval Timer Shooting*.

A few restrictions apply: The feature doesn't work in Live View mode or with the ML-L3 wireless remote. Additionally, you must set the Release mode to a setting other than Self-Timer or Mirror Up mode. (Note that if you use one of the Continuous Release mode options, the camera records your shots as if Single Frame or Quiet Mode were selected, taking one frame at a time, according to the Interval Timer Shooting options you choose.) Finally, if you change the Assign Shutter Button option on the Custom Setting menu to Record Movies, a feature I talk about in Chapter 12, you give up the right to use Interval Timer Shooting.

On the other hand, if you care to get really tricky, you can combine automatic bracketing with Interval Timer Shooting. At each interval, the camera records the number of shots specified for the bracketed series. See the end of Chapter 4 for details on how to establish bracketing settings. (You must set these options before beginning Interval Timer Shooting.)

Follow these steps to set up your time-lapse photo shoot:

1. Choose Interval Timer Shooting from the Photo Shooting menu, as shown on the left in Figure 2-8, and press OK.

The screen on the right in Figure 2-8 appears.

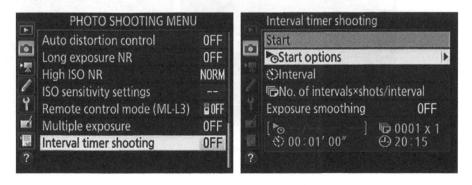

Figure 2-8: The Interval Timer Shooting feature enables you to do time-lapse photography.

2. Choose Start Options to specify when you want the interval-timing session to begin.

The screen shown on the left in Figure 2-9 appears. You get two choices:

- Now: Select this option to begin capturing frames after you complete the shooting setup. Press OK to return to the main setup screen.
- Choose Start Day and Start Time: Select this setting to display the screen shown on the right in Figure 2-9. Use the Multi Selector to set the date, hour, and minute that you want the interval captures to begin. Press the OK button to lock in your choices and return to the main setup screen.

The Start Time option is based on a 24-hour clock, as is the Interval option (explained next). The current time appears in the lower-right corner of the screen and is based on the date/time information you entered when setting up the camera. (Look for the Time Zone and Date setting on the Setup menu.)

3. Select Interval to set the delay time between captures.

You can specify the interval in hours, minutes, and seconds. Make sure that the delay time between frames is longer than the shutter speed you plan to use. Press OK after entering the interval values.

4. Select Number of Intervals x Shots/Interval to display a screen where you can set the number intervals and frames per interval.

You can specify a maximum of nine frames per interval. (Multiplying the two values determines the total number of frames that will be recorded.)

After entering the interval and frames values, press OK to return to the main setup screen.

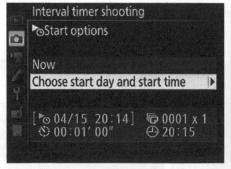

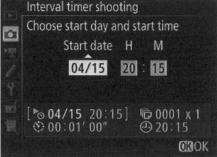

Figure 2-9: You can specify the starting time of the interval captures.

5. Enable or disable Exposure Smoothing.

Exposure Smoothing tells the camera to try to match the exposure of each shot to the one taken previously. Obviously, if your goal is a series of frames that show how the subject appears as the sun rises and falls, you should turn this option off, as it is by default. You may want to enable it, however, if you're shooting a subject that will be illuminated with a consistent light source throughout the entire shooting time or if the light may change only slightly, such as when recording a humming-bird at a feeder during an afternoon.

The Exposure Smoothing option doesn't work in the M (manual) exposure mode unless you enable Auto ISO Sensitivity, which gives the camera permission to increase the ISO setting as necessary to maintain a consistent exposure. Enable the option via the ISO Sensitivity Settings item on the Photo Shooting menu. (Chapter 4 explains this setting, which determines how much the camera reacts to light.)

Press OK if you change the Exposure Smoothing setting. You're once again returned to the main setup screen, shown in Figure 2-10.

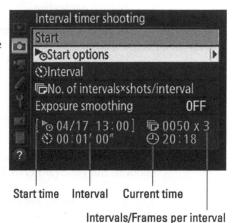

Figure 2-10: Your chosen interval settings appear at the bottom of the setup screen.

6. Verify the interval setup and then choose Start.

Your selected timer settings appear at the bottom of the main Interval Timer Shooting screen, as shown in Figure 2-10.

If you selected Now as the Start Time option in Step 2, the first shot is recorded about 3 seconds after you select Start. If you set a delayed start time, the camera displays a "Timer Active" message for a few seconds, and then the monitor turns off.

A few final factoids:

Monitoring the shot progress: The letters INTVL blink in the Control panel while an interval sequence is in progress. Before each shot is captured, the display changes to show the number of intervals remaining and the number of shots remaining in the current interval. The first value appears in the space usually occupied by the shutter speed; the second takes the place of the f-stop setting. You also can view the values at any time by pressing the shutter button halfway.

- Interrupting interval shooting: Between shots, bring up the Interval Timing menu item, press OK, highlight Pause, and press OK. You can also interrupt the interval sequence by turning off the camera which gives you the chance to install an empty memory card if the current ones are full. When you turn on the camera again, reselect the Interval Timer Shooting menu option, press the Multi Selector right, choose Restart, and press OK to continue shooting. To cancel the sequence entirely, choose Off instead of Restart.
- Autofocusing: If you're using autofocusing, the camera initiates focusing before each shot.
- ✓ Between shots: You can view pictures in Playback mode or adjust menu settings between shots. The monitor goes dark about 4 seconds before the next shot is taken.

Selecting Image Size and Image Quality

Your preflight camera check should also include a look at the Image Size and Image Quality settings. The first option sets resolution (pixel count); the second, file type (JPEG or Raw/NEF).

The names of these settings are a little misleading, though, because the Image Size setting also contributes to picture quality, and the Image Quality setting affects the file size of the picture. Because the two work in tandem to determine quality and size, it's important to consider them together. The next few sections explain each option; following that, I offer a few final tips and show you how to select the settings you want to use.

Considering Image Size (resolution)

The Image Size setting determines how many pixels are used to create your photo. *Pixels* are the square tiles from which digital images are made. You can see some pixels close up in the right image in Figure 2-11, which shows a greatly magnified view of the eye area in the left image.

Pixel is short for picture element.

The number of pixels in an image is referred to as *resolution*. You can define resolution in terms of either the *pixel dimensions* — the number of horizontal pixels and vertical pixels — or total resolution, which you get by multiplying those two values. This number is usually stated in *megapixels* (or MP, for short), with 1 megapixel equal to 1 million pixels.

Your camera offers three Image Size options: Large, Medium, and Small. Table 2-1 lists the resolution values for each setting. (Megapixel values are rounded off.)

Figure 2-11: Pixels are the building blocks of digital photos.

Table 2-1	Image Size (Resolution) Options			
Setting	Resolution			
Large	6000 x 4000 (24.0MP)			
Medium	4496 x 3000 (13.5MP)			
Small	2992 x 2000 (6.0MP)			

However, if you select Raw (NEF) as the Image Quality setting, images are captured at the Large setting. You can vary the resolution only for pictures taken in the JPEG format. The upcoming section "Understanding Image Quality options (JPEG or Raw/NEF)" explains file formats. Also, the numbers you see in Table 2-1 assume that you use the default setting for the Image Area option, which I explain at the end of this chapter. At the default (DX) setting, the camera captures the image using the entire image sensor (the part of the camera on which the image is formed). If you instead use the 1.3x crop setting, which captures the image using only the central portion of the sensor, you get fewer pixels at each Image Size setting. The Large setting drops to 4800 x 3200 pixels, or 15.4MP; Medium, to 3600 x 2400 pixels, or 8.6MP; and Small, to 2400 x 1600, or 3.8MP. To choose the right Image Size setting, you need to understand the three ways that resolution affects your pictures:

✓ Print size: Pixel count determines the size at which you can produce a high-quality print. When an image contains too few pixels, details appear muddy, and curved and diagonal lines appear jagged. Such pictures are said to exhibit pixelation.

Depending on your photo printer, you typically need anywhere from 200 to 300 pixels per linear inch, or ppi, for good print quality. To produce an 8×10 print at 200 ppi, for example, you need a pixel count of 1600×2000 , or about 3.2 megapixels.

Even though many photo-editing programs enable you to add pixels to an existing image — known as *upsampling* — doing so doesn't enable you to successfully enlarge your photo. In fact, upsampling typically makes matters worse.

To give you a better idea of the impact of resolution on print quality, Figures 2-12, 2-13, and 2-14 show you the same image at 300 ppi, at 50 ppi, and then resampled from 50 ppi to 300 ppi (respectively). As you can see, there's no way around the rule: If you want quality prints, you need the right pixel count from the get-go.

- ✓ **Screen display size:** Resolution doesn't affect the quality of images viewed on a monitor or television or another screen device the way it does for printed photos. Instead, resolution determines the *size* at which the image appears. I talk more about this issue in Chapter 10, but for now, just know that you need *way* fewer pixels for onscreen photos than you do for prints. In fact, even the Small resolution setting creates a picture too big to be viewed in its entirety in many e-mail programs.
- File size: Every pixel increases the amount of data required to create the picture file. So a higher-resolution image has a larger file size than a low-resolution image.

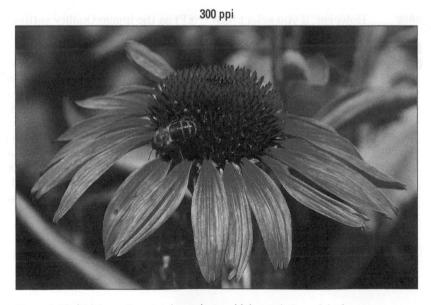

Figure 2-12: A high-quality print depends on a high-resolution original.

50 ppi

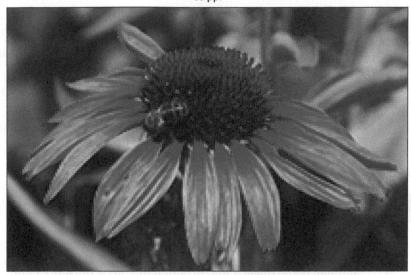

Figure 2-13: At 50 ppi, the image has a jagged, pixelated look.

50 ppi resampled to 300 ppi

Figure 2-14: Adding pixels in a photo editor doesn't rescue a low-resolution original.

Large files present several problems:

- You can store fewer images on the memory card, on your computer's hard drive, and on removable storage media such as DVDs.
- The camera needs more time to process and store the image data after you press the shutter button.
- When you share photos online, larger files take longer to upload and download.
- When you edit photos in your photo software, your computer needs more resources and time to process large files.

As you can see, resolution is a bit of a sticky wicket. What if you aren't sure how large you want to print your images? What if you want to print your photos *and* share them online? I take the better-safe-than-sorry route, which leads to the following recommendations:

- Always shoot at a resolution suitable for print. You then can create a low-resolution copy of the image for use online. In fact, the camera's Retouch menu offers a Resize option that does the job; Chapter 10 tells all.
- For everyday images, Medium is a good choice. I find Large to be overkill for casual shooting, creating huge files for no good reason. Keep in mind that even at the Small setting, the pixel count (2992 x 2000) gives you enough resolution to produce an 8 x 10-inch print at 200 ppi.

- Choose Large for an image that you plan to crop or print very large, or both. The benefit of maximum resolution is that you have the flexibility to crop your photo and still generate a decently sized print of the remaining image.
 - Figure 2-15 offers an example. When I was shooting this photograph, I couldn't get close enough to fill the frame with my main interest the two juvenile herons at the center of the scene. But because I had the resolution cranked up to Large, I could later crop the shot to the composition you see on the right and still produce a great-looking print. In fact, I could have printed the cropped image at a much larger size than fits here.
- Reduce resolution if shooting speed is paramount. If the camera takes too long after you take one shot before it lets you take another, dialing down the resolution may help.

Understanding Image Quality options (IPEG or Raw/NEF)

If I had my druthers, the Image Quality option would instead be called File Type because that's what the setting controls. Here's the deal: The file type, sometimes also known as a file *format*, determines how your picture data is recorded and stored. Your choice does affect picture quality, but so does the Image Size setting, as described in the preceding section, and the ISO setting and exposure

Figure 2-15: A high-resolution original (left) enabled me to crop the photo and still have enough pixels to produce a quality print (right).

time, both covered in Chapter 4. (A high ISO setting and long exposure time can produce a defect called *noise*, which makes your image appear grainy.) In addition, your choice of file type has ramifications beyond picture quality.

At any rate, your camera offers two file types: JPEG and Camera Raw — or Raw, for short, which goes by the specific moniker NEF (Nikon Electronic Format) on Nikon cameras. The next couple of sections explain the pros and cons of each format. If your mind is already made up, skip ahead to the section "Adjusting the Image Size and Image Quality settings," to find out how to make your selection.

JPEG: The imaging (and web) standard

Pronounced "jay-peg," this format is the default setting on your D7200, as it is on most digital cameras. JPEG is popular for two main reasons:

- Immediate usability: All web browsers and e-mail programs can display JPEG files, so you can share pictures online immediately after you shoot them. You also can get a JPEG file printed at any retail photo outlet. The same can't be said for Raw (NEF) files, which must be converted to JPEG for online sharing and to JPEG or another standard format, such as TIFF, for retail printing.
- Small files: JPEG files are smaller than Raw files. And smaller files consume less room on your camera memory card and in your computer's storage tank.

The downside (you knew there had to be one) is that JPEG creates smaller files by applying *lossy compression*. This process actually throws away some image data. Too much compression produces a defect called *JPEG artifacting*. Figure 2-16 compares a high-quality original (left photo) with a heavily compressed version that exhibits artifacting (right photo).

Figure 2-16: The reduced quality of the right image is caused by excessive JPEG compression.

Fortunately, your camera enables you to specify how much compression you're willing to accept. You can choose from three JPEG settings, which produce the following results:

- ✓ **JPEG Fine:** The compression ratio is 1:4 that is, the file is four times smaller than it would otherwise be. Because very little compression is applied, you shouldn't see many compression artifacts, if any.
- ✓ **JPEG Normal:** The compression ratio rises to 1:8. The chance of seeing some artifacting increases as well. This setting is the default.
- ✓ JPEG Basic: The compression ratio jumps to 1:16. That's a substantial amount of compression that brings with it a lot more risk of artifacting.

Note, though, that even the Basic setting doesn't result in anywhere near the level of artifacting you see in the right image in Figure 2-16. I've exaggerated the defect in that example to help you recognize artifacting and understand how it differs from the quality loss that occurs when you have too few pixels (refer to Figures 2-12 through 2-14). In fact, if you keep the image print or display size small, you aren't likely to notice a great deal of quality difference between the Fine, Normal, and Basic compression levels. It's only when you greatly enlarge a photo that the differences become apparent.

Given that the differences between the compression settings aren't that easy to spot until you enlarge the photo, is it okay to stick with the default setting — Normal — or even drop down to Basic to capture smaller files? Well, only you can decide what level of quality your pictures demand. For me, the added file sizes produced by the Fine setting aren't a huge concern, given that the prices of memory cards fall all the time. Long-term storage is more of an issue; the larger your files, the faster you fill your computer's hard drive

and the more DVDs or CDs you need for archiving purposes. But in the end, I prefer to take the storage hit in exchange for the lower compression level of the Fine setting. You never know when a casual snapshot will be so great that you want to print or display it large enough that even minor quality loss becomes a concern. And of all the defects that you can correct in a photo editor, artifacting is one of the hardest to remove.

If you don't want *any* risk of artifacting, change the file type to Raw (NEF). Or consider your other option, which is to record two versions of each file — one Raw and one JPEG. The next section offers details.

Raw (NEF): The purist's choice

The other picture file type you can create is *Camera Raw*, or just *Raw* (as in uncooked), for short.

Each manufacturer has its own flavor of Raw. Nikon's is NEF, for Nikon Electronic Format, so you see the three-letter extension NEF at the end of Raw filenames.

Raw is popular with advanced, very demanding photographers for three reasons:

- Greater creative control: With JPEG, internal camera software tweaks your images, adjusting color, exposure, and sharpness as needed to produce the results that Nikon believes its customers prefer. With Raw, the camera simply records the original, unprocessed image data. The photographer then copies the image file to the computer and uses special software known as a *Raw converter* to produce the actual image, making decisions about color, exposure, and so on at that point. Your camera has a built-in Raw converter, which I cover in Chapter 10. The Nikon website also offers software you can download to do the job (Nikon Capture NX-D).
- Higher bit depth: *Bit depth* is a measure of how many distinct color values an image file can contain. JPEG files restrict you to 8 bits each for the red, blue, and green color components, or *channels*, that make up a digital image, for a total of 24 bits. That translates to roughly 16.7 million possible colors. On the D7200, you can set the camera to capture either 12 or 14 bits per channel when you shoot in the Raw format. (Make the call by choosing Photo Shooting > NEF (RAW) Recording. I provide details in the upcoming section "Adjusting the Image Size and Image Quality settings.")

Although jumping from 8 to 12 or 14 bits sounds like a huge difference, you may never notice any difference in your photos — that 8-bit palette of 16.7 million values is more than enough for superb images. Where the extra bits can come in handy is if you adjust exposure, contrast, or color in your photo-editing program. When you apply extreme adjustments, the extra bits sometimes help avoid a problem known as *banding* or *posterization*, which creates abrupt color breaks where you should

- see smooth, seamless transitions. (A higher bit depth doesn't always prevent this problem, however.)
- Best picture quality: Because Raw doesn't apply the destructive compression associated with JPEG, you don't run the risk of the artifacting that can occur with JPEG.

But Raw isn't without its disadvantages:

- You can't do much with your pictures until you process them in a Raw converter. You can't share them online or put them into a text document or multimedia presentation. You can view and print them immediately if you use the available Nikon software, but most other photo programs require you to convert the Raw files to a standard format first, such as JPEG or TIFF. Ditto for retail photo printing.
- Raw files are larger than JPEGs. Unlike JPEG, Raw doesn't apply lossy compression to shrink files. In addition, Raw files are always captured at the maximum resolution. For both reasons, Raw files are significantly larger than JPEGs, so they take up more room on your memory card and on your computer's hard drive or other picture-storage device.

Whether the upside of Raw outweighs the downside is a decision that you need to ponder based on your photographic needs and whether you have the time to, and interest in, converting Raw files.

Raw+JPEG: Covering both bases

You do have the option to capture a picture in the Raw and JPEG formats at the same time. I often take this route when I'm shooting pictures I want to share right away with people who don't have software for viewing Raw files. I upload the JPEGs to a photo-sharing site where everyone can view them, and then I process the Raw versions when I have time.

If you choose to create both a Raw and JPEG file, note a few things:

- Raw files are captured at the Large Image size; the JPEG files are recorded using the Image Size and Quality settings you select. For example, you can request that the JPEG file be captured at the Fine quality and Medium size settings.
- ✓ If you install only one memory card, you see the JPEG version of the photo during playback. However, the Image Quality data that appears with the photo reflects your capture setting (Raw+Fine, for example). The size value relates to the JPEG version. Again, Raw files are always captured at the Large size.
- If two memory cards are installed, you can choose to send the Raw files to one card and the JPEG files to another: Open the Photo Shooting menu, choose Role Played by Card in Slot 2, and then select Raw Slot 1 - JPEG Slot 2.

If both the JPEG and Raw files are stored on the same memory card, deleting the JPEG image also deletes the Raw file if you use the in-camera delete function. After you transfer the two files to your computer, deleting one doesn't affect the other.

Chapter 10 explains more about deleting photos. Chapter 1 explains how to configure a two-memory-card setup.

My take: Choose JPEG Fine or Raw (NEF)

At this point, you may be finding all this technical goop a bit overwhelming, so allow me to simplify things for you. Until you have the time or energy to completely digest all the ramifications of JPEG versus Raw, here's a quick summary of my thoughts on the matter:

- If you require the absolute best image quality and have the time and interest in doing the Raw conversion, shoot Raw.
- If great photo quality is good enough and you don't have time to spend processing images, stick with JPEG Fine. The trade-off for the smaller files produced by the Normal and Basic settings isn't worth the risk of compression artifacts.
- If you don't mind the added file-storage space requirement and want the flexibility of both formats, choose a Raw+JPEG option, which stores one copy of the image in each format. Set the JPEG size and quality depending on how you plan to use the JPEG image.

Adjusting the Image Size and Image Quality settings

You can view the current Image Size and Image Quality settings in the Information display and Live View displays, in the areas labeled on the left screens in Figures 2-17 and 2-18.

Press the Info button to bring up the Information display during viewfinder photography; press the button to change the display style during Live View photography.

To adjust the settings, use these controls:

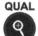

Qual button + command dials (viewfinder photography only): When you press and hold the Qual button, the camera displays the Image Size and Image Quality settings together, as shown on the right in Figure 2-17. The symbols on the screen indicate that you can rotate the Main command dial to adjust the Image Quality setting and rotate the Sub-command dial to change the Image Size setting.

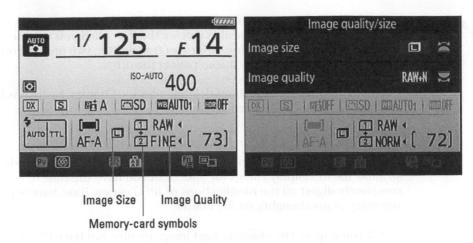

Figure 2-17: After displaying the Information screen (left), press and hold the Qual button to access the Image Quality and Image Size settings (right).

Figure 2-18: In Live View mode, the settings are available via the *i* button menu.

If you installed two memory cards in the camera, the card symbols in the Information display indicate how you configured the cards. In the figure, the symbols show that the camera is set to capture both Raw and JPEG Fine files, sending the Raw files to card 1 and the JPEGs to card 2.

i button menu (Live View only): During Live View, pressing the Qual button magnifies the on-screen display. So instead, the Image Size and Image Quality options are available via the *i* button menu, as shown on the right in Figure 2-18.

100

0

Photo Shooting menu (viewfinder and Live View modes): You also can set Image Quality and Image Size via the Photo Shooting menu, as shown in Figure 2-19.

In addition, you can tweak the way that JPEG and Raw data are recorded via these Photo Shooting menu options:

Figure 2-19) offers two settings:

Storage folder

(refer to the bottom menu item in Size and Image Quality settings via the Photo Shooting menu.

PHOTO SHOOTING MENU

Reset photo shooting menu

Size Priority (the default) and Optimal Quality. Size Priority compresses data with an eye to maintaining consistent file sizes. For example, all your JPEG Fine images will consume about the same amount of space on your memory card. But how much compression is needed to produce those consistent file sizes depends on the level of detail in the photo. Therefore, complex subjects may be more highly compressed — and, thus, suffer more quality loss than simple subjects.

If you care more about quality than consistent file sizes (as I do), change the JPEG Compression setting to Optimal Quality. The camera then gives priority to producing optimum picture quality over file sizes. Of course, because compression amounts then may vary slightly between images, the standard compression ratios for each setting (Fine, 1:4; Normal, 1:8; and Basic, 1:16) also differ from picture to picture.

- NEF (RAW) Recording: This option, found on the second page of the Photo Shooting menu, provides two Raw customization settings:
 - Type: Even Raw files receive a minute amount of file compression to keep file sizes within reason. The Type option lets you choose between two forms of compression. The default option is Lossless Compressed, which results in no visible loss of quality and yet reduces file sizes by about 20 to 40 percent. In addition, any quality loss that does occur through the compression process is reversed at the time you process your Raw images. (Technically, some original data may be altered, but you're unlikely to notice the difference in your pictures.)

Changing the Type setting to Compressed results in a greater degree of compression, shrinking files by about 35 to 55 percent. Nikon promises that this setting has "almost no effect" on image quality. But the compression in this case is not reversible, so if you do experience some quality loss, there's no going back.

 NEF (RAW) bit depth: Again, bit depth refers to how many units of data are used to create the image. More bits mean a bigger file but a larger spectrum of possible colors. By default, the D7200 goes for 14-bit images, but you can reduce the bit depth to 12 through this option.

Together, these two Raw settings make a big difference in file size: 14-bit Lossless Compressed photos weigh in at about 28.0 MB; 12-bit Compressed files are about 20.6MB. Most photographers, I think, will be perfectly happy with 12-bit, Compressed images, and frankly, I doubt that too many people could perceive much difference between a photo captured at that setting and a 14-bit, Lossless Compressed picture. But if you're doing commercial photography or shoot fine-art photography for sale, you may feel more comfortable knowing that you're capturing files at maximum quality and bit depth.

Reducing the Image Area (DX versus 1.3x Crop)

Normally, your D7200 captures photos using the entire *image sensor*, which is the part of the camera on which the picture is formed — similar to the negative in a film camera. However, you have the option to record a smaller area at the center of the sensor. The result is the same as using the entire sensor and then cropping the image by a factor of 1.3.

What's the point? Well, the idea is that you wind up with a picture that has the same angle of view you would get by switching to a lens with a longer focal length. Your subject fills more of the frame, and less background is included. To put it another way, think of this option as on-the-fly cropping.

Of course, because you're using a smaller portion of the image sensor, you're recording the image using fewer pixels, so the resulting image has a lower resolution than one captured using the entire sensor. And as discussed earlier in this chapter, the higher the pixel count, the larger you can print the photo and maintain good print quality. On the flip side, because the camera is working with fewer pixels, the resulting file size is smaller, and it takes less time to record the image to the camera memory card. You also can capture more frames per second when you set the Release mode to the Continuous High or Continuous Low options, as I detail in the earlier section devoted to those two Release modes.

I prefer to shoot using the entire sensor and then crop the image myself if I deem it necessary. You can even crop the image in the camera, by using the Trim feature that I cover in Chapter 12. Even when I'm shooting fast action, I don't find that the small bump up in the maximum frames per second worth the loss of frame area in most situations.

When you use the whole-sensor recording option, you see the letters DX in the Information and Live View displays, as shown in Figure 2-20. (DX is the moniker that Nikon uses to refer to the size of sensor used in the D7200 and similar cameras.) If you opt for the cropped sensor setting, the label 1.3x appears instead.

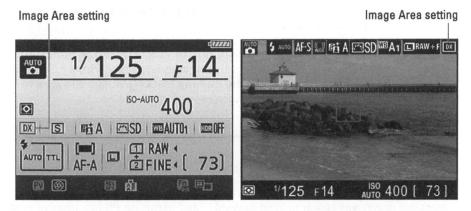

Figure 2-20: The DX symbol indicates that the maximum Image Area option is selected.

To change the Image Area setting, you have these options:

i button menu: The Image Area option is the first setting on the menu, as shown on the left in Figure 2-21. Select the option to display the screen shown on the right, which lists the two image-area sizes.

The numbers in parentheses indicate the image sensor size in millimeters: $24 \times 16 \text{mm}$ for the DX setting, and $18 \times 12 \text{mm}$ for the $1.3 \times$

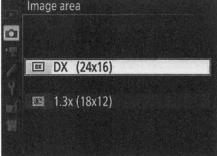

Figure 2-21: Press the *i* button to quickly access the Image Area setting.

- Photo Shooting menu: You also can adjust the setting via the Image Area option on this menu.
- Fn button + command dial (viewfinder photography only): By default, the Fn button is set to provide access to the Image Area setting. Press the button while rotating either command dial to toggle between the DX and 1.3x settings. As you change the setting, the viewfinder display, Information screen, and Control panel display the selected sensor size (24 x 16 or 18 x 12).

When you set the Image Size option to 1.3x, a rectangle indicating the available framing area appears in the viewfinder, along with a 1.3x symbol. In Live View mode, you don't see the framing marks; instead, the area to be captured at the 1.3x frame size fills the screen.

Correcting lens distortion

When you shoot with a wide-angle lens, vertical structures sometimes appear to bend outward from the center of the image. This is known as barrel distortion. On the flip side of the coin, shooting with a telephoto lens can cause vertical structures to bow inward, which is known as pincushion distortion.

The Retouch menu offers a post-capture Distortion Control filter you can apply to try to correct both problems. But the D7200 also has an Auto Distortion Control feature that attempts to correct the image as you're shooting. It works with only certain types of lenses — specifically,

those that Nikon classifies as type G, E, or D, and excluding PC (perspective control), fisheye, and certain other lenses. To activate the option, set Auto Distortion Control on the Photo Shooting Menu to On.

One caveat: Some of the area you see in the viewfinder may not be visible in your photo because the anti-distortion manipulation requires some cropping of the scene. So frame your subject a little loosely when you enable Auto Distortion Control. Also, the feature isn't available for movie recording.

Adding Flash

In This Chapter

- Taking advantage of the built-in flash
- Setting the flash mode
- ▶ Adjusting flash power
- Investigating advanced flash options

ameras have gone through many evolutions since photography was first invented. But one thing that remains constant is that you can't create a photograph without light. In fact, the term *photograph* comes from the Greek words *photo*, for light, and *graph*, for drawing.

Thanks to the built-in flash on your D7200, you're never without at least a little light. You also have the option to attach a larger, more powerful external flash when scenes call for more light than the built-in flash can produce.

Although flash photography seems simple enough on the surface, it actually requires a lot of skill. Where you place the light, how much flash power you use, and when the flash fires are just some of the important components of a good flash photo — which is to say, a picture that doesn't look like you shot it in a police interrogation room, with your subject lit by the glare of a bare, 300-watt bulb.

This chapter helps you start taking better flash pictures by explaining the basics of flash photography with your D7200, from enabling the flash to setting the flash mode and flash power. I also introduce you to some advanced flash features that may come in handy in certain lighting situations.

Understanding Flash Limitations

At the risk of sounding like Debbie Downer, I want to point out a few limitations of the built-in flash before I show you how to take advantage of it:

The maximum flash range is about 28 feet. So don't bother using flash when photographing a stage performance from your seat in the theater balcony — the only things that will be illuminated are the backs of your fellow audience members (who will turn around and glare at you if you keep it up).

Flash range always varies depending on your ISO and f-stop settings. At some combinations, the maximum flash reach is just a few feet. Your camera manual lists the various combinations and how they affect flash reach.

- Some exposure modes prevent you from using the built-in flash. Obviously, Auto Flash Off mode is one such mode. But flash is also disabled in these Scene and Effects modes:
 - Scene modes: Landscape, Sports, Night Landscape, Beach/Snow, Sunset, Dusk/Dawn, Candlelight, Blossom, and Autumn Colors
 - Effects modes: All modes except Color Sketch
- Flash isn't suitable for action photography. Three issues make shooting action with flash difficult:
 - Burst-mode shooting doesn't work. If flash is enabled when you use either Continuous Release mode, the camera takes one photograph for each press of the shutter button instead of recording a burst of frames. Chapter 2 details Release modes.
 - By default, the top shutter speed you can use with the built-in flash is 1/250 second. The faster the action, the higher the shutter speed you need to freeze the motion. At 1/250 second, a rapidly moving subject may blur.
 - The flash needs time to recycle between shots. And Murphy's Law being, well, a law, it's pretty much certain that your flash will be recharging when the highlight-reel moment of the day occurs.

If you attach an external flash head, you *can* use flash in exposure modes that disable the built-in flash, with the exception of Auto Flash Off mode. In addition, your D7200 offers a feature called Auto FP Flash, which is Nikonian for "flash photography at high shutter speeds." For the built-in flash, you can notch the speed up only to 1/320 second, however. If you attach a compatible external flash, Auto FP Flash enables you to access your camera's entire range of shutter speeds. Check out the later section "Enabling High-Speed Flash (Auto FP)" for details.

Flash button

Turning the Built-In Flash On and Off

In certain exposure modes, the built-in flash is set by default to fire automatically if the camera thinks that the ambient light is insufficient. In other modes, you have to manually enable flash. Here's the breakdown:

Autoexposure mode, all Scene modes that permit flash except Food mode, and Color Sketch Effect mode: After you press the shutter button, the camera automatically pops up the built-in flash if it finds the ambient light insufficient. If you don't want to use flash, you may be able to disable it by changing the Flash mode to Flash Off, as explained in the next section.

P, S, A, and M modes and the Food Scene mode: You control whether the flash fires. To pop up the built-in flash, press the Flash button on the side of the camera, labeled in Figure 3-1. Don't want flash? Just press down gently on the top of the flash to close the unit. Except for when you shoot in the Food Scene mode, you also have the option of leaving the flash up and setting the Flash mode to Flash Off.

The camera keeps the flash charged as long as the unit is up, so to save battery power, close the flash unit when possible.

If the flash doesn't pop up as expected, the problem may be related to the aforementioned Flash Off mode. When this option is enabled, the flash won't come out of hiding no matter how many times you press the Flash button. Try pressing the Flash button while rotating the Main command

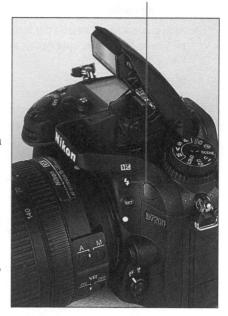

Figure 3-1: In P, S, A, and M modes (and the Food Scene mode), raise the built-in flash by pressing the Flash button.

dial, which changes the flash mode. If that fix doesn't work, don't try to pry the flash up; you could break it for good. Instead, head for a camera-repair shop.

In sync: Flash timing and shutter speed

To properly expose flash pictures, the camera has to synchronize the firing of the flash with the opening and closing of the shutter. For this reason, the range of available shutter speeds is limited when you use flash. The maximum shutter speed for the built-in flash is 1/250 second (or 1/320 if you enable high-speed flash); the minimum shutter speed varies, depending on the exposure mode:

- Auto mode, Color Sketch Effects mode, and all Scene modes except Portrait and Night Portrait: 1/60 second
- ✓ Night Portrait: 1 second
- Portrait: 1/30 second
- P, A: 1/60 second (unless you use one of the Slow-Sync Flash modes, which permit a shutter speed as slow as 30 seconds)

- S: 30 seconds
- M: 30 seconds (for Fill Flash mode, you can exceed that limit if the shutter speed is set to Bulb or Time, which are two special shutter speeds I discuss in Chapter 4)

With a slow shutter speed, any movement of the camera or subject may blur the image. If the shutter speed drops below 1/60 second, use a tripod to steady the camera, and ask your subject to remain as still as possible. (Depending on how steadily you can handhold the camera, you may need that tripod even at faster shutter speeds.)

Choosing a Flash Mode

Whether you're using the built-in flash or an external flash, you can choose from several Flash modes, which determine how and when the flash fires. The next sections detail each mode and explain how to adjust the setting.

Investigating Flash modes

Your D7200 offers the following Flash modes, which are represented in the Information and Live View displays by the symbols shown in the margins:

٠,		١	
ı		١	
ı		1	
ᆫ		J	

Fill Flash: Think of this mode as normal flash. The name stems from the purpose of the flash: to fill in shadows that may be obscuring subject details. You can choose this mode in the P, S, A, and M exposure modes as well as in the Food Scene mode.

Although most people think of flash as an indoor lighting option, adding flash can improve outdoor daylight shots, too. The sun illuminates the top of the subject, but the rest of the subject may need a little extra light. As an example, Figure 3-2 shows a floral image taken with and without a flash. For outdoor portraits, a flash is even more important to properly illuminate the face, especially if the subject is wearing a hat that blocks the sun from the face. (Chapter 7 has examples of this portrait-shooting tip.)

Remember though, that the fastest shutter speed you can use with the built-in flash is 1/250 second. If that shutter speed overexposes your image, try using a higher f-stop (aperture) or lower ISO (light sensitivity) setting, both of which lead to darker exposures. As another option, you can place a neutral density filter over the lens; this accessory reduces the light that comes through the lens without affecting colors. Check out Chapter 4 for help understanding exposure and correcting exposure problems.

Also be aware that mixing flash with daylight can affect photo colors. In Figure 3-2, colors in the flash example appear a bit warmer (more red/yellow). If you don't like the results, Chapter 6 shows you how to use the White Balance control to adjust colors.

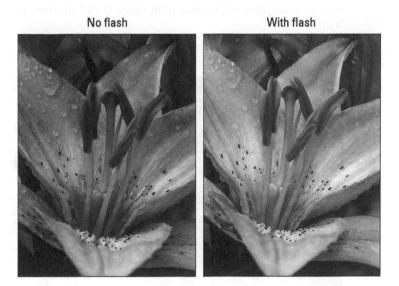

Figure 3-2: Adding flash can often improve outdoor photographs.

Red-Eye Reduction: As its name implies, this Flash mode is designed to reduce red-eye, which is caused when flash light bounces off a subject's retinas and is reflected back to the camera lens. When you select this Flash mode — available only in P, S, A, and M exposure modes — the AF-assist lamp on the front of the camera lights briefly before the flash fires. The subject's pupils constrict in response, allowing less flash light to enter the eye and cause that red reflection. (Warn your subjects not to move until they see the actual flash, or they may stop posing after they see the light from the AF-assist lamp.)

Remember, too, that this mode is called Red-Eye *Reduction*, not Red-Eye Elimination. In very dim lighting or when you use a telephoto lens, your photos may still exhibit red eye. If they do, try using the Red-Eye Removal tool on the Retouch menu, which I cover in Chapter 12.

Slow-Sync Flash: How much of your photo is lit by the flash and how much is illuminated by ambient light depends on your shutter speed. With a long exposure (slow shutter speed), the camera has time to soak up ambient light, which produces two results: Background areas beyond the reach of the flash appear brighter, and less flash power is needed, resulting in softer lighting on your subject. As an example, see Figure 3-3. The shutter speed for the left image was 1/60 second; the right image, 1/8 second. Slow-Sync flash can also work well for portraits; Chapter 7 has an example and explains a bit more about improving portraits lit by flash.

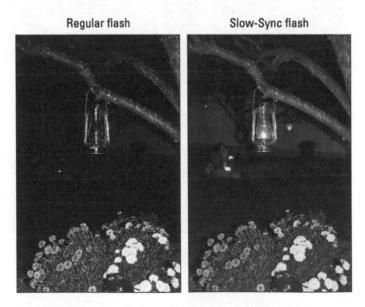

Figure 3-3: Slow-Sync flash produces softer, more even lighting than normal flash in nighttime pictures.

In the M and S exposure modes, you control shutter speed, so you achieve the slow-sync flash effect by simply pairing a slow shutter speed with the Fill Flash mode. But in the P and A exposure modes, the camera controls the shutter speed and, by default, uses a shutter speed no slower than 1/60 second when you use Fill Flash. If you want the Slow-Sync flash look in P and A modes, change the Flash mode to Slow-Sync, which tells the camera to reduce the shutter speed. You can't specify exactly how long a shutter speed you want to use.

SLOW

Remember that the longer the exposure time, the more you have to worry about blurring that can be caused by movement of your subject or your camera. A tripod is essential to a good outcome, as are subjects that can hold still.

✓ Slow-Sync with Red-Eye Reduction: Also designed for P and A modes, this mode combines Slow-Sync flash with the Red-Eye Reduction feature. Given the potential for blur that comes with a slow shutter, plus the potential for subjects to mistake the light from the AF-assist lamp for the real flash and walk out of the frame before the image is actually recorded, I vote this Flash mode as the most difficult to pull off.

Again, if you switch to the S or M exposure modes, you can get the same result by setting the Flash mode to Red-Eye Reduction mode and then selecting a slow shutter speed.

REAR

- Rear-Curtain Sync: Normally, the flash fires at the beginning of the exposure, an arrangement known as front-curtain sync. In Rear-Curtain Sync Flash mode, available in S and M exposure modes, the flash instead fires at the end of the exposure. The classic use of this mode is to combine the flash with a slow shutter speed to create trailing-light effects like the one you see in Figure 3-4. With Rear-Curtain Sync, the light trails extend behind the moving object (my hand, and the match, in this case), which makes visual sense. If instead you use slow-sync flash, the light trails appear in front of the moving object. You can set the shutter speed as low as 30 seconds in this Flash mode.
- Slow Rear-Curtain Sync: Hey, not confusing enough for you yet? This mode enables you to produce the

Figure 3-4: I used Rear-Curtain Sync Flash to create this candle-lighting image.

\$ SLOW REAR

same motion trail effects as with Rear-Curtain Sync, but in the P and A exposure modes. The camera automatically chooses a slower shutter speed than normal after you set the f-stop, just as with regular Slow-Sync mode. Note that the mode symbol initially just shows the word Rear, but after you finish selecting the setting, the word Slow appears as well.

≴ AUTO Auto Flash and Auto+ Flash: Automatic exposure modes that permit flash use Auto Flash by default. If the camera thinks the ambient light is insufficient, the flash pops up automatically and fires when you take the picture. The exception is Food Scene mode, which requires you to raise the flash manually by pressing the Flash button. Auto Flash isn't available for P, S, A, and M modes, either.

Some automatic exposure modes also enable you to choose from these Auto Flash variations: Auto with Red-Eye Reduction, Auto Slow Sync with Red-Eye Reduction, and Auto Slow Sync. The only difference between these modes and the ones described in the preceding bullet points is that the camera decides whether flash is needed. You see the word Auto along with the word Slow, a red-eye symbol, or both when you use these modes.

✓ Flash Off: If you're shooting a mix of flash and flash-free pictures, raising and lowering the flash unit can get tiresome (not to mention noisy). So the camera offers Flash Off mode, which prevents the flash from firing even if the flash is raised. You can choose this option in the P, S, A, and M modes.

In the automatic exposure modes that permit flash, setting the Flash mode to Flash Off is the *only* way to go flash free in dim lighting. If you close the flash unit, the camera will just raise the flash again when you press the shutter button. Again, the weirdo mode is the Food Scene mode, which requires you to close the flash unit to go flash free.

Changing the Flash mode

When flash is enabled, a symbol representing the current Flash mode appears in the Information and Live View displays, as shown in Figure 3-5. The lightning bolt shown in the figures represents Fill Flash mode; see the margins of the preceding section for a look at the other symbols.

Press the Info button to bring up the Information display during viewfinder photography. In Live View mode, press the Info button to cycle through the various data-display modes to get to the one shown in the figure.

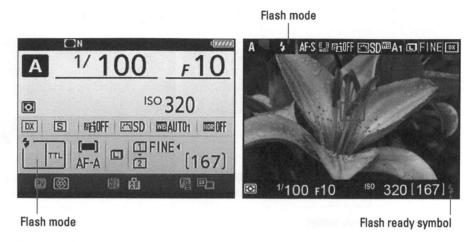

Figure 3-5: An icon representing the Flash mode appears in the displays.

When flash is enabled, you also see a red lightning bolt in the lower-right corner of the Live View display and, during viewfinder photography, at the right end of the viewfinder display. This lightning bolt has nothing to do with the flash mode; it simply tells you that the flash is ready to fire. If flash isn't enabled and the camera thinks you need more light, the red lightning bolt blinks. Find that feature annoying? You can disable it by opening the Custom Setting menu and choosing Shooting/Display > Flash Warning. (You have to set the Mode dial to P, S, A, or M to access the setting.)

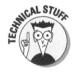

As for the TTL part of the Flash mode symbol on the Information display, it represents the setting of the Flash Cntrl for Built-in Flash option, found in the Bracketing/Flash section of the Custom Setting menu. TTL, which stands for through the lens, represents the normal flash metering operation: The camera measures the light coming through the lens and sets the flash output accordingly. (Your other menu options are manual, repeating flash, and commander mode, all of which I cover later in this chapter.)

The Flash button is key not only to raising the flash in some exposure modes, but also to changing the Flash mode. During viewfinder photography, press the Flash button to display the settings screen shown on the left in Figure 3-6. (You must raise the flash first.) In Live View mode, the Flash mode symbol at the top of the screen appears highlighted, as shown on the right. (The other highlighted options are related to Flash Compensation, a second flash setting you can explore a couple blocks from here.)

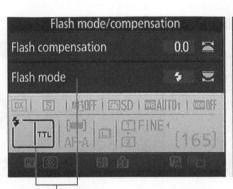

Flash mode setting

Figure 3-6: Press the Flash button while rotating the Main command dial to change the Flash mode.

To adjust the Flash mode, keep pressing the Flash button while rotating the Main command dial. The wheel graphic next to the Flash mode setting on the Information screen is your reminder of which dial to rotate: The wheel with the arrow underneath represents the Main command dial. If you rotate the Sub-command dial, you instead adjust the Flash Compensation setting.

Exposure metering modes and flash output

When the camera calculates how much flash power your subject requires, it does so depending on your exposure metering mode. The metering mode, which I cover in the next chapter, determines which part of the frame the camera considers when making exposure decisions:

In matrix (whole frame) and centerweighted modes, flash power is adjusted to expose the picture using a balance of ambient light and flash light. Nikon uses the term i-TTL Balanced Fill Flash for this technology. The i stands for intelligent; again, the TTL means that the camera calculates exposure by reading the light that's coming throughthe-lens. The *balanced fill* part refers to the fact that the flash is used to fill in shadow areas, while brighter areas are exposed by the available light, resulting (usually) in a pleasing balance of the two light sources.

In spot-metering mode, the camera assumes that you're primarily interested in a single area of the frame, so it calculates flash power and overall exposure based on that point, without much regard for the background. This mode is Standard i-TTL Flash.

Adjusting Flash Strength

By default, your camera automatically calculates the necessary flash output for you. If you want a little more or less flash light than the camera thinks is appropriate, you can apply Flash Compensation or switch to manual flash-power control.

Applying Flash Compensation

This feature, available in P, S, A, and M modes as well as in Scene modes that permit flash, tells the camera that you think that its flash calculation is off base. Adjusting the setting results in greater or lesser flash power on your next shot.

Flash Compensation settings are stated in terms of EV (Exposure Value) numbers. A setting of 0.0 indicates no flash adjustment. You can increase the flash power to EV +1.0 or decrease it to EV –3.0. Each whole number change equates to a one-stop shift. (*Stop* is camera lingo for an increment of exposure change. A one-stop change doubles or halves the current exposure.)

As an example, see Figure 3-7. The first image shows a flash-free shot. Clearly, I needed a flash to compensate for the fact that the horses were shadowed by the roof of the carousel. But at normal flash power, the flash was too strong, creating glare in some spots on the horse's neck and blowing out the highlights in the white mane. By dialing the flash power down to EV –1.0, I got a softer flash that straddled the line perfectly between no flash and too much flash.

Flash EV 0.0

Flash EV -1.0

Figure 3-7: When normal flash output is too strong, dial in a lower Flash Compensation setting.

Here are the two controls you need to know to take advantage of this feature:

Setting the Flash Compensation amount: Press the Flash button while rotating the Sub-command dial.

While the Flash button is pressed, all the displays show the current Flash Compensation amount. As you rotate the Sub-command dial, a plus or minus sign also appears to indicate whether you're dialing in a positive or negative value. Figures 3-8 and 3-9 show you where to find the setting in the displays.

After you release the Flash button, you see the Flash Compensation amount in the Information display, but the Live View display, viewfinder, and Control panel show just the Flash Compensation icon. You can press the Flash button at any time to reveal the Flash Compensation value.

Disabling flash adjustment during Exposure Compensation: Exposure Compensation, a cousin of Flash Compensation, gives you a way to produce a darker or lighter overall exposure. (Chapter 4 covers this feature.) By default, if you use flash when Exposure Compensation is in force, the flash power is affected by your Exposure Compensation setting. But you can tell the camera to leave the flash out of the equation when you apply Exposure Compensation. To do so, open the Custom Setting menu. Choose Bracketing/Flash > Exposure Comp. for Flash, and change the setting from Entire Frame to Background Only. You then can use Flash Compensation to vary the flash output as you see fit.

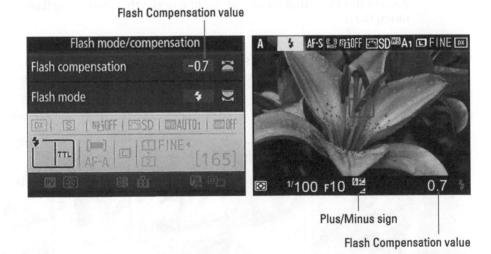

Figure 3-8: Rotate the Sub-command dial while pressing the Flash button to apply Flash Compensation (adjust flash output).

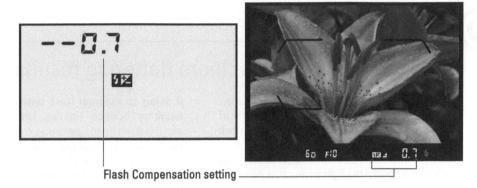

Figure 3-9: While the Flash button is pressed, the Flash Compensation amount also appears in the Control panel and viewfinder.

Any flash-power adjustment you make remains in force until you reset the control. So be sure to check the setting before you next use your flash. Set the value to 0.0 to disable Flash Compensation.

Switching to manual flash-power control

Normally, your flash operates in the TTL (through the lens) mode, in which the camera automatically determines the right flash output for you. If you prefer, you can switch to manual flash control and select a specific flash power. However, you can use this option only in the P, S, A, and M exposure modes.

To use manual flash control, choose Custom Setting > Bracketing/Flash > Flash Cntrl for Built-in Flash, as shown on the left in Figure 3-10. Select Manual, as shown on the right, to display the screen where you can specify the flash power. Settings range from full power to 1/128 power. (If you're hip to rating flash power by Guide Numbers, the camera manual spells out the ratings for the built-in flash.)

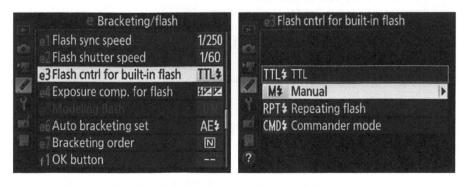

Figure 3-10: In the P, S, A, and M exposure modes, you can set flash power manually.

Softening flash for more flattering results

Flash lighting is a wonderful invention, but when you hit your subject straight on with a burst of flash light, the results are usually less than ideal, causing harsh shadows, skin reflections, and red-eye. So one trick for better flash photos is to soften and spread the light as much as possible.

In addition to using the on-camera options discussed in this chapter to modify flash results, try these tricks:

- Indoors, turn on as many room lights as possible. With more ambient light, you reduce the flash power needed to expose the picture. In portraits, adding light also causes the pupils to constrict, further reducing the chances of red-eye and also allowing more of the subject's eye color to be visible. Remember that mixing flash light with other light sources can affect photo colors; you may need to use the White Balance adjustments covered in Chapter 6 to tweak colors.
- Invest in a flash diffuser. A diffuser is a piece of translucent plastic or fabric that you place over the flash to soften and spread the light, much like how sheer curtains diffuse window light. Diffusers come in lots of different designs, including models that fit over the built-in flash and fold up into a small square that fits easily in your camera bag. Do an online search or visit your local camera store to check out the available options.

- If using an external flash with a rotating head, try "bounce" lighting. That means to aim the flash head upward so that the flash light bounces off the ceiling and falls softly down onto the subject. Make sure that the ceiling or other surface you use to bounce the light is white or another neutral color; otherwise, the flash light will pick up the color of the surface and influence the color of your subject.
- Try using off-camera flash. Your camera supports the Nikon Creative Lighting System (CLS), which enables you to use the built-in flash to trigger one or more remote flash units, freeing you to light your subject from any direction and distance. You might set up a remote flash a few feet to the side of your subject, for example. The onboard flash can be set to trigger only the remote flash, without adding to the subject lighting, or you can set it to add just a bit of extra light.

See the later section "Exploring Additional Flash Options" to find out more about this camera feature (look for the paragraph about *commander mode*). Also visit Nikon online to get a better idea of how the system works. It's pretty cool, and it can provide great added lighting flexibility without requiring you to rely on bulky, traditional lighting equipment.

Enabling High-Speed Flash (Auto FP)

To properly expose flash pictures, the camera has to synchronize the timing of the flash output with the opening and closing of the shutter. On the D7200, this synchronization normally dictates a maximum shutter speed of 1/250 second when you use the built-in flash. But by enabling Auto FP flash, you

can bump the maximum sync speed up to 1/320 second for the built-in flash. If you attach a compatible Nikon flash unit, you can access the full range of shutter speeds.

When Auto FP flash is used, the flash fires a little differently. Instead of a single pop of light, it emits a continuous, rapid-fire burst while the shutter is open. Although that sounds like a good thing, it actually forces a reduction of the flash power, thereby shortening the distance over which subjects remain illuminated. The faster your shutter speed, the greater the impact on the flash power. So at very high speeds, your subject needs to be pretty close to the camera to be properly exposed by the flash.

Because of this limitation, high-speed flash is mostly useful for shooting portraits or other close-up subjects. In fact, it's very useful when you're shooting portraits outside in the daytime and you want the background to appear blurry. One way to get that blurry background is to use a low f-stop (wide aperture). Problem is, a wide aperture lets a ton of light into the camera, and at a shutter speed of 1/250 second, all that light typically overexposes the picture even at ISO 100. With high-speed flash, you can increase the shutter speed enough to compensate for the large aperture. (Chapters 4 and 5 explain f-stops and other exposure and focus issues.)

To access the high-speed flash option, open the Bracketing/Flash section of the Custom Setting menu and select the Flash Sync Speed option, as shown in Figure 3-11. You can choose from the following settings:

⊕ Bracketing/flash		e1 Flash sync speed	
e1 Flash sync speed	1/250	1/320 s (Auto FP)	
a? Flash shutter speed	1/60	1/250 s (Auto FP)	
Blash cntrl for built-in flash	TTL\$	1/250 s	
Exposure comp. for flash	SZZ	1/200 s	
e5 Modeling flash	ON	1/160 s	
ef Auto bracketing set	AE\$	1/125 s	
e7 Bracketing order	N	月 1/100 s	
f1 OK button		? 1/80 s	

Figure 3-11: Through this option, you can enable high-speed flash, permitting a faster maximum shutter speed for flash photos.

- ✓ 1/320 s (Auto FP): At this setting, you can use the built-in flash with shutter speeds up to 1/320 second. For select Nikon flash units (including models SB-910, SB-900, SB-800, SB-700, SB-600, and SB-R200), you can use any shutter speed.
- ✓ 1/250 s (Auto FP): For compatible external flash units, the high-speed flash behavior kicks in at shutter speeds over 1/250 second. With the

built-in flash, the flash sync speed is set to 1/250 second. In P and A exposure modes, the high-speed flash sync is activated if the camera needs to use a shutter speed faster than 1/250 second. (Note that the camera may sometimes use a shutter speed faster than 1/250 second in those modes even if the shutter speed readout is 1/250.)

1/250 s to 1/60 s: The other settings on the menu establish a fixed maximum sync speed. By default, it's set to 1/250 second, and high-speed flash operation is disabled.

Using Flash Value Lock (FV Lock)

By default, the camera measures the light throughout the entire frame to calculate exposure and flash settings when you press the shutter button half-way. But it adjusts those settings up to the time you press the shutter button fully to record the image, ensuring that exposure remains correct even if the light changes between your initial shutter button press and the image capture. FV Lock (Flash Value Lock) enables you to lock flash power at any time before you fully depress the shutter button.

Here's the most common reason for using this feature: Suppose that you want to compose your photo so that your subject is located at the edge of the frame. You frame the scene initially so the subject is at the center of the frame, lock the flash power, and then reframe. If you don't lock the flash value, the camera calculates flash power on your final framing, which could be inappropriate for your subject. You also can use FV Lock to maintain a consistent flash power for a series of shots.

This feature is one of the few advanced flash options that works in Auto mode and in the Scene and Effects modes that permit flash — but only if the camera sees the need for flash in the first place. In Food Scene mode, you must pop up the flash to use flash. However, FV Lock is available only for viewfinder photography; it doesn't work in Live View mode. And when using the built-in flash, you must use the TTL setting for the Flash Cntrl for Built-in Flash option on the Custom Setting menu. (That setting is the default.)

Regardless of your exposure mode, you can't use FV Lock until you first assign the function to the Fn button, which is set up by default to give you access to the Image Area setting (DX or 1.3x crop), or to the Depth of Field Preview button (which normally lets you see how your f-stop will affect depth of field). You can also give the FV Lock button to the AE-L/AF-L button, but I don't recommend that option because the button's normal role (to lock exposure and focus) is one you may use often.

The fastest way to change a button function is to display the i button menu. Choose Assign Fn button or Assign Preview button and select FV Lock as the setting. (Chapter 11 explains more about adjusting button functions.)

After assigning a button to the FV Lock feature, follow these steps to use it:

- 1. Frame the shot so that your subject is in the center of the viewfinder.
- 2. Press and hold the shutter button halfway to engage the exposure meter and, if autofocusing is used, set focus.
- 3. Press and release the button that you assigned to FV Lock.

The flash fires a brief light to determine the correct flash power. When flash power is locked, you see a little flash symbol with the letter L at the left end of the viewfinder. The same symbol appears in the Information display (look in the upper-left corner of the screen).

4. Recompose the picture if desired and then take the shot.

To disable FV Lock, press the assigned button again.

Exploring Additional Flash Options

For most people, the flash options covered to this point in the chapter are the most useful on a regular basis, but your camera does offer a few other features you may appreciate on occasion, as outlined in the following list.

Keep in mind that I'm touching on the highlights here — be sure to dive into the camera manual or your flash manual (if you use an external flash unit) for all the nitty-gritty. Also note that these flash options are available only when the exposure mode is set to P, S, A, or M, and all are found on the Bracketing/Flash submenu of the

Figure 3-12: You can find additional flash features in the Bracketing/Flash section of the Custom Setting menu.

Custom Setting menu, shown in Figure 3-12.

✓ Flash Shutter Speed: This option relates only to the P and A exposure modes. In those modes, the camera normally restricts itself to using a shutter speed no slower than 1/60 second when you use flash. If you need a longer exposure — as may be the case when shooting in very dark conditions — you can waive that 1/60 second limit through the Flash Shutter Speed option. You can set the minimum as slow as 30 seconds.

- Note that the camera totally ignores this value if you set the Flash mode to Slow-Sync flash, Slow-Sync with Red Eye, or Slow Rear-Curtain Sync, which already drops the shutter speed below 1/60 second. Flip back to the section "Investigating Flash modes" for help with these settings.
- Flash Cntrl for Built-in Flash: Earlier sections in this chapter explore two of the four settings for this option, TTL (normal flash exposure) and Manual (you set a specific flash power). You also find the following two features via this menu option:
 - Repeating Flash: This feature fires the flash repeatedly as long
 as the shutter is open. The resulting picture looks as though it
 was shot with a strobe light a special-effects function. You can
 modify certain aspects of the flash output, including how often the
 flash fires per second.
 - Commander Mode: Commander mode enables the built-in flash to act as a master flash, which means that you can use it to trigger remote flash units. When the remote units "see" the light from the master flash, they fire. You can set the power of the remote flashes through the Commander Mode options and specify whether you want the built-in flash to simply trigger other flashes or add its light to the scene. (Your flash units must be compatible with the Nikon Creative Lighting System to respond to the flash commands.)
- Modeling flash: When flash is enabled, you can press the Depth-of-Field Preview button (front of the camera, labeled PV) to emit a modeling flash, which is a rapid series of flash pulses. The idea is to enable you to preview how the light will fall on your subject. However, living subjects aren't likely to appreciate the feature it's a bit blinding to have the flash going off repeatedly in your face. And obviously, using the feature drains the camera battery or the battery of an external flash.
 - To disable this feature, set the Modeling Flash option to Off. Changing the function of the Depth-of-Field Preview button from the default setting, which I show you how to do in Chapter 11, also disables the modeling flash.
- Flash bracketing: The last two options on the Bracketing/Flash submenu relate to the camera's autobracketing feature, which enables you to automatically record a series of images at different exposures and flash-power settings. On the D7200, you also can choose to bracket Active D-Lighting, an exposure tweak I discuss in Chapter 4, and White Balance, which you can explore in Chapter 6. Check out the last section of Chapter 4 to find out how and when to put bracketing to use.

Part II Beyond the Basics

Find out how to customize Picture Controls at www.dummies.com/extras/nikon.

In this part Find out how to control exposure and shoot in the advanced exposure modes (P, S, A, and M). Master the autofocusing system and get help with manual focusing. Understand how to control depth of field.

- Manipulate color by using white balance and other color options.
- Get pro tips for shooting portraits, action shots, landscapes, close-ups, and more.
- Take advantage of your camera's HD movie-recording features.

Taking Charge of Exposure

In This Chapter

- ▶ Understanding the basics of exposure
- ▶ Choosing the right exposure mode: P, S, A, or M?
- Reading meters and other exposure cues
- Solving exposure problems
- Creating a safety net with automatic bracketing

nderstanding exposure is one of the most intimidating challenges for a new photographer. Discussions of the topic are loaded with technical terms — aperture, metering, shutter speed, ISO, and the like. Add the fact that your camera offers many exposure controls, all sporting equally foreign names, and it's no wonder that most people throw up their hands and decide that their best option is to stick with the Auto exposure mode and let the camera take care of all exposure decisions.

You can, of course, turn out good shots in Auto mode, and I fully relate to the confusion you may be feeling — I've been there. But I can also promise that when you take things nice and slow, digesting a piece of the exposure pie at a time, the topic is *not* as complicated as it seems on the surface. I guarantee that the payoff will be worth your time, too. You'll not only gain the know-how to solve just about any exposure problem but also discover ways to use exposure to put your creative stamp on a scene.

To that end, this chapter provides everything you need to know about controlling exposure, from a primer in exposure terminology (it's not as bad as it sounds) to tips on using the P, S, A, and M exposure modes, which are the only ones that offer access to all exposure features.

Note: The one exposure-related topic not covered in this chapter is flash; I discuss flash in Chapter 3 because it's among the options you can access even in Auto mode and many of the other point-and-shoot modes. Also, this chapter deals with still photography; see Chapter 8 for information on movie-recording exposure issues.

Meeting the Exposure Trio: Aperture, Shutter Speed, and ISO

Any photograph is created by focusing light through a lens onto a light-sensitive recording medium. In a film camera, the film negative serves as that medium; in a digital camera, it's the image sensor, which is an array of light-responsive computer chips.

Between lens and sensor are two barriers — the aperture and shutter — which work in concert to control how much light makes its way to the sensor. In the digital world, the design and arrangement of the aperture, shutter, and sensor vary depending on the camera; Figure 4-1 illustrates the basic concept.

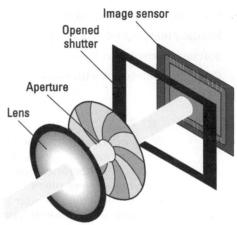

Figure 4-1: The aperture size and shutter speed determine how much light strikes the image sensor.

The aperture and shutter, along with a third feature, ISO, determine *exposure*, or overall brightness and contrast. This three-part exposure formula works as follows:

Aperture (controls the amount of light): The aperture is an adjustable hole in a diaphragm inside the lens. You change the aperture size to control the size of the light beam that can enter the camera.

Aperture settings are stated as *f-stop numbers*, or simply *f-stops*, and are expressed by the letter *f* followed by a number: f/2, f/5.6, f/16, and so on. The lower the f-stop number, the larger the aperture, and the more light is permitted into the camera, as illustrated by Figure 4-2. (If it seems backward to use a higher number for a smaller aperture, think of it this way: A higher value creates a bigger light barrier than a lower value.) The range of aperture settings varies from lens to lens.

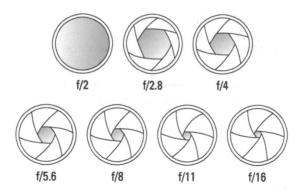

Figure 4-2: A lower f-stop number means a larger aperture, allowing more light into the camera.

Shutter speed (controls the duration of light): The shutter works something like, er, the shutters on a window. The camera's shutter stays closed, preventing light from striking the image sensor (just as closed window shutters prevent sunlight from entering a room) until you press the shutter button. Then the shutter opens briefly to allow light that passes through the aperture to hit the sensor. The exception is when you enable Live View mode: As soon as you switch to Live View mode, the shutter opens and remains open so that the image can form on the sensor and be displayed on the monitor. When you press the shutter button, the shutter first closes and then reopens for the actual exposure.

Either way, the length of time that the shutter is open is the *shutter speed*, which is measured in seconds: 1/60 second, 1/250 second, 2 seconds, and so on.

✓ ISO (controls light sensitivity): ISO, which is a digital function rather than a mechanical structure, enables you to adjust how responsive the image sensor is to light.

The term *ISO* is a holdover from film days, when an international standards organization rated film stock according to light sensitivity: ISO 200, ISO 400, ISO 800, and so on. On a digital camera, the sensor doesn't actually get more or less sensitive when you change the ISO. Instead, the light that hits the sensor is either amplified or dampened through electronics wizardry. The upshot is the same as changing to a more light-reactive film stock, though: Using a higher ISO means that you need less light to produce the image, enabling you to use a smaller aperture, faster

-

shutter speed, or both.

Distilled to its essence, the image-exposure formula is this simple:

- Together, aperture and shutter speed determine how much light strikes the image sensor.
- ✓ ISO determines how much the sensor reacts to that light and thus how much light is needed to expose the picture.

The tricky part of the equation is that aperture, shutter speed, and ISO settings affect pictures in ways that go beyond exposure:

- Aperture affects *depth of field*, or the distance over which focus remains acceptably sharp.
- Shutter speed determines whether moving objects appear blurry or sharply focused.
- ✓ ISO affects the amount of image *noise*, which is a defect that looks like specks of sand.

Understanding these side effects is critical to choosing the combination of aperture, shutter speed, and ISO that will work best for your subject. The next sections explore each issue.

Aperture affects depth of field

The aperture setting, or f-stop, affects *depth of field*, which is the distance over which focus appears acceptably sharp. With a shallow depth of field, your subject appears more sharply focused than faraway objects; with a large depth of field, the sharp-focus zone spreads over a greater distance.

As you reduce the aperture size by choosing a higher f-stop number — *stop down the aperture*, in photo lingo — you increase the depth of field. As an example, see Figure 4-3. For both shots, I established focus on the fountain statue. Notice that the background in the first image, taken at f/13, is sharper than in the right example, taken at f/5.6. Aperture is just one contributor to depth of field, however; the focal length of the lens and the distance between that lens and your subject also affect how much of the scene stays in focus. See Chapter 5 for the complete story.

One way to remember the relationship between f-stop and depth of field is to think of the f as standing for focus. A higher f-stop number produces a larger depth of field, so if you want to extend the zone of sharp focus to cover a greater distance from your subject, you set the aperture to a higher f-stop. Higher f-stop number, greater zone of sharp focus. (Please don't share this tip with photography elites, who will roll their eyes and inform you that the f in f-stop most certainly does not stand for focus but for the ratio between the aperture size and lens focal length — as if that's helpful to know if you're not an optical engineer. Chapter 1 explains focal length, which is helpful to know.)

f/13, 1/25 second, ISO 200

f/5.6, 1/125 second, ISO 200

Figure 4-3: Widening the aperture (choosing a lower f-stop number) decreases depth of field.

Shutter speed affects motion blur

At a slow shutter speed, moving objects appear blurry; a fast shutter speed captures motion cleanly. This phenomenon has nothing to do with the actual focus point of the camera but rather on the movement occurring — and being recorded by the camera — while the shutter is open.

Compare the photos in Figure 4-3. The static elements are perfectly focused in both images although the background in the left photo appears sharper because I shot that image using a higher f-stop, increasing the depth of field. But how the camera rendered the moving portion of the scene — the fountain water — was determined by shutter speed. At 1/25 second (left photo), the water blurs, giving it a misty look. At 1/125 second (right photo), the droplets appear more sharply focused, almost frozen in mid-air. How high a shutter speed you need to freeze action depends on the speed of your subject.

Any movement of the camera during the exposure can blur your entire image, as shown in Figure 4-4. The slower the shutter speed, the longer the exposure time and the longer you have to hold the camera still to avoid that blur. How slow you can set the shutter speed and successfully handhold the camera varies from person to person, so do your own tests to see where your

handheld threshold lies. Also turn on Vibration Reduction, if your lens offers that feature, which is designed to compensate for a small amount of camera shake. (Look for the VR On/Off switch on the left side of a Nikon VR lens.) Of course, you can avoid any possibility of camera shake by using a tripod. (Turn off Vibration Reduction when using a tripod unless the lens manufacturer counsels otherwise.)

Freezing action isn't the only way to use shutter speed to creative effect. When shooting waterfalls, for example, many photographers use a slow shutter speed to give the water even more of a blurry, romantic look than you see in my fountain example. With colorful subjects, a slow shutter can produce some cool abstract effects and create a heightened sense of motion. Chapter 7 offers examples of both effects.

Figure 4-4: If both stationary and moving objects are blurry, camera shake is the usual cause.

150 affects image noise

As ISO increases, making the image sensor more reactive to light, you increase the risk of noise. *Noise* is a defect that looks similar in appearance to film *grain*, a defect that often mars pictures taken with high ISO film. Both problems make your photo look like it was sprinkled with tiny grains of sand. Figure 4-5 offers an example.

Ideally, then, you should always use the lowest ISO setting to ensure top image quality. Sometimes, though, lighting conditions don't permit you to do so and still use the aperture and shutter speeds you need. Take my rose image as an example. When I shot this picture, I didn't have a tripod, so I needed a shutter speed fast enough to allow a sharp handheld image. I opened the aperture to f/5.6, which was the widest setting on the lens I was using, to allow as much light as possible into the camera. At ISO 100, I needed a shutter speed of 1/40 second to expose the picture, and that shutter speed wasn't fast enough for a successful handheld shot. You see the blurred result on the left in Figure 4-6. By raising the ISO to 200, I was able to use a shutter speed of 1/80 second, which enabled me to capture the flower cleanly, as shown on the right in the figure.

Figure 4-5: Caused by a very high ISO or long exposure time, noise becomes more visible as you enlarge the image.

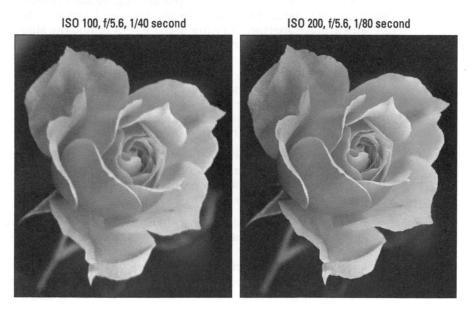

Figure 4-6: Raising the ISO allowed me to bump up the shutter speed enough to capture a blur-free shot while handholding the camera.

Fortunately, you don't encounter serious noise on the D7200 until you really crank up the ISO. In fact, you may even be able to get away with a fairly high ISO if you keep the print or display size small. Some people probably wouldn't even notice the noise in the left image in Figure 4-5 unless they were looking for it. But as with other image defects, noise becomes more apparent as you enlarge the photo, as shown on the right in that same figure. Noise is also easier to spot in shadowed areas of the picture and in large areas of solid color.

How much noise is acceptable — and, therefore, how high of an ISO is safe — is your choice. Even a little noise isn't acceptable for pictures that require the highest quality, such as images for a product catalog or a travel shot that you want to blow up to poster size.

A high ISO isn't the only cause of noise. A long exposure time (slow shutter speed) can also produce the defect. So, how high you can raise the ISO before the image gets ugly varies, depending on shutter speed.

Doing the exposure balancing act

As you change any exposure setting — aperture, shutter speed, or ISO — one or both of the other two must also shift to maintain the same image brightness. Say that you're shooting a soccer game and you notice that although the overall exposure looks great, the players appear slightly blurry at the current shutter speed. If you raise the shutter speed, you have to compensate with a larger aperture (to allow in more light during the shorter exposure time) or a higher ISO setting (to make the camera more sensitive to the light) — or both.

Again, changing these settings affects photos in ways beyond exposure:

- Aperture affects depth of field, with a higher f-stop number increasing the distance over which objects appear sharp.
- Shutter speed affects whether motion of the subject or camera results in a blurry photo. A faster shutter "freezes" action and also helps safeguard against all-over blur that can result from camera shake when you're handholding the camera.
- ISO affects the camera's sensitivity to light. A higher ISO makes the camera more responsive to light but also increases the chance of image noise.

When you boost that shutter speed to capture your soccer subjects, therefore, you have to decide whether you prefer the shorter depth of field that comes with a larger aperture or the increased risk of noise that accompanies a higher ISO.

Everyone has their own approach to finding the right combination of aperture, shutter speed, and ISO, and you'll no doubt develop your own system as you become more familiar with these concepts. In the meantime, here's how I handle things:

- ✓ I use ISO 100, the lowest setting on the camera, unless the lighting conditions are so poor that I can't use the aperture and shutter speed I want without raising the ISO.
- If my subject is moving, I give shutter speed the next highest priority in my exposure decision. I might choose a fast shutter speed to ensure a blur-free photo or, on the flip side, select a slow shutter to intentionally blur that moving object, an effect that can create a heightened sense of motion.
- For nonmoving subjects, I make aperture a priority over shutter speed, setting the aperture according to the depth of field I have in mind.

Keeping all this straight is overwhelming at first, but the more you work with your camera, the more the exposure equation will make sense to you. You can find tips for choosing exposure settings for specific types of pictures in Chapter 7; keep moving through this chapter for details on using your camera's exposure tools.

Stepping Up to Advanced Exposure Modes (P, S, A, and M)

In the fully automatic exposure modes, you have minimal control over exposure. To gain access to all your camera's exposure features, set the Mode dial to one of the four advanced modes highlighted in Figure 4-7: P, S, A, or M. You also need to use these modes to take advantage of many other camera features, including some color and autofocus options.

I introduce these modes in Chapter 2, but because they're critical to your control over exposure, I want to offer additional information here. First, a recap of how the four modes differ:

- ✓ P (programmed autoexposure): The camera selects both aperture and shutter speed to deliver a good exposure at the current ISO setting. But you can choose from different combinations of f-stop and shutter speed for creative flexibility, which is why the official name of this mode is flexible programmed autoexposure.
- ✓ S (shutter-priority autoexposure): You rotate the Main command dial to set the shutter speed, and the camera chooses the aperture setting that produces a good exposure at that shutter speed and the current ISO setting.

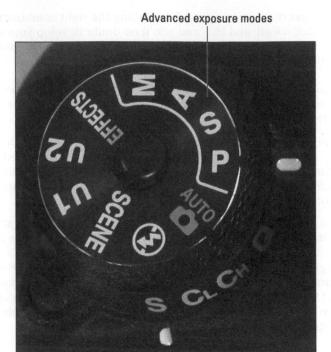

Figure 4-7: You can control exposure and certain other picture properties fully only in P, S, A, or M mode.

- A (aperture-priority autoexposure): The opposite of shutter-priority autoexposure, this mode asks you to select the aperture setting, which you adjust by rotating the Sub-command dial. The camera selects the appropriate shutter speed again, based on the ISO setting.
- M (manual exposure): In this mode, you specify both shutter speed and aperture: Rotate the Main command dial to set shutter speed and the Sub-command dial to adjust aperture. The brightness of your photo depends on the settings you select and the current ISO setting.

To sum up, the first three modes are semiautomatic modes that offer exposure assistance while still providing you with some creative control. Note one important point about P, S, and A modes, however: In extreme lighting, the camera may not be able to select settings that produce a good exposure. You may be able to solve the problem by using features that modify autoexposure results, such as Exposure Compensation (explained later in this chapter) or by adding flash, but you get no guarantees.

Manual mode puts all exposure control in your hands. If you're a longtime photographer who comes from the days when manual exposure was the only

game in town, you may prefer to stick with this mode. If it ain't broke, don't fix it, as they say. And in some ways, manual mode is simpler than the semi-automatic modes — if you're not happy with the exposure, you just change the aperture, shutter speed, or ISO setting and shoot again. You don't have to fiddle with features that tweak autoexposure results.

My choice is to use aperture-priority autoexposure when I'm shooting stationary subjects and want to control depth of field — aperture is my *priority* — and to switch to shutter-priority autoexposure when I'm shooting a moving subject and I'm most concerned with controlling shutter speed. Frankly, my brain is taxed enough by all the other issues involved in taking pictures — what my Release mode setting is, what resolution I need, where I'm going for lunch as soon as I make this shot work — that I appreciate having the camera do some of the heavy lifting.

However, when I know exactly what aperture and shutter speed I want to use or I'm after an out-of-the-ordinary exposure, I use manual exposure. For example, sometimes when I'm doing a still life in my studio, I want to create a certain mood by underexposing a subject or even shooting it in silhouette. The camera will always fight you on that result in the P, S, and A modes because it so dearly wants to provide a good exposure. Rather than dial in all the autoexposure adjustments that would eventually force the result I want, I set the mode to M, adjust the shutter speed and aperture directly, and give the autoexposure system the afternoon off.

But even in Manual exposure mode, you're never flying without a net: The camera assists you in choosing the right exposure settings by displaying the exposure meter, explained next.

Reading the Exposure Meter

One of your camera's most important tools, the *exposure meter* tells you whether the camera thinks your picture will be properly exposed at your chosen f-stop, shutter speed, and ISO settings. Figures 4-8 and 4-9 show you where to find the meter in the Information display, Control panel, viewfinder, and Live View display. Note that in the Live View display, the meter has a vertical orientation.

Here's what you need to know to view and interpret the meter:

You may need to press the shutter button halfway to initiate exposure metering. In Live View mode, the metering system is always active. But during viewfinder photography, the camera saves battery power by turning off the metering system after 6 seconds of inactivity. To initiate exposure metering, press the shutter button halfway. (If you're using autofocusing, your button press also fires up the autofocus system.)

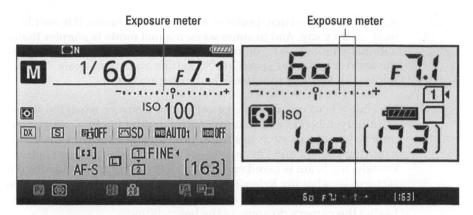

Figure 4-8: In M exposure mode, the exposure meter appears in the Information display, Control panel, and viewfinder.

In M (manual) exposure mode, the meter is always visible and works like a traditional light meter. That is, the camera analyzes the light, checks your exposure settings, and then displays a bar graph that shows where you are on the exposure scale. You can get a close-up look at the meter in Figure 4-10.

The squares on either side of the 0 represent one full stop each, with the full meter spanning 4 stops. The small lines below indicate over- or underexposure, breaking each stop into

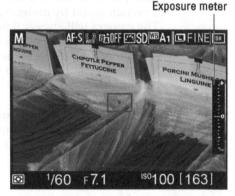

Figure 4-9: In the Live View display, the meter has a vertical orientation.

thirds. The middle readout in Figure 4-10, for example, indicates an over-exposure of 1 and 2/3 stop. The right readout indicates the same amount of underexposure. A triangle at the end of the meter (not shown in the figure) indicates that the amount of over- or underexposure exceeds the range of the meter.

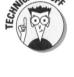

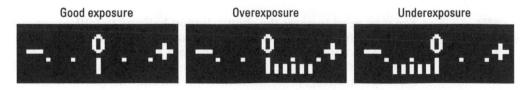

Figure 4-10: Each square on the meter equals one stop; the lines below represent 1/3 stop.

116

This meter setup assumes that you haven't fiddled ting for the EV Steps for Exposure Cntrl option on the menu. If you change that setting from 1/3 step to 1/2 under the meter reflect half-stop increments. The si stops: How many do you want to see?", later in this setting, which also affects other exposure features.

- In exposure modes other than M, the meter may or may not appear. The meter appears only if one or both of the following occurs:
 - The camera anticipates an exposure problem. Again, the bars under the meter tell you whether the camera anticipates a too-bright or too-dark image.
 - You enable Exposure Compensation. Detailed later in this chapter, this feature gives you some control over autoexposure results.
 Applying Exposure Compensation tells the camera to adjust exposure settings so that your next image is brighter or darker. When Exposure Compensation is turned on, the 0 on the meter blinks, and the bars underneath indicate the amount of compensation you requested.

During Live View, the meter appears only in the Control panel. It doesn't show up on the monitor preview, no matter what the circumstances, unless you shoot in the M exposure mode.

- Exposure calculations are based on the Metering mode. This setting determines which part of the frame the camera considers when analyzing the light. At the default setting, exposure is based on the entire frame, but you can select two other Metering modes. See the next section for details.
- In Live View mode, metering may be calculated differently for some scenes than when you use the viewfinder. The rationale is to produce an exposure that's close to what you see in the live preview, which attempts to simulate the final exposure. However, be aware that monitor brightness isn't always an accurate rendition of exposure. First, the perceived display brightness depends on ambient lighting, and second, the monitor can't display the full range of exposure adjustment that you can apply via Exposure Compensation.

Long story short: The meter is a more accurate exposure guide than the monitor when you shoot in Live View mode. (Remember that the meter appears only in the Control panel unless you shoot in the M exposure mode.)

- You can customize certain aspects of the exposure metering system. You can make the following adjustments via the Custom Setting menu:
 - Reverse the meter orientation. For photographers used to a camera
 that orients the meter with the positive (overexposure) side
 appearing on the left and the negative (underexposure) side on the
 right the design that Nikon used for years the D7200 offers

the option to flip the meter to that orientation. From the Custom Setting menu, choose Controls > Reverse Indicators and then select the first menu option (+0-).

- Adjust meter shutdown timing: Choose Custom Setting > Timers/ AE Lock > Standby Timer to reduce or extend the automatic meter shutdown timing.
- Recalibrate the meter: The Fine-Tune Optimal Exposure option (also found in the Metering/Exposure section of the Custom Setting menu) is provided for photographers who always want a brighter or darker exposure than the camera delivers by default. In other words, it enables you to recalibrate the meter. Although it's nice to have this level of control, I advise against making this adjustment. It's sort of like reengineering your oven so that it heats to 300 degrees when the dial is set to 325 degrees. It's easy to forget that you made the shift and not be able to figure out why your exposure settings aren't delivering the results you expected.

Finally, keep in mind that the meter readout is a guide, not a dictator. For example, if you want a backlit subject to appear in silhouette, ignore the meter when it reports that your photo is about to be underexposed.

Exposure stops: How many do you want to see?

In photo terminology, *stop* refers to an increment of exposure. To increase exposure by one stop means to adjust the aperture or shutter speed to allow twice as much light into the camera as the current settings permit. To reduce exposure a stop, you use settings that allow half as much light. Doubling or halving the ISO value also adjusts exposure by one stop.

By default, most exposure-related settings on your camera are based on 1/3 stop adjustments. If you prefer, you can tell the camera to present exposure adjustments in 1/2 stop increments so that you don't have to cycle through as many settings each time you want to make a change.

Make your preferences known through these options, found in the Metering/Exposure section of the Custom Setting menu:

- ISO Sensitivity Step Value: Affects ISO settings only.
- EV Steps for Exposure Cntrl (Control):
 Affects shutter speed, aperture, Exposure
 Compensation, Flash Compensation, and
 exposure bracketing settings. Also determines the increment used to indicate the
 amount of under- or overexposure in the
 exposure meter.

The default setting, 1/3 stop, provides the greatest degree of exposure fine-tuning, so I stick with that option. In this book, all instructions assume that you're using the defaults as well.

Choosing an Exposure Metering Mode

Your camera's exposure decisions and exposure-meter reading vary depending on the *Metering mode*, which defines the area of the frame being analyzed. The D7200 offers these metering modes:

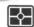

()

- Matrix: Produces a balanced exposure based on the entire frame. (Nikon calls this mode 3D Color Matrix II, which refers to the proprietary metering technology the camera employs.)
- ✓ Center-weighted: Bases exposure on the entire frame but puts extra emphasis weight on the center of the frame. Specifically, the camera assigns 75 percent of the metering weight to an 8mm circle in the center of the frame.

You can adjust the size of the center-weighted metering circle by choosing Custom Setting > Metering/Exposure > Center-Weighted Area, as shown in Figure 4-11. (The option is available only when the Mode dial is set to P, S, A, or M.) You can change the size of the circle to 6mm, 10mm, or 13mm.

The final Center-Weighted Area menu option, Avg, is a goofy one: It doesn't provide centerweighted metering at all, but

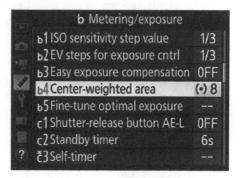

Figure 4-11: You can customize the centerweighted metering area.

rather produces whole-frame metering using a formula older than what Nikon developed for Matrix metering. Longtime Nikon shooters who are familiar with Average metering may appreciate its inclusion, but I suggest that anyone else stick with Matrix for the best whole-frame exposure metering.

✓ Spot: Bases exposure on a circular area about 3.5mm in diameter, or about 2.5 percent of the frame.

The spot that's metered depends on an autofocusing option called AF-area mode. Detailed in Chapter 5, the AF-area mode determines which focus point the camera uses to establish focus. Here's how the camera handles focusing and spot metering at the various AF-area mode settings:

 Auto Area AF-area mode: The camera may select any point for focusing, usually choosing the one that falls over the closest object. But exposure metering is always based on the center focus point. So unless your subject is at the center of the frame, exposure may be incorrect. Any other AF-area mode or manual focusing: Focus and exposure are both based on a single focus point that you select. (Chapter 5 shows you how.) Obviously, this setup provides the most reliable focus and exposure metering.

As an example of how Metering mode affects exposure, Figure 4-12 shows the same image captured in each mode. In the Matrix example, the bright background caused the camera to select an exposure that left the statue quite dark. Switching to center-weighted metering helped somewhat but didn't quite bring the statue out of the shadows. Spot metering produced the best result as far as the statue goes, although the resulting increase in exposure left the sky a little washed out.

Matrix metering

Center-weighted metering

Spot metering

Figure 4-12: The Metering mode determines which area of the frame the camera considers when calculating exposure.

You have control over the Metering mode only in the P, S, A, and M exposure modes. Adjust the setting by pressing the Metering mode button, labeled in Figure 4-13, while rotating the Main command dial. The icons in the margins of the preceding list appear in the Control panel, Information display, and Live View display to indicate the metering mode, as shown in Figures 4-13 and 4-14.

In theory, the best practice is to check the Metering mode before you shoot and choose the one that best matches your exposure goals. But frankly, the Matrix mode produces good results in most situations, so my suggestion is to stick with that option until you're familiar with all the other controls on your camera. After all, you can see in the monitor whether you disagree with how the camera exposed the image and simply reshoot after adjusting the exposure settings to your liking. This option, in my mind, makes the Metering mode setting less critical than it is when you shoot with film.

The one exception might be when you're shooting a series of images in which a significant contrast in lighting exists between subject and background. Then, switching to center-weighted metering or spot metering may save you the time spent having to adjust the exposure for each image. Many portrait photographers always use spot metering, for example, basing exposure only on the subject. If the background is too dark or too bright, so be it. What matters is whether your subject is well exposed.

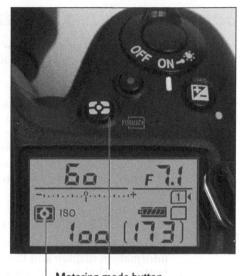

Metering mode button

Matrix Metering mode symbol

Figure 4-13: Press the Metering mode button while rotating the Main command dial to adjust the Metering mode setting.

Figure 4-14: This icon represents the default metering mode, Matrix, which bases exposure on the entire frame.

Setting Aperture, Shutter Speed, and ISO

The next sections detail how to view and adjust these critical exposure settings. For a review of how each setting affects your pictures, check out the first part of this chapter.

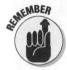

In P, S, or A mode, the settings that the camera selects are based on what it thinks is the proper exposure. If you don't agree, you can switch the camera to manual exposure mode and dial in the aperture and shutter speed that deliver the exposure you want. Or, if you want to stay in P, S, or A mode, you can tweak exposure using the features explained in the section "Solving Exposure Problems," later in this chapter.

Adjusting aperture and shutter speed

You can view the aperture setting (f-stop) and shutter speed at the top of the Information display and Control panel, as shown in Figure 4-15, and at the bottom of the viewfinder and Live View display, as shown in Figure 4-16. You may need to give the shutter button a quick half-press to wake up the exposure system before the data appears. Or, in Live View mode, you may need to press the Info button to change to a display mode that reveals the data.

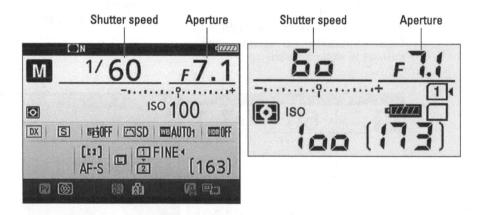

Figure 4-15: You can view the current f-stop and shutter speed at the top of the Information display and Control panel.

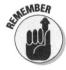

In the viewfinder, shutter speeds are presented as whole numbers, even if the shutter speed is set to a fraction of a second. For example, the number 60 indicates a shutter speed of 1/60 second. When the shutter speed slows to 1 second or more, quote marks appear after the number — 1" indicates a shutter speed of 1 second, 4" means 4 seconds, and so on.

Which of the settings you can adjust — and how you dial in those settings — depends on your exposure mode, as follows.

Figure 4-16: In the Live View display and viewfinder, exposure settings appear at the bottom of the display.

M (manual exposure)

You control both settings. Rotate the Main command dial to adjust shutter speed; rotate the sub-command dial to select the f-stop.

As you change the settings, the exposure meter indicates whether the camera thinks you're headed for a good result or an under- or over-exposed image, basing its decision on the Metering mode and ISO setting.

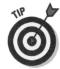

In Manual mode, you can access two shutter speeds not available in the other modes:

- ✓ Bulb: Lower the shutter speed one notch past the 30-second setting to access the Bulb setting, which keeps the shutter open as long as the shutter button is pressed. This option is perfect when you want to experiment with shutter speed but don't have time to change the setting between frames for example, when shooting fireworks. In Bulb mode, you press the shutter button down, count off a few seconds, release the button to record the image, and then press the button and start the count anew for the next frame, varying the exposure time for each shot.
- ✓ Time: This setting, found one step past Bulb and represented by two
 dashes (--), is designed for use with the ML-L3 wireless remote control
 unit. Press the remote's shutter button once to begin the exposure and a
 second time to end it. The maximum exposure time is 30 minutes.

If you set the shutter speed to Bulb or Time and then change the Mode dial to S, the word *Bulb* or *Time* blinks in the displays to let you know that you can't use that option in S mode. You must shift back to M mode to take advantage of these two.

A (aperture-priority autoexposure)

Rotate the Sub-command dial to set the f-stop. As you do, the camera automatically adjusts the shutter speed as needed to expose the image at that aperture and current ISO setting. A few tips on using A mode:

- The range of f-stop settings depends on your lens. For zoom lenses, the range typically also changes as you zoom in and out. For example, a lens may offer a maximum aperture of f/3.5 when set to its widest angle (shortest focal length) but limit you to f/5.6 when you zoom in to a longer focal length. Check your lens manual for details on the minimum and maximum aperture settings.
- Always note the shutter speed that the camera selects. If you're handholding the camera, make sure that the shutter speed isn't so low that you risk blurring the image due to camera shake. And if your scene contains moving objects, make sure that the shutter speed is fast enough to stop action (or slow enough to blur it, if that's your creative goal).
- If the camera can't expose the image at your selected f-stop, warnings appear in the displays. During viewfinder photography, the exposure meter appears to indicate the extent of the problem. In the Live View display, you instead see a blinking shutter-speed value. If you can't adjust the lighting on your subject, your options are to change the ISO or f-stop setting.

S (shutter-priority autoexposure)

Rotate the Main command dial to set shutter speed. Again, the camera automatically adjusts the aperture to maintain proper exposure at the current ISO.

Available shutter speeds range from 30 seconds to 1/8000 second *except* when flash is enabled. When you use the built-in flash, the top shutter speed is 1/250 second. See Chapter 3 for information on how you may be able to use a faster shutter speed with flash.

P (programmed autoexposure)

The camera displays its recommended f-stop and shutter speed when you press the shutter button halfway. But you can rotate the Main command dial to select a different combination. The number of possible combinations depends on the aperture settings the camera can select, which depends on your lens.

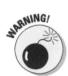

An asterisk (*) appears next to the P symbol in the upper-left corner of the Information and Live View displays if you adjust the aperture/shutter speed settings. You see a tiny P* symbol at the left end of the viewfinder display as well. To get back to the initial combo of shutter speed and aperture, rotate the Main command dial until the asterisk disappears from the displays and the P* viewfinder symbol turns off.

Because the camera can modify both the shutter speed and f-stop setting in P mode, you're unlikely to encounter under- or overexposure issues. However, there's no guarantee that you can use a shutter speed fast enough to freeze your subject (or handhold your camera) or to use an f-stop that provides sufficient depth of field. So be alert if you use this mode: The camera doesn't warn you of these pitfalls as long as it knows the exposure will be okay.

Controlling 150

The ISO setting adjusts the camera's sensitivity to light. A higher ISO enables you to use a faster shutter speed or a smaller aperture (higher f-stop number) because less light is needed to expose the image. But a higher ISO also increases the possibility of noise (refer to Figure 4-5).

As with other picture settings, your ISO choices vary by exposure mode:

- ✓ Night Vision Effects mode: Because this effect is meant to produce a grainy, black-and-white picture, the camera automatically chooses a high ISO setting, intentionally creating noise. You can't adjust the ISO setting.
- Scene modes and all Effects modes except Night Vision: You can choose ISO values ranging from 100 to 25600 or stick with Auto ISO and let the camera select the setting.
- P, S, A, and M modes: You can dial in a specific ISO setting or choose manual control with auto override: If the camera can't expose the photo at your selected ISO, it changes the setting automatically.

The advanced exposure modes give you access to two specialty ISO settings: Hi BW1 and Hi BW2, which provide the equivalent of ISO 51200 and 102400, respectively. Before you get too excited about these überhigh ISO settings, though, understand that both modes produce results similar to what you get in Night Vision Effects mode: a noisy, black-and-white image (thus the BW part of the setting name).

Also, using the Hi settings always results in a JPEG photo, even if you have the Image Quality option set to Raw. Set the JPEG Image Quality option (Basic, Normal, or Fine) before choosing the Hi settings; you can't adjust Image Quality while Hi ISO is in force. Ditto for the Image Size setting. Active D-Lighting, Auto ISO Sensitivity Control, HDR, Multiple Exposure, and Interval Timer Shooting are off-limits as well. As I said, these are specialty modes, which is why they are hidden by default. (Info on how to enable them is upcoming.)

You can view the ISO setting in the Information, Live View, and Control panel displays, as shown in Figure 4-17. To view the value in the viewfinder, press the ISO button; the ISO value temporarily replaces the shots remaining value, as shown in Figure 4-18. When you release the button, ISO data disappears unless you use Auto ISO, in which case the words ISO Auto appear.

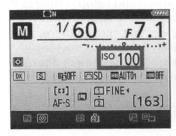

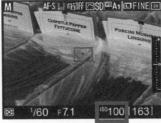

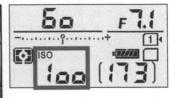

Figure 4-17: You can view the ISO setting in these displays.

To adjust the ISO setting, choose from these options:

✓ **ISO button** + **command dials:**During viewfinder photography, press the ISO button to display the options shown in Figure 4-19. Pressing the button also activates both settings in the Control panel, viewfinder, and Live View display.

While pressing the button, rotate the Main command dial to choose the ISO Sensitivity setting. In P, S, A, and M exposure modes, rotate the Sub-command

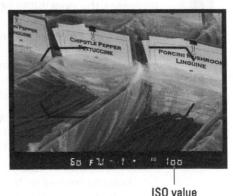

Figure 4-18: Press the ISO button to display the current setting in the viewfinder.

dial to toggle Auto ISO Sensitivity Control on and off. (This setting is the one that gives the camera permission to change your selected ISO if needed.)

Photo Shooting menu: Select ISO Sensitivity Settings, as shown on the left in Figure 4-20, and choose ISO Sensitivity, as shown on the right, to dial in your preferred ISO setting.

Figure 4-19: Press the ISO button to access the ISO options.

Figure 4-20: You can access additional ISO options through the Shooting menu.

In the P, S, A, and M exposure modes, use the other menu options to control these ISO features:

- Hi ISO command dial access: Although you can select the Hi BW1 and Hi BW2 settings from the ISO Sensitivity menu, they don't show up as options when you change the ISO setting by pressing the ISO button and rotating the Main command dial. If you want to be able to use that technique to get to the Hi BW settings, change this menu option to On.
- Auto ISO Sensitivity Control: This option turns Auto ISO override on and off.

During shooting, the camera alerts you that it is about to override your ISO setting by blinking the ISO Auto label in the displays. When you view your pictures in the monitor, the ISO value appears in red if you use certain playback display modes. (Chapter 9 has details.)

- Maximum Sensitivity: This option sets the highest ISO that the camera can use when it overrides the selected setting a great feature because it enables you to decide how much noise you're willing to accept in order to get a good exposure. You can't select either HiBW setting as a maximum. If you want to use a Hi BW setting, you have to select it as the ISO Sensitivity setting yourself. However, you don't have to turn off Auto ISO Sensitivity Control to do so.
- Minimum Shutter Speed: Set the minimum shutter speed at which the Auto ISO override engages. At the Auto setting, the camera selects the minimum shutter speed based on the focal length of your lens, the idea being that with a longer lens, you need a faster shutter speed to avoid the blur that camera shake can cause when you handhold the camera. However, exposure is given priority over camera-shake considerations, so if the camera can't expose the picture at a "safe" shutter speed even when it uses the maximum ISO value you set, it will use a slower speed.
- Enable Easy ISO: This setting, found in the Shooting/
 Display section of the Custom
 Setting menu and shown in
 Figure 4-21, is one of those
 "proceed at your own risk"
 options. Turning the option on
 has two results:
 - You can adjust the ISO settings in P, S, and A exposure modes without pressing the ISO button. In P and S exposure modes, rotate the Subcommand dial; in A mode, the Main command dial. For M exposure mode, you still

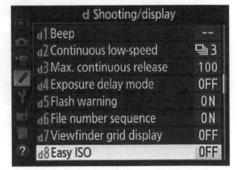

Figure 4-21: Be careful if you enable this option, which allows you to alter ISO by simply rotating a command dial.

have to press the ISO button and rotate the Main command dial to change the setting.

• The ISO value always appears in the viewfinder in place of the shotsremaining value. You have to check the other displays to find out how many more pictures you can fit on your memory card.

Dampening noise

High ISO settings and long exposure times can result in *noise*, a defect that gives pictures a speckled look. To help solve the problem, your camera offers two noise-removal filters: *Long Exposure Noise Reduction*, which dampens the type of noise that occurs during long exposures; and *High ISO Noise Reduction*, designed to reduce the appearance of ISO-related noise. You enable both filters from the Photo Shooting menu or, during viewfinder photography, via the *i* button menu.

If you turn on Long Exposure Noise Reduction, the camera applies the filter to pictures taken at shutter speeds of longer than 1 second. For High ISO Noise Reduction, you can choose from four settings: The High, Normal, and Low settings let you control the strength of the noise-removal effect; at the fourth setting, Off, the camera actually still applies a tiny amount of noise removal "as required." In other words, you can't really disable this function altogether. Nikon does promise that the amount of noise reduction at the Off setting is less than at the Low setting, so that's something.

Why would you want to turn off noise reduction anyway? Because enabling these features

has a few disadvantages. First, the filters are applied after you take the picture, as the camera processes the image data. While the Long Exposure Noise Reduction filter is being applied, the message "Job Nr" appears in the viewfinder. The time needed to apply this filter can significantly slow your shooting speed. In fact, it can double the time the camera needs to record the file to the memory card.

Second, although filters that go after long-exposure noise work fairly well, those that attack high ISO noise work primarily by applying a slight blur to the image. Don't expect this process to totally eliminate noise, and do expect some resulting image softness. You may be able to get better results by using the blur tools or noise-removal filters found in many photo editors, because you can blur just the parts of the image where noise is most noticeable — usually in areas of flat color or little detail, such as skies.

Note, too, that if you shoot in the Raw format, you can apply High ISO Noise Reduction after the fact through the in-camera Raw processing tool. Nikon Capture NX-D also has a noise-removal tool built into its Raw converter. (Chapter 10 covers both Raw conversion options.)

In my opinion, it's too easy to forget that this function is enabled and accidentally change the ISO setting without realizing it. And I don't see a huge benefit in permanently swapping out the viewfinder's shots remaining value with the ISO value, either. You can always see the ISO value in the other displays or just press the ISO button to view it in the viewfinder. So I keep this option disabled, as it is by default.

Solving Exposure Problems

Along with controls over aperture, shutter speed, and ISO, your camera offers a collection of tools designed to solve tricky exposure problems.

If the problem is underexposure due to a lack of ambient light, your camera's built-in flash is at the top of the list of exposure aids to consider. Chapter 3 explains how to get good flash results. But you also have several other exposure-correction features at your disposal, whether your subject appears under- or overexposed. The next several sections introduce you to these features.

Applying Exposure Compensation

In the P, S, and A exposure modes, you have some input over exposure: In P mode, you can choose from different combinations of aperture and shutter speed; in S mode, you can dial in the shutter speed; and in A mode, you can select the aperture setting. But because these are semiautomatic modes, the camera ultimately controls the final exposure. If your picture turns out too bright or too dark in P mode, you can't simply choose a different f-stop/shutter speed combo because they all deliver the same exposure — which is to say, the exposure that the camera has in mind. And changing the shutter speed in S mode or adjusting the f-stop in A mode won't help either because as soon as you change the setting that you're controlling, the camera automatically adjusts the other setting to produce the same exposure it initially delivered. What about changing the ISO? Nope, won't do the trick. The camera just recalculates the f-stop or shutter speed (or both) it needs to maintain the "proper" exposure at that new ISO.

Not to worry: You actually do have final say over exposure in P, S, and A modes. The secret is Exposure Compensation, which tells the camera to produce a brighter or darker exposure on your next shot.

As an example, take a look at the first image in Figure 4-22. The initial exposure selected by the camera left the balloon too dark, so I used Exposure Compensation to produce the brighter image.

How the camera arrives at the brighter or darker image depends on the exposure mode: In A mode, the camera adjusts the shutter speed but leaves your selected f-stop in force. In S mode, the camera adjusts the f-stop and keeps its hands off the shutter speed control. In P, the camera decides whether to adjust aperture, shutter speed, or both. In all three modes, the camera may also adjust ISO if you enable Auto ISO Sensitivity Control.

Keep in mind, though, that the camera can adjust f-stop only so much, according to the aperture range of your lens. And the range of shutter speeds, too, is limited by the camera itself. So there's no guarantee that the camera can actually deliver a better exposure when you dial in Exposure Compensation. If you reach the end of the f-stop or shutter speed range, you have to adjust ISO or compromise on your selected f-stop or shutter speed.

EV +1.0

EV 0.0

Figure 4-22: For a brighter exposure, raise the Exposure Compensation value.

With that background out of the way, here are details you need to know to take best advantage of this feature:

- **Exposure Compensation settings are stated in terms of EV numbers, as in EV +2.0.** Possible values range from EV +5.0 to EV -5.0. (*EV* stands for *exposure value*.) Each full number on the EV scale represents an exposure shift of 1 stop. A setting of EV 0.0 results in no exposure adjustment. For a brighter image, raise the Exposure Compensation value; for a darker image, lower the value. For my balloon image, I set the value to EV +1.0.
- Where and how you check the current setting depends on the display, as follows:
 - *Information display:* This one's straightforward: The setting appears in the area labeled on the left in Figure 4-23. In addition, the meter shows the amount of compensation being applied. In Figure 4-23, for example, the meter indicator appears 1 stop toward the positive end of the meter, reflecting the EV +1.0 setting. The 0 in the meter blinks to remind you that the meter is reporting the Exposure Compensation setting.

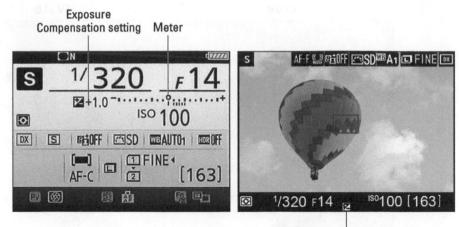

Exposure Compensation enabled

Figure 4-23: These indicators tell you whether Exposure Compensation is enabled.

• Live View display: If Exposure Compensation is turned on, you see the plus/minus symbol labeled on the right in the figure; otherwise, that area of the display appears empty.

To view the selected adjustment amount in Live View mode, press and hold the Exposure Compensation button. The EV value takes the place of the shots remaining value, and the Exposure Compensation symbol changes to show a plus sign for a positive EV value and a minus sign for a negative value.

- Viewfinder and Control panel: These displays also show the plus/minus symbol only, but again, you can press the Exposure Compensation button to temporarily view the EV setting. Or just look at the exposure meter, which tells you how much exposure shift is in force.
- ✓ Press the Exposure Compensation button while rotating the Main command dial to adjust the setting. As you adjust the setting in Live View mode, the monitor brightness updates to show you how the change will affect exposure. However and this is a biggie, so stop texting and pay attention the preview can only show an adjustment up to +/- EV 3.0, even though you can set the adjustment as high as +/- EV 5.0.
- You also can enable this feature in several Scene modes and Night Vision Effects mode. Unlike some of the options I cover in this chapter, using Exposure Compensation isn't limited to the P, S, and A exposure modes. To check whether the feature is available for your selected

- mode, just look at the Information display or Live View display or press the Exposure Compensation button. If the option is off-limits, the camera tells you so.
- Exposure Compensation affects the meter in M exposure mode. Although the camera doesn't change your selected exposure settings in M exposure mode if Exposure Compensation is enabled, the exposure *meter* is affected. It indicates whether your shot will be properly exposed based on the Exposure Compensation setting.
- In the P, S, A, and M exposure modes, your Exposure Compensation setting remains in force until you change it, even if you power off the camera. So check the setting before each shoot or always set the value to EV 0.0 after taking the last shot that needs compensation.

For the Scene and Effects modes that allow you to set Exposure Compensation, the adjustment is reset to zero when you turn the camera off or choose a different exposure mode.

- For flash photos, the Exposure Compensation setting normally affects background brightness and flash power. If you don't want flash power adjusted, open the Custom Setting menu, choose Bracketing/Flash > Exposure Comp. for Flash, and change the setting from Entire Frame to Background Only. You then can use Flash Compensation to vary the flash output as you see fit. (Chapter 3 details that option.)
- Think twice before enabling the Easy Exposure Compensation option on the Custom Setting menu. This feature is a cousin to the Easy ISO option discussed earlier: If you enable Easy Exposure Compensation, you can adjust Exposure Compensation without having to press the Exposure Compensation button. In the P and S exposure modes, rotate the Sub-command dial; in A exposure mode, rotate the Main command dial. (You can't use either trick in M mode.) As with the Easy ISO feature, I don't recommend enabling this feature because you can easily rotate the dials by mistake and not realize that Exposure Compensation is in force.

Expanding tonal range

A scene like the one in Figure 4-24 presents the classic photographer's challenge. Choosing exposure settings that capture the darkest parts of the subject appropriately causes the brightest areas to be overexposed. And if you instead *expose for the highlights* — set the exposure settings to capture the brightest regions properly — darker areas are underexposed.

In the past, you had to choose between favoring highlights or shadows. But with the D7200, you can expand *tonal range* — the range of brightness values in an image — through two features: Active D-Lighting and automatic HDR (high dynamic range). The next two sections explain both options.

Active D-Lighting Off

Active D-Lighting Auto

Figure 4-24: Active D-Lighting captured the shadows without blowing out the highlights.

Applying Active D-Lighting

One way to cope with a high-contrast scene like the one in Figure 4-24 is to turn on Active D-Lighting. The D is a reference to $dynamic\ range$, the term used to describe the range of brightness values that an imaging device can capture. By turning on this feature, you enable the camera to produce an image with a slightly greater dynamic range than usual.

Specifically, Active D-Lighting gives you a better chance of keeping highlights intact while better exposing the darkest areas. In my seal scene, Active D-Lighting produced a brighter rendition of the darkest parts of the rocks and the seals, for example, yet the color in the sky didn't get blown out, as it did when I captured the image with Active D-Lighting turned off. The highlights in the seal and in the rocks in the lower-right corner of the image also are toned down a tad in the Active D-Lighting version.

Active D-Lighting does its thing in two stages. First, it selects exposure settings that result in a slightly darker exposure than normal, which helps to retain highlight details. After you snap the photo, the camera brightens the darkest areas of the image to rescue shadow detail.

Symbols representing the current Active D-Lighting setting appear in the Information and Live View displays, in the areas labeled in Figure 4-25. The symbol that you see in the figures represents the Auto setting, which lets the camera select the amount of adjustment. (I used this setting for my seal image.) If you have sharp eyesight, you also can spot the letters ADL in the viewfinder data readout when Active D-Lighting is enabled.

Figure 4-25: These symbols represent the Auto Active D-Lighting setting.

When you shoot in Effects mode, Active D-Lighting is always turned off. (The camera doesn't want you doing anything to mess with the effect it's trying to provide.) In the Scene modes, Auto mode, and Auto Flash Off modes, the option is always set to Auto, which means the camera decides whether any Active D-Lighting adjustment is needed and, if so, how much. In the P, S, and A modes, you can choose from these Active D-Lighting settings: Auto, H* (extra high), H (high), N (normal), L (low), and Off. In M exposure mode, choosing Auto produces the same results as selecting Normal. The default setting for all four exposure modes is Off.

I usually keep this option set to Off so that I can decide for myself whether I want any adjustment instead of having the camera apply it to every shot. Even with a high-contrast scene that's designed for the Active D-Lighting feature, you may decide that you prefer the "contrasty" look that results from disabling the option.

To select the setting you want to use, you can take two paths:

i button menu: Figure 4-26 shows how the menu appears during view-finder photography (left) and Live View mode (right). Select the Active D-Lighting option and then press OK to display a screen where you can set the adjustment level.

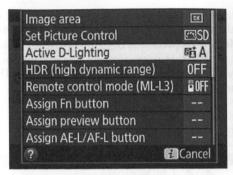

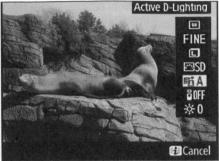

Figure 4-26: The fastest way to adjust the Active D-Lighting setting is via the i button menu.

Photo Shooting menu: You also can change the Active D-Lighting setting via the Photo Shooting menu, as shown in Figure 4-27. (Scroll to the second page of the menu to get to the option.)

A few final pointers about Active D-Lighting:

- You get the best results in Matrix metering mode.
- If you're not sure whether the picture will benefit from Active D-Lighting, try Active D-Lighting bracketing, which automatically

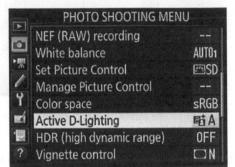

Figure 4-27: Or select the setting via the Shooting menu.

Exploring high dynamic range (HDR) photography

D-Lighting adjustment. Chapter 10 details that feature.

In the past few years, digital photographers have been experimenting with a technology called HDR photography. HDR stands for *high dynamic range* — again, dynamic range refers to the spectrum of brightness values that a camera or another imaging device can record.

The idea behind HDR is to capture the same shot multiple times, using different exposure settings for each image. You then use special imaging software, called *tone mapping software*, to combine the exposures in a way that uses

specific brightness values from each shot. By using this process, you get a shot that contains a much higher dynamic range than the camera can capture in a single image.

For quick and easy HDR photography, the D7200 offers automated HDR. When you enable this option, the camera records two images, each at different exposure settings, and then does the tone-mapping manipulation for you to produce a single HDR image. This feature is available only in the P, S, A, and M exposure modes.

So how is HDR different from Active D-Lighting — other than the fact that it records two photos instead of manipulating a single capture? Well, with the HDR feature, you can request an exposure shift that results in up to three stops difference between the two photos. That enables you to create an image that has a broader dynamic range than you can get with Active D-Lighting.

Figure 4-28 shows the type of results you can expect. In this scene, half of the area is in bright sunshine, and the other is in shadow. For the top-left photo in the figure, I exposed for the highlights, which left the right side of the scene too dark. For the top-right image, I set exposure for the shaded area, which blew out the highlights in the sunny areas. With the HDR feature,

Exposed for highlights

Exposed for shadows

HDR, Extra High

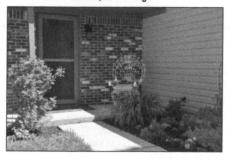

Figure 4-28: The HDR option enables you to produce an image with an even greater tonal range than Active D-Lighting.

I was able to produce the bottom image in the figure. The shadows aren't completely eliminated, and some parts of the rose bush on the left side of the shot are a little brighter than I want, but on the whole, the camera balanced the exposure fairly well.

Before you try the HDR feature, note these important points:

- Although the camera shoots two frames, you wind up with a single HDR photo. The two original shots aren't retained.
- Because the camera is merging two photos, the feature works well only on stationary subjects. If the subject is moving, it appears as two translucent forms in the merged frame.
- Use a tripod to make sure that you don't move the camera between shots. Otherwise, the merged shots may not align.
- You can't use auto HDR if you set the Image Quality option to Raw (NEF) or Raw+JPEG. It works only for JPEG photos.
- The following features also are incompatible with auto HDR: flash, autobracketing, movie recording, bulb and time shutter speeds, and Multiple Exposure. You can, however, enable Active D-Lighting for your HDR shots. Because both features affect tonal range, experiment to see whether you get better results with or without Active D-Lighting turned on.
- Even if the Release mode is set to one of the Continuous settings, you get one HDR shot per press of the shutter button.

I should also explain that to produce the more-extreme HDR imagery that you see in photography magazines, you need to go beyond the two-frame, three-stop limitations of auto HDR. To give you a point of comparison, Figure 4-29 shows an example I created by blending five frames with a variation of five stops between frames. The first two images show you the brightest and darkest exposures; the last image shows the HDR composite.

The effect created by the camera's HDR tool looks more realistic than the one in Figure 4-29 because the tonal range isn't stretched to such an extent. When applied to its extreme limits, HDR produces something of a graphic-novel look. My example is pretty tame; some people might not even realize that any digital trickery has been involved. To me, it has the look of a hand-tinted photo.

And of course, even though the in-camera HDR tool may not be enough to produce the surreal HDR look that's all the rage these days, you can still use your D7200 for HDR work — you just have to adjust the exposure settings yourself between shots and then merge the frames using your own HDR software. You should also shoot the images in the Raw format because HDR tone-mapping tools work best on Raw images, which contain more bits of picture data than JPEG files. Also, it's best to use the same f-stop throughout all frames so that depth of field remains consistent.

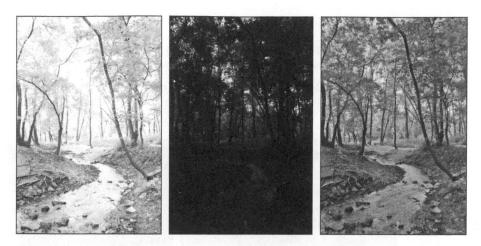

Figure 4-29: Using HDR software tools, I merged the brightest and darkest exposures (left and middle) along with several intermediate exposures, to produce the composite image (right).

All that said, the HDR feature is worth investigating when you're confronted with a high-contrast scene and you want to see how much you can broaden the dynamic range. Just take one shot with the feature enabled and a second with it turned off, and then compare the results to see which setting works best.

The Information display indicates the HDR setting in the area labeled in Figure 4-30. In the Live View display, the setting appears in the area shown on the right, but only if you enable HDR. When the feature is off, that part of the display is empty.

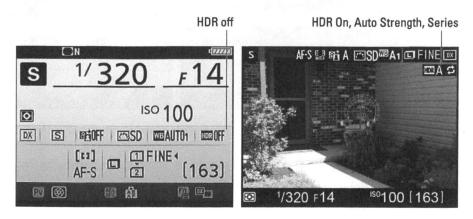

Figure 4-30: These symbols indicate the HDR setting.

To try out automated HDR, take these steps:

1. Select HDR (High Dynamic Range) from the Photo Shooting menu or *i* button menu, as shown in Figure 4-31.

In Live View mode, you must go through the Photo Shooting menu; the HDR option doesn't show up on the Live View i button menu.

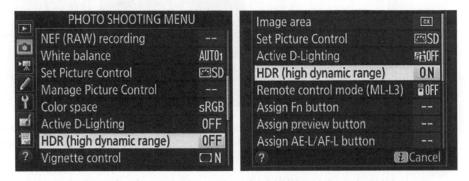

Figure 4-31: For viewfinder photography, you can access the HDR feature from the Photo Shooting menu (left) or *i* button menu (right).

2. Press OK to display the left screen shown in Figure 4-32.

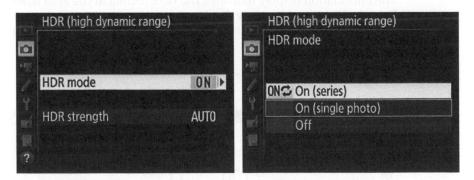

Figure 4-32: Set the HDR Mode to Series unless you want to take just one HDR shot before returning to normal photography.

3. Select your HDR settings.

You get two options for controlling HDR shooting:

• *HDR Mode:* Select On (Series), as shown on the right in Figure 4-32, to enable HDR for all shots until you disable the feature. Choose

On (Single Photo) to enable the option for just your next shot. Choose Off to disable the feature.

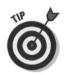

If you want to get fancy, you can use Interval Timer Shooting (time-lapse photography) with HDR enabled. Just be sure to select the On (Series) HDR setting *before* you begin Interval Timer shooting. (Chapter 2 details Interval Timer shooting).

• HDR Strength: You can choose from four levels of exposure shift: Low, Normal, High, or Extra High. Choose Extra High for the 3-stop exposure maximum. I used this setting to produce the image in Figure 4-28. At the Auto setting, the camera chooses what it considers the best adjustment. However, when a metering mode other than Matrix is in effect, choosing Auto results in the same adjustment you get at the Normal setting.

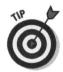

The HDR symbol in the Live View and Information displays shows your choices for both settings. For example, the symbol shown on the Live View screen in Figure 4-30 indicates Auto HDR Strength and On (Series) HDR Mode.

Press the shutter button halfway and release it to exit the menu screen.

The Information and Live View displays update to show you the HDR settings, and the letters *HDR* appear in viewfinder data display (although I need my +4 magnifying glasses to see them there).

5. Select exposure settings and other picture settings as usual.

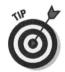

6. Frame, focus, and shoot.

Frame your subject a little loosely; the camera may need to trim the edges of the frame to perfectly align the two shots in the HDR image.

The camera records two frames in quick succession and then creates the merged HDR image. The message "Job Hdr" appears in the viewfinder and Control panel as this digital manipulation is being accomplished.

Eliminating vignetting

Because of some optical science principles that are too boring to explore, some lenses produce pictures that appear darker around the edges of the frame than in the center, even when the lighting is consistent throughout. This phenomenon goes by several names, but the two heard most often are *vignetting* and *light fall-off*. How much vignetting occurs depends on the lens, your aperture setting, and the lens focal length.

To help compensate for vignetting, your camera offers a Vignette Control feature, which adjusts image brightness around the edges of the frame. Figure 4-33 shows an example. In the left image, just a slight amount of light fall-off occurs at the corners, most noticeably at the top of the image. The right image shows the same scene with Vignette Control enabled.

Vianette Control Off

Vignette Control, Normal setting

Figure 4-33: Vignette Control tries to correct the corner darkening that can occur with some lenses.

Now, this "before" example hardly exhibits serious vignetting. It's likely that most people wouldn't even notice if it weren't shown next to the "after" example. But if you're a stickler for this sort of thing or your lens suffers from stronger vignetting, it's worth trying the feature. The adjustment is available in all your camera's exposure modes.

The only way to enable Vignette Control is via the Photo Shooting menu, as shown on the left in Figure 4-34. You can choose from four settings: High, Normal, Low, and Off. (Normal is the default.)

When the feature is enabled, the Information display contains a symbol showing the setting at the top of the screen, as shown on the right in Figure 4-34. The Live View display doesn't offer any indication of the Vignette Control status.

Also be aware of these issues:

- ✓ The correction is available only for still photos. Sorry, video shooters; this feature doesn't apply in Movie mode.
- ✓ **Vignette Correction works only with certain lenses.** First, your lens must be Nikon Type G, E, or D (PC, or Perspective Control, lenses

excluded). If the menu option is dimmed, the feature isn't available for your lens. Also, enabling the feature may not make any difference with certain lenses.

In some circumstances, the correction may produce increased noise at the corners of the photo. This problem occurs because exposure adjustment can make noise more apparent.

Figure 4-34: If you enable Vignette Control (left), a symbol indicating the setting appears in the Information display (right).

Using autoexposure lock

To help ensure a proper exposure, your camera continually meters the light until the moment you depress the shutter button fully. In autoexposure modes, it also keeps adjusting exposure settings as needed to maintain a good exposure.

For most situations, this approach works great, resulting in the right settings for the light that's striking your subject at the moment you capture the image. But on occasion, you may want to lock in a certain combination of exposure settings. For example, perhaps you want your subject to appear at the far edge of the frame. If you were to use the normal shooting technique, you'd place the subject under a focus point, press the shutter button halfway to lock focus and set the initial exposure, and then reframe to your desired composition to take the shot. The problem is that exposure is then recalculated based on the new framing, which can leave your subject under- or overexposed.

The easiest way to lock in exposure settings is to switch to M (manual) exposure mode and use the f-stop, shutter speed, and ISO settings that work best for your subject. But if you prefer to stay with an autoexposure mode, you can press the AE-L/AF-L button to lock exposure before you reframe.

This feature is known as *autoexposure lock*, or AE Lock for short. You can take advantage of AE Lock in any autoexposure mode except Auto or Auto Flash Off.

A few fine points about using this feature:

- While AE Lock is in force, the letters AE-L appear in the viewfinder and Live View display. Look for this indicator at the left end of the viewfinder and next to the Metering mode icon at the bottom of the Live View display.
- ✓ By default, focus is also locked when you press the button if you're using autofocusing. You can change this behavior by customizing the AE-L/AF-L button function, as outlined in Chapter 10.
- For the best results, pair this feature with the Spot Metering mode and autofocus settings that enable to you select a single focus point. Then, if you frame your subject under that focus point, exposure is set and locked based on your subject.

Press the Metering mode button while rotating the Main command dial to change the metering mode; see Chapter 5 for help with autofocus settings.

Don't release the AE-L/AF-L button until after you snap the picture. And if you want to use the same focus and exposure settings for your next shot, just keep the AE-L/AF-L button pressed between shots.

Taking Advantage of Automatic Bracketing

Many photographers use *exposure bracketing* to ensure that at least one shot of a subject is properly exposed. *Bracketing* simply means to shoot the same subject multiple times, slightly varying the exposure settings for each image.

In the P, S, A, and M exposure modes, your camera offers *automatic exposure* bracketing. You specify how many frames you want to record, how much adjustment should be made between frames, and then just press the shutter button to record the images. The camera automatically adjusts the exposure settings between each click.

The D7200, however, takes things one step further than most cameras that offer automatic bracketing, enabling you to bracket not just basic exposure, but also flash and overall exposure together, flash only, Active D-Lighting, or white balance.

Chapter 6 explains how to use the white-balance bracketing option. To try your hand at exposure, flash, or Active D-Lighting bracketing, follow these steps:

1. Set your camera to the P, S, A, or M exposure mode.

You can't take advantage of the feature in any other mode.

If you're bracketing shots for the purpose of creating an HDR image, maintaining a consistent depth of field between frames is important. Because the f-stop helps determine depth of field, shoot in the A or M mode; in both modes, the camera sticks with your selected f-stop and instead varies shutter speed to achieve the exposure shift between bracketed frames. In P and S modes, the f-stop may change, leading to frames that don't blend properly because of shifting depth of field. If you enable Auto ISO Sensitivity, the camera also may adjust ISO between frames in all four exposure modes.

2. Display the Custom Setting menu and select Bracketing/Flash > Auto Bracketing Set, as shown on the left in Figure 4-35.

You then see the options shown on the right in the figure. This screen is where you tell the camera whether you want to bracket the exposure and flash together, exposure only (AE), flash only, white balance (WB), or Active D-Lighting (ADL). Note that even though the exposure options are labeled AE (for autoexposure), you can bracket exposure in M (manual exposure) mode just the same.

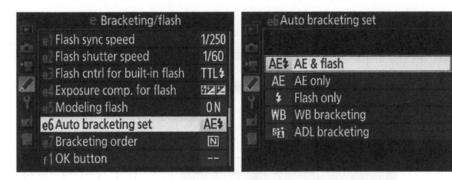

Figure 4-35: Before enabling auto bracketing, select the feature you want the camera to adjust between shots.

3. Choose the order in which you want the bracketed shots recorded.

Make the call via the Bracketing Order option, found just beneath the Auto Bracketing Set option on the Custom Setting menu and shown in Figure 4-36. You have two options:

- Normal (MTR>Under>Over): This setting is the default. For a three-shot exposure bracketing series, your first shot is captured at your original settings. (MTR stands for metered and designates the initial settings suggested by the camera's exposure meter.) The second image is captured at settings that produce a darker image, and the third, at settings that produce a brighter image.
- *Under>MTR>Over:* The darkest image is captured first, then the metered image, and then the brightest image.

This sequence varies depending on how many frames you include in your bracketed series. If you're a detail nut, the camera manual lists the order used in every scenario.

BKT

4. Press and hold the BKT (Bracketing) button on the left-front side of the camera to access the bracketing options.

While the button is pressed, bracketing settings appear in the Information display and Control panel. Figure 4-37 shows the display as it appears when you

Figure 4-36: You can choose the order in which you want the bracketed shots to be captured.

bracket autoexposure (AE) only. The Number of Shots setting controls the number of bracketed frames; the Increment setting, the amount of exposure shift between frames.

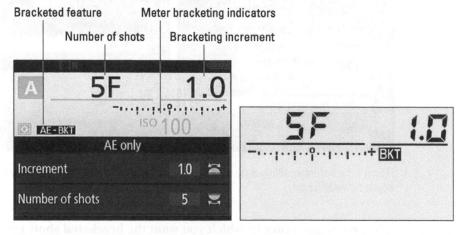

Figure 4-37: Press the BKT button while rotating the command dials to adjust the number of bracketed frames and the amount of shift between each frame.

In Live View mode, the settings for AE bracketing appear as shown in Figure 4-38, with the bars on the exposure meter indicating both the number of frames and the bracketing increment. The top value, highlighted in yellow, shows the number of selected frames and the number of remaining frames in that series. For example, 5/5 means that you're set to shoot the first frame in a five-frame series.

5. Set the number of bracketed frames and bracketing increment, as follows:

· AE, AE+Flash, and Flash bracketing: Rotate the Main command dial while pressing the BKT button to set the number of shots: rotate the Sub-command dial to set the increment of adjustment between frames. In Figures 4-37 and 4-38, the displays show five as the number of shots, with a shift of 1 stop between frames

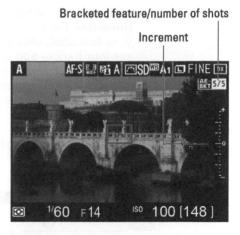

Figure 4-38: Here's how the bracketing options appear in Live View mode.

The maximum allowable

frames in each bracketed series depends on the bracketing increment. You can ask for as much as a three-stop shift between frames, but only for a total of five frames. At increments of 2 stops or more, the number of frames is automatically reduced to five.

• Active D-Lighting (ADL) bracketing: Rotate the Main command dial to set the number of shots, which in turn determines the level of Active D-Lighting adjustment applied to each frame. Set the frame

number to 2, and you get one frame with the feature disabled and one using the current Active D-Lighting setting. Raise the number of frames, and you get one shot with no adjustment and the rest captured with increasing amounts of adjustment (Low, Normal, High, and High Plus). Set the Number of shots to 5. as shown in Figure 4-39, to capture the subject using Active D-Lighting settings except Auto.

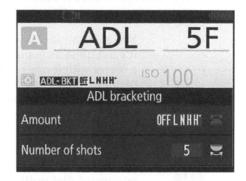

Figure 4-39: When bracketing Active D-Lighting, you're limited to a five-shot series.

6. Return to shooting mode by pressing the shutter button halfway.

7. Shoot your first bracketed series.

When AE, AE+flash, or Flash bracketing is enabled, the Information display offers a bracketing indicator, as shown on the left in Figure 4-40. That's a technical way of saying, "Little bars appear under the meter, each one representing one shot in your bracketed series." The indicator

updates after each picture to show you how many more shots are left in the series. For example, in a five-frame series, the middle bar represents your first shot; after you take your first picture, it disappears. You then see four bars — and thus, four shots left in the series. A label to the left of the meter reminds you which feature you're bracketing — AE-BKT (autoexposure) bracketing, in the figure. For ADL bracketing, the bracketing indicators appear as shown on the right in the figure.

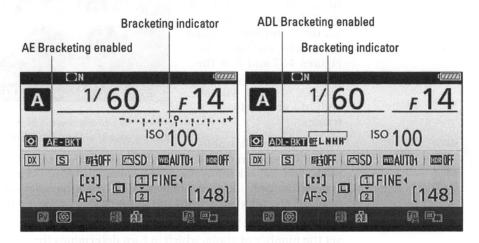

Figure 4-40: The Information display provides a reminder of which frame of the bracketed series you're about to shoot.

You also can see bracketing information in the Control panel, although it's not quite as complete as in the Information display: All you get is a meter with frame-count markers and the word BKT. In the Live View display, you see the basic bracketing symbol and the number of shots/frames remaining value. The meter showing the bracketing increments disappears. (If you're shooting in the M exposure mode, the meter appears but without any bracketing information.) To redisplay the bracketing settings in these displays, press the BKT button.

8. To disable bracketing, press the BKT button while rotating the Main command dial until the number of shots is set to 0.

If you set the Release mode to Continuous Low or Continuous High, you can save yourself some button pressing: In those two Release modes, the camera records bracketed frames as long as you hold down the shutter button. The trick is to keep count of each click so that you know when one series is completed and the next one begins. (You can always check the bracketing indicators on the exposure meter if you get lost.) Remember, though, that you can't use flash in either Continuous Release mode. See Chapter 2 for more details about the Release mode setting.

Controlling Focus and Depth of Field

In This Chapter

- Understanding autofocusing options
- Choosing a specific autofocusing point
- ▶ Tracking focus when shooting moving subjects
- Taking advantage of manual-focusing aids
- Manipulating depth of field

image.

o many people, the word *focus* has just one interpretation when applied to a photograph: Either the subject is in focus or it's blurry. But an artful photographer knows that there's more to focus than simply getting a sharp image of a subject. You also need to consider *depth of field*, or the distance over which other objects in the scene appear sharply focused. This chapter explains how to manipulate both aspects of an

Setting the Basic Focusing Method (Auto or Manual)

Assuming that your lens supports autofocusing with the D7200, the first step in taking advantage of autofocusing is to set the lens focus method to auto. On most lenses, you find a switch with two settings: A (or AF) for autofocusing and M (or MF) for Manual focusing, as shown in Figure 5-1. Some lenses, though, sport a switch with a dual setting, such as AF/M, which enables you to use autofocusing initially but then fine-tune focusing by turning the lens focusing ring. On this type of lens, select the M (or MF) setting for manual-only focusing.

Next you need to move the camera's Focus-mode selector switch, also labeled in the figure, to the AF position to use autofocusing. If you prefer manual focusing, you may need to move the switch to the M position. If your lens has the specification AF-S in the name — AF-S standing for silent-wave autofocusing — you can leave the camera switch set to AF and still focus manually. With other lenses (or if you're just not sure if your lens is the AF-S type), go ahead and set the camera switch to M. You can damage the lens and camera if you don't take this step.

In the advanced exposure modes (P, S, A, and M), as well as in certain Scene and Effects modes, you can control autofocusing behavior through the Focus mode and AF-area mode options, which you adjust by pressing the AF-mode button, labeled in Figure 5-1, while rotating the Main command dial and Sub-command dial, respectively. But the available settings and focusing techniques depend on whether you use the viewfinder to compose your shots or take advantage of Live View. (You have to use Live View for movie recording.)

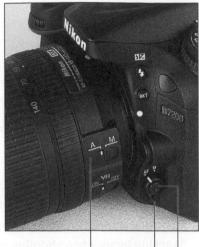

Lens focus switch

Camera Focus-mode selector

AF-mode button

Figure 5-1: On this lens, as on many Nikon lenses, you set the switch to A for autofocusing and to M for manual focusing.

That means, unfortunately, that you have to master two autofocusing systems. I'm not going to kid you: Figuring out one system is challenging enough, without adding a second into the mix. Things aren't made any easier by the names Nikon uses for its focus controls. For example, the AF-mode button accesses both the Focus mode and the AF-area mode, in spite of the fact that the switch that shifts the camera from auto to manual focusing is called the Focus-mode selector. And the AF-S label that indicates the Nikon lens silent-wave autofocusing technology? Well, one of the Focus mode settings is also named AF-S, and the S in that name has nothing to do with silent anything but instead stands for single-servo autofocusing. (Are you listening, Nikon? Buehler? Buehler?)

At any rate, I suggest that you first nail down normal (viewfinder) focusing, which is covered in the next several sections. Then move on to explore Live View focusing details, presented in the second part of the chapter.

Shutter speed and blurry photos

A poorly focused photo isn't always caused by issues discussed in this chapter. Any movement of the camera or subject can also cause blur. Movement-related blur is tied to shutter speed,

an exposure control that I cover in Chapter 4. Be sure to also visit Chapter 7, which provides some additional tips for capturing moving objects without blur.

Exploring Standard Focusing Options (Viewfinder Photography)

During normal photography, you can view the Focus mode and AF-Area mode settings in the Information display, as shown in Figure 5-2. (Press the Info button to display and hide the Information screen.) The symbols in the figure represent AF-A for the Focus mode and Auto Area for the AF-Area mode. The next several sections explain these settings and provide an overview of focusing techniques for shooting still and moving subjects.

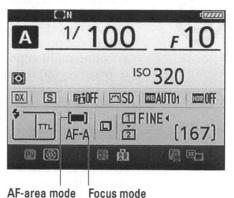

A note before you dig in: You must focus manually in Night Vision Effects mode during viewfinder photography. If you need to use autofocusing in that mode, you must switch to Live View.

Figure 5-2: The Focus mode and AF-area mode settings appear here.

Setting the Focus mode (AF lock or continuous AF)

When you use autofocusing, pressing the shutter button halfway kick-starts the autofocusing system. Whether the camera locks focus then or adjusts focus until you press the button the rest of the way depends on the Focus mode. You have these options:

✓ **AF-S (single-servo autofocus):** Designed for shooting stationary subjects, this mode locks focus when you depress the shutter button halfway. (Think *S* for *still*, *stationary*.)

In AF-S mode, the camera insists on achieving focus before it releases the shutter. If this behavior annoys you, open the Custom Setting menu, choose Autofocus > AF-S Priority Selection and change the setting to Release. The picture is then recorded when you fully depress the shutter button even if focus isn't yet achieved.

✓ **AF-C (continuous-servo autofocus):** Geared to capturing moving targets, AF-C mode adjusts focus continuously as long as the shutter button is pressed halfway. (Think *C* for *continuous motion*.)

By default, the camera records the shot the instant you depress the shutter button, regardless of whether focus is set. As with AF-S mode, though, you can alter the focus/shutter-release connection. Again, head for the Autofocus section of the Custom Setting menu, but this time look for the AF-C Priority Selection option. Change the setting to Focus to prevent the shutter from being released until focus is set.

To decide which shutter-release option is right for you, consider whether you'd rather have any shot, even if it's out of focus, or capture only those that are in focus. I prefer the latter, so I set both AF-S and AF-C modes to Focus. Why waste battery power, memory card space, and inevitable time deleting out-of-focus pictures? Yes, if you're shooting rapid action, you may miss a few shots waiting for the focus to occur — but if they're going to be lousy shots, who cares? Sports shooters who fire off hundreds of shots while covering an event, though, may want to unlock shutter release for both AF-C and AF-S modes. Again, you may wind up with lots of wasted shots, but you increase the odds that you'll capture that split-second "highlight reel" moment.

✓ AF-A (auto-servo autofocus): In this mode, which is the default setting for most exposure modes, the camera analyzes the scene, and if it detects motion, automatically selects continuous-servo mode (AF-C). If the camera instead believes you're shooting a stationary object, it selects single-servo mode (AF-S).

This mode is easiest to use, but it can get confused by some subjects. For example, if your subject is motionless but something is moving in the background, the camera may mistakenly switch to continuous autofocus. By the same token, if the subject is moving only slightly, the camera may not make the switch to continuous autofocusing. So my advice is to choose AF-S or AF-C instead.

To change the Focus mode setting, press and hold the AF-mode button (refer to Figure 5-1) while rotating the Main command dial. While the button is pressed, you see the selection screen shown on the left in Figure 5-3, and all data but the Focus mode and AF-area mode disappear from the Control panel, as shown on the right in the figure.

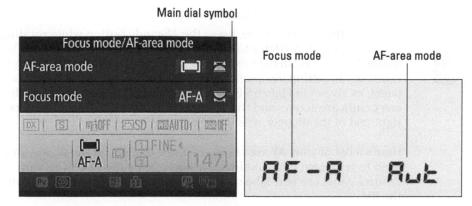

Figure 5-3: While pressing the AF-mode button, rotate the Main command dial to change the Focus mode.

The viewfinder display also changes when you press the AF-mode button, showing the Focus mode and AF-area mode settings in the areas labeled in Figure 5-4. The autofocus brackets. which indicate the area of the frame that contains the camera's autofocus points, also appear, as do rectangles representing the active points. One quirk here, though: In the default AF-Area mode, Auto Area, all 51 autofocus points are active. But the viewfinder shows points only around the perimeter of the autofocus brackets. as shown in the figure, so that you can still get a good view of your subject. All 51 points are active just the same: the rest are spaced evenly throughout the area enclosed by the autofocus brackets.

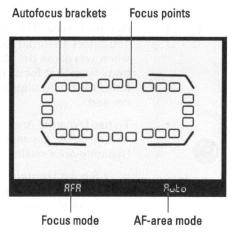

Figure 5-4: The viewfinder also shows the current settings while you press the AF-mode button.

Choosing an AF-area mode: One focus point or many?

In addition to controlling whether focus is locked or continually adjusted when you press the shutter button halfway, you can tell the camera which autofocus point (or points) to consider when setting the focusing distance. Make your wishes known through the AF-area mode, detailed in the next two sections.

Changing the AF-area mode setting

To adjust the AF-area mode, press the AF-mode button while rotating the Sub-command dial. (Refer to Figure 5-1 for a look at the button.) When the button is pressed, all data except the current AF-area mode setting and the Focus mode setting disappear from the Information display and Control panel, as shown in Figure 5-3. The viewfinder also shows you which autofocus points are active, and the current AF-area mode setting appears at the right end of the display, as shown in Figure 5-4.

Here's a list of your AF-area mode choices, along with the digital shorthand used to represent each mode in the Information display. (The viewfinder and Control panel use text labels for each mode, which I show in parentheses in the list.)

✓ Single Point (S): This mode is designed to quickly and easily lock focus on a still subject. You select a single focus point, and the camera bases focus on that point only. See the next section for details on selecting an autofocus point.

✓ Dynamic Area: This option is meant for photographing moving subjects. You select an initial focus point, and the camera focuses on that point when you press the shutter button halfway. But if your subject moves away from that focus point before you snap the picture, the camera looks to surrounding points for focusing information and adjusts focus if needed.

To use Dynamic Area autofocusing, you must set the Focus mode to AF-C or AF-A. Assuming that condition is met, you can choose from three Dynamic Area settings:

• 9-point Dynamic Area (d9): The camera takes focusing cues from

your selected point plus the eight surrounding points. This setting is ideal when you have a moment or two to compose your shot and your subject is moving in a predictable way, making it easy to reframe as needed to keep the subject within the 9-point area.

(₽)21

This setting also provides the fastest Dynamic Area autofocusing because the camera has to analyze the fewest autofocusing points.

[©]**51**

• 21-point Dynamic Area (d21): Focusing is based on the selected point plus the 20 surrounding points. This setting enables your subject to move a little farther from your selected focus point and still remain in the target zone, so it works better than 9-point mode when you can't quite predict the path your subject is going to take.

• 51-point Dynamic Area (d51): The camera makes use of the full complement of autofocus points. This mode is designed for subjects that are moving so rapidly that it's hard to keep them within the framing area of the 21-point or 9-point setting — a flock of birds, for example. The drawback is that with all 51 points to consider, the camera may be slower in adjusting focus.

3D Tracking (3d): Also geared to action photography, the 3D Tracking option is a variation of 51-point Dynamic Area mode. Like that mode, the 3D Tracking option is available only when the Focus mode is set to AF-C or AF-A.

Start by selecting a single focus point and then press the shutter button halfway to set focus. If you recompose the shot before taking the picture, the camera tries to refocus on your subject.

The problem with 3D Tracking is that it works by analyzing the colors of the object under your selected focus point. So, if not much difference exists between the subject and other objects in the frame, the camera may not be able to find a new focusing target when needed. And if your subject moves out of the frame, you must release the shutter button and reset focus by pressing it halfway again.

Auto Area (Aut): The camera chooses which of the 51 focus points to use; all you do to focus is press the shutter button halfway. Focus is typically set on the object closest to the camera. Remember that in this mode, only the points around the perimeter of the autofocus brackets light up in the viewfinder when you press the AF-mode button (refer to Figure 5-4), but all 51 points are active nonetheless.

Selecting (and locking) an autofocus point

When you use any AF-area mode except Auto Area, you see a single autofocus point in the viewfinder. That point is the one the camera will use to set focus in the Single Point mode and to establish the starting focusing distance in the Dynamic Area and 3D Tracking modes. By default, the center point is selected.

To choose a different focus point, set the Focus Selector Lock switch to the position shown in Figure 5-5. Then press the Multi Selector right, left, up, or down to cycle through the available focus points, which are located within the area surrounded by the autofocus brackets. I moved the focus point over the clock tower, for example, in Figure 5-5. (If nothing happens when you press the Multi Selector, press the shutter button halfway to activate the metering system. Then release the button and try again.)

A couple of additional tips:

✓ You can reduce the number of focus points available for selection from 51 to 11. Why would you do this? Because it enables you to choose a focus point more quickly — you don't have to keep pressing the Multi Selector zillions of times to get to the one you want to use. Make the change via the Number of Focus Points option, found on the Autofocus section of the Custom Setting menu and shown on the left in Figure 5-6. The right half of the figure shows you which autofocus points are available at the reduced setting.

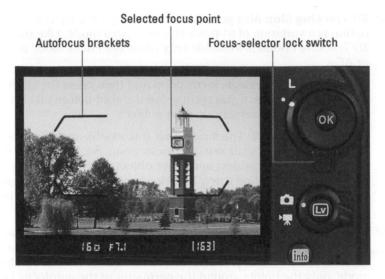

Figure 5-5: When the Focus Selector Lock switch is set to this position, you can press the Multi Selector to select a different focus point.

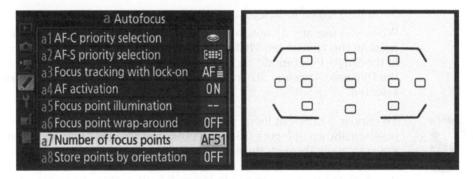

Figure 5-6: You can limit the number of available focus points to the 11 shown here.

Note that the camera still uses the full complement of normal focus points to focus in the Dynamic Area and 3D Tracking modes. The Number of Focus Points option just limits the points you can choose for your initial focus point.

✓ You can quickly select the center focus point by pressing OK. This assumes that you haven't changed the function of that button, an option you can explore in Chapter 11.

- ✓ If you want to use a certain focus point for a while, you can "lock in" that point by moving the Focus Selector Lock switch to the L position. This feature ensures that an errant press of the Multi Selector doesn't accidentally change your selected point.
- The selected focus point is also used to meter exposure when you use spot metering. See Chapter 4 for details about metering.

Autofocusing for still subjects: AF-S + Single Point

For stationary subjects, I recommend pairing AF-S Focus mode with Single Point AF-area mode, as shown in Figure 5-7. To access both settings, press the AF-mode button (left-front side of the camera). Rotate the Main command dial to set the Focus mode, and rotate the Sub-command dial to change the AF-area mode.

Follow these steps to focus:

1. Looking through the viewfinder, use the Multi Selector to position the focus point over your subject.

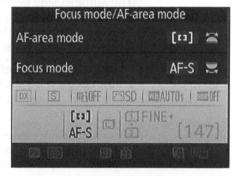

Figure 5-7: For stationary subjects, I recommend these autofocus settings.

You may need to press the shutter button halfway and release it to wake up the camera before you can take this step. (By default, the system automatically shuts down after 6 seconds of inactivity.) Also make sure

that the Focus Selector Lock switch isn't set to the L (locked) position. To change the focus point, the white marker on the switch must point to the white dot (refer to Figure 5-5).

2. Press the shutter button halfway to set focus.

When focus is achieved, the camera displays a dot at the left end of the viewfinder, as shown in Figure 5-8. Focus is locked as long as you keep the shutter button pressed halfway.

3. Press the shutter button the rest of the way to take the shot.

Focus achieved

Figure 5-8: In AF-S mode, a white dot appears when focus is achieved.

Here are a few additional details about this autofocusing setup:

White triangles appear instead of the focus dot when the current focusing distance is in front of or behind the subject. A right-pointing arrow means that focus is set in front of the subject; a left-pointing arrow means that focus is set behind the subject. Release the shutter button, reposition the focus point over your subject, and try again. Still no luck? Try backing away from your subject a little; you may be exceeding the minimum focusing distance of the lens.

The autofocusing system also can have trouble locking onto some subjects, especially reflective objects or those that contain little contrast. Don't waste too much time letting the camera hunt for a focusing point; it's easier to simply switch to manual focus.

- Remember that by default, the camera doesn't release the shutter if it can't achieve focus. If you want the shutter to release regardless of focus, choose Custom Setting > Autofocus > AF-S Priority and select the Release option.
- You can ask the camera to beep when focus is achieved. To enable this audio cue, choose Custom Setting > Shooting/Display > Beep and choose any Volume option but Off. The Pitch option sets the loudness of the beep.
- Initial exposure settings are also chosen at the moment you press the shutter button halfway. However, assuming that you're relying on autoexposure, the settings are adjusted as needed up to the time you take the shot.
- If needed, you can position your subject outside a focus point. Just compose the scene initially so that your subject is under a point, press the shutter button halfway to lock focus, and then reframe. However, if you're using autoexposure, you may want to lock focus and exposure together before you reframe, by pressing the AE-L/AF-L button. Otherwise, exposure is adjusted to match the new framing, which may not work well for your subject. See Chapter 4 for more details about autoexposure lock.
- ✓ Your half-press of the shutter button also replaces the shots-remaining value with the buffer capacity (r23 in Figure 5-8). This bit of data comes into play only when you use the Continuous Release modes; the number indicates how many shots the camera can record in a continuous burst before filling the buffer (temporary data storage space). When the value drops to 0, the camera pauses until it has time to finish recording all current images to the memory card.

Focusing on moving subjects: AF-C + Dynamic Area

When autofocusing on a moving subject, I select AF-C for the Focus mode and choose one of the Dynamic Area options for the AF-area mode, as shown in Figure 5-9. The earlier section "Choosing an AF-area mode: One focus point or many?" provides information to help you decide whether to use the 9-, 21-, or 51-point Dynamic Area setting.

The initial focusing process is the same as just outlined: Choose a focus point, position your subject under that point, and press the shutter button halfway. The only difference is that focus isn't locked at that point.

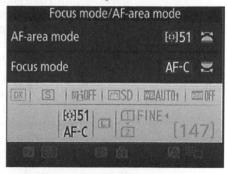

Figure 5-9: For moving subjects, I combine AF-C Focus mode (continuous autofocusing) with one of the Dynamic Area AF-area settings.

Instead, if your subject moves from the focus point, the camera checks surrounding points for focus information and adjusts focus using that data.

Also, the focus dot in the viewfinder may flash on and off as focus is adjusted. Note, though, that even if you enable the Beep option (Custom Setting > Shooting/Display > Beep), the camera doesn't provide audio confirmation of focus as it does in AF-S mode, which is a Good Thing — things could get pretty noisy if the beep sounded every time the camera adjusted focus.

Getting comfortable with continuous autofocusing takes some time, so it's a good idea to practice before you need to photograph an important event. After you get the hang of the AF-C/Dynamic Area system, though, I think you'll really like it. Keep these additional thoughts in mind to get the best results:

- Try to keep the subject under the selected focus point to increase the odds of good focus. But as long as the subject falls within one of the other focus points (9, 21, or 51, depending on which Dynamic Area mode you selected), focus should be adjusted accordingly. Note that you don't see the focus point actually move in the viewfinder, but the focus tweak happens just the same. You can feel and hear the focus motor doing its thing, if you pay attention.
- ✓ By default, the camera takes the picture when you fully depress the shutter button, even if focus isn't yet achieved. To prevent the shutter release before focus is set, locate the AF-C Priority Selection option, found in the Autofocus section of the Custom Setting menu, and change the setting to Locked.

Prevent focusing miscues with tracking lock-on. You're shooting your friend's volleyball game, practicing your action-autofocusing skills. You set the initial focus, and the camera is doing its part by adjusting focus to accommodate her pre-serve moves. Then all of a sudden, some clueless interloper walks in front of the camera. Okay, it was the referee, who probably did have a right to be there, but still.

The good news is that as long as the ref gets out of the way before the action happens, you're probably okay. A feature called *focus tracking with lock-on*, designed for just this scenario, tells the camera to ignore objects that appear temporarily in the scene after you begin focusing. Instead of resetting focus on the newcomer, the camera continues focusing on the original subject.

You can vary the length of time the camera waits before starting to refocus through the Focus Tracking with Lock-On option, found on the Autofocus section of the Custom Setting menu and shown in Figure 5-10. Normal (3 seconds) is the default setting. You can choose a longer or shorter delay or turn off the lock-on altogether. If you turn off the lock-on, the camera starts refocusing on any object that appears in the frame between you and your original subject.

Figure 5-10: This option controls how the autofocus system deals with objects that appear between the lens and the subject after you initiate focusing.

You can interrupt continuous autofocusing and lock focus by pressing the AE-L/AF-L button. Focus remains set as long as you hold down the button. Don't forget, though, that by default, pressing the AE-L/AF-L button also locks autoexposure. You can change this setup so that the button locks just one or the other; Chapter 11 explains how.

when using continuous autofocusing. For example, if you're photographing a tuba player in a marching band, you want to be sure that the camera tracks focus on just that musician. With Dynamic Area, it's possible that the focus may drift to another nearby band member. The difficulty with the Single Point/AF-C pairing is that you must constantly reframe to keep your subject under the point you selected. I like to use the center point with this setup; I find it more intuitive because I just reframe as needed to keep my subject in the center of the frame. (You can always crop your image to achieve a different composition after the shot.)

Exploring even more autofocus options

You can further customize the autofocus system via these options, found on the Autofocus section of the Custom Setting menu:

- AF Activation: By default, pressing the shutter button halfway initiates autofocusing as well as exposure metering. Some photographers prefer to use separate buttons for each function, so this menu option enables you to relieve the shutter button of its focusing assignment. (Change the setting to AF-ON only.) You can then use the button-customization tools that I cover in Chapter 11 to assign focusing duties to another button, such as the AE-L/AF-L button.
- Focus Point Illumination: When you press the shutter button halfway, the selected focus point in the viewfinder flashes red and then goes back to black. At the default setting for this option (Auto), the red highlights are displayed only when the background is dark and makes the black focus points difficult to see. Choose On to make the highlights appear all the time; choose Off to disable the highlights altogether.
- Focus Point Wrap-Around: When you press the Multi Selector to cycle through the available focus points, you normally hit a "wall" when you reach the edge of the focusing area. So if the leftmost point is selected, for example, pressing left again gets you nowhere. But if you turn on this

option, you instead jump to the rightmost point.

- you're shooting a landscape, framing the shot in a horizontal orientation, and select the top-right focus point. Normally, that focus point remains selected when you rotate the camera to a vertical orientation. But if you turn on this menu option, the camera instead automatically activates the focus point that was on duty the last time you shot a vertically oriented photo.
- Built-In AF-Assist Illuminator: In dim lighting, the AF-assist lamp on the front of the camera shoots out a beam of light to help the focusing system find its target. If the light is distracting, you can disable it by setting this menu option to Off.

Additionally, the Setup menu offers an AF Fine Tune option, which enables you to create custom focusing adjustments for specific lenses. This feature is one for the experts, though; even Nikon doesn't recommend that you use the fine-tuning tool unless it's unavoidable. If you consistently have focusing trouble with a lens, have your local camera tech inspect the lens to be sure it doesn't need repair. The D7200 manual provides few details on this option, but if you search the Nikon website (enter the search term AF Fine Tune), you can find instructions for using it.

Focusing manually

Some subjects confuse even the most sophisticated autofocusing systems, causing the autofocus motor to spend a long time hunting for a focus point. Animals behind fences, reflective objects, water, and low-contrast

subjects are just some of the autofocus troublemakers. Autofocus systems also struggle in dim lighting, although that difficulty is often offset by the AF-assist lamp, which shoots out a beam of light to help the camera find its focusing target.

When you encounter situations that cause an autofocus hang-up, you can try adjusting the autofocus options discussed earlier in this chapter. But often, it's easier and faster to switch to manual focusing. For the best results, follow these manual-focusing steps:

1. Adjust the viewfinder to your eyesight.

If you don't adjust the viewfinder, scenes that are in focus may appear blurry and vice versa. If you haven't already done so, look through the viewfinder and rotate the little dial near its upper-right corner. As you do, the viewfinder data and the AF-area brackets become more or less sharp. (Press the shutter button halfway to wake up the meter if you don't see any data in the viewfinder.)

2. Set the lens and camera to manual focusing.

First, move the focus-method switch on the lens to the manual position. The setting is usually marked M or MF. Next, set the camera to manual focusing by setting the Focus-mode switch on the front-left side of the camera to MF.

Remember, if you use an AF-S lens, you can leave the camera's switch set to AF and still focus manually. (The letters AF-S appear as part of the Nikon label on the lens.) However, if you're not sure that your lens is an AF-S type, set the switch to the M position.

3. Select a focus point.

Use the same technique as when selecting a point during autofocusing: Press the Multi Selector right, left, up, or down to select a point. (You may need to press the shutter button halfway and release it first to wake up the camera.)

Technically speaking, you don't *have* to choose a focus point for manual focusing — the camera focuses according to the position you set by turning the focusing ring. However, choosing a focus point offers two benefits: First, the camera displays the same focus-achieved (or not-achieved) symbols in the viewfinder as when you autofocus, and that feedback is based on the selected focus point. Second, if you use spot metering, an exposure option covered in Chapter 4, exposure is metered on the selected focus point.

4. Frame the shot so that your subject is under the selected focus point.

- Press and hold the shutter button halfway to initiate exposure metering.
- 6. Rotate the focusing ring on the lens to bring the subject into focus.

When focus is set on the object under the focus point, the focus dot in the viewfinder lights. If you see a triangle in that part of the display instead, focus is set in front of or behind the object in the focus point.

7. Press the shutter button the rest of the way to take the shot.

I know that when you first start working with an SLR-style camera, focusing manually is intimidating. But if you practice a little, you'll find that it's really no big deal and saves you the time and aggravation of trying to bend the autofocus system to your will when it has "issues."

Mastering Live View Focusing

When you use Live View, either for shooting stills or recording video, the initial focusing setup is the same as for viewfinder photography, detailed at the start of this chapter. First, set the lens and camera to automatic or manual focusing. Then specify your autofocusing preferences through the Focus mode and AF-area mode settings. A quick reminder of what each setting does:

- Focus mode: This setting tells the camera whether to use continuous autofocusing or lock focus at a specific distance.
- AF-area: This option determines which part of the frame is analyzed to set focus.

As with viewfinder photography, you adjust these settings by pressing the AF-mode button, shown on the left in Figure 5-11. While the button is pressed, the Focus mode and AF-area mode settings appear highlighted in the Live View display, as shown on the right in the figure. (The figure shows the display for still photography; the symbols appear in the same spot in Movie mode.) Rotate the Main command dial to change the Focus mode; use the Sub-command dial to set the AF-area mode.

It's at this point that things diverge from viewfinder photography. As you rotate the dials to set the Focus mode and AF-area mode, you discover that the available settings are different in Live View mode, save for one Focus mode option (AF-S). The technique you use to establish focus varies from normal focusing, too.

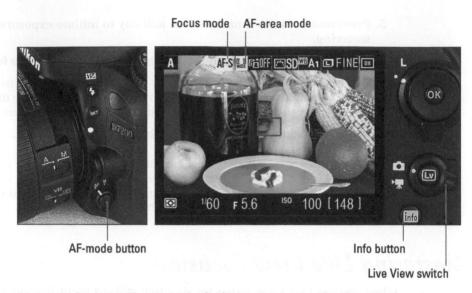

Figure 5-11: Press the AF-mode button (left) to access the Live View Focus mode and AF-area mode options (right).

Upcoming sections detail both options and then walk you step-by-step through the actual focusing process. Just a few pointers before you head out:

After you release the AF-mode button, the Focus mode and AF-area mode symbols appear only in the default Live View display. In other displays modes, press the AF-mode button to temporarily display the symbols. Neither setting appears in the Control panel even when the button is pressed — the monitor is your only avenue for checking Focus mode and AF-area mode during Live View shooting.

Press the Info button to change Live View display modes. Figure 5-11 shows where to find this button. The figure also reminds you where to find the control that engages Live View; rotate the switch to either the still or movie camera position and then press the LV button to start and stop Live View.

Live View autofocusing is slower than viewfinder autofocusing. The reason why isn't important; just understand that Live View isn't your best choice for focusing on fast-moving targets. Unfortunately, for movie shooting, you don't have a choice: You can't use the viewfinder to compose shots when you set the Live View switch to Movie mode.

Refer to Chapter 1 for a review of basic Live View tips and precautions. And for details about movie shooting, see Chapter 8.

Choosing a Live View Focus mode

In Live View mode, you don't have the option of going fully automatic, letting the camera decide whether to use continuous autofocus or to lock focus when you press the shutter button halfway. You get just these two options:

- ✓ AF-S (single-servo autofocus): The camera locks focus when you press the shutter button halfway. (This focus setting is one of the few that works the same during Live View shooting as it does during viewfinder photography.) Generally speaking, AF-S works best for focusing on still subjects.
- ✓ AF-F (full-time servo autofocus): This option, which provides continuous autofocusing, is available for all exposure modes except for certain Effects modes (Color Sketch, Toy Camera, and Miniature).

Remember these keys to using AF-F mode:

- Don't press the shutter button halfway to initiate autofocusing. The
 autofocus motor begins doing its thing as soon as you change to
 AF-F Focus mode. Focus is set on the object under the Live View
 focus frame, which looks like a red box by default. (Its appearance depends on the AF-area mode, explained in the next section.)
 Focus is adjusted as needed if your subject moves through the
 frame or you pan the camera.
- Press and hold the shutter button halfway down to lock focus at the current distance. Release the button, and continuous autofocusing begins again.
- For movie recording, AF-F mode is great for maintaining focus, but it creates an audio problem: If you record sound using the internal microphone, the noise made by the autofocus motor may be audible in the soundtrack. You can get around this problem by attaching an external microphone and placing it far enough away that it doesn't pick up the camera sounds. See Chapter 8 for details on audio recording.

Selecting the AF-area mode

This setting tells the camera which part of the frame contains your subject so that it can set the focusing distance correctly. Here's how things work at each of the four AF-area mode settings, represented in the Live View display by the icons shown in the margins here:

✓ Wide Area: The camera focuses on the area under the red focusing frame, shown on the left in Figure 5-12. Use the Multi Selector to reposition the focus frame if needed.

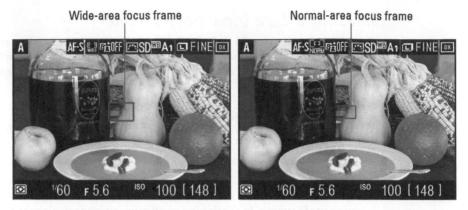

Figure 5-12: In Wide Area and Normal Area modes, use the Multi Selector to move the red focus frame over your subject.

Normal Area: This mode works the same way as Wide Area autofocusing but uses a smaller focusing frame, as shown on the right in Figure 5-12. The idea is to enable you to base focus on a very specific area. With such a small focusing frame, however, you can easily miss your focus target when handholding the camera. If you move the camera slightly as you're setting focus and the focusing frame shifts off your subject as a result, focus will be incorrect. For the best results, use a tripod in this mode.

Face Priority: Designed for portrait shooting, this mode displays a yellow focus frame over each face the camera detects, as shown on the left in Figure 5-13. If more than one face is detected, the camera picks one to use for its focusing cue, and the focus frame for that face contains the interior corner markings you see in the figure. You can move the target frame to a different face by using the Multi Selector. (If your subjects are the same distance from the camera, as in the example photo, it doesn't matter which face you pick.)

Face Priority typically works only when your subjects are facing the camera. If the camera can't detect a face, things work as they do in Wide Area mode.

Subject Tracking: Like the Dynamic Area and 3D Tracking modes available for viewfinder photography, Subject Tracking is designed for shooting moving subjects. Start by using the Multi Selector to position the focus target over your subject, as shown on the right in 5-13. (The frame may be red instead of white depending on your subject.) Then press OK to initiate focus tracking. If your subject moves, the focus frame tags along. The idea is to keep the camera informed about your subject's position so that when you initiate autofocusing, focus can be set more quickly. To stop tracking, press OK again. You need to take this step if

your subject leaves the frame: Press OK to stop tracking, reframe, and then press OK to start tracking again.

In AF-F Focus mode, you can see focus being adjusted as the Subject Tracking frame moves; in AF-S mode, focusing doesn't occur until you press the shutter button halfway.

Unfortunately, if your subject occupies only a small part of the frame — say, a butterfly flitting through a garden — the autofocus system may lose track of it. Ditto for subjects moving at a fast pace, subjects getting larger or smaller in the frame (when moving toward you and then away from you, for example), or scenes in which not much contrast exists between the subject and the background. Oh, and scenes in which there's a great deal of contrast can create problems, too. My take on this feature is that when the conditions are right, it works well, but otherwise you're better off using the Wide Area setting and reframing as necessary to keep your subject in the focus frame.

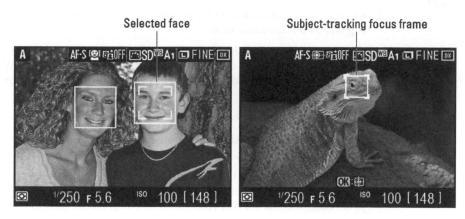

Figure 5-13: The focusing frames appear differently in Face Priority mode (left) and Subject Tracking mode (right).

You adjust the AF-area mode by pressing the AF-mode button while rotating the Sub-command dial. But with Live View, you can control the setting only in some exposure modes, including P, S, A, and M. In Auto mode or Auto Flash Off mode, the camera insists on using Face Priority mode (which shifts you automatically into Wide Area mode if no faces are detected). Nor do you have control in the Miniature Effects mode, which always uses Wide Area focusing. Subject Tracking mode isn't available for the Night Vision, Color Sketch, and Selective Color Effects modes.

Stepping through the Live View autofocusing process

Having laid out the whys and wherefores of Live View autofocusing options, I offer the following summary of the steps involved in choosing the autofocus settings and actually setting focus:

 Choose the Focus mode by pressing the AF-mode button while rotating the Main command dial.

Remember, this setting determines whether focus is locked at a specific distance or adjusted continuously as you or your subject move. Choose AF-S to lock focus; select AF-F for continuous autofocusing. (Look for the button on the left-front side of the camera, at the center of the Focus-mode selector switch. Refer to Figure 5-11 if you need help finding it.)

In AF-F mode, the autofocus system perks up and starts hunting for a focus point immediately.

2. Choose the AF-area mode by pressing the AF-mode button while rotating the Sub-command dial.

This setting determines what part of the frame the camera considers when establishing focus. Your choices are Face Priority, Wide Area, Normal Area, and Subject Tracking, as outlined in the preceding section.

3. Use the Multi Selector to move the focusing frame over your subject.

For example, I moved the focus frame over the garnish on the soup bowl for my example image, as shown on the left in Figure 5-14.

The figure shows how the focus frame appears in the Wide Area mode; in other modes, the frames appear slightly different. See figures in the preceding section for a review of the various frame designs.

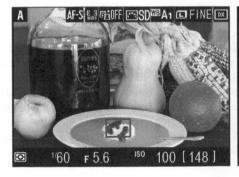

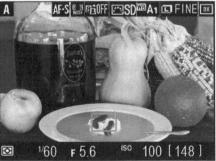

Figure 5-14: Use the Multi Selector to move the frame over your subject (left); the frame turns green when focus is achieved (right).

In Face Priority mode, you can use the Multi Selector to move the box with the corner marks — which indicates the final focusing point — from face to face in a group portrait. In Wide Area and Normal Area modes, press OK to move the focus point to the center of the frame.

When the Focus mode is set to AF-F (continuous autofocusing), the frame turns green as soon as the object under the frame comes into focus.

4. In Subject Tracking AF-area mode, press OK to initiate focus tracking.

If your subject moves, the focus frame moves with it. To stop tracking, press OK again. Again, when you use the AF-F Focus mode, focusing begins automatically and is adjusted as the target frame moves.

- 5. In AF-S Focus mode, press and hold the shutter button halfway down to begin focusing.
- 6. Wait for the focus frame to turn green, as shown on the right in Figure 5-14.

The green frame means that the initial focus point is set. What happens next depends on your Focus mode:

- AF-S mode: Focus remains locked as long as you keep the shutter button pressed halfway.
- *AF-F mode:* Focus is adjusted if the subject moves. The focus frame turns red (or yellow or white) if focus is lost; green signals that focus has been achieved again. You can lock focus by pressing the shutter button halfway. Release the button to restart continuous autofocusing.

QUAL

7. (Optional) Press the Zoom In button to magnify the display to double-check focus.

Each press gives you a closer look at the subject. A small thumbnail in the corner of the monitor appears, with the yellow highlight box indicating the

area that's currently being magnified, as shown in Figure 5-15. Press the Multi Selector to scroll the display if needed.

To reduce the magnification, press the Zoom Out button. If you're not using Subject Tracking mode, you can also press OK to quickly return to normal magnification.

When focusing is complete, press the shutter button all the way to take the picture or press the red Movie-record button (top of the camera) to start shooting a movie.

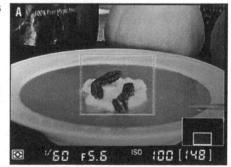

Figure 5-15: Press the Zoom In button to magnify the display so that you can double-check focus.

Manual focusing during Live View and movie shooting

Manual focusing works the same in Live View mode as it does for viewfinder photography: Set the focus-method switch on the lens to the manual-focus position and set the camera's Focus-mode selector switch to the M position. Then rotate the lens focusing ring to bring the scene into focus.

With AF-S lenses, you can leave the camera's switch in the AF position if you prefer. Just *make sure* that you're using an AF-S lens, or you could damage the lens and the camera.

Live View does introduce a few variations into the manual focusing routine:

- Even with manual focusing, you still see the Live View focus frame. Its appearance depends on the current AF-area mode setting. In Face Priority mode, the frame automatically jumps into place over a face if it detects one. And if you press OK when Subject Tracking mode is enabled, the camera tries to track the subject under the frame until you press OK again. I find these two behaviors irritating, so I always set the AF-area mode to Wide Area or Normal Area for manual focusing.
- The focus frame doesn't turn green to indicate successful focusing as it does with autofocusing. In Live View mode, the camera doesn't give you any manual-focusing cues as it does for viewfinder photography.

You can press the Zoom In button to check focus in manual mode just as you can during autofocusing. Refer to the preceding section for details. Press the Zoom Out button to reduce the magnification level.

Manipulating Depth of Field

Getting familiar with the concept of depth of field is one of the biggest steps you can take to becoming a better photographer. I introduce you to depth of field in Chapter 2, but here's a quick recap:

- Depth of field refers to the distance over which objects in a photograph appear acceptably sharp.
- With a shallow, or small, depth of field, distant objects appear more softly focused than the main subject (assuming that you set focus on the main subject, of course).
- With a large depth of field, the zone of sharp focus extends to include objects at a distance from your subject.

Which arrangement works best depends on your creative vision and your subject. In portraits, for example, a classic technique is to use a short depth of field, as I did for the photo on the left in Figure 5-16. This approach increases emphasis on the subject while diminishing the impact of the background. But for the photo shown on the right, I wanted to emphasize that the foreground figures were in St. Peter's Square, so I used a large depth of field, which kept the background buildings sharply focused and gave them equal weight in the scene.

Shallow depth of field

Large depth of field

Figure 5-16: A shallow depth of field blurs the background (left); a large depth of field keeps both foreground and background in focus (right).

Depth of field depends on the aperture setting, lens focal length, and distance from the subject, as follows:

Aperture setting (f-stop): The aperture is one of three main exposure settings, all explained in Chapter 4. Depth of field increases as you stop down the aperture (by choosing a higher f-stop number). For shallow depth of field, open the aperture (by choosing a lower f-stop number).

Figure 5-17 offers an example. In the f/22 version, focus is sharp all the way through the frame; in the f/2.8 version, focus softens as the distance from the flag increases. I snapped both images using the same focal length and camera-to-subject distance, setting focus on the flag.

Aperture, f/22; focal length, 93mm

Aperture, f/2.8; focal length, 93mm

Figure 5-17: A lower f-stop number (wider aperture) decreases depth of field.

Lens focal length: Focal length, measured in millimeters, determines what a lens "sees." As you increase focal length, the angle of view narrows, objects appear larger in the frame, and depth of field decreases. As an example, Figure 5-18 compares the same scene shot at 127mm and 183mm. I used the same aperture and camera-to-subject distance for each shot, setting focus on the parrot.

Whether you have focal length flexibility depends on your lens. If you have a zoom lens, you can adjust the focal length by zooming in or out. If you have a prime lens, focal length is fixed, so scratch this method of manipulating depth of field.

Camera-to-subject distance: As you move the lens closer to your subject, depth of field decreases. This statement assumes that you don't zoom in or out to reframe the picture, thereby changing the focal length. If you do, depth of field is affected by both the camera position and focal length.

Aperture, f/5.6; focal length, 183mm

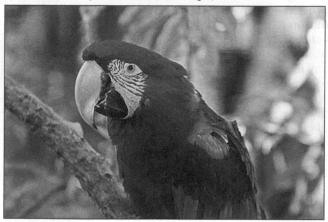

Figure 5-18: Zooming to a longer focal length also reduces depth of field.

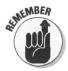

Together, these three factors determine the maximum and minimum depth of field that you can achieve, as follows:

- To produce the shallowest depth of field: Open the aperture as wide as possible (the lowest f-stop number), zoom in to the maximum focal length of your lens, and get as close as possible to your subject.
- ✓ To produce maximum depth of field: Stop down the aperture to the highest possible f-stop number, zoom out to the shortest focal length (widest angle) your lens offers, and move farther from your subject.

A couple of final tips related to depth of field:

- Aperture-priority autoexposure mode (A) enables you to easily control depth of field while enjoying exposure assistance from the camera. In this mode, you rotate the Sub-command dial to set the f-stop, and the camera selects the appropriate shutter speed to produce a good exposure. The range of available aperture settings depends on your lens.
- For greater background blurring, move the subject farther from the background. The extent to which background focus shifts as you adjust depth of field also is affected by the distance between the subject and the background.
- ✓ In Live View mode, depth of field doesn't change in the preview as you change the f-stop setting. The camera can't display the effect of aperture on depth of field properly because the aperture doesn't actually open or close until you take the photo.
- During viewfinder shooting, you can press the Depth-of-Field Preview button to get an idea of how your f-stop will affect depth of field. Normally, the viewfinder can't give you any indication of f-stop-related changes to depth of field because again, the aperture remains wide open until you take the picture. By using the Depthof-Field Preview button, however, you can preview how the f-stop will affect the image. Almost hidden away on the front of your camera, the button is highlighted in Figure 5-19. When you press the button, the camera temporarily sets the aperture to your selected f-stop. At small apertures (high f-stop settings), the viewfinder display may become quite dark, but this doesn't indicate a problem with exposure — it's just a function of how the preview works.

Depth-of-Field Preview button

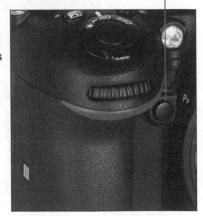

Figure 5-19: Press this button to preview the effect of your f-stop setting on depth of field.

If flash is enabled, the camera emits a modeling flash when you press the Depth-of-Field Preview button. The modeling flash is designed to give you an idea of how the flash will light your subject. You can turn this feature off via the Modeling Flash option, found in the Bracketing/Flash section of the Custom Setting menu.

Also, if you don't use the Depth-of-Field Preview button often, see Chapter 11 to find out how to assign the button a different role in life.

Mastering Color Controls

In This Chapter

- Exploring white balance and its effect on color
- ▶ Creating custom White Balance settings
- Bracketing white balance
- ▶ Setting the color space (sRGB versus Adobe RGB)
- ▶ Taking a quick look at Picture Controls

ompared with understanding certain aspects of digital photography, making sense of your camera's color options is easy-breezy. First, color problems aren't common, and when they occur, they're usually simple to fix with your camera's White Balance setting. Second, getting a grip on color requires learning only a few new terms, an unusual state of affairs for an endeavor that often seems more like high-tech science than art. This chapter explains White Balance along with other features that enable you to fine-tune colors.

Understanding White Balance

Every light source emits a particular color cast. The fluorescent lights in some restrooms, for example, put out a greenish light that makes everyone look sick. And if you think that your beloved looks especially attractive by candlelight, you aren't imagining it: Candlelight casts a flattering yellow-red glow onto the skin.

Science-y types measure the color of light, officially known as *color temperature*, on the Kelvin scale, which is named after its creator. You can see the Kelvin scale in Figure 6-1.

When photographers talk about "warm light" and "cool light," though, they aren't referring to the position on the Kelvin scale — or at least not in the way most people think of temperatures, with a higher number meaning hotter. Instead, the terms describe the appearance of the light. Warm light falls in the red-yellow spectrum at the bottom of the Kelvin scale; cool light has a bluish tint and appears at the top of the scale.

Most people don't notice fluctuating colors of light because human eyes automatically compensate for them. Similarly, a digital camera compensates for different colors of light through white balancing.

Simply put, white balancing neutralizes light so that whites are always white, which in turn ensures that other colors are rendered accurately. If the camera senses warm light, it shifts colors slightly to the cool side of the color

Snow, water, shade
Overcast skies
Flash
Bright sunshine
Fluorescent bulbs

Tungsten lights
Incandescent bulbs

Figure 6-1: Each light source emits a specific color.

spectrum; in cool light, the camera shifts colors in the opposite direction.

Your camera's White Balance setting usually works very well when set to automatic mode, which is the default. But if the scene is lit by two or more light sources that cast different colors, the white balance sensor can get confused, producing an unwanted color cast like the one you see in the left image in Figure 6-2.

I shot this image using tungsten lights, which are similar in color temperature to incandescent bulbs. However, the scene also was illuminated partially by daylight coming through a nearby window. In automatic White Balance mode, the camera reacted to that daylight — which has a cool color cast — and applied too much warming, giving my photo a yellow tint. Changing the White Balance setting to Incandescent, the closest light type to my main light source, produced the corrected colors shown on the right.

There's one problem with white balancing as it's implemented on your D7200, though: You can't make this kind of manual White Balance selection if you shoot in the fully automatic exposure modes. So if you spy color problems in your camera monitor, switch to P, S, A, or M exposure mode.

The next section explains how to make a simple white balance correction; following that, you can explore advanced options.

Figure 6-2: Multiple light sources resulted in a yellow color cast when I relied on automatic white balancing (left); switching to the Incandescent setting solved the problem (right).

Changing the White Balance setting

You can view the current White Balance setting in the Information and Live View displays, as shown in Figure 6-3. The figures show the symbols that represent the automatic setting; other settings are represented by the icons you see in Table 6-1.

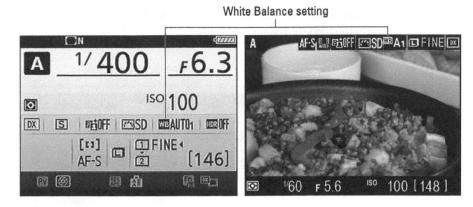

Figure 6-3: These icons represent the current White Balance setting.

Table 6-1	Manual White Balance Settings	
Symbol	Light Source	
*	Incandescent	
	Fluorescent	
*	Direct sunlight	
4	Flash	
2	Cloudy	
1 /1.	Shade	
K	Choose Kelvin color temperature	
PRE	Custom preset	

To access the setting, you have two options:

WB button plus command dials: The quickest method is to press the WB button, which brings up the selection screen shown on the left in Figure 6-4 during viewfinder shooting. In Live View mode, the White Balance setting becomes highlighted, as shown on the right. Rotate the Main command dial while pressing the WB button to cycle through the various White Balance options.

White Balance setting

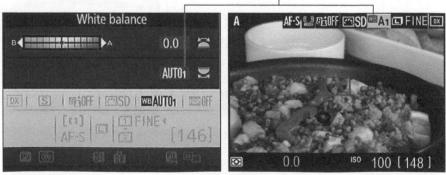

Figure 6-4: Press the WB button while rotating the Main command dial to change the White Balance setting.

- In Live View mode, the display simulates how each White Balance setting affects colors. So if you're not sure which setting to select, experiment in Live View mode even if you plan to return to viewfinder photography to take the shot.
- Photo Shooting menu/Movie Shooting menu: Scroll to the second page of the Photo Shooting menu to find the White Balance setting for still shooting, as shown on the left in Figure 6-5. The White Balance option on the Movie Shooting menu controls video colors, as you probably deduced. But the Movie Shooting menu's version of the option includes one additional White Balance setting: Same as Photo Settings. When that option is selected, as it is by default, the camera uses your still-photography White Balance setting when you switch to movie recording. But if you prefer, you can choose a totally different setting for movies.

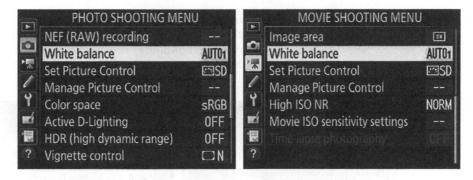

Figure 6-5: You can use different White Balance settings for stills and movies.

For some White Balance settings, you can specify more specific color characteristics, as follows:

Select from two Auto settings: I know what you're thinking: "For heaven's sake, even the Auto setting is complicated?" Yeah, but just a little: See the subscript number 1 next to the Auto label in the displays and menus? The 1 represents the default Auto White Balance setting, Normal. At this setting, the camera adjusts colors to render the scene accurately. Your other Auto option, Keep Warm Lighting Colors, is marked with a subscript 2 and does pretty much what it says: Leaves warm hues produced by incandescent lighting intact.

I prefer the default, but if you want to use the other setting, you must select it via the menus. Choose White Balance > Auto, as shown on the left in Figure 6-6, and press the Multi Selector right to display the screen shown on the right in Figure 6-6. Make your selection and press OK.

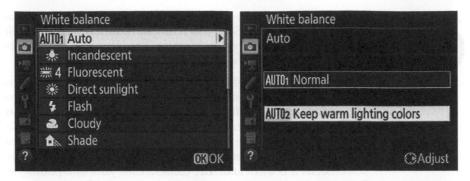

Figure 6-6: The second Auto setting preserves some of the warm hues that incandescent lighting lends to a scene.

✓ Specify a fluorescent bulb type: This option also is available only via the menus. After selecting Fluorescent from the menu, press the Multi Selector right to display the list of bulbs, as shown in Figure 6-7. Select the option that most closely matches your bulbs and press OK.

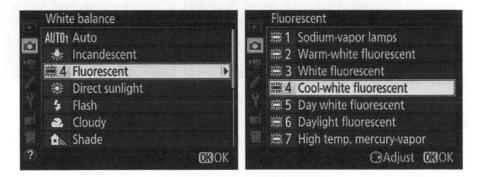

Figure 6-7: You can select a specific type of fluorescent bulb.

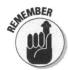

After you select a bulb type, it's used for the Fluorescent setting until you return to the menu and choose another bulb.

✓ **Specify a Kelvin color temperature:** Start by selecting the K White Balance setting. (*K* for *Kelvin*, get it?) Then press the WB button while rotating the Sub-command dial to set the color temperature. While the button is pressed, you can see the temperature value in the Information screen, as shown on the left in Figure 6-8, as well as in the Live View display and Control panel.

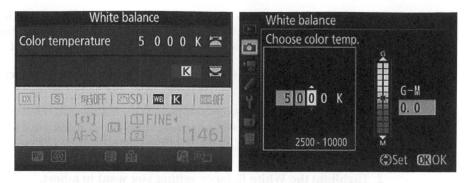

Figure 6-8: After setting the WB option to K, you can set a specific Kelvin temperature.

You also can set the temperature through the Photo and Movie Shooting menus. Select K (Choose Color Temp) as the White Balance setting and press the Multi Selector right to display the screen shown on the right in Figure 6-8. Use the options on the left side of the screen to dial in the Kelvin temperature; the option on the right side enables you to fine-tune colors, as outlined in the next section. Press the Multi Selector right or left to jump between the two controls.

✓ Create a custom White Balance preset: The PRE (Preset Manual) option enables you to store a customized White Balance setting. This feature provides the fastest way to achieve accurate colors when your scene is lit by multiple light sources that have differing color temperatures. I explain it a few miles down the road from here.

Your selected White Balance setting remains in force for the P, S, A, and M exposure modes until you change it. So you may want to get in the habit of resetting the option to your preferred Auto setting after you finish shooting whatever subject it was that caused you to switch out of that mode.

Fine-tuning white balance

You can fine-tune any White Balance setting. Specifically, you can adjust colors along two spectrums: blue to amber and green to magenta. So for example, if you think that the Cloudy setting leaves colors a bit too cool, you can tell the camera to add a pinch more amber whenever you use that White Balance setting.

Fine-tuning a White Balance preset that you create via the PRE option requires a special process that I spell out later, in the section "Editing presets." For other White Balance settings, follow these fine-tuning steps:

1. Open the Photo Shooting or Movie Shooting menu and select White Balance.

If you want to use the same settings for both stills and movies, you don't have to go through these fine-tuning steps twice. Input your changes via the Photo Shooting menu and then open the Movie Shooting menu, choose White Balance, and select Same as Photo Settings.

2. Highlight the White Balance setting you want to adjust.

I selected Cloudy in the left screen in Figure 6-9.

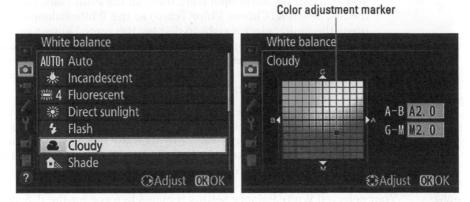

Figure 6-9: Move the black square in the color grid to fine-tune the selected White Balance setting.

3. Press the Multi Selector right.

Which controls you see next and how you use them depends on the White Balance setting you're adjusting:

• All settings except Fluorescent and K: The color grid shown on the right in Figure 6-9 appears. The grid is set up around two color pairs: Green and Magenta (G and M); and Blue and Amber (B and A). Press the Multi Selector to move the adjustment marker in the direction you want to shift colors. The A–B and G–M boxes on the right side of the screen show you the current amount of color shift. A value of 0 indicates no shift.

With traditional colored lens filters, the density of a filter determines the degree of correction it provides. Density is measured in *mireds* (pronounced *my-redds*). The white balance grid is designed around this system: Moving the marker one level is the equivalent of a five-mired shift.

- *Fluorescent*: You see the screen listing types of bulbs (refer to Figure 6-7). Select your choice and press the Multi Selector right to get to the fine-tuning screen shown in Figure 6-9.
- *K* (*Choose Color Temperature*): Instead of the four-way grid, you see the two-part screen shown in Figure 6-8, with the only obvious fine-tuning setting being the green-to-magenta bar on the right. What gives? Well, raising or lowering the Kelvin temperature is equivalent to shifting colors across the blue to amber spectrum. Remember, colors at the top of the Kelvin temperature scale are blue; at the bottom, amber. So for this White Balance setting, you control the amber-to-blue shift by raising or lowering the Kelvin temperature. Then press the Multi Selector right to access the green-to-magenta control.

4. Press the OK button to complete the adjustment.

After you fine-tune a White Balance setting, an asterisk appears next to the icon representing the setting on the menus, as shown in Figure 6-10. You see an asterisk next to the White Balance setting in the Information and Live View displays as well.

For White Balance settings except PRE, take this shortcut to shift colors along the blue-to-amber spectrum:

1. Press the WB button to display the screens shown in Figure 6-11.

The amount of amber-to-blue adjustment appears as the top

Figure 6-10: The asterisk next to the White Balance setting name indicates that you applied a fine-tuning adjustment.

White Balance shift indicator

SD

sRGB

OFF

OFF

ON

PHOTO SHOOTING MENU

NEF (RAW) recording

Set Picture Control

Active D-Lighting

Vignette control

Manage Picture Control

HDR (high dynamic range)

White balance

Color space

adjustment appears as the top control on the Information display and at the bottom of the Live View displays (0.0, by default). You also can see this value in the Control panel. For the K White Balance setting, the color bar shown in the figure on the left is replaced by the Kelvin temperature.

4

MI.

2. Rotate the Sub-command dial to adjust colors.

The letter B indicates that you're moving toward the blue end of the color scale; A, the amber end. If you're adjusting the Kelvin temperature for the K White Balance setting, raising the value sends colors toward the cool end of the scale; lowering it, toward the warm end.

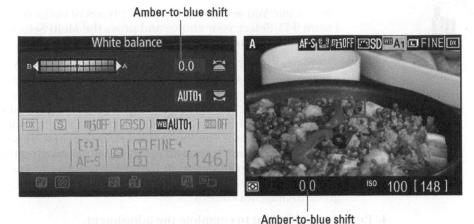

- I I'm I WD I was hije and in

Figure 6-11: For a blue-to-amber shift, press the WB button while rotating the Subcommand dial.

Creating Custom White Balance Presets

If none of the White Balance settings do the trick and you don't want to fool with fine-tuning one, take advantage of the PRE (Preset Manual) feature to create a custom White Balance setting. You can create up to six presets; the next few sections show you how to take advantage of this handy feature.

Any presets you create are shared by the Photo Shooting menu and Movie Shooting menu. In other words, you can't create a set of six presets for still photography and another set for movies. It doesn't matter which menu you use to create the presets; they always go into the same container of presets.

Setting white balance with direct measurement

This technique requires taking a reference photo of a *gray card*, which is a piece of neutral card stock. You can buy gray cards (or equivalent materials) in many camera stores for less than \$20.

The following steps show you how to create a preset when Live View isn't engaged; I spell out the Live View variations later.

1. Set the exposure mode to P, S, A, or M.

As with all white balance features, you can take advantage of this one only in those exposure modes.

2. Open the Photo Shooting menu, choose White Balance, and highlight PRE (Preset Manual), as shown on the left in Figure 6-12.

Again, if you prefer, you can create your presets via the Movie Shooting menu.

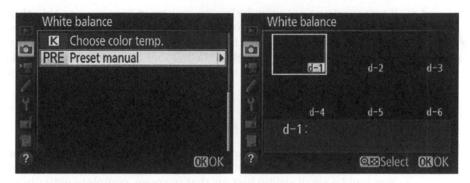

Figure 6-12: You can store as many as six custom White Balance presets.

- 3. Press the Multi Selector right to display the screen shown on the right in Figure 6-12.
- 4. Highlight the preset number (d-1 through d-6) you want to assign to the custom White Balance setting.

If you select an existing preset, it will be overwritten by your new preset.

- 5. Press OK, press the shutter button halfway, and release it to return to shooting mode.
- 6. Position your gray card so that it receives the same light that will illuminate your subject.
- 7. Frame your shot so that the gray card fills the viewfinder.
- 8. Check exposure and adjust settings if needed.

This process won't work if your settings produce an underexposed or overexposed shot of your reference card.

- 9. Press the WB button until the letters PRE flash in the Control panel, Information display, and viewfinder.
- 10. Release the WB button and take a picture of the reference card before the PRE alert stops flashing.

If the camera records the white balance data, you see the letters *Gd* or *Good* in the displays. If you see the message *No Gd*, adjust your lighting or exposure settings and try again. Remember, the reference card shot must be properly exposed for the camera to create the preset successfully.

Now for the promised Live View variation: After you take Step 9, release the WB button. A little box appears in the center of the Live View display. Position that box over your gray card (or other object you want to use as the white-balance reference) and press OK. Press the WB button again to return to shooting mode.

If you create presets regularly, you may want to memorize this shortcut: Instead of doing the job through the menus, press the WB button while rotating the Main command dial to set the White Balance to Pre, and then rotate the Sub-command dial to select the number of the preset you want to create. Release the WB button and then press and hold it again until the letters *PRE* start to flash in the display. Then take your reference shot.

Matching white balance to an existing photo

Suppose that you're the marketing manager for a small business, and one of your jobs is to shoot portraits of the company bigwigs for the annual report. You build a small studio just for that purpose, complete with photo lights and a conservative beige backdrop. The bigwigs can't all come to get their pictures taken on the same day, but you have to make sure that the colors in that backdrop remain consistent for each shot, no matter how much time passes between photo sessions. This scenario is one possible reason for creating a preset based on an existing photo. After photographing the first subject, you use that file as a White Balance reference for the other shots.

Basing white balance on an existing photo works only in situations where the color temperature of your lights is consistent from day to day. Otherwise, the White Balance setting that works for Big Boss Number One may add an ugly color cast to Big Boss Number Two.

To give this option a try, follow these steps:

1. Copy the reference photo to a memory card.

You can copy the picture to the card using a card reader and whatever method you usually use to transfer files from one drive to another. The main folder on the card is DCIM; open that folder and store the picture in the camera's image folder, named 100D7200 by default.

- 2. Put the card in either of the camera's memory card slots.
- 3. Set the exposure mode to P, S, A, or M; then open the Photo Shooting or Movie Shooting menu.
- 4. Choose White Balance, select PRE (Preset Manual) and press the Multi Selector right.

You see the screen shown on the right in Figure 6-12.

5. Use the Multi Selector to highlight the number of the preset you want to create (d-1 through d-6).

If you already created a preset, choosing its number will overwrite that preset with your new one.

- 6. Press the Zoom Out button to display the menu shown in Figure 6-13.
- 7. Highlight Select Image and press the Multi Selector right.

You see thumbnails of your photos.

8. Use the Multi Selector to move the yellow highlight box over your reference photo and then press OK.

You return to the screen showing your White Balance preset thumbnails. The thumbnail for the photo you selected in Step 7 appears as the thumbnail for the preset you chose in Step 5.

Figure 6-13: This option uses an existing image as the basis for a White Balance preset.

9. Press OK to return to the Photo or Movie Shooting menu.

The White Balance setting is automatically changed to use the preset.

Selecting the preset you want to use

If you create multiple presets, take either of these approaches to select the one you want to use:

- WB button + command dials: First, select PRE as the White Balance setting by pressing the WB button as you rotate the Main command dial. Then press the button while rotating the Sub-command dial to cycle through the available presets. The number of the selected preset (d1 through d6) appears in the displays while the button is pressed.
- Photo Shooting or Movie Shooting menu: Select White Balance, choose PRE, and press the Multi Selector right to display the screen shown on the right in Figure 6-12. Use the Multi Selector to highlight a preset and press OK to select it.

Editing presets

After creating a preset, the only way to get rid of it is to overwrite it with a new one. However, you can edit a preset in a few ways.

ISO To access these features, choose White Balance from the Photo Shooting or Movie Shooting menu. Select PRE (Preset Manual), press the Multi Selector right, and highlight the number of the preset you want to edit. Finally, press the Zoom Out button to display the screen shown on the left in Figure 6-14.

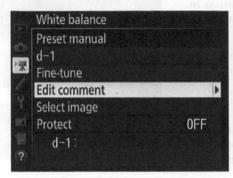

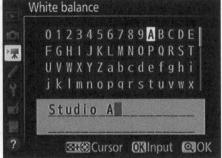

Figure 6-14: Add a text label to a preset to remind you which lighting conditions you used when creating it.

Here's what you can accomplish with each menu option:

- Preset number (d-1, in the figure): To edit a different preset, highlight this option and press the Multi Selector right or left to cycle through the six presets.
- Fine-tune: Press the Multi Selector right to access the same fine-tuning screen that's available for other White Balance settings. See "Fine-tuning white balance," earlier in this chapter, for help.
- Edit comment: This option enables you to name a preset. After highlighting Edit Comment, press the Multi Selector right to display the textentry screen shown on the right in Figure 6-14. Use these techniques to create your text:
 - To enter a character: Use the Multi Selector to highlight the character and press OK.
 - To move the cursor in the text-entry box: Hold down the Zoom Out button while pressing the Multi Selector in the direction you want to move the cursor.
 - To delete a character: Move the cursor over the character and then press the Delete button.

After you enter your text, press the Zoom In button to exit the keyboard screen. When you display the preset selection screen, your text appears as shown in Figure 6-15.

- Select Image: This option enables you to base a preset on an existing photo; see the preceding section for how-to's.
- Protect: Set this option to On to lock a preset so that you can't accidentally overwrite it. If you enable this feature, you can't alter the preset comment or finetune the setting.

To return to the previous menu screen, press Menu. Or, to return to shooting, press the shutter button halfway and release it. The camera

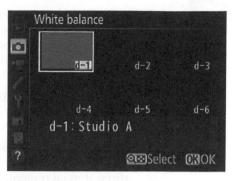

Figure 6-15: Your comment appears with the selected preset.

automatically uses the preset you just edited as the White Balance setting.

Bracketing White Balance

Chapter 4 introduces you to automatic bracketing, which records the same image at different exposure settings. In addition to bracketing exposure, flash, and Active D-Lighting, you can bracket white balance. For example, I used this feature to record the three candle photos in Figure 6-16.

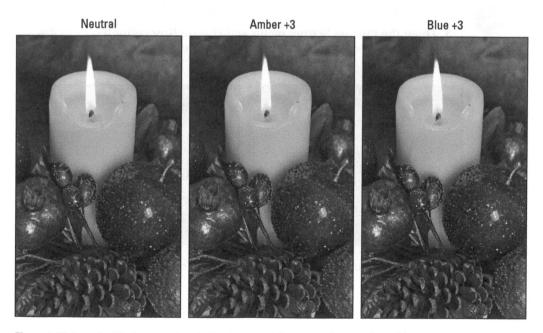

Figure 6-16: I used white balance bracketing to record three variations on the subject.

Note a couple of things about this feature:

- You can capture three frames in each bracketing series. One frame is captured with no adjustment, and you can record one or two more frames using the color shift you specify.
- You take just one picture to record each bracketed series. Each time you press the shutter button, the camera records a single image and then makes the bracketed copies.
- You can shift colors only along the blue-to-amber axis, with a maximum of three steps between frames. For my example photo, I used the three-step increment. As you can see, the shift isn't dramatic even at this setting (although results vary depending on your subject).
- ✓ You can bracket JPEG shots only. The feature is unavailable when the Image Quality option is set to Raw or RAW+JPEG. Don't sweat that limitation: You can precisely tune colors of Raw files when you process them. Chapter 10 has details.

To apply white balance bracketing, take these steps:

Set the Mode dial to P, S, A, or M.
 Only these exposure modes provide White Balance control.

2. Set the Image Quality to Fine, Normal, or Basic.

To adjust the setting, press the Qual button while rotating the Main command dial. (Choose Fine for best image quality.)

3. Open the Custom Setting menu and choose Bracketing/Flash to display the screen shown on the left in Figure 6-17.

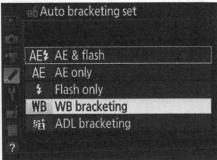

Figure 6-17: Set the Auto Bracketing Set option to WB Bracketing.

- 4. Choose Auto Bracketing Set to display the options shown on the right in the figure.
- 5. Select WB Bracketing and press OK.
- 6. Press the shutter button halfway and release it to exit the menus and return to shooting mode.

7. Press the BKT button wile rotating the Main command dial to specify the number of bracketed frames and direction of the color shift.

While the button is pressed, you can view this setting in the displays. Choose from these options:

- b3F: Records three frames: one with no adjustment and two shifted toward blue.
- a3F: Records three frames: one neutral and two shifted toward amber.
- b2F: Records two frames: one without any adjustment and one shifted toward blue.
- a2F: Again, you get two frames, but the second is shifted toward amber.
- 3F: Records three frames: one neutral, one pushed toward amber, and one shifted toward blue.
- 0F: Turns off bracketing.
- 8. Press the BKT button while rotating the Sub-command dial to set the level of color shift between frames.

Again, the current value appears in the displays while the BKT button is pressed. You can set the amount to 1, 2, or 3.

As with the White Balance fine-tuning grid, this setting is based on mireds, the standard used to measure lens-filter density. Each step is equivalent to a change of five mireds.

9. Release the BKT button to return to shooting mode.

When you release the button, the displays include a WB-BKT symbol to remind you that bracketing is enabled.

10. Take a picture.

After capturing the neutral image, the camera makes the additional color-shifted copies according to your bracketing instructions. (The shutter is released just once; the rest of the magic occurs during post-capture processing.)

11. To disable bracketing, set the frame number to 0F.

Remember, you change the frame number by holding down the BKT button and rotating the Main command dial.

Choosing a color space: sRGB versus Adobe RGB

By default, your camera captures images using the *sRGB color space*, which refers to an industry-standard spectrum of colors. (The *s* is for *standard*, and the *RGB* is for *red*, *green*, *b*lue, which are the primary colors in the digital color world.) This color space was created to help ensure color consistency as an image moves from camera (or scanner) to monitor and printer; the idea was to create a spectrum of colors that all devices can reproduce.

Because sRGB excludes some colors that *can* be reproduced in print and onscreen, at least by some devices, your camera also enables you to shoot in the Adobe RGB color space, which contains a larger spectrum of colors. For still photos, you can select your choice from the Photo Shooting menu. Movies always use the sRGB space.

Consider these factors when choosing between sRGB and Adobe RGB:

Some colors in the Adobe RGB spectrum can't be reproduced in print; the printer

- substitutes the closest printable color, if necessary.
- If you print and share your photos without making adjustments in your photo editor, sRGB is a better choice because most printers and web browsers are designed around that color space.
- To retain the original Adobe RGB colors when you work with your photos, your editing software must support that color space. You also must study the topic of digital color a little because you need to use specific software and printing settings to avoid mucking up the color works.

One final tip: The picture filename indicates which color space you used. Filenames of Adobe RGB images start with an underscore, as in _DSC0627.jpg. For pictures captured in sRGB, the underscore appears in the middle of the filename, as in DSC_0627.jpg.

If you view your photos in a playback mode that displays color data, the White Balance readout indicates the shift applied to the bracketing shots. For the amber version, you see the letter A; for the blue version, B. Next to the letter, the value 1, 2, or 3 indicates the increment of color shift. For the neutral shot, the readout displays 0, 0. Chapter 9 shows you how to view this type of data during playback.

Taking a Quick Look at Picture Controls

When you shoot movies or capture photos using the JPEG Image Quality settings (Fine, Normal, or Basic), colors are also affected by the Picture

Control setting. This option also sets other visual characteristics, including contrast and sharpening.

Sharpening is a software process that boosts contrast in a way that creates the illusion of slightly sharper focus. Let me emphasize, "slightly sharper focus." Sharpening produces a subtle *tweak*; it's not a fix for poor focus.

In the P, S, A, and M exposure modes, you can choose from the following Picture Controls, represented on the menus and in the Information and Live View displays by the two-letter codes labeled in Figure 6-18. In other exposure modes, the camera selects the Picture Control setting.

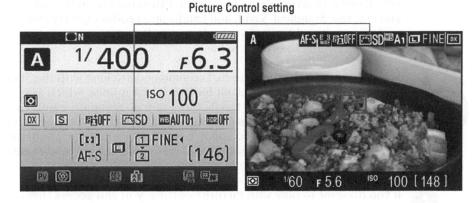

Figure 6-18: This two-letter code represents the Picture Control setting.

- Standard (SD): The default setting, this option captures the image "normally" — that is, using the characteristics that Nikon research has determined suitable for most subjects.
- ✓ Neutral (NL): The camera doesn't enhance color, contrast, and sharpening as much as in Standard mode. The setting is designed for people who want to manipulate these characteristics in a photo editor. By not overworking colors, sharpening, and so on when producing your original file, the camera gives you more latitude in the digital darkroom.
- ✓ Vivid (VI): This mode amps up saturation, contrast, and sharpening.
- Monochrome (MC): This setting creates a black-and-white photo. However, I suggest that you instead shoot in color and then create a black-and-white copy in your photo software. Good photo programs have tools that let you choose how original tones are translated to the black-and-white palette. And remember that you can always convert a color image to black and white, but you can't go the other direction.

That said, Monochrome is a fun option to try for movie recording, producing an instant *film noir* look. For still photos, also check out the Monochrome tool on the Retouch menu, which I explain in Chapter 12.

- Portrait (PT): This mode tweaks colors and sharpening to flatter skin.
- Landscape (LS): This mode emphasizes blues and greens.
- Flat (FL): Flat images display even less contrast, sharpness, and saturation than Neutral and, according to Nikon, capture the widest tonal range possible with the D7200. Videographers who do a lot of post-processing to their footage may find this setting especially useful.

The extent to which Picture Controls affect an image depends on the subject, but Figure 6-19 gives you an idea of what to expect from the color options. As you can see, Standard, Vivid, and Landscape produce pretty similar results, as do Portrait and Neutral. As for Flat — well, to my eye, that rendition *needs* extensive editing to bring it to life.

While you're new to the camera, I recommend sticking with the Standard setting. Again, this is the default for P, S, and A modes, which are the only ones that let you to change the Picture Control. Standard captures most subjects well, and you have lots of other, more important settings to remember. Also keep in mind that if you shoot in the Raw format, you choose a Picture Control during Raw processing (the camera uses the currently selected setting just to create the image preview you see on the monitor).

If you do want to play with Picture Controls, you can access them via the i button menu, the Photo Shooting menu, or the Movie Shooting menu.

While a Picture Control is highlighted on either menu, you can press the Multi Selector right to display settings that enable you to modify that Picture Control. You can increase or decrease color saturation, adjust the amount of sharpening, and so on. I provide step-by-step instructions online; just go to the Extras page for this book at www.dummies.com/extras/nikon.

Also note that as with the White Balance setting, the Picture Control option on the Movie Shooting menu offers an option named Same as Photo Settings, which means the choice you make for stills also affects movies. This setting is the movie default.

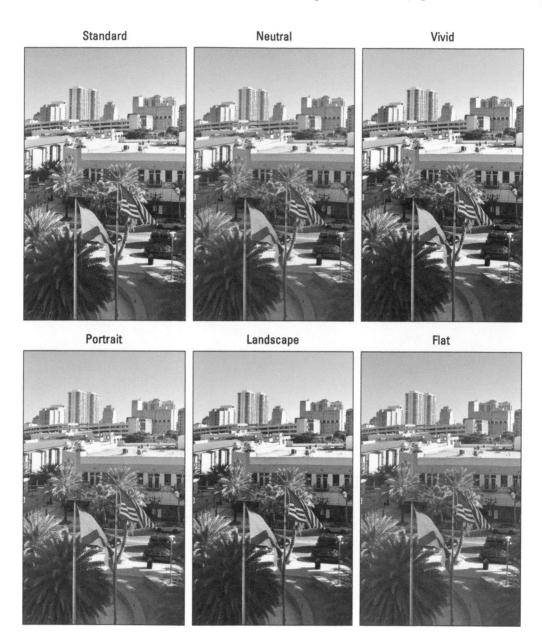

Figure 6-19: Picture controls apply preset adjustments to color, sharpening, and contrast.

Figure 6-21 Pictric ecateds aboly present difference of color, sharpaning, and colors.

Putting It All Together

In This Chapter

- Reviewing the best all-around picture-taking settings
- Adjusting the camera for portrait photography
- Discovering the keys to super action shots
- Dialing in the right settings to capture landscapes and other scenic vistas
- ► Capturing close-up views of your subject

arlier chapters of this book break down every picture-taking feature on your camera, describing in detail how the various controls affect exposure, picture quality, focus, color, and the like. This chapter pulls together all that information to help you set up your camera for specific types of photography.

Keep in mind, though, that there are no hard-and-fast rules as to the "right way" to shoot a portrait, a landscape, or whatever. So feel free to wander off on your own, tweaking this exposure setting or adjusting that focus control, to discover your own creative vision. Experimentation is part of the fun of photography, after all — and thanks to your camera monitor and the Delete button, it's an easy, completely free proposition.

Recapping Basic Picture Settings

Your subject, creative goals, and lighting conditions determine which settings you should use for some picture-taking options, such as aperture and shutter speed.

I offer my take on those options throughout this chapter. But for many basic options, I recommend the same settings for almost every shooting scenario. Table 7-1 shows you those recommendations and also lists the chapter where you can find details about each setting.

One key point: Instructions in this chapter assume that you set the exposure mode to P, S, A, or M, as indicated in the table. These modes, detailed in Chapter 4, are the only ones that give you access to the entire cadre of camera features. In most cases, I recommend using S (shutter-priority autoexposure) when controlling motion blur is important, and A (aperture-priority autoexposure) when controlling depth of field is important. These two modes let you concentrate on one side of the exposure equation and let the camera handle the other. Of course, if you're comfortable making both the aperture and shutter speed decisions, you may prefer to work in M (manual) exposure mode instead. P (programmed autoexposure) is my last choice because it makes choosing a specific aperture or shutter speed more cumbersome.

Additionally, this chapter discusses choices for viewfinder photography. Although most picture settings work the same way during Live View photography as they do for viewfinder photography, the focusing process is quite different. For help with Live View focusing, visit Chapter 5.

Table 7-1	All-Purpose Picture-Taking Settings	
Option	Recommended Setting	Chapter
Exposure mode	P, S, A, or M	4
mage Quality	JPEG Fine or Raw (NEF)	2
Image Size	Large or medium	2
White Balance	Auto ₁	6
SO Sensitivity	100	4
Focus mode	For still subjects, AF-S; moving subjects, AF-C	5
AF-area mode	Still subjects, Single Point; moving subjects, 9-, 21-, or 51-point Dynamic Area	5
Release mode	Action photos: Continuous Low or High; all others: Single Frame	2
Metering	Matrix	4
Active D-Lighting	Off	4

Shooting Still Portraits

By *still portrait*, I mean that your subject isn't moving. For subjects who aren't keen on sitting still, skip to the next section and use the techniques given for action photography instead. Assuming that you do have a subject willing to

pose, the classic portraiture approach is to keep the subject sharply focused while throwing the background into soft focus. This artistic choice emphasizes the subject and helps diminish the impact of any distracting background objects. The following steps show you how to achieve this look:

1. Set the Mode dial to A (aperture-priority autoexposure) and select a low f-stop value.

A low f-stop setting opens the aperture, which not only allows more light to enter the camera but also shortens *depth of field*, or the distance over which focus appears sharp. So dialing in a low f-stop value is the first step in softening your portrait background. However, for a group portrait, don't go too low, or the depth of field may not be enough to keep everyone in the sharp-focus zone. Take test shots and inspect your results at different f-stops to find the right setting.

I recommend using aperture-priority mode when depth of field is a concern, because you can control the f-stop while relying on the camera to select the shutter speed. Just rotate the Sub-command dial to select your f-stop. (You need to pay attention to shutter speed as well, however, to make sure that it's not so slow that movement of the subject or camera will blur the image.)

You can monitor the current f-stop and shutter speed in the Information display and viewfinder, as shown in Figure 7-1. The Control panel also shows this information.

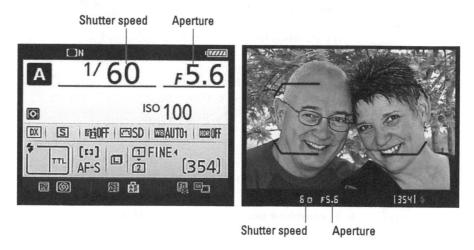

Figure 7-1: You can monitor aperture (f-stop) and shutter speed settings in the displays.

2. To further soften the background, zoom in, get closer, and put more distance between the subject and background.

Zooming in to a longer focal length reduces depth of field, as does moving physically closer to your subject. And the greater the distance between the subject and background, the more the background blurs. (A good rule is to place the subject at least an arm's length away from the background.)

WIREWING!

Avoid using lenses with extremely short or long focal lengths (wide-angle and super-telephoto lenses), which can distort the face and other features. A focal length of 85–120mm is ideal for a classic head-and-shoulders portrait.

3. For indoor portraits, shoot flash-free if possible.

Shooting by available light produces softer illumination and avoids the problem of red-eye. To get enough light to go flashfree, turn on room lights or, during daylight, pose your subject next to a sunny window, as I did in Figure 7-2.

In the A exposure mode, all you need to do to disable the built-in flash is to close the unit. If using flash is unavoidable, try enabling Red-Eye Reduction Flash mode, which fires a preflash to prompt the subject's pupils to close a little, reducing the chance of red-eye. (Ask your subjects to keep smiling until the preflash ends and the actual flash fires.)

Figure 7-2: For more pleasing indoor portraits, shoot by available light instead of using flash.

Change the Flash mode by pressing the Flash button while rotating the Main command dial. Red-Eye Reduction mode is indicated by an eyeball symbol.

4. For outdoor portraits, use a flash if possible.

Even in daylight, a flash adds a beneficial pop of light to subjects' faces, as illustrated in Figure 7-3. A flash is especially important when the background is brighter than the subjects, as in this example.

No flash

Fill flash

Figure 7-3: To properly illuminate the face in outdoor portraits, use flash.

In the A exposure mode, press the Flash button on the side of the camera to raise the built-in flash. Press the button while rotating the Main command dial to set the Flash mode; the default mode, Fill Flash, works best for most outdoor photos.

By default, the top shutter speed you can use with the built-in flash is 1/250 second. At that speed, you may need to stop down the aperture to avoid overexposure in bright light. I used this option when capturing the bottom image in Figure 7-3. Doing so, of course, brings the background into sharper focus; if that creates an issue, move the subject into the shade. Also, you can get around this problem if you use an external flash that supports Nikon Auto FP flash. This feature enables you to use fast shutter speeds with flash, so you can perfectly expose the subject even if you open the aperture all the way. (Chapter 3 has details on this flash feature.)

5. Press and hold the shutter button halfway to initiate exposure metering and autofocusing.

If focusing manually, rotate the focusing ring to set focus.

6. Press the shutter button the rest of the way to capture the image.

These additional pointers can also improve your portraits:

- Find the right background. Too many portraits are ruined by intrusive objects in the background. So scan the frame looking for anything that may distract the eye from the subject. If necessary, reposition the subject against a more flattering backdrop.
- Frame the subject loosely to allow for later cropping to a variety of frame sizes. Your camera produces images that have an aspect ratio of 3:2. That means that your portrait perfectly fits a 4 x 6-inch frame but will require cropping to fit other standard frame sizes, such as 5 x 7 or 8 x 10.
- Pay attention to white balance when you combine flash with other light sources. If you set the White Balance setting to Auto₁, as I recommend in Table 7-1, enabling flash tells the camera to warm colors to compensate for the cool light of a flash. If your subject is also lit by another light source that emits a different color cast, the white-balance mechanism can get confused, causing photo colors to appear redder or bluer than you'd like. See Chapter 6 to find out how to fine-tune white balance.
- Experiment with Slow-Sync flash. That's photo lingo for combining a slow shutter speed with flash. Chapter 3 details this technique, but I want to remind you about it here because it can work well for indoor portraits, as shown in Figure 7-4.

For the left image, the shutter speed was 1/60 second. That exposure time gave the camera little time to soak up ambient light, so the scene is lit primarily by the flash. The strong flash produced glare on the subject's skin and also created a background distraction by lighting up the white window frames, increasing the contrast between them and the darker landscaping outside. Although it was daylight when I shot the picture, the 1/60-second shutter speed was too fast for the daylight to properly expose the exterior, and anything outside the windows was beyond the reach of the flash.

In the second example, shot at 1/4 second, the exposure was long enough to permit the ambient light to brighten the exterior so much that the window frame almost blends into the background. And because less flash power was needed to expose the subject, the lighting is more flattering. In this case, the bright background also sets the subject apart because of her dark hair and shirt. (If the subject had been a pale blonde, this setup wouldn't have worked as well.) Note, too, the subtle color shift between the normal flash and slow-sync example. Again, that

Regular fill flash, 1/60 second

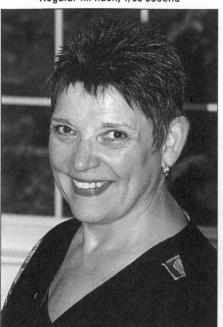

Slow-Sync flash, 1/4 second

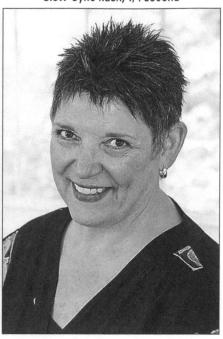

Figure 7-4: Slow-Sync flash produces softer, more even lighting and brighter backgrounds.

Remember that a slow shutter speed can result in blurring due to movement of the camera or subject. So slow-sync portraiture calls for a tripod and a subject able to remain still during the exposure.

For professional results, invest in an external flash with a rotating flash head. External flashes are pricey, but the results make the purchase worthwhile if you shoot lots of portraits. First, you get the advantage of using high-speed flash for better outdoor portraits, as mentioned earlier. Second, you can rotate the flash head so that the flash light doesn't hit the subject straight on. Instead, you can aim the flash at the ceiling, which then reflects a soft, diffused light onto your subject. (This technique is called *bounce lighting*.)

Compare the portraits in Figure 7-5 for an illustration. Using the built-in flash resulted in strong shadowing behind the subject and harsh, concentrated light. To produce the better result on the right, I used a Nikon Speedlight and bounce lighting. I also moved the subject a few feet farther in front of the background to create more background blur.

Direct flash

Bounce flash

Figure 7-5: To eliminate harsh lighting and strong shadows (left), use bounce flash and move the subject farther from the background (right).

When you bounce flash, the reflected light picks up the color of the ceiling, so this option works well only for white or neutral-colored ceilings. The ceiling also needs to be low enough that the bounced light can reach your subject.

Remember that you can adjust flash power through Flash Compensation. To do so, press the Flash button while rotating the Subcommand dial. You also can modify the light from a flash by attaching a flash diffuser, which spreads and softens the light.

Capturing Action

Using a fast shutter speed is the key to capturing a blur-free shot of any moving subject, whether it's a flower in the breeze, a spinning Ferris wheel, or, as in the case of Figure 7-6, a racing cyclist.

Along with the basic settings outlined in Table 7-1, try the techniques described in the following steps to photograph a subject in motion:

1. Set the Mode dial to S (shutter-priority autoexposure).

In this mode, you control the shutter speed, and the camera selects an aperture setting that will produce a good exposure.

2. Rotate the Main command dial to set the shutter speed.

What shutter speed should you choose? Well, it depends on the speed of your subject. so you need to experiment. But generally speaking, 1/320 second should be plenty for all but the fastest subjects (race cars, boats, and so on). For very slow subjects, you can even go as low as 1/250 or 1/125 second. My cycling subject was zipping along at a pretty fast pace, so I set the shutter speed to 1/500 second. Remember, though, that when you increase shutter speed in S exposure mode, the camera may need to open the aperture (select a low f-stop setting) to expose the photo properly. As the aperture opens, depth of field becomes shorter, so you

Figure 7-6: Use a high shutter speed to freeze motion.

have to be more careful to keep your subject within the sharp-focus zone as you compose and focus the shot.

You also can take an entirely different approach to capturing action: Instead of choosing a fast shutter speed, select a speed slow enough to blur the moving objects, which can create a heightened sense of motion and, in scenes that feature very colorful subjects, cool abstract images. I took this approach when shooting the carnival ride featured in Figure 7-7. For the left image, I set the shutter speed to 1/30 second; for the right version, 1/5 second. In both cases, I used a tripod, but because nearly everything in the frame was moving, the entirety of both photos is blurry.

3. For rapid-fire shooting, set the Release mode to Continuous Low or Continuous High.

In both modes, the camera shoots a continuous burst of images as long as you hold down the shutter button. At the camera's default settings, Continuous Low captures up to 3 frames per second (fps), and Continuous High bumps the frame rate up to about 6 fps. (Chapter 2 provides details on how you can modify these capture settings.)

Figure 7-7: Using a shutter speed slow enough to blur moving objects can be a fun creative choice, too.

4. Consider raising the ISO setting to permit a faster shutter speed.

Unless you're shooting in bright daylight, you may not be able to use a fast shutter speed at a low ISO, even if the camera opens the aperture as far as possible. If auto ISO override is in force, ISO may go up automatically when you increase the shutter speed — Chapter 4 has details. Raising the ISO does increase the possibility of noise, but a little noise is usually preferable to a blurry subject.

Why not add flash to bring more light to the scene instead of raising ISO? Well, for one thing, the Continuous Release mode settings don't work with flash; if you enable flash, you get just one frame each time you press the shutter button. Even if you can get past that limitation, the flash needs time to recycle between shots, which also slows your capture rate. Finally, the fastest shutter speed you can use with the built-in flash is 1/250 second by default. Although you can use an option I discuss in Chapter 3 to bump the speed up to 1/320 second, that still may not be enough to freeze some subjects.

5. Select speed-oriented focusing options.

For fastest shooting, try manual focusing: It eliminates the time the camera needs to lock focus when you use autofocusing. If you use autofocus, select these two autofocus settings for best performance:

- Set the AF-area mode to one of the Dynamic Area settings.
 Chapter 5 has information to help you decide whether the 9-point,
 21-point, or 51-point Dynamic Area setting is best for your subject.
- Set the Focus mode to AF-C (continuous-servo autofocus).

At these settings, the camera sets focus initially on your selected focus point but looks to surrounding points for focusing information if your subject moves from the selected one. Focus is adjusted continuously until you take the shot.

You can adjust the AF-area mode by holding down the AF-mode button while rotating the Sub-command dial; change the Focus mode by rotating the Main command dial while pressing the button. (The button is in the center of the Focus-mode selector switch on the left front side of the camera.)

6. Frame loosely to allow for movement across the frame.

Frame your shot a little wider than you normally might so that you lessen the risk that your subject will move out of the frame before you record the image. You can always crop to a tighter composition later. (I used this approach for my cyclist image — the original shot includes a lot of background that I later cropped away.) It's also a good idea to leave more room in front of the subject than behind it. This makes it obvious that your subject is going somewhere.

Using these techniques should give you a better chance of capturing any fast-moving subject, but action-shooting strategies also are helpful for shooting candid portraits of kids and pets. Even if they aren't currently running, leaping, or otherwise cavorting, snapping a shot before they do move is often tough. So if an interaction catches your eye, set your camera into action mode and fire off a series of shots as fast as you can.

Capturing Scenic Vistas

Providing specific settings for landscape photography is tricky because there's no single best approach to capturing a stretch of countryside, a city skyline, or other vast subject. Most people prefer using a wide-angle lens to include a large area of the landscape into the scene, but if you're far from your subject, you may need a telephoto or medium-range lens. When shooting the scene in Figure 7-8, for example, I had to position myself across the street from the buildings, so I used a focal length of 82mm.

And consider depth of field: One person's idea of a super cityscape might be to keep all buildings sharply focused, but another photographer might prefer to shoot the same scene so that a foreground building is sharply focused while the others are less so, thus drawing the eye to that first building.

Figure 7-8: Use a high f-stop value to keep foreground and background sharply focused.

That said, I can offer tips to help you photograph a landscape the way you see it:

- ✓ Shoot in aperture-priority autoexposure mode (A) so that you can control depth of field. If you want extreme depth of field so that both near and distant objects are sharply focused, as in Figure 7-8, select a high f-stop value. I used an aperture of f/18 for this shot.
- Remember that the shorter your lens focal length, the greater the depth of field. With the 18–140mm kit lens, for example, the 18mm position provides the largest depth of field (and widest angle of view).
- Verify that the shutter speed isn't so slow that camera shake will be a problem. Remember that in A mode, the camera sets the shutter speed based on the f-stop you choose. In dim lighting, the camera may need to use a shutter speed that's too slow to allow successful handholding, especially if you stop down the aperture to achieve greater depth of field. Put the camera on a tripod to avoid the possibility of camera shake blurring the image.
- For dramatic waterfall shots, consider using a slow shutter to create that "misty" look. The slow shutter blurs the water, giving it a soft, romantic appearance, as shown in Figure 7-9. Again, use a tripod to ensure that the rest of the scene doesn't also blur due to camera shake. The shutter speed for the image in Figure 7-9 was 1/5 second.

In bright light, a shutter speed slow enough to blur the water may overexpose the image even if you stop the aperture all the way down and select the lowest ISO setting. As a solution, consider investing in a *neutral density filter* to put on the end of your lens. The filter reduces the amount of light that passes through the lens so that you can use a slower shutter speed than would otherwise be possible.

will be dark, but you can usually brighten it in a photo editor if needed. If you base exposure on the foreground, on the other hand, the sky will become so bright that all the color will be washed out — a problem you usually can't fix after the fact. You can also invest in a graduated neutral-density filter, which is clear on one side and dark on

Figure 7-9: For misty waterfalls, use a slow shutter speed and a tripod.

the other. You orient the filter so that the dark half falls over the sky and the clear side over the dimly lit portion of the scene. This setup enables you to better expose the foreground without blowing out the sky colors.

For sunset photos where you want to use the sky as the backdrop for a portrait, statue, or other foreground subject, using flash is key. You can set the overall exposure low enough to retain the colors of the darkening sky and rely on the flash to illuminate your subject. Also experiment with the Active D-Lighting and HDR features that I cover in Chapter 4. Both are designed to create images that contain a greater range of brightness values than is normally possible.

For cool nighttime city pics, experiment with slow shutter speeds. Assuming that cars or other vehicles with their lights on are moving through the scene, the result is neon trails of light like those you see in the foreground of the image in Figure 7-10. Shutter speed for this image was about 10 seconds.

Instead of changing the shutter speed manually between each shot, try *Bulb* mode. Available only in M (manual) exposure mode, this option records an image for as long as you hold down the shutter button. So just take a series of images, holding down the button for different lengths of time for each shot. In Bulb mode, you also can exceed the standard maximum exposure time of 30 seconds.

For the best lighting, shoot during the magic hours. That's the term photographers use for early morning and late afternoon, when the light cast by the sun is soft and warm, giving everything that beautiful, gently warmed look.

Can't wait for the perfect light? Tweak your camera's White Balance setting, using the instructions laid out in Chapter 6, to simulate magic-hour light.

is a good idea in difficult lighting situations, such as sunrise and sunset. Chapter 4 shows you how to make bracketing easier by using automatic exposure bracketing.

For wide-angle landscape shots, try including a person in the frame.

By comparing the size of the person with the surrounding landscape, the viewer gets a better idea of the vastness of the setting.

Figure 7-10: Using a slow shutter speed creates neon light trails in nighttime city street scenes.

Capturing Dynamic Close-Ups

For great close-up shots, try these techniques:

- Check your lens manual to find out its minimum close-focusing distance. How "up close and personal" you can get to your subject depends on your lens.
- Take control over depth of field by setting the camera mode to A (aperture-priority autoexposure) mode. Whether you want a shallow, medium, or extreme depth of field depends on the point of your photo.

In classic nature photography, for example, the artistic tradition is a very shallow depth of field, as shown in Figure 7-11, and requires an open aperture (low f-stop value). If you want the viewer to be able to clearly see all details throughout the frame — for example, you're shooting a product shot for a sales catalog — you need to go the other direction, stopping down the aperture as far as possible.

Remember that zooming in and getting close to your subject both decrease depth of field. So back to that product shot: If you need depth of field beyond what you can achieve with the aperture setting, you may need to back away, zoom out, or both. (You can always crop your image to show just the parts of the subject that you want to feature.)

Figure 7-11: Shallow depth of field is a classic technique for floral images.

- When shooting flowers and other nature scenes outdoors, pay attention to shutter speed, too. Even a slight breeze may cause your subject to move, producing blur at slow shutter speeds.
- ✓ **Use flash for better outdoor lighting.** Just as with portraits, a tiny bit of flash typically improves close-ups when the sun is your primary light source. Again, keep in mind that the default shutter speed limit when you use the built-in flash is 1/250 second. So in very bright light, you may need to use a high f-stop setting to avoid overexposing the picture. You can also adjust the flash output via the Flash Compensation control. Chapter 3 offers details.
- When shooting indoors, try not to use flash as your primary light source. If you're shooting at close range, the flash light may be too harsh even at a low Flash Compensation setting. So as with indoor portraits, try positioning your subject next to a sunny window so that you can go flash-free. To fill in shadows, do what the pros do: Have someone stand opposite the window and hold a white or foil-covered piece of matte board at an angle that reflects the window light onto the subject. If you like this technique, I recommend buying photo

reflectors made for this purpose. They're not expensive, and when your shoot is over, you can collapse them to a size that fits in a small carrying case — much easier than toting around matte board or a windshield cover.

To really get close to your subject, invest in a macro lens or a set of diopters. A true macro lens, which enables you to get really, really close to your subjects, is an expensive proposition; expect to pay many hundreds

of dollars. If you enjoy capturing the tiny details in life, though, it's worth the investment.

Nikon has a great guide to its macro lenses — officially titled "Micro-Nikkor Lenses" — at its www.nikonusa.com website, if you're ready to start shopping.

For a less-expensive way to go, you can spend about \$40 for a set of diopters, which are sort of like reading glasses that you screw onto your existing lens. Diopters come in several strengths -+1, +2, +4, and so on - with a higher number indicating a greater magnifying power. I took this approach to capture the extreme close-up in Figure 7-12, attaching a +2 diopter to my lens. The downfall of using diopters, sadly, is that they typically produce images that are very soft around the edges, a problem that doesn't occur with a good macro lens.

Figure 7-12: To extend your lens's close-focus capability, you can add magnifying diopters.

Shooting, Viewing, and Trimming Movies

In This Chapter

- Recording your first movie using the default settings
- Taking a still photo during recording
- ▶ Understanding the frame rate, frame size, and movie quality options
- Adjusting audio-recording options
- Controlling exposure during movie recording
- Playing and trimming movies

n addition to being a stellar still-photography camera, your D7200 enables you to record HD (high-definition) video. This chapter tells you everything you need to know to take advantage of the movie-recording options.

Check that: This chapter tells you *almost* everything about movie recording. What's missing here is detailed information about focusing, which works the same way for movie shooting as it does when you use Live View to take a still photo. Rather than cover the subject twice, I detail your focusing options in Chapter 5 and provide a basic recap in these pages.

Also be sure to visit the end of Chapter 1, which lists precautions to take while Live View is engaged whether you're shooting stills or movies. (To answer your question: No, you can't use the viewfinder for movie recording; Live View is your only option.)

For even more insight into recording movies with a dSLR, hop online and check out Nikon Cinema, at cinema.nikonusa.com.

Shooting Movies Using Default Settings

Video enthusiasts will appreciate the fact that the D7200 enables you to tweak a variety of movie-recording settings. But if you're not up to sorting through those options, just use the default settings. (You can restore the critical defaults by opening the Movie Shooting menu and choosing Reset Movie Shooting Menu.) The defaults produce a full-HD movie with sound enabled.

The following steps show you how to record a movie using autofocusing. If you prefer manual focusing, just bypass the autofocusing instructions (again, you can find specifics on manual focusing during Live View in Chapter 5):

1. Set the Mode dial to Auto, as shown in Figure 8-1.

In this mode, the camera takes care of most movie settings for you, including ones that affect exposure and color.

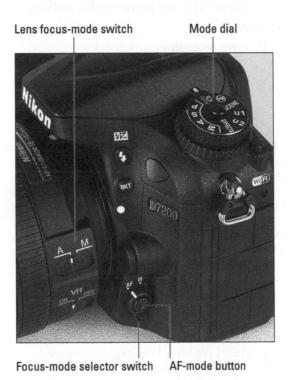

Figure 8-1: Choose the Auto exposure mode to let the camera handle movie exposure, color, and other recording settings.

2. Set the lens and camera to autofocus mode.

Depending on your lens, you accomplish this by setting the lens switch to A, AF, or AF/M (auto with manual focus override). Next, look for the Focus-mode selector switch on the front-left side of the camera and set that switch to AF. Figure 8-1 offers a reminder of where to find these switches and also highlights the AF-mode button, which comes into play shortly.

3. Set the camera to movie mode by rotating the Live View switch to the movie camera icon, as shown in Figure 8-2.

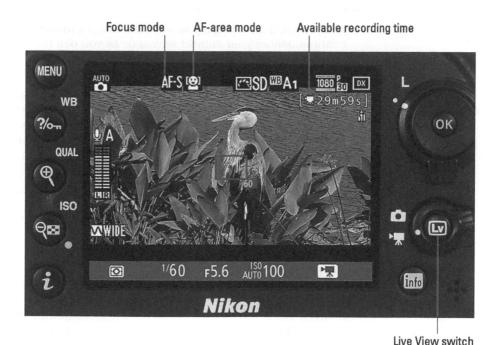

Figure 8-2: After setting the camera to movie mode, press the LV button to display movie settings over your subject.

4. Press the LV button to engage the Live View display.

The viewfinder goes dark, and your subject appears on the monitor. By default, the camera uses the Information On display mode, which offers the data shown in Figure 8-2.

info

If your camera is set to a different display mode, press the Info button as needed to get to the Information On screen.

Later sections decode the various bits of data; for now, just pay attention to the available recording time readout, labeled in the figure. At the

default settings, your movie can be 29 minutes and 59 seconds long, but that presumes that your memory card has enough space to hold the entire movie. The maximum file size for a movie is 4GB (gigabytes).

If the upper-left corner of the screen displays the letters *REC* with a slash through them, movie recording isn't possible. You see this symbol if no memory card is inserted or the card is full, for example.

5. Set the Focus mode by pressing the AF-mode button while rotating the Main command dial.

Refer to Figure 8-1 for a reminder of where the button lives. You can choose from two Focus mode settings:

AF-F: Select this setting if you want the camera to adjust focus
continuously as your subject moves or as you pan the camera to
follow the action. (AF stands for *autofocus*; the second F, for *full-time*.)

Although continuous autofocusing seems ideal for movie recording, there's one hitch: The built-in microphone sometimes picks up the sound of the focus motor, spoiling your movie audio. To avoid this issue, attach an external microphone and place it far enough from the camera body that it can't hear the focus motor.

 AF-S: This setting enables you to lock focus at a specific distance before you start recording. Choose AF-S if you expect your subject to remain about the same distance from the camera throughout the movie — for example, if you're recording a piano performance. (Think AF-S, for stationary.)

The current Focus mode setting appears at the top of the monitor, as shown in Figure 8-2.

6. Compose your initial shot.

The shaded areas at the top and bottom of the monitor indicate the boundaries of the default frame size, 1920×1080 pixels, which produces a 16:9 aspect ratio.

7. If necessary, move the focusing frame over your subject.

The appearance of the frame depends on a second autofocus setting, the AF-area mode. At the default setting, Face Priority mode, the camera scans the frame looking for faces. If it finds one, a yellow focus frame appears over the face, which becomes the focusing target. If the scene contains more than one face, you see multiple frames; the one with the interior corner markings indicates the face chosen as the focus point. You can use the Multi Selector to move the frame over a different face.

If the camera doesn't detect a face, it instead uses the Wide Area AF-area mode, and the focus frame appears as a red rectangle, as shown in Figure 8-2. Use the Multi Selector to move the frame over your subject.

8. Focus the shot.

With AF-F focusing, this step requires no input from you. The camera automatically begins focusing on the subject under the focus frame. The frame turns green when focus is established.

To focus in AF-S mode, press the shutter button halfway. Again, a green focus frame indicates that focus is achieved. In this mode, focus is now locked, so you can lift your finger off the shutter button — you don't have to keep it pressed halfway while recording your video.

9. To begin recording, press the movie-record button, shown in Figure 8-3.

Most shooting data disappears from the screen, and a red Rec symbol appears in the upper-left corner, as shown in Figure 8-4. As recording progresses, the area labeled *Time remaining* in the figure shows how many more minutes of video you can record.

10. To stop recording, press the movie-record button again.

By default, movies are recorded to the memory card in the top slot (Slot 1). If two memory cards are installed, you can specify which card should hold the video file. A symbol representing the selected card appears on the monitor, just under the recording time readout (see Figure 8-4).

To switch to a different card, choose Destination from the Movie Shooting menu, as shown in Figure 8-5, to view the screen shown on the right, which indicates how many minutes of recording time each card can hold. You also can change the Destination setting via the *i* button menu. Either way, the menu option that normally determines card use (Photo Shooting menu > Role Played by Card in Slot 2) has no effect on movie recording. The entire movie always goes on the card you select via the Destination option.

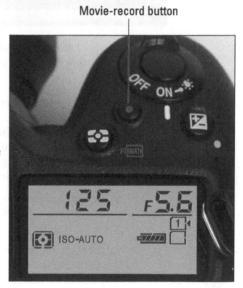

Figure 8-3: Press the red button to start and stop movie recording.

Recording symbol

Time remaining

REC

1000 80

29 1059 51

1000 80

1000 80

1000 80

1000 80

1000 80

1000 80

1000 80

1000 80

1000 80

1000 80

1000 80

1000 80

1000 80

1000 80

1000 80

1000 80

1000 80

1000 80

1000 80

1000 80

1000 80

1000 80

1000 80

1000 80

1000 80

1000 80

1000 80

1000 80

1000 80

1000 80

1000 80

1000 80

1000 80

1000 80

1000 80

1000 80

1000 80

1000 80

1000 80

1000 80

1000 80

1000 80

1000 80

1000 80

1000 80

1000 80

1000 80

1000 80

1000 80

1000 80

1000 80

1000 80

1000 80

1000 80

1000 80

1000 80

1000 80

1000 80

1000 80

1000 80

1000 80

1000 80

1000 80

1000 80

1000 80

1000 80

1000 80

1000 80

1000 80

1000 80

1000 80

1000 80

1000 80

1000 80

1000 80

1000 80

1000 80

1000 80

1000 80

1000 80

1000 80

1000 80

1000 80

1000 80

1000 80

1000 80

1000 80

1000 80

1000 80

1000 80

1000 80

1000 80

1000 80

1000 80

1000 80

1000 80

1000 80

1000 80

1000 80

1000 80

1000 80

1000 80

1000 80

1000 80

1000 80

1000 80

1000 80

1000 80

1000 80

1000 80

1000 80

1000 80

1000 80

1000 80

1000 80

1000 80

1000 80

1000 80

1000 80

1000 80

1000 80

1000 80

1000 80

1000 80

1000 80

1000 80

1000 80

1000 80

1000 80

1000 80

1000 80

1000 80

1000 80

1000 80

1000 80

1000 80

1000 80

1000 80

1000 80

1000 80

1000 80

1000 80

1000 80

1000 80

1000 80

1000 80

1000 80

1000 80

1000 80

1000 80

1000 80

1000 80

1000 80

1000 80

1000 80

1000 80

1000 80

1000 80

1000 80

1000 80

1000 80

1000 80

1000 80

1000 80

1000 80

1000 80

1000 80

1000 80

1000 80

1000 80

1000 80

1000 80

1000 80

1000 80

1000 80

1000 80

1000 80

1000 80

1000 80

1000 80

1000 80

1000 80

1000 80

1000 80

1000 80

1000 80

1000 80

1000 80

1000 80

1000 80

1000 80

1000 80

1000 80

1000 80

1000 80

1000 80

1000 80

1000 80

1000 80

1000 80

1000 80

1000 80

1000 80

1000 80

1000 80

1000 80

1000 80

1000 80

1000 80

1000 80

1000 80

1000 80

1000 80

1000 80

1000 80

1000 80

1000 80

1000 80

1000 80

1000 80

1000 8

Figure 8-4: The red Rec symbol appears while recording is in progress.

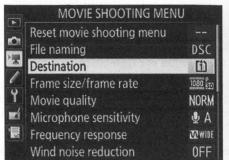

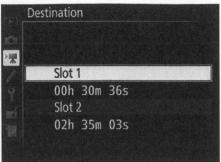

Figure 8-5: If you install two memory cards, use this menu option to choose which card the camera should use when storing your movie.

A few additional basic recording tips:

✓ You can adjust focus during recording. In AF-F Focus mode, you can interrupt continuous autofocusing and lock focus at the current distance by pressing and holding the shutter button halfway down. Release the button to resume continuous autofocusing.

In AF-S mode, press the shutter button halfway to reset focus. When focus is achieved, lift your finger off the shutter button to lock focus at the new distance.

In both cases, expect your video to include a few out-of-focus frames as the camera finds its new focusing target. If you're using the built-in microphone, focusing noise may increase during this process, too.

To change the data displayed on the monitor, press the Info button. Your first press shifts the monitor to Information Off display mode. The recording symbol, time remaining, and focus frame remain visible, as does the shooting information at the bottom of the screen. All other data disappears to give you a clear view of your subject.

Keep pressing Info to cycle through the other three movie display modes, which display a grid, level, and histogram, respectively. One more press of the button takes you back to the default display. ("See Manipulating Movie Exposure," later in this chapter, for help with interpreting the histogram.)

✓ Enabling Vibration Reduction may affect sound recording. Although turning this feature on can lead to steadier shots when you handhold the camera, the built-in microphone may pick up the sounds made by the Vibration Reduction system. Experiment with your lens to find out if this issue crops up, and remember that you have the option of attaching an external microphone to solve the problem if so.

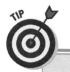

Adding index markers during recording

When you spot a special moment during recording, you may want to tag it with an *index marker*. Then during playback, you can quickly jump to that part of the movie by rotating the Subcommand dial. You can add as many as 20 index markers to a recording.

By default, the Depth-of-Field Preview button is set to perform this function when the camera is in Movie mode. (Look for the button labeled PV, located on the front of the camera, just under the AF-assist lamp.) When you press the button, a little blue mark appears for a second

in the upper-right corner of the screen to let you know that the index point has been stored.

Be careful not to jostle the camera when you press the button, or your special moment will include some wobbly frames. You may want to consider assigning the index-marking function to the AE-L/AF-L button on the back of the camera, which is a little easier to get to during recording than the Depth-of-Field Preview button. Chapter 11 explains how to reassign this button duty for movie recording.

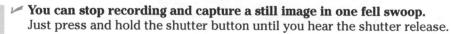

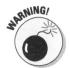

This picture-taking feature depends on the setting selected for the Assign Shutter Button option, found in the Movie section of the Custom Setting menu. At the default setting, Take Photos, things work as just described. If you change the setting to Record Movies, you can use the shutter button to start and stop recording, but you can no longer take a still picture without shifting out of movie mode.

Movies are created in the MOV format. You can view this type of video on your computer monitor using most video-playback programs, including Nikon ViewNX-i, the free software available at the Nikon website. You also can screen movies on an HDTV; just connect the camera to the TV via the HDMI port on the side of the camera. Chapter 12 guides you through this process.

Adjusting Basic Video Settings

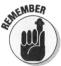

If you're interested in taking more control over your recordings, start by exploring the Frame Size/Frame Rate and Movie Quality settings. Together, these settings determine the look of your video and its file size, which in turn determines the length of the movie you can record. (The sidebar "Maximum recording times" lists the maximum movie length at each combination of these settings.)

If you take a magnifying glass to the Live View display, you may be able to make out symbols representing these settings, which I label in Figure 8-6. Here's what you need to know about each option:

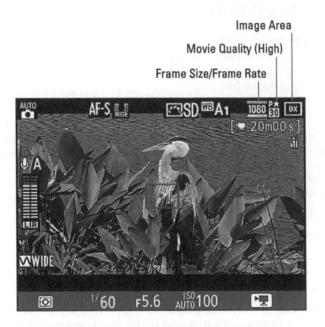

Figure 8-6: In the default Movie display mode, the Frame Size/Frame Rate and Movie Quality settings appear here.

Frame Size/Frame Rate: The first pair of values indicates frame size, or movie *resolution* (number of pixels). In the world of HDTV, 1920 x 1080 pixels is considered *Full HD*, whereas 1280 x 720 is known as *Standard HD* and produces slightly lesser quality than Full HD (although I suspect few people can determine the difference). Both options result in a frame with a 16:9 aspect ratio.

The second value — 30, in the figure — represents the frame rate, measured in frames per second (fps). Available frame rates range from 24 to 60 frames per second. The best option depends on the visual goal you have for your video:

- 24 fps is the standard for motion pictures. It gives your videos a softer, more movie-like look.
- 25 fps gives your videos a slightly sharper, more "realistic" look. This
 frame rate is the standard for television broadcast in countries
 that follow the PAL video-signal standard, such as some European
 countries. If you bought your camera in a PAL part of the world,
 this setting should be the default.

- 30 fps produces an even crisper picture than 25 fps. This frame rate
 is the broadcast video standard for the United States and other
 countries that use the NTSC signal standard. It's the default setting
 for cameras bought in those countries.
- 50 and 60 fps are often used for recording high-speed action and creating slow-motion footage. With more frames per second, fast movements are rendered more smoothly, especially if you slow down the movie playback for a slo-mo review of the action.

How about 50 versus 60? You're back to the PAL versus NTSC question: 50 fps is a PAL standard, and 60 is an NTSC standard.

As for the letter *p* resting atop the frame rate readout, it indicates that footage is recorded using the *progressive* video format, which is the most current dSLR video-recording technology. The D7200 uses only this format; the older *interlaced* (*i*) format isn't provided.

Movie Quality: This setting determines how much compression is applied to the video file, which in turn affects the *bit rate*, or how much data is used to represent 1 second of video, measured in Mbps (megabits per second). You get two choices: High and Normal (the default). The High setting results in a higher bit rate, which means better quality and larger files. Normal produces a lower bit rate and smaller files. In the Live View display, a star indicates the High setting, as shown in Figure 8-6. No star means that the option is set to Normal.

You can set the Frame Size/Frame Rate and Movie Quality options via the \boldsymbol{i} button menu, as shown on the left in Figure 8-7, or the Movie Shooting menu, shown on the right.

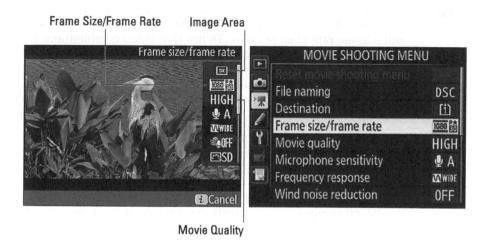

Figure 8-7: Access video settings via the i button menu (left) or Movie Shooting menu (right.)

Maximum recording times

The maximum recording time of a single video clip depends on the Frame Size/Frame Rate and Movie Quality options, as outlined here. The Image Area setting also plays a role because the two highest frame size/frame rate combos (1920 x 1080 at 50p or 60p) are available only when you switch from the default Image Area setting (DX) to the 1.3x setting, which records

your movie using a smaller area of the image sensor.

Remember to select a frame rate of 60, 30, or 24 if you're creating a movie for use in a part of the world that follows the NTSC video standard (including the U.S.) and stick with 50, 25, or 24 for areas that follow the PAL standard.

Frame Size	FPS	Quality	Maximum Movie Length
1920 x 1080	60, 50	High Normal	10 minutes 20 minutes
1920 x 1080	30, 25, 24	High Normal	20 minutes 29 minutes, 59 seconds
1280 x 720	60, 50	High Normal	20 minutes 29 minutes, 59 seconds

One important note about the Frame Size/Frame Rate option: Which combinations of size and fps you can choose depends on the Image Area setting, which determines whether the camera uses the entire image sensor to record your photos and movies. At the default setting, DX, the entire sensor is used, and you're locked out of recording movies using a frame size of 1920×1080 and a frame rate of 60 or 50fps. To use that video combination, you must change the Image Area option to 1.3x, which restricts recording to a smaller portion of the sensor. For movie recording, the Image Area setting appears as the first entry on the i button menu and on the second page of the Movie Shooting menu. (You can't change the setting by pressing the Fn button while rotating a command dial as you can during viewfinder photography.)

Controlling Audio

You can record sound using the camera's built-in stereo microphone, labeled on the left in Figure 8-8, or attach an external microphone such as the Nikon ME-1 to the jack labeled on the right in the figure. To monitor audio during recording, you can attach headphones via the headphone jack, also labeled in the figure.

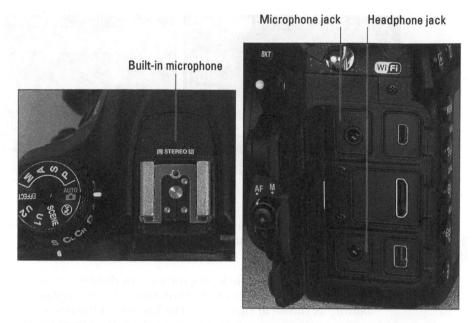

Figure 8-8: You can record audio with the internal microphone (left) or plug in an external microphone and headphones (right).

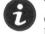

The camera offers three main audio-recording settings, which you access either via the Movie Shooting menu or the i button menu, as shown in Figure 8-9. After you begin recording, however, you can adjust the options only by using the i button menu. That menu also contains a control for adjusting headphone volume, which the Movie Shooting menu lacks. (Scroll to the second page of the i button menu to find the headphone volume setting.)

Here's an introduction to the audio-recording controls:

- Microphone Sensitivity: This option controls whether audio is recorded and, if so, how loud a sound must be for the mic to pick it up. Choose from these options:
 - Auto Sensitivity: The camera automatically adjusts the volume according to the level of ambient noise. This setting is the default.
 - Manual Sensitivity: You specify a sensitivity level from 1 to 20.
 - Microphone Off: Choose this setting to record a movie with no sound or when you're using an off-camera microphone and you don't want the camera itself to record audio.

Figure 8-9: As with other movie settings, you can adjust audio-recording options via the Movie Shooting menu or the i button menu.

To help you gauge audio levels, the camera displays volume meters on the screens that appear after you select the Microphone Sensitivity option, as shown in Figure 8-10. The left side of the figure shows the screen as it appears when you access the setting from the Movie Shooting menu; the right side shows the arrangement provided via the i button menu. When you use a stereo microphone, one bar on the meter represents the left audio channel; the other, the right channel. For monaural recording, both bars reflect the same data.

Audio levels are measured in decibels (dB), and levels on the volume meters range from -40 (very, very soft) to 0 (as loud as can be measured digitally). Ideally, sound should peak consistently in the -12 range. The indicators on the meter turn yellow in this range, as shown in Figure 8-10. If the sound level is too high, the bar at the top of the meter turns red — a warning that audio may be distorted.

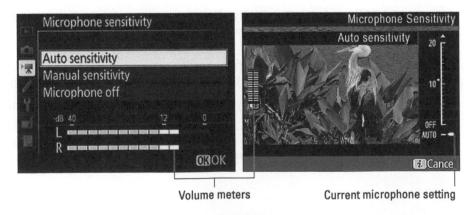

Figure 8-10: Refer to the volume meters when setting microphone sensitivity.

If you adjust the setting via the *i* button menu, the bar on the right side of the screen has a yellow marker to indicate the current setting, as well as a text label near the top of the screen. For example, in the figure, the Auto Sensitivity setting is selected. Press the Multi Selector up once to change the setting to Microphone Off; press up again to shift to Manual Sensitivity control. Then press up to raise the microphone sensitivity; press down to reduce it. The yellow marker moves to show you the current microphone level.

- Frequency Response: By default, this option is set to Wide, which tells the camera to listen for sounds across a large sound frequency, from very high-pitched noises to deep, booming bass notes. If you're recording a speech, you may prefer to change the setting to Vocal, which focuses the microphone's recording efforts on the frequency of the human voice.
- Wind Noise Reduction: Ever seen a newscaster out in the field, carrying a microphone that looks like it's covered with a big piece of foam? That foam thing is a wind filter. It's designed to lessen the sounds that the wind makes when it hits the microphone. When using the built-in microphone, you can enable a digital version of the same thing via the Wind Noise Reduction option.

Wind Noise Reduction option. Essentially, the filter works by reducing the volume of noises that are similar to those made by wind. The problem is that some noises *not* made by wind can also be muffled when the filter is enabled. So when you're indoors or shooting on a still day, keep this option set to Off, as it is by default. Also note that when you use an external microphone, the Wind Filter feature has no effect.

In the default movie display mode, you can view the current Microphone Sensitivity setting and volume meters, as shown in Figure 8-11. You also see a symbol representing the Frequency Response setting. The Wind Noise Reduction icon and headphone volume data appear only if you take advantage of those features.

Headphone volume

Microphone Sensitivity setting

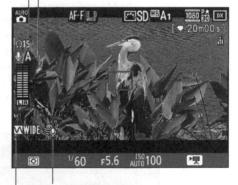

Wind Noise Reduction on

Frequency Response

Figure 8-11: The default movie-recording display mode offers these audio-recording clues.

Manipulating Movie Exposure

Depending on your exposure mode (Auto, M, Scene, and so on), you can tweak movie exposure through the options detailed in the following list. To see what settings are currently in force, check the bottom of the monitor display. If you don't see data similar to what's shown in Figure 8-12, press the Info button to cycle through the display styles until it appears.

- Metering mode: In the P, S, A, and M exposure modes, you can use Matrix (whole-frame) metering or center-weighted metering. Spot metering isn't available. To change the setting, press the Metering mode button while rotating the Main command dial.
- ✓ **ISO:** The camera adjusts ISO (light sensitivity) automatically in all exposure modes except M. In M mode, you can specify ISO

Exposure mode

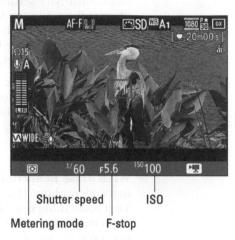

Figure 8-12: Your options for controlling these exposure settings during movie recording are a little different than they are when you snap still photos.

settings through the ISO Sensitivity Setting option on the Movie Shooting menu, shown in Figure 8-13. You can select a specific ISO or enable Auto ISO Sensitivity, which works like it does for still photography: The camera uses your selected ISO unless it can't deliver a good exposure at that setting, in which case it raises or lowers ISO automatically. Use the Maximum Sensitivity option to tell the camera how high it can raise ISO.

Figure 8-13: You can control ISO only in M (manual) exposure mode and only through the Movie Shooting menu.

The Movie Shooting menu is your only route to adjusting ISO. You can't access the setting by pressing the ISO button as you can when taking still photos. Also, the Hi BW1 and Hi BW2 ISO options, which record a black-and-white photo at an ultra-high ISO, aren't available for movie shooting.

✓ Shutter speed: Again, you must set the Mode dial to M to select the shutter speed; the camera automatically adjusts that setting in all other modes, including S (shutter-priority autoexposure). Rotate the Main command dial to set the shutter speed.

You can select shutter speeds as high as 1/8000 second. The slowest shutter speed matches your chosen frame rate. For example, at 30 fps, the slowest shutter speed is 1/30 second. The exception is 24 fps, which sets the low limit to 1/25 second.

✓ **Aperture (f-stop):** You can adjust the f-stop in A (aperture-priority auto-exposure) or M (manual exposure) modes.

Remember that as you raise the f-stop value, the aperture narrows, letting less light into the camera. The aperture setting also is one of three factors contributing to depth of field (the distance over which focus appears sharp). A higher f-stop number translates to a greater depth of field.

One important complication to note: You can't adjust f-stop after you begin recording. In fact, you can't even adjust f-stop while the camera is set to Movie mode and Live View is engaged. You must rotate the Live View switch to the still-photography position, rotate the Sub-command dial to select the f-stop, and then move the Live View switch back to the Movie camera icon.

Also keep in mind that the live preview doesn't indicate the depth of field that your f-stop setting will produce. The camera can't provide this feedback because the aperture doesn't actually open to your selected setting until you start recording. The Depth-of-Field Preview feature available for viewfinder photography isn't available, either.

Exposure Compensation: Exposure Compensation, detailed in Chapter 3, enables you to override the camera's autoexposure decisions, asking for a brighter or darker picture. You can apply this adjustment for movies when you use the following exposure modes: P, S, or A; any Scene mode; or the Night Vision Effects mode. However, you're limited to an adjustment range of EV +3.0 to -3.0 rather than the usual five steps that are possible during normal photography.

Z

To adjust the setting, press the Exposure Compensation button while rotating the Main command dial. While the button is pressed, the Exposure Compensation value appears in the display, along with a teeny tiny triangle sporting either a plus or minus sign to indicate whether you're asking for a brighter exposure (positive value) or darker exposure (negative value). After you release the button, you see just the plus/minus symbol in the display, as shown in Figure 8-14.

You can request Exposure Compensation in M exposure mode, too, but the result is nil unless you enable the Auto ISO Sensitivity option on the Movie Shooting menu. In that case, the camera fiddles with ISO to achieve the exposure shift.

Autoexposure lock: In any exposure, you can lock exposure at the current settings by pressing and holding the AE-L/AF-L button. Chapter 4 also tells you more about autoexposure lock.

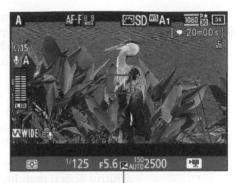

Exposure Compensation enabled

Figure 8-14: This symbol indicates that you asked for a brighter or darker exposure through Exposure Compensation.

Although the camera doesn't display an exposure meter in Movie mode, you have two other exposure assists at your disposal:

Histogram Display: Press the Info button to cycle to a display that includes a histogram, as shown in Figure 8-15. A histogram is a chart that plots out the brightness values of pixels in the image, from black (left end of the chart) to white (right end). The vertical axis indicates how many pixels fall at a particular brightness value. So a heavy concentration of pixels at the right side of the histogram may indicate overexposure, and a large clump of pixels at the left end may indicate underexposure. However, the histogram doesn't tell the whole exposure story, so

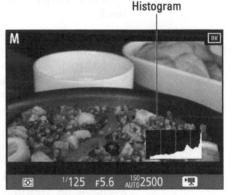

Figure 8-15: Press the Info button as needed to add an exposure histogram to the display.

don't assume that you need to tweak exposure if the histogram looks worrisome. Instead, pinpoint potential trouble spots using the next feature.

✓ Highlight Display: The problem with the histogram is that it doesn't tell you where in the scene the problem pixels lie, which is key to knowing whether you need to adjust exposure. Your subject may be perfectly exposed, with the under- or overexposed areas located entirely in the background — in which case, no exposure adjustment is needed, no matter what the histogram says.

The camera leaves it up to you to spot underexposed areas, but it offers a great tool to help you locate blown highlights. Enable the Highlight

Display option, found on the second page of the *i* button menu and shown on the left in Figure 8-16, to display a black-and-white striped pattern atop areas that have a concentration of white pixels, as shown on the right. The black-and-white box labeled Highlight Display On in Figure 8-16 appears in the default movie-display mode to let you know when the feature is turned on.

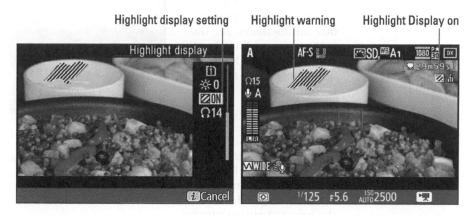

Figure 8-16: Visit the *i* button menu and enable Highlight Alert (left) to display a black-and-white pattern (right).

Why not just refer to the live preview to gauge exposure? Because it's simply not that reliable. The monitor can approximate exposure, but the apparent image brightness varies depending on the ambient lighting. Nikon enables you to adjust the brightness of the display (also via the i button menu, in Movie mode), which can make things easier to see when you're composing your shots. But if you don't reset the brightness option to 0 before recording, any exposure decisions you make based on monitor brightness may be flawed.

Exploring Other Recording Options

In addition to settings reviewed in the preceding sections, you can control a few other aspects of your cinematic effort. The following list runs through these options; Figure 8-17 labels the symbols that represent them in the display. (Remember: Press Info to cycle through the various Movie display modes.)

- Exposure mode: You can record movies in any exposure mode (Auto, Scene modes, Effects modes, P, M, and so on). As with still photography, your choice determines which camera settings you can access.
- Focus options: Your options are the same as for Live View still photography, detailed in Chapter 5. As a quick recap, you adjust autofocusing

behavior through Focus mode and AF-area mode; look for the current settings in the spots labeled in Figure 8-17.

- Focus mode: Choose AF-S to lock focus when you press the shutter button halfway; choose AF-F for continuous autofocusing. See the first section of this chapter for details about how each option works for movie recording.
- AF-area mode: You can choose from Face Priority, Wide Area, Normal Area, or Subject Tracking. The default setting is Face Priority; if the camera doesn't detect a face in the frame, it automatically

Figure 8-17: Here's your road map to other major settings you can monitor in the default Movie display mode.

uses Wide Area focusing instead. With any of these modes, you start by moving the focusing frame over your subject. How things work from there depends on the specific mode; again, Chapter 5 provides step-by-step instructions.

To change these focus settings, locate the AF-mode button (front-left side of the camera, in the middle of the Focus-mode selector switch). Press the button while rotating the Main command dial to change the Focus mode and while rotating the Sub-command dial to change the AF-area mode.

- High ISO NR (Noise Reduction): Like its counterpart on the Photo Shooting menu, this Movie Shooting menu option attempts to soften the appearance of *noise*, a defect that can appear when movies are recorded using a high ISO setting. Noise makes your movie appear grainy, just as it does in still photos. Normal is the default noise-removal setting; you can raise or lower the amount of correction a notch or disable it altogether by setting the option to Off. (Record some test footage at each setting to determine which setting, if any, improves video quality given the current lighting.)
- White Balance and Picture Control: The colors in your movie are rendered according to the these settings, both detailed in Chapter 6. If you shoot your movie using the P, S, A, or M exposure modes, you can choose which White Balance and Picture Control settings you want to use.

Symbols representing these options appear in the areas labeled in Figure 8-17. You can adjust both options via the Movie Shooting menu. The \boldsymbol{i} button menu also provides access to the Picture Control setting. (The WB button doesn't provide access to the White Balance setting in Movie mode.)

Shooting a time-lapse movie

Chapter 2 introduces you to the Interval Timer Shooting option on the Photo Shooting menu. This feature enables you to set the camera to automatically record a series of photos at specified intervals. The Movie Shooting menu offers a related option, Time-Lapse Photography. This feature also records a timed series of still shots, but after all shots are recorded, they're compiled into a video. The Frame Size/Frame Rate and Destination options on the Movie Shooting menu determine the resolution of the video and which memory card is used to store the video.

After selecting Time-Lapse Photography from the menu, you see the same setup screen that

appears for still time-lapse photography, which I detail in Chapter 2. You can specify the start time of the recording, the length of the interval between shots, and whether or not you want exposure smoothing applied. The only difference in the settings is that for movie recording, you don't set the number of intervals and number of shots per interval. Instead, you specify the total recording time, and the number of still frames recorded depends on the interval time you set.

If you're interested in this feature, the camera manual offers lots more details and shooting tips.

Note that on the Movie Shooting menu, you get two Picture Control items. The one named Set Picture Control is the one that determines the Picture Control used for your movie. The Manage Picture Controls option enables you to modify and store custom Picture Controls. (See the last part of Chapter 6 for information.)

Screening Your Movies

To play your movie, press the Playback button. In single-image playback mode, you can spot a movie file by looking for the little movie camera icon in the top-left corner of the screen, as shown in Figure 8-18. You also can view other movie-related data, including the image area, frame size, frame rate, and Movie Quality setting. (Remember: A star means that you set the Movie Quality option to High; the blue box labeled Index marker in the figure appears only if you added markers during recording.) To start playback, press OK.

In the thumbnail and Calendar playback modes, both described in Chapter 9, little dots along the edges of image thumbnails represent movie files. To view those movies, press OK twice: once to shift to single-image view and again to start movie playback.

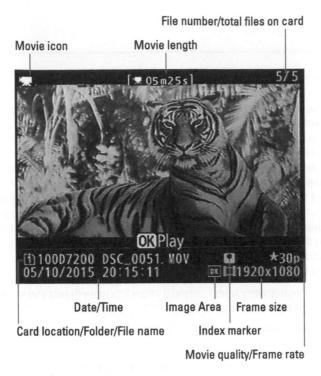

Figure 8-18: Press OK to start movie playback.

After playback begins, you see the data labeled in Figure 8-19. The progress bar and Elapsed Time value show you how much of the movie has played so far; you can also see the total movie length. The other symbols at the bottom of the screen are there to remind you that you can use various dials and buttons to control playback, as follows:

- Stop playback: Press the Multi Selector up. The white circle labeled Playback controls in the figure represents the Multi Selector.
- Pause/resume playback: Press down to pause playback; press OK to resume playback.
- Fast-forward/rewind: Press the Multi Selector right or left to fast-forward or rewind the movie, respectively. Press again to double the fast-forward or rewind speed; keep pressing to increase the speed. Hold the button down to fast-forward or rewind all the way to the end or beginning of the movie.
- Forward/rewind 10 seconds: Rotate the Main command dial to the right to jump 10 seconds through the movie; rotate to the left to jump back 10 seconds. Again, note the white dial symbol near the Multi Selector symbol. It's your cue to use the Main command dial to jump 10 seconds forward or backward.

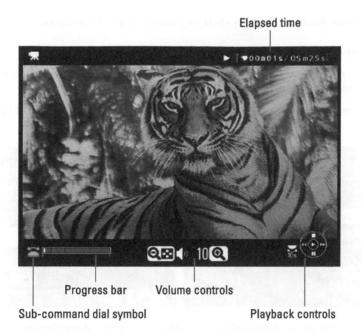

Figure 8-19: The icons at the bottom of the screen remind you which buttons and dials to use to control playback.

- Skip to the next/previous index marker or first/last frame: At the left end of the progress bar, the blue wheel represents the Sub-command dial. Rotate that dial to jump from one index marker to the next, if you added markers during recording. If your movie doesn't include any index markers, playback jumps to the first frame if you rotate the dial to the left and to the last frame if you rotate the dial right.
- Advance frame by frame: Press the Multi Selector down to pause playback and then press right to advance one frame; press left to go back one frame.

Adjust playback volume: See the markings labeled Volume controls in Figure 8-19? They remind you that you can press the Zoom In button to increase volume and press the Zoom Out button to lower it.

Trimming Movies

You can do some limited movie editing in camera. I emphasize: *limited* editing. You can trim frames from the start of a movie and clip off frames from the end, and that's it.

To eliminate frames from the start of a movie, take these steps:

- 1. Begin playing your movie.
- 2. When you reach the first frame you want to keep, pause the movie by pressing the Multi Selector down.

3. Press the *i* button to display the screen shown on the left in Figure 8-20.

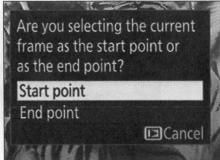

Figure 8-20: With the movie paused, press the i button to access this editing screen.

- Select Choose Start/End Point to display the second screen shown in the figure.
- 5. Select Start Point.

You're returned to the playback screen, which now sports a couple additional symbols. First, you see two yellow markers on the progress bar at the bottom of the screen. The left marker indicates the start point; the right marker, the end point. You also see a symbol that sports the same icons that decorate the WB button (a question mark and key). (More about that button's function momentarily.)

Press the Multi Selector up to lop off all the frames that came before the current frame.

Now you see the options shown in Figure 8-21. To preview the movie, select Preview and press OK. After the preview plays, you're returned to the menu screen.

7. To preserve your original movie and save the trimmed one as a new file, choose Save as New File and press OK.

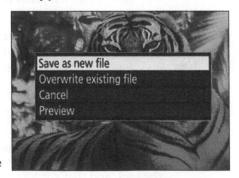

Figure 8-21: Choose Save as New File to avoid overwriting the original movie file.

Alternatively, you can opt to over- Trimmed movie symbol write the existing file, but you can't get the original file back if vou do.

A message appears, telling you that the trimmed movie is being saved. During playback, edited files are indicated by a little scissors icon that appears in the upper-left corner of the screen, as shown in Figure 8-22.

To trim footage from the end of a film, follow the same steps, but this time pause playback on the last frame you want to keep in Step 2. Then in Step 5, select Choose End Point instead of Choose Start Point.

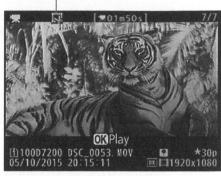

Figure 8-22: The scissors symbol tells you that you're looking at a trimmed movie.

You can trim an already trimmed movie, by the way. So you can go through the steps once to set a new start point and a second time to set a new end point.

If you prefer, you can trim files from both the beginning and end of a movie in one pass. Follow Steps 1 through 5 and then press the WB button. The marker at the right end of the progress bar turns yellow, indicating that you can now rewind the movie to the frame that you want to use as the end of the video. You can keep pressing the WB button to toggle between the start/end point controls on the progress bar. To finalize the edit, press the Multi Selector up.

Saving a Movie Frame As a Still Image

You can save a frame of the movie as a still photo. Here's how:

- 1. Begin playing your movie.
- 2. When you reach the frame you want to capture, press the Multi Selector down to pause playback.

- 3. Press the *i* button to bring up the Edit Movie screen.
- 4. Choose Save Selected Frame.

The frame appears on the monitor.

- 5. Press the Multi Selector up.
- 6. On the confirmation screen that appears, select Yes.

Your frame is saved as a JPEG photo.

Remember a few things about pictures you create this way:

- When you view the image, it's marked with a little scissors icon in the upper-left corner. (It looks just like the one labeled in Figure 8-22.)
- The resolution of the picture depends on the resolution of the movie: For example, if the movie resolution is 1920 x 1080, your picture resolution is 1920 x 1080.
- You can't apply editing features from the Retouch menu to the file, and neither can you view all the shooting data that's normally associated with a JPEG picture.

You can also access this feature and the movie-trimming feature via the Retouch menu. Just select the Edit Movie option from that menu. Chapter 12 provides more details about working with the Retouch menu.

Part III After the Shot

Discover five easy composition tricks you can use to shoot more captivating photos at www.dummies.com/extras/nikon.

In this part . . .

- Get the details on picture playback, including how to customize playback screens.
- Erase files you don't want and protect the ones you like from being accidentally deleted.
- Hide files during playback without deleting them.
- Download files from the camera to the computer.
- Convert Raw (NEF) images using the in-camera converter and the one found in Nikon ViewNX-D.
- Prepare low-resolution copies of photos for online sharing.
- Transfer photos to a smartphone or other smart device via the built-in Wi-Fi feature.

Playback Mode: Viewing Your Photos

In This Chapter

- Exploring picture playback functions
- Magnifying photos to check small details
- Taking advantage of Calendar view
- ▶ Deciphering the picture information displays
- ▶ Understanding histograms

ithout question, my favorite thing about digital photography is being able to view my pictures the instant after I shoot them. No more guessing whether I captured the image or need to try again, as in the film days; no more wasting money on developing pictures that stink.

Seeing your pictures is just the start of the things you can do when you switch your camera to playback mode, though. You can also review settings you used to take the picture, display graphics that alert you to exposure problems, and magnify a photo to check details. This chapter introduces you to these playback features and more.

Picture Playback 101

Unless the D7200 is your first digital camera, you're probably familiar with the basics of picture playback, which are pretty much the same on every digital camera. But just in case, here's a quick refresher:

1. Press the Playback button to put the camera in playback mode.

Figure 9-1 shows you where to find the button. By default, you see a single photo along with some picture information, as shown in the figure.

If you see multiple thumbnails after you press the Playback button, press the OK button to switch to single-photo view. If you instead see a calendar display, press OK twice. (Upcoming sections explain how to use these alternative displays.)

2. To scroll through your pictures, press the Multi Selector right or left.

If you have two memory cards installed, the camera automatically displays all the photos and movies on one card and then switches to the second card. At the bottom of the photo display, the number of the current card appears just to the left of the folder and file name (refer to Figure 9-1).

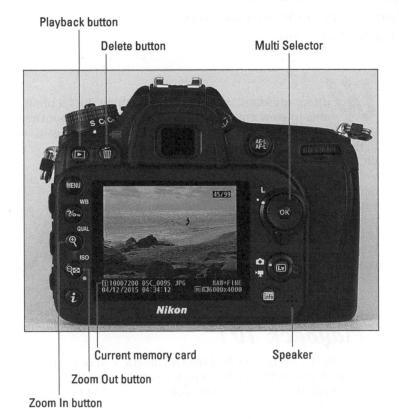

Figure 9-1: These buttons play the largest roles in picture playback.

You can magnify the current image by pressing the Zoom In button, labeled in the figure. While the image is magnified, press the Multi Selector to scroll the display. Press the Zoom Out button to reduce picture magnification.

This trick works only for photographs. During movie playback, pressing the Zoom In and Zoom Out buttons increases and decreases audio volume, respectively. (Sound plays through the little holes marked Speaker in the figure.) To start a movie, press OK; to pause playback, press the Multi Selector down. Press OK again to restart the movie.

3. To erase an embarrassing photo or movie before anyone can see it, press the Delete button.

A confirmation screen appears; press Delete again to give the go-ahead to erase the photo. (Chapter 10 offers additional ways to erase pictures and also shows you how to keep the files but hide them during playback.)

To return to picture-taking mode, press the Playback button again or press the shutter button halfway and then release it.

Of course, just as with every other aspect of using the D7200, Nikon provides you with a variety of options for customizing playback. Chapter 8 covers movie-specific techniques, such as how to fast forward, rewind, and trim movies. The rest of this chapter explains playback features that relate only to still images or work for both stills and movies.

Choosing Which Images to View

Your camera organizes pictures automatically into folders that are assigned generic names: 100D7200, 101D7200, and so on. You can see the name of the current folder by looking at the Storage Folder option on the Photo Shooting menu. (The default folder name appears on this menu as simply 100.) You can also create custom folders by using the process outlined in Chapter 11. Which folders' photos appear during playback depends on the Playback Folder option on the Playback menu, shown in Figure 9-2.

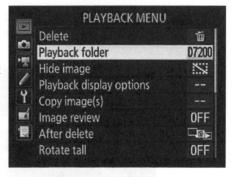

Figure 9-2: If your memory card contains multiple image folders, specify which folder you want to view.

You probably don't have to worry about this setting — all your photos likely are contained in one folder, and the camera selects that folder by default. But if you use a gargantuan memory card that contains zillions of images (and therefore may contain multiple

folders), if you created custom folders, or if your card contains pictures taken on another Nikon camera, specify which folder(s) you want to view by choosing one of the following options:

- ▶ D7200: All pictures taken with the D7200 are viewable, regardless of which folder they call home. If two memory cards are installed, you can view files on both cards. This setting is the default.
- ✓ All: The only difference between this setting and the D7200 setting is that if your card(s) contains pictures shot with a different camera, they're also displayed. The only requirement is that the files be in an image format that the camera recognizes. For example, you may not be able to view Raw files shot with another brand of camera.
- ✓ Current: The camera displays only images contained in the folder selected as the Storage Folder option on the Photo Shooting menu — in other words, the folder in which new photos are currently being stored.

When the camera is in playback mode, use this shortcut to jump from card to card or folder to folder:

1. Press the *i* button.

You see the playback version of the i button menu, shown on the left in Figure 9-3.

2. Select the first option: Playback Slot and Folder.

The screen shown on the right in the figure pops up.

- 3. Select a card slot and press OK to display a list of folders on that card.
- 4. Choose a folder and press OK.

The menu screen disappears, and the first picture or movie in your selected folder appears.

Figure 9-3: In Playback mode, the *i* button menu gives you a quick way to select a folder or card to view.

Adjusting Playback Timing

You can specify when and for how long each photo is displayed, too. Here's a look at your options:

Adjust the timing of automatic shutoff. After you press the Playback button, the monitor turns off automatically if 10 seconds elapse without any activity. Change this shutoff timing by opening the Custom Setting menu and choosing Timers/AE Lock > Monitor Off Delay > Playback, as shown in Figure 9-4. Remember that the monitor is a big battery drain, so keep the display time as short as you find practical.

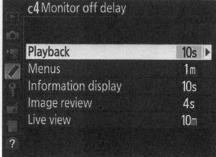

Figure 9-4: You can control how long pictures are displayed before automatic monitor shutdown occurs.

Turn on Image Review. This feature, found on the Playback menu and turned off by default, enables you to get a quick look at a photo without having to shift out of shooting mode and into playback mode. Instead, the camera displays the photo for 4 seconds immediately after it finishes recording the shot to the memory card.

If you turn on Image Review, as shown in Figure 9-5, you can change the length of the display time through the same Custom

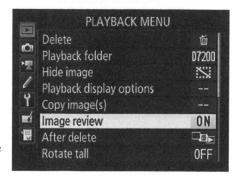

Figure 9-5: Enable Image Review to display each photo for a few seconds immediately after you capture it.

Setting menu option that controls regular playback shutoff (Timers/AE Lock > Monitor Off Delay). Just choose Image Review instead of Playback from the right screen shown in Figure 9-4.

Enabling Automatic Picture Rotation

When you take a picture, the camera records the image *orientation* — whether you held the camera normally, creating a horizontally oriented image, or turned the camera on its side to shoot a vertically oriented photo. During playback, the camera reads the orientation data and rotates vertical images so that they appear in the upright position, as shown on the left in Figure 9-6. The picture is also automatically rotated when you view it in any photo programs that can read the data.

Figure 9-6: You can display vertically oriented pictures in their upright position (left) or sideways (right).

If you prefer, you can disable rotation, in which case vertically oriented pictures appear sideways, as shown on the right in Figure 9-6. To make the change, you need to visit two menus:

- Setup > Auto Image Rotation: This option determines whether orientation data is included in the picture file. Select Off to leave out the data. Pictures then aren't rotated during on-camera playback or in your photo software.
- Playback > Rotate Tall: This option controls whether the camera pays attention to the orientation data during playback. Choose Off if you don't want the camera to rotate pictures that are tagged with orientation data.

Regardless of the settings you choose, no rotation occurs during the instantreview picture display. Nor are movies rotated. Also be aware that shooting with the lens pointing directly up or down sometimes confuses the camera, causing it to record the wrong orientation data.

Shifting from Single-Image to Thumbnails Display

Instead of displaying each photo or movie one at a time, you can display 4 or 9 thumbnails, as shown in Figure 9-7, or even a whopping 72 thumbnails.

Figure 9-7: You can view multiple image thumbnails at a time.

Here's how this display option works:

Display thumbnails. Press the Zoom Out button to cycle from single-picture view to 4-thumbnail view, press again to shift to 9-picture view, and press once more to bring up those itty-bitty thumbnails featured in 72-image view. One more press takes you to Calendar view, a nifty feature explained in the next section.

- Display fewer thumbnails. Pressing the Zoom In button takes you from Calendar view back to the standard thumbnails display or, if you're already in that display, reduces the number of thumbnails so you can see each one at a larger size. Again, your first press takes you from 72 thumbnails to 9, your second press to 4 thumbnails, and your third press returns you to single-image view.
- ✓ Toggle between thumbnails display and full-frame view. Don't waste time pressing the Zoom In button repeatedly to return to the full-frame view: Instead, just press OK. The selected frame takes over the screen. Press OK again to go back to thumbnails display.
- Scroll the display. Press the Multi Selector up and down to scroll to the next or previous screen of thumbnails.

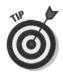

Select an image. To perform certain playback functions, such as deleting a photo, you first need to select an image. A yellow box surrounds the selected image, as shown in Figure 9-7. To select a different image, use the Multi Selector to move the highlight box over the image.

If you're using dual memory cards, you can tell which card contains the selected photo by looking at the card icons, labeled in Figure 9-7. The icon for the current card is yellow.

Displaying Photos in Calendar View

Calendar display mode, shown in Figure 9-8, makes it easy to locate pictures according to the date you shot them. Try it out:

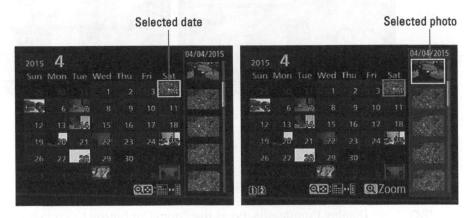

Figure 9-8: Calendar view makes it easy to view all photos shot on a particular day.

1. Press the Zoom Out button as needed to cycle from single-image view to thumbnails view to Calendar view.

If you're currently viewing images in full-frame view, for example, you need to press the button four times to get to Calendar view.

2. Using the Multi Selector, move the yellow highlight box over a date that contains an image.

In the left example in Figure 9-8, the 4th of April is selected. (The number of the month appears in the top-left corner of the screen.) After you select a date, the right side of the screen displays thumbnails of pictures taken on that date.

3. To view all thumbnails from the selected date, press the Zoom Out button again.

After you press the button, the vertical thumbnail strip becomes active, as shown on the right in Figure 9-8, and you can scroll through the thumbnails by pressing the Multi Selector up and down. A highlight box indicates the currently selected image.

QUAL

 To temporarily get a larger view of the selected image, as shown in Figure 9-9, hold down the Zoom In button.

When you release the button, the large preview disappears, and the calendar comes back into view.

5. To jump back to the calendar and select a different date, press the Zoom Out button again.

You can just keep pressing the button to jump between the calendar and the thumbnail strip as much as you want.

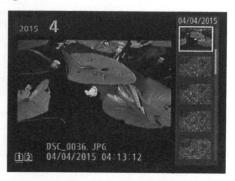

Figure 9-9: After highlighting a thumbnail, press the Zoom In button to temporarily view it at a larger size.

Notice the symbols at the bottom of the display, which represent the Zoom In and Zoom Out buttons. (Refer to Figure 9-8.) They're your reminder of the function these buttons play in Calendar view.

6. To exit Calendar view and return to single-image view, highlight the image you want to view in the thumbnails strip. Then press OK.

Press OK again to switch back to Calendar view.

Using the command dials to scroll through pictures

When you have lots of pictures to view, pressing the Multi Selector to scroll through them all can get tedious quickly. Fortunately, you can customize the camera so that you can rotate the Main command dial to scroll a little more quickly through your files.

To take advantage of this option, open the Custom Setting menu, select Controls, and

then choose Customize Command Dials, as shown on the left in the figure here. On the next screen, shown on the right, change the Menus and Playback option from Off to On. The other available setting for this option, On (Image Review Excluded), enables command-dial scrolling during regular playback but not during the instant review period.

(continued)

Also notice the option directly under the Menus and Playback setting: Sub-dial frame advance. By default, rotating the Sub-command dial whisks you through pictures 10 at a time. You

can change that setting to use the dial to jump forward or back 50 frames or to jump from folder to folder, if your memory card contains multiple folders.

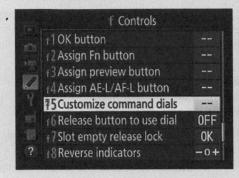

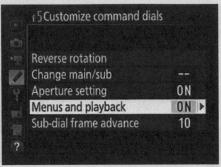

Magnifying Photos During Playback

After displaying a photo in single-frame view, as shown on the left in Figure 9-10, you can magnify it, as shown on the right. You can zoom in on still photos only, however; this feature isn't available for movies.

To shift from Thumbnails view to single-image view, select the photo and then press OK. If the display is in Calendar view, press OK twice.

Magnified area

Figure 9-10: Use the Multi Selector to move the yellow outline over the area you want to inspect.

After the photo is onscreen all by its lonesome, try these magnification features:

Magnify the image. Press the Zoom In button. You can magnify the image to a maximum of 19 to 38 times its original display size, depending on the *resolution* (pixel count) of the photo. Just keep pressing the button until you reach the magnification you want. (Notice the plus-sign magnifying glass symbol on the button, indicating zoom in.)

- Reduce magnification. Press the Zoom Out button the one that sports the minus-sign magnifying glass. (That gridlike thingy next to the magnifying glass reminds you that the button also comes into play when you want to go from full-frame view to Thumbnails view.)
- View another part of the magnified picture. When an image is magnified, a small thumbnail showing the entire image appears briefly in the lower-right corner of the screen, as shown in Figure 9-10. The yellow outline in this picture-in-picture image indicates the area that's currently consuming the rest of the monitor space. Use the Multi Selector to scroll the yellow box and display a different portion of the image. After a few seconds, the navigation thumbnail disappears; just press the Multi Selector in any direction to redisplay it.

- Inspect faces. When you magnify portraits, the picture-in-picture thumbnail displays a white border around each face. Rotate the Sub-command dial to examine each face at the magnified view. Unfortunately, the camera sometimes fails to detect faces, especially if the subject isn't looking directly at the camera. When it works correctly, though, this is a pretty great tool for checking for closed eyes, red-eye, and, of course, spinach in the teeth.
- View more images at the same magnification. While the display is zoomed, you can rotate the Main command dial to display the same area of the next photo at the same magnification. (This feature works regardless of whether you set the Main dial to scroll through pictures during normal playback, as outlined in the sidebar "Using the command dials to scroll through pictures.")
- Return to full-frame view. You don't need to keep pressing the Zoom Out button until the entire photo is displayed. Instead, just press OK.

Viewing Picture Data

In single-image picture view, you can choose from a variety of display modes, all shown in Figure 9-11. Each mode presents different shooting data along with the image or movie file.

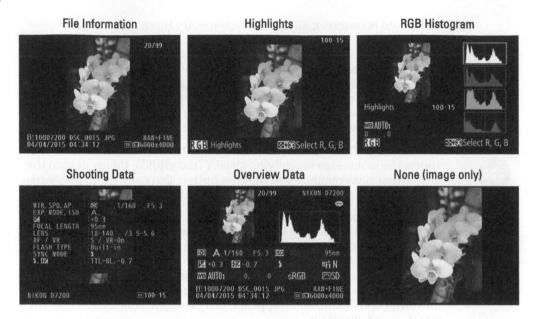

Figure 9-11: You can choose from these display modes during picture playback.

During playback, you shift from one display to the next by pressing the Multi Selector up and down. However, the File Information mode is the only one available by default; to use the others, you must enable them as explained in the next section. Following that, I help you decipher the data that each display mode offers.

Note: Information and figures in these sections relate to still photography. For help with understanding data that appears during movie playback, see the playback section of Chapter 8. Although you can view the first frame of your movie in any of the standard photo display modes, after you start playback, the movie takes over the whole screen and playback data appears as described in that part of Chapter 8.

Enabling and changing playback display modes

Again, only the first display mode shown in Figure 9-11 appears by default. To take advantage of the other displays, you have to enable them via the Playback Display Options setting on the Playback menu, as shown in Figure 9-12.

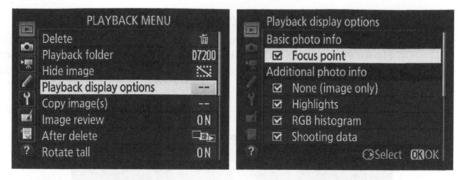

Figure 9-12: Enable the display options you want to use via this Playback menu screen.

The menu options work as follows:

Focus Point: When this option is turned on, a red rectangle marks the focus point (or points), as shown in Figure 9-13. You also see the same brackets that represent the autofocus area in the viewfinder. These focus indicators appear only when you use the display mode shown in the figure — File Information mode. covered in the next section. Also, focus marks aren't displayed if you focused manually or used the AF-C (continuousservo) autofocusing mode setting (or the camera chose that setting for you in AF-A mode). I find the focus marks distracting, but make your own call.

Figure 9-13: You can view the focus point you used when taking the photo.

Chapter 5 explains these autofocusing options.

Additional Photo Info: This section of the menu lets you enable and disable all display modes except File Information, which can't be turned off. You have to scroll to the second page of options, not shown in Figure 9-12, to access the Overview Data display mode.

A check mark in the box next to an option means that the feature is turned on. To toggle the check mark on and off, highlight the option and then press the Multi Selector right. After turning on the options you want to use, press OK.

The next sections explain what details you can glean from the data that appears in the various display modes.

File Information mode

In File Information display mode, the monitor displays the data shown in Figure 9-14. Again, the illustrations here and in the upcoming sections apply to still photos; Chapter 8 helps you sort out movie playback screens.

Figure 9-14: In File Information mode, you can view these bits of data.

Here's the key to what information appears, starting at the top of the screen and working down:

- Frame Number/Total Pictures: The first value here indicates the frame number of the currently displayed photo; the second tells you the total number of pictures on the memory card.
- Focus point: If you enable the Focus Point feature, as outlined in the preceding section, you may see the red focus-point indicator and the autofocus area brackets, as shown in Figure 9-13, depending on the focus settings you used when shooting the picture.
- Card slot: This value tells you which memory card slot holds the card containing the picture.
- Folder: Folders are named automatically by the camera unless you create custom folders, an advanced trick you can explore in Chapter 11. The first camera-created folder is named 100D7200. When that folder is full, the next folder is named 101D7200, and so on.

Filename: The camera also automatically names your files. Filenames end with a three-letter code that represents the file format, which is either JPG (for JPEG) or NEF (for Raw) for still photos. Chapter 2 discusses these formats. If you record a movie, the file extension is MOV.

The first four characters of filenames can also vary as follows:

- DSC_: You captured the photo in the default Color Space, sRGB.
 This setting is the best choice for most people, for reasons you can explore in Chapter 6.
- _DSC: If you change the Color Space setting to Adobe RGB, the underscore character comes first. (You can't use this color space when recording movies, by the way.)

See Chapter 11 to find out how you can use the File Naming option on the Photo Shooting and Movie Shooting menus to swap out the DSC character string with your own trio of characters.

Each image is also assigned a four-digit file number, starting with 0001. When you reach image 9999, the file numbering restarts at 0001, and the new images go into a new folder to prevent any possibility of overwriting the existing image files.

- Date and Time: Just below the folder and filename info, you see the date and time that you took the picture. Of course, the accuracy of this data depends on whether you set the camera's date and time correctly, which you do via the Setup menu.
- Image Area: This symbol tells you whether the DX or 1.3x crop area of the image sensor was used to record the photo. DX is the default and records the image using the entire sensor. See Chapter 2 for an explanation of this feature.
- Image Quality: Here you can see which Image Quality setting you used when taking the picture. Again, Chapter 2 has details, but the short story is this: Fine, Normal, and Basic are the three JPEG options, with Fine representing the highest JPEG quality. Raw refers to the Nikon Camera Raw format, NEF. If you captured the photo in both formats, you see both labels, as in the figure.
- Image Size: This value tells you the image resolution, or pixel count. See Chapter 2 to find out about resolution.

In the top-left corner of the screen, you may see the following symbols, labeled in Figure 9-15:

✓ Protected symbol: The key indicates that you used the file-protection feature to prevent the image or movie from being erased when you use the camera's Delete function. See the next chapter to find out more. This area appears empty if you didn't apply protection. (Note: Formatting your memory card, a topic discussed in Chapter 1, does erase even protected pictures.)

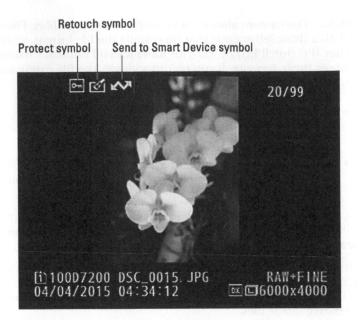

Figure 9-15: These symbols indicate the protect, retouch, and send-to-smart device features.

- Retouch symbol: This icon appears on images that you created by applying one of the Retouch menu features to a picture. (The camera preserves the original and applies your alterations to a copy of the file.) Chapter 12 explains Retouch menu options that apply to photos. See Chapter 8 for help with the movie-editing function found on the menu; for edited movies, you see a little scissors icon instead of the Retouch symbol shown in the figure.
- Send to Smart Device symbol: After you tag a file for Wi-Fi transfer to a smartphone or tablet, this symbol appears. Chapter 10 explains this Wi-Fi feature.

Highlights display mode

One of the most difficult photo problems to correct in a photo-editing program is known as *blown highlights* in some circles and *clipped highlights* in others. Both terms mean that the brightest areas of the image are so overexposed that areas that should include a variety of light shades are instead totally white.

In Highlights display mode, areas that the camera thinks may be overexposed blink in the camera monitor. To use this mode, you must first enable it via the Display Options setting on the Playback menu. Then press the Multi Selector down to shift from File Information mode to Highlights mode.

To fully understand all the features of Highlights mode, you need to know a little about digital imaging science. First, digital images are called *RGB images* because they're created from the three primary colors of light: red, green, and blue. In Highlights mode, you can display the exposure warning for all three color components — sometimes called color *channels* — combined or view the data for each individual channel.

When you look at the brightness data for a single channel, though, greatly overexposed areas don't translate to white in photos — rather, they result in a solid blob of some other color. I don't have space in this book to provide a full lesson in RGB color theory, but the short story is that when you mix red, green, and blue light, and each component is at maximum brightness, you get white. Zero brightness in all three channels gives you black. If you have maximum red and no blue or green, you have fully saturated red. If you mix two channels at maximum brightness, you also get full saturation. For example, maximum red and blue produce fully saturated magenta. And this is why it matters: Wherever colors are fully saturated, you can lose picture detail. For example, a rose petal that should have a range of tones from light to dark red may instead be bright red throughout.

The moral of the story is that when you view your photo in single-channel display, large areas of blinking highlights in one or two channels indicate that you may be losing color details. Blinking highlights that appear in the same spot in all three channels indicate blown highlights — again, because when you have maximum red, green, and blue, you get white. Either way, you may want to adjust your exposure settings and try again.

Okay, with today's science lesson out of the way, Figure 9-16 displays an image that contains some blown highlights to show you how things look in Highlights display mode. I captured the screen at the moment the highlight blinkies blinked "off" the black areas in the figure indicate the blown highlights. (I labeled a few of them in the figure.) But as this image proves, just because you see the flashing alerts doesn't mean that you should adjust exposure — the decision depends on where the alerts occur and how the rest of the image is exposed.

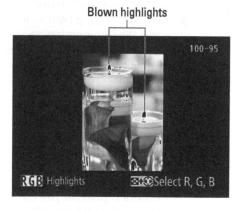

Figure 9-16: In Highlights mode, blinking areas indicate blown highlights.

In my candle photo, there are indeed small white areas in the flames and the glass vase, yet exposure in the majority of the image is fine. If I reduced exposure to darken the brightest spots, some areas of the flowers would be underexposed. In other words, sometimes you simply can't avoid a few clipped highlights when the scene includes a broad range of brightness values.

In the lower-left corner of the display, the letters highlighted in yellow tell you whether you're looking at a single channel (R, G, or B) or the three-channel, composite display (RGB). The latter is selected in the figure. To cycle between the settings, press the Zoom Out button as you press the Multi Selector right or left.

Highlights display mode also presents the same symbols shown in Figure 9-15 if you used the related features. In the upper-right corner, you see the folder number and the frame number — 100 and 95, respectively, in Figure 9-16. The label "Highlights" also appears to let you know the current display mode.

RGB Histogram mode

From Highlights mode, press the Multi Selector down to get to RGB Histogram mode, which displays your image as shown on the left in Figure 9-17. (*Remember:* You can access this mode only if you enable it via the Playback Display Options setting on the Playback menu.)

The data underneath the thumbnail shows the White Balance settings used for the shot. (White balance is a color feature you can explore in Chapter 6.) The first value tells you the setting (Auto₁, in the figure), and the two number values tell you whether you fine-tuned that setting along the amber to blue axis (first value) or green to magenta axis

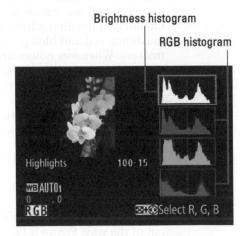

Figure 9-17: In RGB Histogram mode, you see both a brightness histogram and an RGB histogram.

(second value). Zeros, as in the figure, indicate no fine-tuning. You also see symbols representing the protect, retouched, and send-to-smart device tag if you used those features.

In addition, you get four charts, called *histograms*. You actually get two types of histograms, as labeled in the figure: The top one is a Brightness histogram and reflects the composite, three-channel image data. The three others represent the data for the single red, green, and blue channels. This trio is sometimes called an *RGB histogram*, thus the display mode name.

The next two sections explain what information you can glean from the two types of histograms. But first, here are two quick tips:

Highlights data: As with Highlights mode, blown highlights blink in the thumbnail, and you can view the warning for either the composite image (RGB) or each individual channel. Press the Zoom Out button as you press the Multi Selector right to cycle between the single-channel and multichannel views. A yellow box also surrounds the histogram representing the active view. For example, the composite view is active in the figure. To get rid of the blinkies, select the Blue channel and then press the Multi Selector right one more time.

Zooming the view: Press the Zoom In button to zoom the thumbnail to a magnified view. The histograms then update to reflect only the magnified area of the photo. Press the Multi Selector to scroll the image display. To return to the regular view, press OK.

Reading a Brightness histogram

You can get an idea of image exposure by viewing your photo on the monitor and by looking at the blinkies in Highlights mode, but the Brightness histogram provides a way to gauge exposure that's a little more detailed.

A Brightness histogram indicates the distribution of shadows, highlights, and *midtones* (areas of medium brightness) in your image. Figure 9-18 shows you the histogram for the orchid image featured in Figure 9-17, for example.

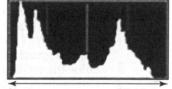

Shadows

Highlights

The horizontal axis of the histogram represents possible brightness values — the maximum tonal range, in photography-speak — from the darkest shadows on the left to the brightest highlights on the right. And the vertical axis shows you how many pixels fall at a particular

gram indicates tonal range, from shadows on the left to highlights on the right.

Figure 9-18: The Brightness histo-

brightness value. A spike indicates a heavy concentration of pixels at that brightness value.

There is no one "perfect" histogram that you should try to achieve. Instead, interpret the histogram with respect to the distribution of shadows, highlights, and midtones that comprise your subject. You wouldn't expect to see lots of shadows, for example, in a photo of a polar bear walking on a snowy landscape. Pay attention, however, if you see a very high concentration of pixels at the far right or left end of the histogram, which can indicate a seriously overexposed or underexposed image, respectively. To find out how to resolve exposure problems, visit Chapter 4.

Understanding RGB histograms

In RGB Histogram display mode, you see two histograms: the Brightness histogram, covered in the preceding section, and an RGB histogram. Figure 9-19 shows you the RGB histogram for the orchid image.

As explained in the earlier section about Highlights mode, digital images are made up of red, green, and blue light. With the RGB histograms, you can view the brightness values for each of those color channels. Again, overexposure in one or two channels can produce oversaturated colors — and thus a loss of picture detail. So, if most of the pixels for one or two channels are clustered toward the right end of the histogram, adjust your exposure settings, as outlined in Chapter 4, and try again.

Photographers schooled in the science of RGB histograms can spot color-balance issues by looking at the pixel values, too. But frankly, color-balance problems are easy to notice just by looking at the image itself on the camera monitor. And understanding how to translate

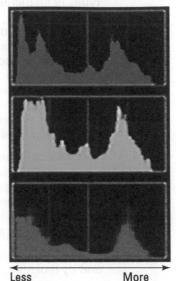

Figure 9-19: The RGB histogram can indicate problems with color

Saturated

Saturated

saturation.

the histogram data for this purpose requires more knowledge about RGB color theory than I have room to present in this book. For information about manipulating color, see Chapter 6.

Shooting Data display mode

Before you can access this mode, you must enable it via the Playback Display Options setting on the Playback menu. See the earlier section, "Enabling and changing playback display modes," for details.

In Shooting Display mode, you can view up to five screens of information, which you scroll through by pressing the Multi Selector up and down. Figure 9-20 shows just the first two screens of data.

Most of the data you see won't make sense until you explore Chapters 3–7, which explain the flash, exposure, color, and focusing settings available on your camera. But I want to call your attention to a few facts now:

✓ The upper-left corner of the monitor shows the Protected, Retouch, and Send to Smart Device icons, if you used these features. (Refer to Figure 9-15 to see each of these icons.)

```
MHITE BALANCE : AUTO1 . 0 . 0
COLOR SPACE : SRGB
PICTURE CTRL : STANDARD
OUICK ADJUST : 0
SHARPENING : 3
CLARITY : +1
CONTRAST : 0
BRIGHINESS : 0
SATURATION : 0
HUE : 0

NIKON D7200
```

Figure 9-20: Here you see the first two Shooting Data screens.

- The current folder and frame number appear in the lower-right corner of the display, as does the Image Area setting (DX or 1.3x crop).
- The Comment item, which is the final item on the third screen, contains a value if you use the Image Comment feature on the Setup menu.
- ✓ If the ISO value on Shooting Data Page 1 appears in red (refer to the left screen in Figure 9-20), the camera overrode the ISO Sensitivity setting that you selected in order to produce a good exposure. This shift occurs only if you enable automatic ISO adjustment in the P, S, A, and M exposure modes; see Chapter 4 for details.
- The fourth screen appears if you include copyright data with your picture, a feature you can explore in Chapter 11. The fifth screen appears if you attach the optional GPS unit to the camera, in which case GPS location data appears on that screen.

Overview Data mode

In this mode, the playback screen contains a small thumbnail along with scads of shooting data plus a Brightness histogram. Figure 9-21 offers a look. You enable this display mode via the Playback Display Options setting on the Playback menu.

The earlier section "Reading a Brightness histogram" tells you what to make of that part of the screen. The Frame Number/Total Pictures data appears near the upper-right corner of the image thumbnail. As with the other display modes,

Image Comment enabled

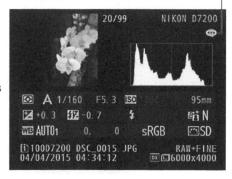

Figure 9-21: In Overview mode, you can view your picture along with the major camera settings you used to take the picture.

symbols representing the protect, retouch, and send-to-smart device tags show up if you used those features. The speech bubble just above the histogram indicates that you enabled the Image Comment feature (Chapter 11). To read the comment, go to the Shooting Data display mode.

To sort out other information, the following list breaks things down into the five rows that appear under the thumbnail and histogram. If any items don't appear on your screen, the relevant feature wasn't enabled when you captured the shot:

Rows 1 and 2: You see the exposure-related settings labeled in Figure 9-22 and 9-23. The ISO value appears red, if you had Auto ISO override enabled and the camera adjusted the ISO for you.

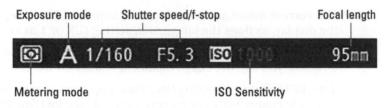

Figure 9-22: This row shows exposure and focal-length data.

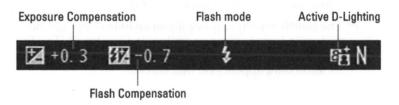

Figure 9-23: This row contains additional exposure information.

- **Row 3:** Items on this row, shown in Figure 9-24, pertain to color options.
- Rows 4 and 5: The final two rows show the same information you get in File Information mode, explained earlier.

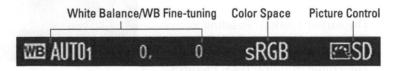

Figure 9-24: Look at this row for details about color settings.

Working with Camera Files

In This Chapter

- ▶ Protecting, hiding, and deleting picture and movie files
- Downloading files to your computer
- Processing Raw files
- Shrinking files for online use
- Copying files from one memory card to another
- Transferring files to a smartphone or tablet via Wi-Fi

very creative pursuit involves its share of cleanup and organizational tasks. Painters have to wash brushes, embroiderers have to separate strands of floss, woodcrafters have to haul out the wet/dry vac to suck up sawdust. Digital photography is no different: At some point, you have to stop shooting so that you can download and process your files.

This chapter explains these after-the-shot tasks. First up is a review of several in-camera file-management operations: hiding files (preventing them from being viewed without deleting them); deleting files you're sure you no longer want, and protecting your best work from accidental erasure.

Following that, you can get help with transferring files to your computer, processing files that you shot in the Raw (NEF) format, creating low-resolution copies of photos for online sharing, copying files between memory cards, and using Wi-Fi to send pictures from the camera to a smartphone or tablet. Along the way, I introduce you to Nikon's free software, Nikon ViewNX-i and Capture NX-D, which can handle some of these tasks.

Protecting Photos

You can safeguard pictures from accidental erasure by giving them *protected status*. After you take this step, the camera doesn't allow you to erase the picture by using the Delete button or the Delete option on the Playback menu.

To protect a picture, display it (or select it, in Thumbnails or Calendar playback view) and press the Protect button, highlighted in Figure 10-1. A key symbol appears on your photo, as shown in the figure. Press the button again to unlock the photo.

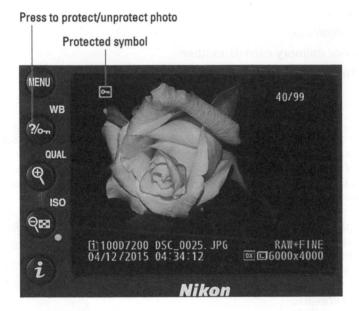

Figure 10-1: Press the Protect button to prevent accidental deletion of the selected image.

Formatting your memory card *does* erase protected pictures. In addition, when you protect a picture, it shows up as a read-only file when you transfer it to your computer. Read-only files can't be altered until you unlock them. You can unlock the files in your camera or in certain photo-management programs. (In Nikon ViewNX-i, choose File > Protect Files > Unprotect.)

Hiding Photos During Playback

Suppose that you took 100 pictures of your staff at a business conference — 50 during official meetings and 50 at after-hours schmooze-fests. You want to show your boss photos of your team acting all businesslike at the meetings, but you'd rather not share the images of your group dancing on the hotellobby bar. You can always delete the photos, but if you want to keep them — you never know when a good blackmail picture will come in handy — you can simply hide them during playback. In fact, you can prevent photos from appearing in two ways:

- Playback menu > Playback Folder: If you stored the business photos in a different folder from the after-work shots, you can specify that only the "safe" folder appears during playback. Make your folder selection via the Playback Folder option on the Playback menu. (Chapter 11 explains how you can create custom folders.)
- Playback menu > Hide Image: Didn't think about the separate-folder thing before you took the incriminating frames? Yeah, I wouldn't either. Fortunately, you have a fallback position: Through the Hide Image option on the Playback menu, shown in Figure 10-2, you can tag files that you don't want the camera to display.

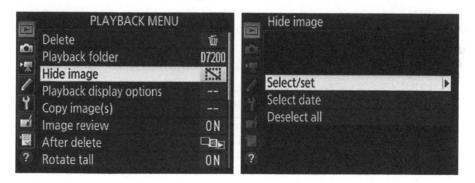

Figure 10-2: The Hide Image function prevents photos from appearing during picture playback.

Use either of these techniques to apply the Hide Image tag:

✓ Tag photos one by one: Choose Select/Set, as shown on the right in Figure 10-2, to display image thumbnails. Use the Multi Selector to highlight a picture and then press the Zoom Out button to place the Hide Image tag on the thumbnail, as shown on the left in Figure 10-3. If you change your mind, press the button again to remove the tag. Press OK to return to the playback menu. Your tagged pictures are now hidden.

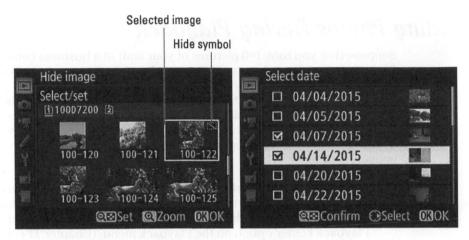

Figure 10-3: You can select photos one by one (left) or by date (right).

Hide all photos taken on a specific date: On the screen shown on the right in Figure 10-2, choose Select Date and press the Multi Selector right. You see a list of dates, as shown on the right in Figure 10-3. Highlight the date in question and press the Multi Selector right to select the box for that date. Press OK to finalize the process.

Can't remember which photos or movies you took on which dates? Use the Zoom Out button and the Zoom In button, shown in the margin, to perform these tricks:

- To display file thumbnails, press the Zoom Out button.
- To temporarily view the selected thumbnail at full-size view, press and hold the Zoom In button.
- To return from the thumbnails view to the date list, press the Zoom Out button again.

A couple of fine points about the Hide Image feature:

- ✓ To redisplay hidden pictures, just reverse the process, removing the hide marker. Or, to redisplay all hidden pictures quickly, choose Deselect All from the first Hide Image screen (the right screen in Figure 10-2).
- If you protected a photo before hiding it, redisplaying the picture removes its protected status.
- Before you can delete hidden photos, you must unhide them. Or you can format your memory card, which wipes out all files, regardless of whether you hid or protected them. (Choose Setup > Format Memory Card.)
- Hidden images remain viewable from within the Hide Image file-selection screens. In other words, if your boss picks up your camera and selects Hide Image, you're busted. Thumbnails of hidden images appear along with all your other pictures.

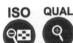

Deleting Files

You have three options for erasing files from a memory card when it's in your camera. The next few sections give you the lowdown.

Two notes before you begin: First, and most important, none of the Delete features erase protected or hidden files. See the preceding two sections to find out how to remove the protect and hide file markers. Once again: Formatting your memory card *does* wipe out both protected and hidden files. Only the camera's Delete function is blocked from erasing the files.

Second, if you really want to get down into your camera's customization weeds — and I do believe this is about as weedy as it gets — you can control which picture the camera displays after you delete the current one. Open the Playback menu, select After Delete, and then choose one of these options: Show Next displays the picture after the one you just deleted; Show Previous displays the one that fell before the one you deleted; Continue as Before tells the camera to keep going in the same direction you were heading before deleting. Wow, now *that's* control. Have you thought about getting some help for that?

Deleting files one at a time

During picture playback, you press the Delete button to erase individual photos and movies. But the process varies depending on the playback mode:

- In single-image view, press the Delete button.
- In thumbnails view, select the photo you want to erase and then press Delete.

In calendar view, select the date that contains the image. Then press the Zoom Out button to activate the thumbnail list on the right side of the screen. Use the Multi Selector to highlight the image and press Delete.

After you press Delete, the camera asks whether you really want to erase the file. If you do, press Delete again. To cancel the process, press the Playback button.

Deleting all files

You can quickly delete all files — with some exceptions — by opening the Playback menu, selecting Delete, and then choosing All, as shown in Figure 10-4. Press the Multi Selector right and select the card containing the photos you want to erase. Press OK to display a confirmation screen that shows the folder you're about to empty. Highlight Yes and press OK.

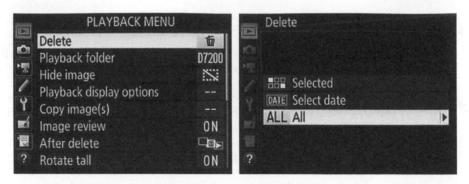

Figure 10-4: This menu option deletes all files stored in the folder you're currently viewing, except for those you protected or hid.

Regarding the exceptions: Again, images that you hid or protected are left unscathed by the Delete > All menu command. In addition, the only pictures deleted are the ones in the folder currently selected via the Playback Folder option on the Playback menu.

Deleting a batch of selected files

To get rid of more than a few files — but not all of them — don't waste time erasing each file one at a time. Instead, you can tag multiple files for deletion and trash them all at once.

As with other Delete tools, remember that you can't delete hidden or protected files; see the first two sections of the chapter to find out how to remove the protected or hidden status from a file.

After you take that step, select Delete from the Playback menu. You then see the screen shown on the right in Figure 10-4. Along with the All option just discussed, you get the following options for selecting specific files to erase:

✓ **Select photos one by one.** Choose Selected, as shown on the left in Figure 10-5, and press the Multi Selector right to display image thumbnails, as shown on the right. Use the Multi Selector to select the first photo you want to delete and then press the Zoom Out button. A trash can icon appears in the upper-right corner of the thumbnail, as shown in the figure.

Press the button again to remove the Delete tag. To remove tags from all photos, press the Playback button.

Delete symbol

Delete

Delete

Selected

Date Select date

ALL All

Delete

Selected

100-139

100-140

100-141

100-142

Delete Symbol

Delete

Selected

Date Selected

Date Select date

ALL All

Figure 10-5: Choose this option to tag specific photos for deletion.

Erase all photos taken on a specific date. Choose Select Date from the main Delete screen (left screen in Figure 10-5). Press the Multi Selector right to display a list of dates on which you took the pictures on the memory card. Use the Multi Selector to highlight a date and then press right. A check mark appears next to the date, tagging all images taken on that day for deletion. To remove the check mark and save the photos from the dumpster, press the Multi Selector right again.

After tagging files or dates, press OK. A confirmation screen asks permission to destroy the images; select Yes and press OK. The camera trashes the photos and returns you to the Playback menu.

You have one alternative way to erase all images taken on a specific date. In the Calendar display mode, highlight the date in question and then press the Delete button. You get the standard confirmation screen asking you whether you want to go forward. Press Delete again to dump the files. See Chapter 9 for full details on viewing photos in calendar view.

Taking a Look a Nikon's Free Photo Software

To move pictures and movies to your computer, you need some type of software to download, view, and manage the files. If you don't have a favorite photo program for handling these tasks, Nikon offers the following free solutions:

✓ Nikon ViewNX-i: Shown in Figure 10-6, this program replaces Nikon's longtime image viewer, Nikon ViewNX 2. A tool built into the program, Nikon Transfer, simplifies the job of sending pictures from a memory card or your camera to your computer.

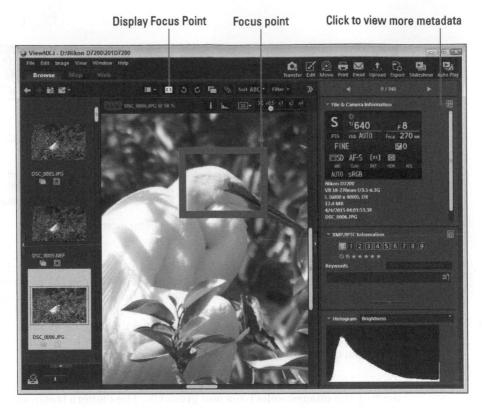

Figure 10-6: You can see the selected focus point and other camera settings when you view photos in Nikon ViewNX-i.

Your program won't initially look like the one in the figure because I customized the screen layout to suit my needs. You can do the same via the options on the View and Window menus.

Two features I especially like about this program: First, in the upperright corner of the program, a version of the camera's Information screen shows settings you used when shooting the picture. This *metadata* (extra data) is hidden in each picture's file. You can display more metadata by clicking the icon I labeled in the figure. Although other photo programs can display some metadata, they often can't show all the detailed information that you can see in ViewNX-i.

Second, if you click the Focus Point button, also labeled in Figure 10-6, a red rectangle appears to indicate which focus point the camera used to establish focus, which can be helpful for troubleshooting focus problems. If the focus point is over your subject, but the subject is blurry, the cause is likely not due to focusing at all, but to subject or camera movement during a too-long exposure (slow shutter speed). You don't see the

focus point if you used manual focusing, and it also may not appear if you used continuous autofocusing.

Now the downside of NX-i: Unlike ViewNX 2, NX-i does not contain photo-retouching tools. Instead, when you click the Edit button at the top of the window, your picture opens in Nikon Capture NX-D so that you can access that program's editing tools. Additionally, although you can convert a Raw file to a JPEG file through the File > Export menu command in View NX-i, you don't have the opportunity to set any picture characteristics (exposure, color, and so on), as you did in ViewNX 2. Again, this feature now lives in Capture NX-D only. (There is some talk of Nikon putting editing features back into NX-i, but if and when that will happen is anyone's guess.)

Nikon Capture NX-D: This program replaces Capture NX 2, which was aimed at photographers who wanted serious photo-editing tools — and who didn't mind paying about \$200 for them. Actually, "replace" is too strong a word; NX-D is a completely different animal than its predecessor. The most important change is that NX-D does not offer the so-called "u-point technology" found in Capture NX, which provided a way to limit the effects of retouching tools to certain parts of the photo. In NX-D, all changes affect the entire image. However, like Capture NX 2, NX-D offers a good Raw processing tool, a feature not found in ViewNX-i. And don't forget, NX-D is free.

You can download both programs from the Nikon website (in the United States, www.nikonusa.com). Head for the Support section of the website, where you'll find a link to camera software. Be sure to download the latest versions. At the time I write this chapter, ViewNX-i is Version 1.0.0; NX-D is Version 1.2.0. Older versions of the software lack support for D7200 files. Also make sure that your computer meets the software operating-system requirements.

Upcoming sections show you how to use Nikon ViewNX-i to download pictures and Capture NX-D to process Raw files. For details on other features, read the user manuals, which you access via the respective programs' Help menus.

Downloading Pictures to Your Computer

Before you can use the Nikon software — or any software, for that matter — to transfer files, you have to give your computer access to the files on your memory card, which can be done in two ways:

Connect the camera to the computer via a USB cable. The cable you need is supplied in the camera box. After making sure that your battery is fully charged (you don't want it to lose power during the file transfer), turn the camera off. Then connect the smaller of the two plugs on the cable to the USB port labeled in Figure 10-7 and turn the camera back on.

Use a memory card reader. If your computer has a card reader that accepts SD memory cards or you have a standalone card reader attached to the computer, turn the camera off, pop the memory card out of the camera, and insert it into the card reader.

Not all card readers work with the newest or highest-capacity SD cards. So if you're shopping for a reader, make sure that it's compatible with your memory cards.

From here, you can use whatever photo software you prefer to transfer photos to your computer. If you don't yet have a program for handling this task, give Nikon ViewNX-i a try. (It's free, after all.) Follow these steps to transfer your photos in that program:

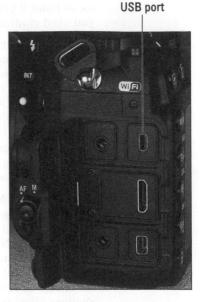

Figure 10-7: The port for connecting the USB cable is hidden under a door on the left side of the camera.

Depending on how you installed ViewNX-i, the Nikon Transfer 2 window, shown in Figure 10-8, may appear automatically when you connect your camera or insert a card into your card reader. If not, open ViewNX-i and then choose File ⇒ Launch Transfer or click the Transfer button at the top of the window. (Note that although my figures show the Windows version of the program, these steps work for the Mac version as well.)

2. Display the Source tab to view your pictures.

Don't see any tabs? Click the Options triangle (refer to Figure 10-8) to display them. Then click the Source tab. The icon representing your camera or card should be selected. In the figure, the icon shows Removable Disk F, which is the name my computer assigned to my card reader.

If you're transferring photos directly from the camera via USB cable and you have two memory cards in the camera, choose the card you want to access from this same tab.

Either way, thumbnails appear in the bottom half of the dialog box. If you don't see them, click the Thumbnails triangle (refer to Figure 10-8) to open the thumbnails area.

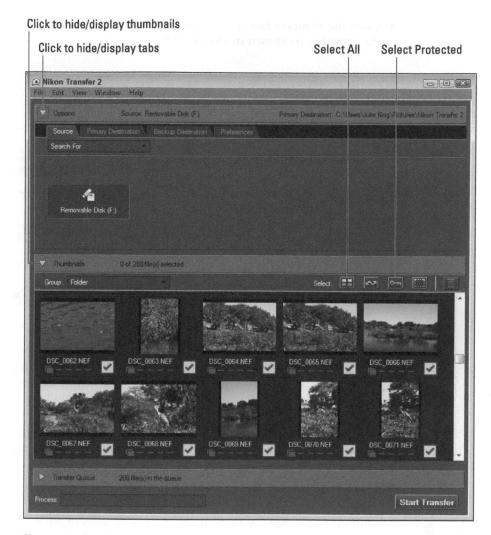

Figure 10-8: Select the check boxes of the images that you want to download.

3. Select the files that you want to download.

Click a thumbnail to highlight it and then click the box underneath to mark the file for downloading. These tricks speed up the process:

- Select protected files only. If you used the in-camera function to protect pictures, select just those images by clicking the Select Protected icon (refer to Figure 10-8).
- Select all files. Click the Select All icon, also labeled in the figure.

4. Click the Primary Destination tab to display options for handling the file transfer, as shown in Figure 10-9.

Choose drive/folder to store files

Figure 10-9: Specify the folder where you want to put the downloaded images.

The most important setting on this tab is Primary Destination Folder, which determines where the program puts your transferred files. Open the drop-down list and choose the folder on your computer's hard drive (or external drive) where you want to put the pictures.

Other options on this tab enable you to specify how pictures should be organized inside the primary destination folder and to rename files during the transfer.

5. Click the Backup Destination tab (labeled in Figure 10-9) to transfer copies of the files to a second location.

Options on this tab enable you to download copies of photos to your primary drive and to a backup drive in one step — a great archival timesaver. Select the Backup Files box and then specify where you want the backup files to go.

6. Click the Preferences tab to set other transfer options.

Pay special attention to these settings:

- Transfer New Files Only: Choose this option to avoid downloading images that you already transferred.
- Delete Original Files after Transfer: Turn off this option. Otherwise, your pictures are erased from your memory card when the transfer is complete. Always make sure the pictures made it to the computer before you delete them from your memory card.

Drag-and-drop file transfer

As an alternative to using a photo program to download files, you can use Windows Explorer, the Mac Finder, or any other file-management program to drag and drop files from your memory card to your computer, just as you can copy any file from a CD, DVD, or flash drive onto your computer. If you use a memory-card reader, the computer sees the memory card as just another drive on the system. Windows Explorer also shows the camera as a storage device when you connect the camera via USB. (With some versions of the Mac OS, the Finder doesn't recognize cameras in this way.)

The downside is that not all file-management programs can display thumbnails of your photos, especially those shot in the Raw format. So if

time permits, I prefer to use a photo program that lets me preview my images and decide which ones I want to download. But I drag-and-drop if I'm in a hurry to unload a memory card so that I can use it on my next shoot. The process is marginally faster because I can tell the file-management program not to take the time to create thumbnails of each image, and I don't get distracted looking at each photo. When I return to the computer later, I can use my photo software to view and organize the files.

Be careful to copy, and not move, files when you drag and drop. That way, files remain on the memory card as a backup if something goes awry.

• Open Destination Folder with the Following Application after Transfer: You can tell the program to immediately open your photo program after the transfer is complete. Choose ViewNX-i to view and organize your photos using that program. To choose another program, open the drop-down list, choose Browse, and select the program from the dialog box that appears. Click OK after doing so.

7. Click the Start Transfer button.

After you click the button, the Process bar in the lower-left corner of the program window indicates how the transfer is progressing. What happens when the transfer completes depends on the choices you made in Step 6. If you selected Nikon ViewNX-i as the photo program, it opens and displays the folder that contains your just-downloaded images.

Processing Raw (NEF) Files

Chapter 2 introduces you to the Raw file format. The advantage of capturing Raw files — NEF files on Nikon cameras — is that you make the decisions about how to translate the original picture data into an actual photograph.

You take this step by using a software tool known as a *Raw converter*. To process your NEF files, you have the following free options:

- ✓ Use the in-camera processing feature. From the Retouch menu, you can process Raw images right in the camera. You can specify only limited image attributes, and you can save the processed files only in the JPEG format, but still, having this option is a nice feature.
- Process and convert in Capture NX-D. For more control over how your raw data is translated into an image, use this option. Not only do you get access to tools not found on the camera, but you can save the adjusted files in either the JPEG or TIFF format. You also have the advantage of evaluating your photos on a larger screen than the one on your camera.

TIFF stands for Tagged Image File Format and has long been the standard format for images destined for professional publication. I recommend saving your converted Raw files in this format because it does a better job than JPEG of holding onto your original image data. As explained in Chapter 2, JPEG compresses the file, meaning that it does away with what it considers "unnecessary" data.

Of course, you can use any third-party Raw-processing tool you prefer, such as the one provided with Adobe Photoshop and Adobe Lightroom. Just don't pay for a third-party tool until you've tried Capture NX-D — the fact that it's free doesn't mean that it isn't a good program. Whatever program you use, you may need to download a software update to enable the program to work with your D7200 files. (For Nikon Capture NX-D, you need version 1.2.0.)

Processing Raw images in the camera

Follow these steps to create a JPEG version of a Raw file right in the camera:

- 1. Press the Playback button to switch to playback mode.
- Display the picture you want to process in the single-image view.If necessary, you can shift from thumbnails view to single-image view by pressing OK.

- 3. Press the i button to display the menu shown on the left in Figure 10-10.
- Choose Retouch and then select NEF (RAW) Processing, as shown on the right in the figure.

You see a screen similar to the one in Figure 10-11, which is where you specify what settings you want the camera to use when creating the JPEG version of your Raw image.

Press the Multi Selector down to access a second page of options, shown in Figure 10-12.

Figure 10-10: Press the *i* button to display the Retouch menu.

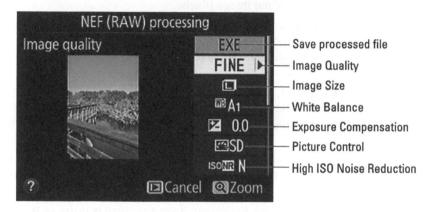

Figure 10-11: These Raw conversion options are on the first page of the menu screen.

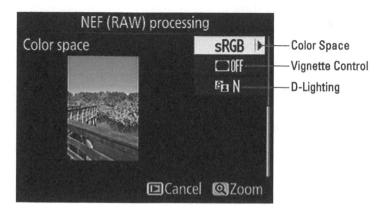

Figure 10-12: Press the Multi Selector down to scroll to the second page of conversion settings.

5. Set the conversion options.

After highlighting an option, press the Multi Selector right to see the available settings. Use the Multi Selector to make your choice. If a triangle appears to the right of an option, you can press the Multi Selector right again to uncover additional adjustments. Select your preferences and then press OK as needed to get back to the main processing screen.

The following list points you to the chapter that explains the characteristics you can adjust during the conversion:

- Image Quality: See the Chapter 2 section related to the JPEG format for details on this option. Choose Fine to retain maximum picture quality.
- *Image Size:* Chapter 2 explains this one, too. Choose Large to retain all the original image pixels.
- White Balance: Check out Chapter 6 for details about White Balance options, which affect picture colors. Unless colors look off, stick with the default, Auto, (A1).
- Exposure Compensation: With this option, which I cover in Chapter 4, you can adjust image brightness. When using this feature for Raw conversion, you're limited to a range of -2.0 and +2.0. When shooting, you can choose from settings ranging from -5.0 to +5.0.
- Picture Control: This option affects saturation, contrast, and sharpness. For a review of the available settings, see the last part of Chapter 6.
- High ISO Noise Reduction: If your picture is noisy that is, marred by a speckled look — playing with this setting may help. See Chapter 4 for an explanation of this feature, which is designed to reduce the amount of noise in pictures shot using a high ISO Sensitivity setting.
- Color Space: You can choose to create your JPEG copy using the default color space, sRGB, or the larger Adobe RGB color space. Stay with sRGB until you digest the Chapter 6 section that details both options.
- *Vignette Control:* If your picture appears unnaturally dark in the corners a phenomena called *vignetting* try using this option to even out the lighting. Chapter 4 has more information.
- D-Lighting: To brighten the darkest part of your picture without also brightening the lightest areas, try this feature. It's the postcapture equivalent of the Active D-Lighting feature that's available during shooting; see Chapter 4 for details.

At any time, you can magnify the image by pressing the Zoom In button. Release the button to return to the normal display.

For a reminder of what a particular setting does, press and hold the Help button, which displays a screen with a bit of information about the option.

6. After setting conversion options, highlight EXE on the first conversion screen (refer to Figure 10-11) and press OK.

The camera records a JPEG copy of your Raw file and displays the copy in the monitor. The camera assigns the next available file number to the JPEG copy. A Retouch symbol (box with a paintbrush) appears with the copy during playback.

You can also access the Raw processing tool by displaying the Retouch menu and then choosing NEF (RAW) Processing. The camera displays thumbnails of Raw images; use the Multi Selector to select an image and then press OK to move forward.

Processing Raw files in Capture NX-D

Figure 10-13 offers a look at the Capture NX-D program window after I customized it to display my preferred Raw conversion layout. (Customize the window through the View and Window menus.) As you can see, this isn't a program for sissies; expect a little bit of a learning curve. Then again, you can't really "break" your photo no matter what you do, so don't be afraid to experiment. Your original file is never overwritten because you can't resave it in the Raw format — you can only create a copy in the TIFF or JPEG format.

I have room for only a brief explanation of the Raw-processing tools, but these pointers should get you headed in the right direction. For details, choose Help > NX-D Help, which opens the program's electronic user manual.

✓ **Select the Raw file:** After opening Capture NX-D, click the thumbnail of the Raw image. (If you don't see thumbnails, choose View ▷ View Mode ▷ Thumbnail.)

If you're viewing images in Nikon ViewNX-i, you can switch to Capture NX-D by selecting the Raw photo and then choosing File → Open in Capture NX-D.

- Magnify the preview by choosing a magnification level from the View menu. You also can change the image magnification by using these keyboard shortcuts:
 - Windows: Press the Ctrl key and + key to zoom in; press Ctrl and the – key to zoom out.
 - *Mac*: Press the Command key with the + key to zoom in; press Commnd and the key to zoom out.

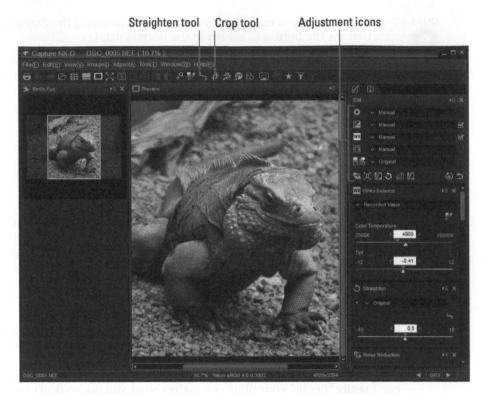

Figure 10-13: Capture NX-D offers a large assortment of tools for finalizing the look of your Raw images.

When the preview is magnified, drag inside the preview window to scroll the display. The Bird's Eye window to the left enables you to see which part of the photo is displayed in the preview.

✓ **Display the Edit panel:** Controls for adjusting your Raw image appear in the Edit panel along the right side of the window, as shown in Figure 10-13. If you don't see the panel, choose Window ⇒ Edit.

Also check out the tab behind the Edit panel, marked with an i symbol. Click this tab to view image metadata (the *i* stands for photo *information*).

Use the tools in the Edit panel to adjust your photo. You have to do a little work to uncover all the available options. See the icons along the left and bottom edges of the top pane of the edit panel, marked Adjustment icons in the figure? Click those icons to display related tools. For example, in the figure, I clicked the WB (White Balance) symbol to access the color settings. Use the scroll bar on the right side of the window to scroll the display to reveal more settings if needed.

Pause your cursor momentarily over an icon to display a text label that tells you what the symbol represents.

- To crop and straighten the photo, select the tools at the top of the program window. I labeled them in Figure 10-13. With the Straighten tool, drag across a line that should be vertical or horizontal. To crop, drag the edges of the crop box that appears when you choose the Crop tool. (The crop is applied when you choose a different tool.)
- To undo all your changes, choose Original from the top drop-down list on the adjustments panel. You then see the photo as it would appear if you used the default Raw-processing settings established by Nikon.
- When you finish adjusting the image, choose File ⇒ Convert Files. In the Save dialog box, choose 8-bit TIFF as the file format for your processed version of the Raw original. (If you choose 16-bit TIFF, you may not be able to use the image in other programs, such as Microsoft PowerPoint.) The rest of the file-saving options work as they do when you save files in most programs: Specify where you want to store the file, give the file a name, and then click Save.

One neat thing about working with Raw images is that you can easily create as many variations of the photo as you want. For example, you might choose one set of options when processing your Raw file as a color image and then a different set to create a black-and-white version of the photo. Just be sure to give each processed file a unique name so that you don't overwrite the first TIFF file you create with your second version.

Making Copies for Online Sharing

Have you ever received an e-mail containing a photo so large that you can't view the whole thing without scrolling the e-mail window? This annoyance occurs because monitors can display only a limited number of pixels. The exact number depends on the monitor resolution, but suffice it to say that today's digital cameras produce photos with pixel counts in excess of what the monitor can handle. In fact, even if you shoot at your camera's lowest Image Size setting (2992 x 2000), you wind up with more pixels than you need for onscreen viewing. So it's good practice to make low-resolution copies of your photos for online sharing.

Some e-mail programs and social media sites offer a photo-upload feature that creates a temporary low-res version for you, and you can always make a small copy of the image in any photo-editing program. But the fastest option is to use the Resize feature on the camera's Retouch menu. This option shrinks your photo and then saves the copy in the JPEG format, which is required for online use. (Web browsers and email programs can't display Raw files.)

You can create your low-resolution, JPEG copy in two ways:

Prepare a copy of single photo: Set the camera to playback mode, display the photo in single-image view (or select it in thumbnails or calendar view), and press the *i* button to display the left screen in Figure 10-14. Select Retouch to display the Retouch menu, as shown on the right in the figure.

Figure 10-14: Use Resize to create a low-resolution copy of a picture.

Next, select Resize to display a screen that asks you to choose which memory card you want to use to store the copy. (You see the screen even if you have only one card installed.) After choosing the destination card, press the Multi Selector right to get to the screen shown in Figure 10-15, where you choose the size of your low-resolution copy. The first value shows the pixel dimensions of the copy; the second, the total number of pixels, measured in megapixels. Select a size and press the Multi

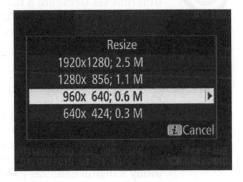

Figure 10-15: For each option, you can see the pixel dimensions of the copy, followed by the file size, in megapixels.

Selector right. The camera asks permission to create the resized copy; answer in the affirmative.

The available sizes depend on the size of your original and whether you captured the photo using the DX (whole sensor) Image Area setting or the 1.3 crop setting. Either way, I suggest limiting the longest side of your photo to under 1000 pixels to ensure easy e-mail reading and quick uploads to social media sites. (Remember that every pixel adds to the file size and, thus, the online transfer time.)

Resize symbol

Create resized versions of multiple photos: Press Menu, display the Retouch menu, and choose Resize to display the left screen in Figure 10-16. Select Choose Size to set the pixel count of the copies: then select Choose Destination and specify which memory card you want to use to store the copy. Lastly, choose Select Image to display thumbnails of your photos. as shown on the right in the figure.

Resize

Select image

Choose size

Select the first image you want to resize by using the Multi Selector to move the vellow box over the thumbnail. Then press the Zoom Out button to add the Resize tag, which you can see in the figure. Select the next photo, rinse, and repeat. After tagging all the photos you want to share, press OK to display the confirmation screen and then select Yes.

Resize Select image [1] 10007200 [2] 1 Choose destination (i) 100-96 06м 100-99 100-100 100-101 © Set © Zoom © 3OK

Figure 10-16: To resize a batch of photos, it's quicker to do the job via the Retouch menu.

In both cases, the camera duplicates the selected images and downsamples (eliminates pixels from) the copies to achieve the size you specified. The small copies are saved in the JPEG file format, using the same Image Quality setting (Fine, Normal, or Basic) as the original. Raw originals are saved as JPEG Fine images. Either way, your original picture files remain untouched. During on-camera playback, the Resize symbol appears along with the pixel count of the photo. In the default display mode, look for this information in the lower-right corner of the screen. (Press the Multi Selector up or down to change the playback display mode.)

One side note: If you're uploading or emailing a photo for the purpose of having it printed, you don't want to reduce its size; rather, you should send all the original pixels to give yourself the most print-size flexibility. Chapter 2 has the complete scoop, but the short story is that for good-quality prints. you should aim for 200 to 300 pixels per linear inch of the photo.

Copying Files from One Card to Another

When you have two memory cards installed in the camera, you can copy pictures from one card to the other. You might take advantage of this option so that you can give a batch of pictures to a friend immediately, for example. (Of course, this assumes that your friend has a device that can access SD cards.) Or if you didn't originally set up the second card to store backups of your originals, you can use the copy option to create backups after the fact. (See Chapter 1 for details on configuring memory cards.)

Here's the card-to-card copy process:

1. On the Playback menu, choose Copy Image(s), as shown on the left in Figure 10-17.

You see the screen shown on the right in the figure.

2. Highlight Select Source and press the Multi Selector right.

You see a screen offering two choices: Slot 1 and Slot 2. Slot 1 is the top memory-card slot.

3. Highlight the memory card that contains the pictures you want to copy and press OK.

You return to the main Copy Image(s) screen.

4. Choose Select Image(s), as shown in Figure 10-17.

You see a screen listing all folders on the selected card.

5. Highlight the folder that contains your pictures and press the Multi Selector right.

You see a screen with three options: Select All Images, Select Protected Images, and Deselect All.

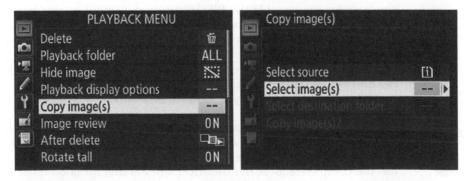

Figure 10-17: This Playback menu feature enables you to copy pictures from the card installed in one card slot to the card in the other slot.

6. Choose an initial picture-selection option.

Choose Select All Images to copy every picture on the card; choose Select Protected Images to copy just photos that you tagged with the Protect feature.

The third option, Deselect All, is a little counterintuitive: The camera initially assumes that you want to copy every picture on the card, so it tries to help by automatically preselecting all of them. You can later deselect the ones you don't want to copy, but if you're copying just a few pictures out of a large group, it's faster to choose Deselect All so that you start out with no pictures selected. Then you don't have to waste time "untagging" all the ones you don't want to copy.

7. Press OK to display thumbnails of your photos.

Check marks appear with any photos currently selected for copying, as shown on the left in Figure 10-18.

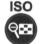

8. Use the Multi Selector to select a file and then press the Zoom Out button to add or remove the check mark.

9. After selecting the photos you want to copy, press OK.

Now you see the screen shown on the right in Figure 10-18. (Note that for the Select Images value, the number represents the folder number of the original images, not the number of pictures tagged for copying.)

10. Choose Select Destination Folder.

You get two options: Select Folder by Number enables you to specify a three-digit folder number; Select Folder from List displays all available folders. After choosing a folder number or folder, press OK.

Figure 10-18: Press the Zoom Out button to tag photos for copying (left); then set the Destination folder for the copies (right).

- 11. Choose Copy Image(s)? and press OK.
- 12. Highlight Yes and press OK to copy the photos.

Remember these final pointers:

- If the destination card doesn't have enough space for all the selected images, the camera alerts you that all images may not be copied. You can choose to go forward or cancel the operation and install a card that has more free space.
- If the destination card contains an image that has the same filename as one you select for copying, the camera gives you the option to overwrite the existing file, overwrite all existing files without any further confirmation notices, skip copying that file, or cancel the copy operation.
- When you copy a protected picture, both the copy and the original remain protected. See the first section of this chapter for details about protecting images.

Taking Advantage of Wi-Fi Transfer

Your camera's Wi-Fi feature enables you to connect your camera wirelessly to certain "smart" devices — specifically, Android and Apple iOS-based phones, tablets, and media players (such as Apple's iPod touch).

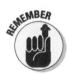

To enjoy this function, install the free Nikon Mobile Wireless Utility app on your device. For Android-based devices, search for the app at the Google Play Store; for Apple iOS devices, head for the Apple App store. Read the details on the download page to make sure that your device is compatible with the app.

After installing the app, you can perform the following functions:

- Use the smart device to view photos that are on the camera.

 Depending on the size of your device, this enables you to get a larger view of your photos than the camera's monitor offers.
- Transfer photos to the smart device. You can then view photos, upload them to Facebook or other social media sites, or attach them to email or text messages. (Files sent from your device transfer via your normal wireless network or cell-based data connection.)
 - Pictures captured in the (NEF) format are automatically converted to the JPEG format during the camera-to-device transfer so that they're ready for online sharing.
- Use the smart device to trigger the camera's shutter. A live preview of your subject appears on the device's screen; you then tap the screen to set focus and snap the picture.

There are a few critical limitations to understand:

- You can't use Wi-Fi to download images to your computer over a regular wireless network. The camera's Wi-Fi only works on a *peer-to-peer* basis: That is, the two devices must be able to talk to each other directly rather than over an intermediate network.
- **You can't transfer high-resolution photos.** All pictures are downsized during the transfer process. You select one of two Image Size options within the app: Recommended Size, which translates to about 1920 x 1090 pixels, or VGA, which delivers 640 x 480 pixels.
- You can transfer movie files, but you need an app on your smart device to play them. The video player must be able to play files in the MOV format.
- The Wi-Fi feature is a battery hog. The feature's insatiable appetite for battery juice is why Wi-Fi is disabled by default. The remote-shutter trigger function is also disabled automatically if the battery level on the camera or the device drops below the level that the camera thinks it needs to perform its job. Long story short: If you routinely use the Wi-Fi functions, consider investing in a spare camera battery so that you don't run out of power during a shoot.

I cover the Wi-Fi shutter-release feature in Chapter 12. The next several sections provide a general overview of the other Wi-Fi functions. Because the way you use the app depends on your device, I can't provide full details on each function. However, at the following Nikon web pages, you can download instructions tailored to the D7200, complete with screen shots of where to tap on your device to access the various app features:

- ✓ Android: http://nikonimglib.com/ManDL/WMAU/index.html.en
- ► iOS: http://nikonimglib.com/ManDL/WMAU-ios/index.html.en

Connecting the camera to your device

To connect your camera to your smart device, take these steps:

- 1. Open the camera's Setup menu and select Wi-Fi, as shown on the left in Figure 10-19.
- 2. On the next screen, choose Network Connection, select Enable, and then press OK.

You're returned to the Wi-Fi setup screen, with the Network Connection option now set to On, as shown on the right in Figure 10-19. The Wi-Fi symbol shown in the figure blinks to let you know that your camera is sending out its Wi-Fi signal.

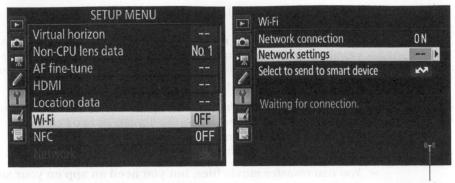

Wi-Fi symbol

Figure 10-19: Enable Wi-Fi via the Setup menu.

3. Select Network Settings, as shown on the right in Figure 10-19, and press the Multi Selector right.

Now you see the options shown on the left in Figure 10-20.

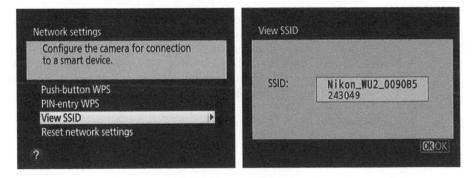

Figure 10-20: You can connect both Android and iOS devices via the View SSID option.

4. Select a connection option.

Which option you use depends on your device:

Push-Button WPS (Android only): Some Android devices offer WPS
 (Wi-Fi Protected Setup), which enables you to initiate a connection
 just by pushing a button. If your device has this feature, choose
 Push-Button. The camera displays a screen prompting you to
 press the WPS button on the device and begins searching for a
 connection.

- *PIN-Entry WPS (Android only):* If your device uses a PIN (personal identification number) for wireless security, select this option. Enter the PIN and choose OK to attempt the connection.
- View SSID (Android or iOS): When you choose this option, you see the screen shown on the right in Figure 10-20. Your camera is assigned an SSID number (Service Set Identifier), and after a few moments, the SSID appears as an available network on your smart device. Select the camera's SSID on your device, and then choose the Connect option on the device.

If the stars are in alignment and the devices connect, you see the confirmation screen shown in Figure 10-21, and the Wi-Fi symbol stops blinking. The Wi-Fi symbol also appears in the top-left corner of the Information display and Control panel. In the Live View display, look for the symbol in the lower-right corner of the screen. (Some Live View display modes hide this symbol; press the Info button to change display modes.)

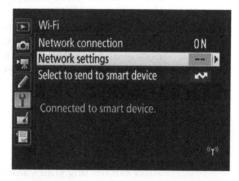

Figure 10-21: The message at the bottom of the screen tells you that the camera is connected to your smart device.

5. Launch the Wireless Mobile Utility app on your device.

The initial app screen offers two main options: Take Photos and View Photos, as shown in Figure 10-22. (This figure and others to follow show how the app screens appear on my Android tablet; the design varies depending on your device and its operating system.) Somewhere on the screen, you should also see an icon that lets you access other app settings; usually, the icon looks like a little wheel. (It's in the upper-right corner in Figure 10-22.) Again, for details, download and review the Nikon app user guide from the web addresses given in the preceding section.

To sever the connection between the two devices, set the Wi-Fi option on the camera's Setup menu to Off.

Don't confuse the Network option on the Setup menu with the Wi-Fi network options. The Network menu setting is related to using certain remote controllers

Figure 10-22: The initial app screen gives you the option to view or shoot photos.

with the camera, including the Nikon UT-1. See the controllers' user manual for help setting up communication between the two devices.

Connecting via NFC (Android Only)

In addition to connecting your camera to your smart device using the steps just outlined, you may be able to take advantage of NFC connection. NFC stands for Near Field Communication. If your smart device supports this feature, you can establish a connection by simply placing the camera's NFC logo, shown in Figure 10-23, near the antenna on the smart device. To try it, turn the NFC option on the Setup menu to Enable. You also need to enable NFC and Wi-Fi on the device itself.

Viewing photos on the smart device

After connecting your camera with the device and firing up the WMU app, tap View Photos on the smart device. You see a screen similar to the one shown on the left in Figure 10-24. Tap Pictures Figure 10-23: The 7200 offers NFC connection on Camera. (On some devices, you may instead see your D7200 specifi-

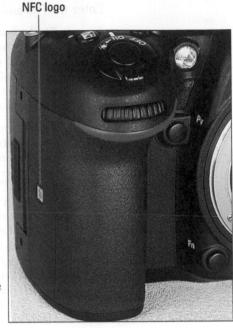

with Android devices.

cally listed as the camera option.) After a few seconds, thumbnails of your images appear, as shown on the right in the figure, and you can view your pictures using the same techniques you use to view photos stored on your device.

Selecting photos for transfer

While viewing photos on the device, you can use options built into the WMU app to select files that you want to transfer to the device. You also can tag photos for transfer before connecting your camera to the device. I prefer that option because I don't have to have both devices powered up during the process. When you do connect the two devices, the WNU app recognizes files tagged for transfer and asks your permission to download them.

Here's how to take advantage of in-camera tagging:

Tag a single photo: When the camera is in playback mode, display the photo and press the i button to display the menu shown on the left in Figure 10-25. Choose Select to Send to Smart Device/Deselect. The tag is added to the photo and is indicated by a two-headed arrow symbol, as shown on the right in the figure. If you change your mind, choose the menu option again to remove the tag.

Figure 10-24: You can display thumbnails of photos stored on the camera's memory card.

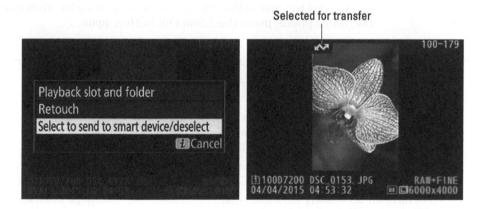

Figure 10-25: During playback, select this *i* button menu option to tag a file for transfer to your smart device.

Select a batch of photos for transfer: To tag multiple photos at a time, open the Setup menu and select the Wi-Fi option. Then choose Select to Send to Smart Device, as shown on the left in Figure 10-26, and press the Multi Selector right to display thumbnails of your images, as shown on the right.

Selected for transfer

Wi-Fi
Network connection
Network settings

Select to send to smart device

100-120
100-121
100-122
100-125

□ 100-123
100-124
100-125
□ 100-125
□ 100-125
□ 100-126
□ 100-127
□ 100-127
□ 100-128
□ 100-128
□ 100-128
□ 100-128
□ 100-128
□ 100-128
□ 100-128
□ 100-128
□ 100-128
□ 100-128
□ 100-128
□ 100-128
□ 100-128
□ 100-128
□ 100-128
□ 100-128
□ 100-128
□ 100-128
□ 100-128
□ 100-128
□ 100-128
□ 100-128
□ 100-128
□ 100-128
□ 100-128
□ 100-128
□ 100-128
□ 100-128
□ 100-128
□ 100-128
□ 100-128
□ 100-128
□ 100-128
□ 100-128
□ 100-128
□ 100-128
□ 100-128
□ 100-128
□ 100-128
□ 100-128
□ 100-128
□ 100-128
□ 100-128
□ 100-128
□ 100-128
□ 100-128
□ 100-128
□ 100-128
□ 100-128
□ 100-128
□ 100-128
□ 100-128
□ 100-128
□ 100-128
□ 100-128
□ 100-128
□ 100-128
□ 100-128
□ 100-128
□ 100-128
□ 100-128
□ 100-128
□ 100-128
□ 100-128
□ 100-128
□ 100-128
□ 100-128
□ 100-128
□ 100-128
□ 100-128
□ 100-128
□ 100-128
□ 100-128
□ 100-128
□ 100-128
□ 100-128
□ 100-128
□ 100-128
□ 100-128
□ 100-128
□ 100-128
□ 100-128
□ 100-128
□ 100-128
□ 100-128
□ 100-128
□ 100-128
□ 100-128
□ 100-128
□ 100-128
□ 100-128
□ 100-128
□ 100-128
□ 100-128
□ 100-128
□ 100-128
□ 100-128
□ 100-128
□ 100-128
□ 100-128
□ 100-128
□ 100-128
□ 100-128
□ 100-128
□ 100-128
□ 100-128
□ 100-128
□ 100-128
□ 100-128
□ 100-128
□ 100-128
□ 100-128
□ 100-128
□ 100-128
□ 100-128
□ 100-128
□ 100-128
□ 100-128
□ 100-128
□ 100-128
□ 100-128
□ 100-128
□ 100-128
□ 100-128
□ 100-128
□ 100-128
□ 100-128
□ 100-128
□ 100-128
□ 100-128
□ 100-128
□ 100-128
□ 100-128
□ 100-128
□ 100-128
□ 100-128
□ 100-128
□ 100-128
□ 100-128
□ 100-128
□ 100-128
□ 100-128
□ 100-128
□ 100-128
□ 100-128
□ 100-128
□ 100-128
□ 100-128
□ 100-128
□ 100-128
□ 100-128
□ 100-128
□ 100-128
□ 100-128
□ 100-128
□ 100-128
□ 100-128
□ 100-128
□ 100-128
□ 100-128
□ 100-128
□ 100-128
□ 100-128
□ 100-128
□ 100-128
□ 100-128
□ 100-128
□ 100-128
□ 100-128
□ 100-128
□ 100-128
□ 100-128
□ 100-128
□ 100-128
□ 100-128
□ 100-128
□ 100-128
□ 100-128
□ 100-128
□ 100-128
□ 100-128
□ 100-128
□ 100-128
□ 100-12

Figure 10-26: Access the tool for tagging multiple photos for transfer through the Wi-Fi option on the Setup menu.

Use the Multi Selector to choose the first photo you want to tag and then press the Zoom Out button. The transfer symbol appears with that photo's thumbnail, as shown on the right in the figure. Keep highlighting and tagging the rest of the photos you want to transfer. To remove the tag from a photo, press the Zoom Out button again.

Exploring two special printing options

The camera offers two features that enable you to print directly from the camera or memory card *if* your printer offers the same technology:

DPOF (Digital Print Order Format): This feature is designed for use with printers that have an SD memory card slot. After selecting DPOF Print Order from the camera's Playback menu, you select pictures to print and specify how many copies you want of each. Then you just put the memory card into the printer's card slot. The printer reads the "print order" and outputs the requested prints. You use the printer

controls to set paper size, print orientation, and other print settings.

PictBridge: If you have a PictBridgeenabled photo printer, you can connect
the camera to the printer by using a USB
cable. The PictBridge interface appears
on the camera monitor, and you use the
camera controls to select the pictures you
want to print. Using PictBridge, you specify
additional print options from the camera,
such as page size and whether to print a
border around the photo.

Part IV The Part of Tens

Enjoy an additional Part of Tens article about ten cool digital photography websites at www.dummies.com/extras/nikon.

Ten More Ways to Customize Your Camera

In This Chapter

- Creating your own exposure modes and menu
- Adding copyright data and hidden text to picture files
- Using your own folder and filenames
- Changing the behavior of some buttons and dials
- Adjusting automatic camera shutdown

s you've no doubt deduced, Nikon is eager to let you customize almost every aspect of the camera's operation. This chapter discusses customization options not considered in earlier chapters, including ways to create custom exposure modes and menus, embed a copyright notice or other text information in

your picture files, and even tweak the function of buttons and other controls.

Creating Custom Exposure Modes

After you gain some experience with your camera, you'll find that you rely on certain picture-taking options for specific types of photos. For example, you might prefer one set of options when shooting landscapes and another for shooting portraits. If you routinely spend a lot of time adjusting options for different scenes, here's a way to make life easier: You can store two sets of picture options as custom exposure modes, represented on the Mode dial by U1 and U2 (for User 1 and 2), as shown in Figure 11-1.

Setting up your custom exposure modes is easy:

1. Set the Mode dial to P, S, A, or M.

The mode determines what picture settings you can control, and thus what options you can store as part of your custom exposure mode. For example, in A mode, you control the aperture setting; in S mode, you control shutter speed.

2. Select the settings you want to store.

In A mode, for example, select the initial f-stop that you want the camera to use. In S mode, select the initial shutter speed. Also choose settings such as Image Quality, Image

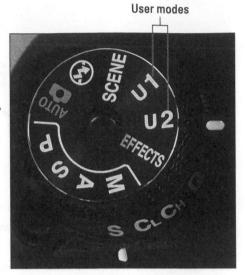

Figure 11-1: You can create two custom exposure modes: U1 and U2.

Size, Exposure Compensation, Flash Compensation, Flash mode, White Balance, Focus and AF-area modes, and so on.

A handful of settings can't be stored: Image Area, Storage Folder, File Naming, Manage Picture Control, Multiple Exposure, Remote Control Mode (ML-L3), Interval Timer Shooting, and Time-Lapse Photography. Neither can you set the camera to automatically choose the Reset Photo Shooting Menu or Reset Movie Shooting Menu options.

3. Display the Setup menu and choose Save User Settings, as shown on the left in Figure 11-2.

You see the screen shown on the right in the figure.

4. Highlight the user mode (U1 or U2) that you want to use to store your settings and press the Multi Selector right.

A confirmation screen appears.

5. Select Save Settings and press OK.

Now when you turn the Mode dial to the custom mode you created, the camera immediately recalls the settings you stored. You can still adjust any settings — you don't have to stick with your default f-stop or shutter speed, for example. You can return to the stored settings at any time by rotating the Mode dial to another setting and then back to your custom mode. To reset U1 or U2 to the default settings for each option, choose Reset User Settings on the Setup menu.

Figure 11-2: Choose the Save User Settings option to store the current camera settings as custom exposure mode U1 or U2.

Don't confuse these menu settings with the Save/Load Settings option on the Setup menu. That feature creates a data file that stores camera settings on the memory card in Slot 1. To restore the settings, insert the memory card and choose Save/Load Settings again. The feature is helpful in situations where multiple photographers share a camera; it enables each user to easily return to a particular camera setup before a shoot.

Creating Your Own Menu

In addition to creating custom exposure modes, you can build your own menu that holds up to 20 options. Check it out:

1. Open the My Menu screen, shown on the left in Figure 11-3.

If the Recent Settings menu appears instead, select Choose Tab, press OK, select My Menu, and press OK again.

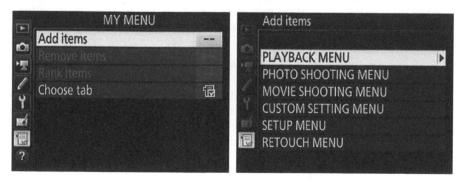

Figure 11-3: You can create a custom menu that holds up to 20 settings.

- 2. Choose Add Items to display a list of other camera menus, as shown on the right in the figure.
- 3. Choose a menu that contains an option you want to add to your menu and then press the Multi Selector right.

You see options on that menu, as shown in Figure 11-4.

4. To add an item, highlight it and press OK.

Your selected item appears on the Choose Position screen, where you can change the order of menu items. For now, press OK to return to the My Menu screen; you can adjust the order of your menu later.

5. Repeat Steps 2–4 to add more items to your menu.

Figure 11-4: Highlight a menu item and press OK to add it to your custom menu.

A few items can't be added to a custom menu. A little box with a slash through it appears next to those items. (See the first menu item in Figure 11-4.) A check mark means that the item is already on your menu; for example, the Storage Folder box is selected in the figure.

When you finish adding items, return to shooting mode by pressing the shutter button halfway and release it.

After creating your custom menu, you can edit it as follows:

- Change the menu order. On the main My Menu screen, choose Rank Items, as shown on the left in Figure 11-5. The current menu appears. Highlight a menu item and press OK to select it and display the Move symbol at the bottom of the screen, as shown on the right in the figure. Press the Multi Selector up or down to move the item and then press OK. When you get the order the way you want it, press the Multi Selector left to return to the My Menu screen.
- Remove menu items. Again, head for the My Menu screen but choose Remove Items. You see your current menu, with an empty box next to each item. To remove an item, highlight it and press the Multi Selector right to put a check mark in that item's box. After tagging items you want to remove, press OK. A confirmation screen appears; press OK.

Figure 11-5: Choose Rank Items to change the order of menu items.

Adding Hidden Comments and Copyright Notices

Through the Image Comment feature, you can add hidden comments to your picture files. Suppose, for example, that you're on vacation and visiting a different destination every day. You can annotate all the pictures you take on a particular outing with the name of the location. Similarly, the Copyright Information feature enables you to tag files with your name and other copyright data.

The text doesn't appear on the photo itself; instead, it's stored with other *metadata* (hidden data, such as shutter speed, date and time, and so on). You can view metadata during playback in the Shooting Data display mode (see Chapter 9) or along with other metadata in Nikon ViewNX-i and Capture NX-D (Chapter 10).

Enable both options via the Setup menu, as follows:

- Setup > Image Comment: On the first screen that appears after you choose this menu option, select Input Comment and press the Multi Selector right to display the keyboard shown on the left in Figure 11-6. Use these methods to create your comment, which can be up to 36 characters long:
 - *Enter a character*: Use the Multi Selector to highlight a character in the keyboard and press OK to enter that character in the text box.
 - *Enter a space:* Select the blank key next to the lowercase letter *z*. (It's selected in the figure.)
 - Move the cursor in the text box: Press and hold the Zoom Out button as you press the Multi Selector in the direction you want to shift the cursor. Release the button to return to the keyboard section of the screen.

 To delete a letter: Move the cursor under the offending letter and then press the Delete button.

After entering your comment, press the Zoom In button to display the screen shown on the right in Figure 11-6. Your text appears under the Input Comment line. Highlight the Attach Comment box and press the Multi Selector right to add a check mark to the box. Finally, press OK to exit to the Setup menu. The Image Comment item should now read On.

Copyright Information: The drill is the same except that you can enter two items: Artist and Copyright. Select Artist and press the Multi Selector right to access the keyboard; enter your text as just described. Then do the same for the Copyright item. The maximum character count for the Artist name is 36; for the Copyright item, 54 characters. After exiting the keyboard screen, remember to select the Attach box and press OK to officially turn the feature on.

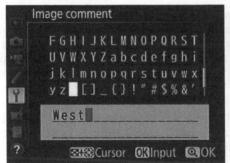

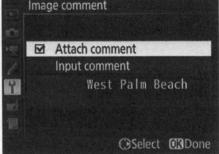

Figure 11-6: After entering text (left), select the Attach Comment box (right) and press OK.

Your comment or copyright information is then added to any new pictures you shoot. To disable either feature, visit its menu screen, remove the check mark from the Attach box, and press OK.

Customizing Filenames

Normally, picture filenames begin with the characters DSC_, for photos captured in the sRGB color space, or _DSC, for images that use the Adobe RGB color space. (Chapter 6 explains color spaces.) Movie files are always captured in the sRGB space, so their filenames always begin with DSC_. You have the option of replacing the letters DSC with your own characters for both

movies and stills. For example, you could replace DSC with TIM before you take pictures of your brother Tim and then change the prefix to SUE before you shoot Sue's wedding.

You customize filenames separately for still photos and movies:

- Customizing filenames for still images: Open the Photo Shooting menu and choose File Naming, as shown on the left in Figure 11-7. On the next screen, shown on the right in the figure, you see the current naming structure. Select File Naming and press the Multi Selector right to display a text-entry keyboard. Use the techniques listed in the preceding section to replace DSC with your chosen characters.
- Customizing filenames for movies: Open the Movie Shooting menu and select File Naming. This time, you're taken directly to the keyboard screen where you can enter your custom prefix.

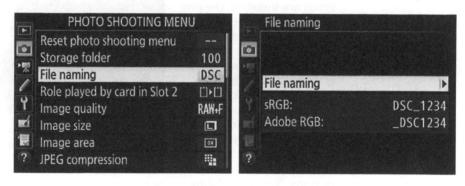

Figure 11-7: You can customize the first three characters of filenames.

Customizing Folder Names

By default, your camera stores all files in one folder, which it names 100D7200. When the initial folder is full, the camera creates a new folder, assigning the next available folder number. If you choose, you can create your own folder-numbering scheme. For example, you can create a folder numbered 200D7200 for work images and use the default 100D7200 folder for personal photos. Here's how to create a custom-numbered folder:

1. Display the Photo Shooting menu and highlight Storage Folder, as shown in Figure 11-8.

The menu shows the first three numbers of the currently selected folder (100 in the figure).

2. Press OK. Then choose Select Folder by Number and press the Multi Selector right.

You see the screen shown in Figure 11-9. Two things to note:

- Folder icon: A folder icon next to the number indicates that the folder already exists. A half-full icon like the one in Figure 11-9 shows that the folder contains images. A full icon means that the folder is stuffed to capacity.
- Memory card: If two memory cards are installed, the one highlighted in the upperright corner (Card 1, in the figure) will house your new folder. This card selection is controlled by the Role Played by Card in Slot 2 option on the Shooting menu. If that option is set to Overflow, the new folder goes to the card currently in use. For the other two options, Backup and Raw Slot 1-JPEG Slot 2, the new folder is created on both

Figure 11-8: This option determines which folder the camera uses to store the next pictures or movies you shoot.

Figure 11-9: Use this screen to create a new folder.

cards. (Chapter 1 details how to configure memory cards.)

3. Assign the new folder a number.

Use the Multi Selector to highlight one of the three digits and then press up and down to change the number. If a folder icon appears, the number you entered is already in use. When you create a new folder, the icon disappears.

4. Press OK.

The new folder is selected as the current storage folder.

To select a different folder, return to the Photo Shooting menu and choose Storage Folder. You then can display a list of all folders or return to the folder-numbering screen and enter the number of the folder you want to use. Note that even though you select storage folders through the Photo Shooting menu, your choice affects movie storage as well as still photos. However, the memory *card* used to store the movie depends on the Destination setting on the Movie Shooting menu.

Changing the Purpose of the OK Button

You can customize the role that the OK button plays during shooting, playback, and Live View mode through the aptly named OK Button option, found in the Controls section of the Custom Setting menu and shown on the left in Figure 11-10. After you choose the option, work your way through the following settings, shown on the right in the figure:

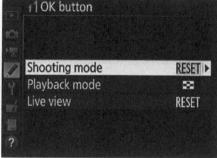

Figure 11-10: You can change the role the OK button plays during shooting, during playback, and in Live View mode.

Shooting mode: Choose from these options:

- *RESET* (*Select Center Focus Point*): At this setting, which is the default, the button selects the center autofocus point. I think that's a handy feature, so it's my choice.
- *Highlight Active Focus Point*: Pressing OK highlights the active focus point in the viewfinder the same thing you accomplish by pressing the shutter button halfway.
- Not Used: This setting disables the OK button during shooting. I don't know why you would do this unless you keep pressing the button by accident.

Playback mode: For playback, you get four options:

• *Thumbnail On/Off:* This setting is the default; pressing OK toggles the display between thumbnails view and single-image view.

- View Histograms: If you're a histogram fan, this option may be for you: You can press OK to display a larger histogram than you can view in the normal playback modes. This is your only route to viewing a bigger histogram, by the way.
- Zoom On/Off: Normally, you magnify an image by pressing the Zoom In button. But if you select this option, you can press OK to toggle between single-image or thumbnails view to a magnified view of your photo, with the zoomed view centered on the active focus point. After highlighting the option, press the Multi Selector right to select the initial magnification level (low, medium, or high).
- Choose Slot and Folder: Select this option to use the OK button
 to display the screen that lets you select the memory card and
 image folder containing the photos you want to view. (You can
 still choose the card and folder via the *i* button menu even if you
 enable this setting.)

For movie files, pressing OK always begins movie playback regardless of this setting.

- Live View mode: For Live View mode, you get three settings:
 - RESET (Select Center Focus Point): This one works as it does during viewfinder shooting: Pressing OK selects the center focus point. It's the default.
 - Zoom On/Off: Choose this setting to use the OK button to magnify the Live View display. (Normally, you use the Zoom In button.)
 If you select this option, press the Multi Selector right to choose the initial magnification level.
 - Not Used: The OK button plays no role during Live View.

Customizing the Command Dials

Through the Customize Command Dials option, found in the Controls section of the Custom Setting menu and shown in Figure 11-11, you can control several aspects of how the command dials behave, as follows:

Reverse Rotation: This setting determines which direction you spin the dials when adjusting shutter speed, f-stop, and Exposure Compensation values. At the default setting, Off, rotating the dial to the right raises the value; rotating to the left lowers it. To switch things up, highlight Reverse Rotation and press the Multi Selector right. You can reverse the orientation for shutter and aperture settings separately from the Exposure Compensation setting. To "turn on" reverse orientation, highlight the option and press the Multi Selector right to place a check mark in the adjacent box. Then press OK. Remove the check mark to return to the default setup.

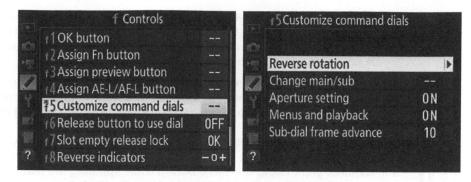

Figure 11-11: You can modify functions performed by the command dials.

- Change Main/Sub: This option determines which dial you use to adjust aperture and shutter speed:
 - Off: This setting is the default. The Main command dial adjusts shutter speed, and the Sub-command dial controls aperture.
 - On (Mode A): Sets the Main command dial to adjust f-stop in the A exposure mode.
 - On: Reverses dial functions for S, A, and M exposure modes. The Sub-command dial changes shutter speed in the M and S modes, and the Main command dial changes f-stop in A and M modes. (Select this option to totally mess with another D7200 user who borrows your camera.)
- Aperture Setting: At the default, the Aperture Setting item on the menu appears set to On, as shown on the right in Figure 11-11, and the Subcommand dial adjusts aperture. The other setting, Aperture Ring (Off) relates to lenses that have an aperture ring. If you select this option, you can adjust the f-stop only by using that aperture ring.
- Menus and Playback: Change from the default setting, Off, to On to use the command dials for these functions:
 - Playback: Use the Main command dial to scroll through pictures.
 Rotate the Sub-command dial to jump forward or backward multiple frames or from folder to folder (specify your preference through the Sub-dial frame advance option, described momentarily).
 - Menu navigation: Rotate the Main command dial to scroll a menu page up and down. Rotate the Sub-command dial right to display the submenu for the selected item; rotate left to jump to the previous menu.

- If you choose On (Image Review Excluded), things work the same way as with On except that the command dials don't work during the image-review period. (That feature, if enabled via the Playback menu, displays a photo for a few seconds immediately after you shoot it.)
- ✓ Sub-dial frame advance: If you set the Menus and Playback option to On, use this setting to specify whether you want to jump 10 frames, 50 frames, or to the next folder when you spin the Sub-command dial.

You can modify one additional aspect of how the command dials work. Normally, an operation that involves both a camera button and a command dial requires you to hold down the button while spinning the dial. For example, to change the Flash mode, you hold down the Flash button while rotating the Main command dial. If you find it cumbersome to press the button while rotating the dial, choose Custom Setting > Controls > Release Button to Use Dial and select Yes. Now to adjust a camera setting, press the relevant button, release it, rotate the associated command dial, and then press the button again to deactivate the option. (I dislike this option because it's easy to forget that final button press and end up adjusting that still-active setting when you think you're using the command dial for some other purpose.)

Assigning New Tasks to a Few Buttons

You can assign a variety of tasks to the Fn (Function) button, Depth-of-Field Preview button, and the AE-L/AF-L button. In fact, you can give the buttons different functions for still photography and movie recording, and you can specify a function for a simple button press or choose what happens when you press the button while rotating the Main or Sub-command dials. (Figure 11-12 reminds you where to find these controls.) Additionally, you can give the movie-record button, found on top of the camera, a job to do when you shoot stills. The next two sections detail these options.

Customizing buttons for still photography

By default, these four buttons perform the following tasks when you're shooting still pictures:

- ✓ AE-L/AF-L button: Autofocus and autoexposure are locked while the button is pressed.
- ✓ Fn button: Pressing the button while rotating either command dial toggles the Image Area setting between the DX and 1.3x crop settings for viewfinder photography. For Live View photography, this button function doesn't work.

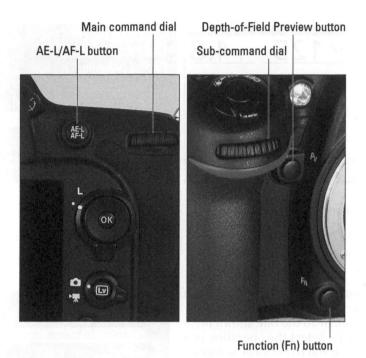

Figure 11-12: You can modify the functions of these buttons.

- Depth-of-Field Preview button: When you press the button, the view-finder display changes to give you an idea of how your current f-stop setting affects depth of field. If flash is enabled, it emits a brief burst of light to help you preview how your subject will be lit. This modeling flash feature works only for viewfinder photography, too.
- Movie-record button: Pressing the button has no effect.
- During viewfinder photography, symbols representing the current settings for the Depth-of-Field Preview, AE-L/AF-L, and Fn buttons appear at the bottom of the Information screen, as shown on the left in Figure 11-13. You can get to the modification options for these buttons quickly via the *i* button menu, as shown on the right in the figure.

To access the Movie-record button assignment and to change the functions of the other buttons when the camera is in Live View mode, visit the Custom Setting menu. The button assignment options live in the Controls section of the menu, as shown in Figure 11-14. (Scroll to the next page of the menu to access the Assign Movie Record Button option.)

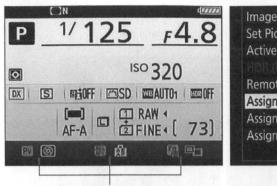

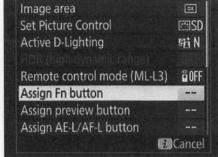

Current button assignments

Figure 11-13: During viewfinder photography, you can see button settings in the Information display (left) and modify them via the *i* button menu (right).

Either way, after you select the button you want to customize, you see a screen similar to the one shown in Figure 11-15. Select the operation you want the button to perform as follows:

- Choose Press to change the function that's accomplished by simply pressing the button. (This option is not available for the movie-record button.)
- Choose Press + Command Dials to set the action that occurs when you press the button and rotate a command dial.

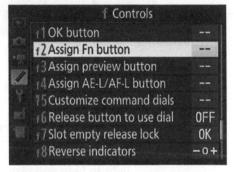

Figure 11-14: You can also adjust the button functions via the Custom Settings menu.

Next, press the Multi Selector right to display a list of the functions you can assign. Your options depend on which button you're modifying. Make your selection and press OK.

If you're not sure what a particular option does, press the Help button to display an information screen that spells things out.

Just after the Assign Movie Record Button option on the Controls submenu, you find two additional options related to camera accessories:

Figure 11-15: The red dot on the camera reminds you which button you're adjusting.

Assign MB-D15 AE-L/AF-L button and Assign Remote (WR) Fn Button. The first option programs the AE-L/AF-L button on the MB-D15 battery pack; the second option assigns a job to the Function (Fn) button on the Nikon WR-1 remote-controller.

Customizing buttons for movie recording

By default, pressing the AE-L/AF-L button locks autofocus and autoexposure during movie recording, as it does during still photography. But the Fn and Depth-of-Field Preview buttons are normally off duty in Movie mode. If you want to change things up, head for the Movie submenu of the Custom Setting menu, shown in Figure 11-16. Select the button you want to modify and press OK to display a list of available functions.

The final menu option, Assign Shutter substantial Button, enables you to change the role of the shutter button during movie shooting. That's just one of two

Figure 11-16: Use the options in the Movie section of the Custom Setting menu to define the button roles during movie recording.

shutter-button modifications you can make, both explained next.

Modifying the Role of the Shutter Button

Getting a headache considering all the ways you can customize buttons and dials? Me, too. Remember, you *wanted* an advanced camera. LOL, as the kids say. (Well, I suppose the kids have some new expression, now that we old-timers finally figured out that LOL means Laugh Out Loud and not Lots of Love.)

At any rate, the good news is that only one more button, the shutter button, requires discussion. You can set the button to perform the following functions:

Lock exposure. Normally, pressing the shutter button halfway initiates autofocusing and exposure metering, but the camera adjusts exposure settings up to the time you take the picture. To lock exposure before that point, you can press the AE-L/AF-L button. But by default, pressing that button also locks focus, even if the camera is set to continuous autofocusing.

You can adjust the focus/exposure-locking functions of the AE-L/AF-L button to separate the two operations, as outlined in the preceding sections. You also have the option to set the shutter button to lock both exposure and focus. To try this setup, choose Custom Setting menu > Timers/AE Lock > Shutter-Release Button AE-L and change the setting to On.

Use the shutter button to start/stop movie recording. By default, pressing the button during movie recording ends the recording and captures a still photograph. You can make different use of the button during movie recording through the Assign Shutter Button option, the final setting on the Movie section of the Custom Setting menu.

If you change the setting from Take Photos to Record Movies, press the shutter button halfway to fire up the Live View display when the camera is in Movie mode. Release the button and press halfway again to autofocus. Press the button all the way down to start recording; press all the way again to stop recording. To end Live View, press the LV button.

Adjusting Automatic Shutdown Timing

To save battery power, your camera automatically shuts off the exposure meter, viewfinder display, and monitor after a period of inactivity. You can specify how long you want the camera to wait before taking this step through the following options, both found on the Timers/AE Lock portion of the Custom Setting menu:

- Standby Timer: Controls the exposure meter and viewfinder display shutoff; the default is 6 seconds. You can raise the value as high as 30 minutes or, by choosing the No Limit option, disable the shutdown entirely.
- Monitor Off Delay: Determines monitor shutoff for picture playback, menu displays, the Information display, Live View display, and Image Review period. Because the monitor is one of the biggest drains on battery power, keep the shutoff delay times as short as you find practical.

Ten Features to Explore on a Rainy Day

In This Chapter

- Editing photos with the Retouch menu tools
- ▶ Having fun with special effects
- Using your smart device to trigger the camera's shutter
- Connecting your camera to a TV
- Creating a slide show

onsider this chapter the literary equivalent of the end of an infomercial — the part where the host exclaims, "But wait! There's more!" Features covered here aren't the sort that drive people to choose one camera over another, and they may come in handy only on certain occasions. Still, they're included at no extra charge, so check 'em out when you have a few spare moments.

Investigating the Retouch Menu

Through the Retouch menu, you can do simple photo editing in the camera. It's a no-risk proposition: The camera doesn't alter your original file; it makes a copy and applies changes to the copy only. Here are the basics you need to get started:

Access retouching tools: You can take two routes:

 Retouch menu: Display the Retouch menu, shown on the left in Figure 12-1. (Scroll to the menu's second page to see more tools.) Select a tool and press OK to display image thumbnails, as shown on the right in the figure. Use the Multi Selector to select a thumbnail and press OK to display options related to the chosen retouching tool.

Figure 12-1: After selecting a Retouch menu option (left), select the photo you want to edit (right).

Playback i-button menu: In Playback mode, select the photo you
want to alter, press the i button, and choose Retouch to display
the Retouch menu over your photo. Select a tool and press OK to
access the tool settings.

You can't use the *i*-button menu to access one tool, Image Overlay. See "Two roads to a multi-image exposure," later in this chapter, for details about this feature, which combines two Raw files to create a new Raw original.

- Determine which files can be edited: If the camera can't apply the selected tool, it displays an X over the thumbnail, as shown on the right in Figure 12-1, or dims or hides the tool on the menu. A file or tool may be off-limits for these reasons:
 - The tool isn't relevant to the current file. For example, if you didn't
 use flash when taking the picture, the Red-Eye Correction tool is
 dimmed. For Movie files, indicated by the dotted frame shown in
 Figure 12-1, the only available Retouch option is Edit Movies.
 - You previously applied a tool that prevents further editing. You can apply multiple tools to the same original, but you need to be careful in what order you use them because some tools produce a file that can't be altered. After you use the Trim tool to crop your image, for example, you can't do anything else to the cropped version. A Retouch symbol, shown on the right in Figure 12-1, indicates an edited file. (I mention tools that prevent further adjustments as I detail them in this chapter.)

Adjust tool settings: After you select certain tools, you see a preview of your image along with options that enable you to adjust the tool effect. In most cases, you use the Multi Selector to adjust settings, and the monitor updates the preview to show you the results. For example, Figure 12-2 offers a look at the adjustment available for the D-Lighting tool.

You can find details on settings available for the Resize and NEF (Raw Processing) tools in Chapter 10; Chapter 8 discusses the Edit Movie options. In this chapter, I explain other tools that are especially useful, complicated, or both.

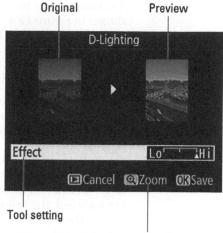

Press Zoom In button to magnify preview

Figure 12-2: Some tools enable you to vary the impact of the adjustment and offer a before-and-after preview of the effect.

- Zoom or the Zoom In button symbol appears on a screen, as shown on the right in Figure 12-2, press the Zoom In button to magnify the image. Release the button to exit the magnified view.
- Save the edited copy: Unless I specify otherwise, press OK to finalize your edits and save the edited copy. The file is saved in the JPEG format, using the same Image Quality setting as the original. If you began with a Raw image, the JPEG version is saved using the Fine setting. (Again, Image Overlay is the exception: It combines two Raw files to create a new Raw file.)

The retouched image is assigned the next available file number. Make note of the number so that you can find the image later.

Compare the original and retouched image: Put the camera in playback mode and display the original or retouched image. Then press the *i* button, choose Retouch, and select Sideby-Side Comparison, as shown in Figure 12-3. (You can't get to this feature via the standard Retouch menu; you must use the Playback mode version of the *i* button menu.)

Figure 12-3: To get to this option, put the camera in playback mode, press the *i* button, and select Retouch.

A screen similar to the one shown in Figure 12-4 appears, with your original on the left and the edited version on the right. A text label indicates the tool used to create the edited version.

The yellow box indicates the selected image; use the Multi Selector to switch between the original and edited version. You can then press the Zoom In button to study the selected image at a larger size. If two memory cards are installed, the yellow card icon in the top-right corner of the screen indicates which card holds the selected file (Card 1, in the figure).

When the retouched version is selected, you can also use these tricks:

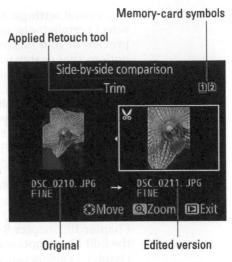

Figure 12-4: The left image is your original; the right, the retouched version.

- If you applied more than one tool to the picture, press the Multi Selector right and left to display thumbnails that show how each tool affected the image.
- If you created multiple edited copies of the photo, press the Multi Selector up and down to scroll through them.

To return to normal playback, select the image you want to display (the original or the altered version). Then press the Playback button.

Straightening Crooked and Distorted Photos

Try the following Retouch menu tools to level a tilting horizon line, eliminate lens distortion, and correct perspective:

Leveling the horizon: Despite my best efforts, my landscape photos rarely feature a level horizon line. I don't understand why I can't "shoot straight." All I know is that I'm glad that I can use the Straighten tool to rotate the picture to level, as I did for the image in Figure 12-5.

After you select the tool, an alignment grid appears over your photo, along with a scale that indicates the amount and direction of rotation. Press the Multi Selector right to rotate the picture clockwise; press left to rotate counterclockwise. You can achieve a maximum rotation of 5 degrees.

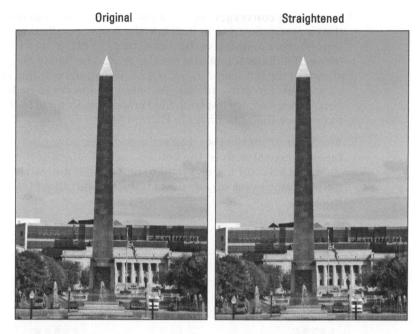

Figure 12-5: You can level crooked photos with the Straighten tool.

✓ Removing barrel and pincushion distortion: Certain lenses create barrel distortion, in which objects at the center of a picture appear to be magnified and pushed forward — as if you wrapped the photo around the outside of a barrel. Pincushion distortion produces the opposite result, making center objects appear smaller and farther away.

Your camera offers two anti-distortion features. The Auto Distortion Control option on the Photo Shooting menu is designed to correct distortion as the picture is recorded to the memory card; the Distortion Control tool on the Retouch menu is available for post-capture editing.

The Retouch menu version provides two settings:

- Auto: This option, like the Auto Distortion Control feature on the Photo Shooting menu, is available for certain lenses. If the camera recognizes your lens, it attempts to correct distortion based on its knowledge of the lens.
- Manual: If the Auto option is dimmed or you prefer to do the correction on your own, select Manual. A scale indicating the degree and direction of the correction appears under the photo. Use the Multi Selector to move the yellow marker along the scale until you remove as much distortion as possible.

Correcting convergence: When you photograph a tall building and tilt the camera upward to fit it all into the frame, an effect known as *convergence* occurs, causing vertical structures to tilt toward the center of the frame. Buildings sometimes even appear to be falling away from you, as shown in the left image in Figure 12-6. If the lens is tilting down, vertical structures lean outward, and the building appears to be falling toward you. Either way, try applying the Perspective Control tool. I used the tool to produce the right image in Figure 12-6.

After you select the tool, you see a grid over your photo and a horizontal and vertical scale at the bottom and left edges of the screen. Press the Multi Selector left and right to move the out-of-whack structure horizontally; press up and down to rotate the object toward or away from you.

Original

After perspective correction

Figure 12-6: The original photo exhibited convergence (left); applying the Perspective Control filter corrected the problem (right).

One important detail about these tools: In order for the camera to perform this magic, it actually distorts the original, tugging the corners this way and that to get things in proper alignment. This distortion produces an irregularly shaped image, which then must be cropped and enlarged or reduced to create a copy that has the same pixel dimensions as the original. That's why the After photos in Figures 12-5 and 12-6 contain slightly less subject matter than the original. (The same cropping occurs if you make these changes in a photo editor.) Framing your originals a little loosely ensures that you don't lose important parts of the image due to the adjustment.

Manipulating Exposure and Color

Chapters 4 and 6 explain picture-taking settings that affect exposure and color. Of course, it's best to nail down these characteristics as you shoot,

but if things go awry, you can make minor modifications through these Retouch tools:

▶ D-Lighting: Chapter 4 explains Active D-Lighting, an exposure setting which brightens too-dark shadows in a way that leaves highlight details intact. You can apply a similar adjustment to an existing photo by choosing D-Lighting from the Retouch menu. I used this tool on the photo in Figure 12-7, where strong backlighting left the balloon underexposed in the original image. Use the Multi Selector to set the Effect amount, which determines the strength of the adjustment.

D-Lighting, High

Figure 12-7: The D-Lighting tool brightens shadows without affecting highlights.

You can't apply this tool to pictures taken using the Monochrome Picture Control. Nor does D-Lighting work on pictures to which you previously applied the Quick Retouch tool, explained next, or Monochrome tool, detailed later.

- Quick Retouch: This filter increases contrast and color saturation and, if your subject is backlit, also applies a D-Lighting adjustment to restore some shadow detail that otherwise might be lost. As with D-Lighting, you can choose from three levels of Quick Retouch correction. And the same restrictions apply: You can't apply the filter to monochrome images or to pictures that you adjusted via D-Lighting.
- Red-Eye Correction: For flash portraits marred by red-eye, give this tool a whirl, which replaces the red pixels with more suitably colored ones.
- Filter Effects: This menu option gives you access to tools designed to mimic traditional lens filters. The first two are color-manipulation filters, which work like so:
 - Skylight filter: Reduces the amount of blue to create a subtle warming effect.

 Warm filter: Produces a warming effect that's just a bit stronger than the Skylight filter.

After you chose either tool, the camera displays a preview of your photo with the effect applied. Both tools produce minimal color shift, and neither enables you to adjust the strength of the effect. And to answer your question, no, you can't apply the filter several times in a row to produce a stronger effect.

The other two filters on the Filter Effects submenu, Cross Screen and Soft, are special-effects filters. I describe both later in this chapter.

Monochrome: Choose this tool to create a black-and-white, sepia, or cyanotype (blue and white) copy of color photo. For the sepia and cyanotype tools, you can adjust the intensity of the tint by pressing the Multi Selector up and down.

After creating your monochrome image, you can't apply the D-Lighting, Quick Retouch, and Soft tools to it. Obviously, color adjustments such as the Warm and Skylight filter are also no longer available. So if you want to apply any of those tools to your image, use them before the Monochrome tool.

Cropping Your Photo

To *crop* a photo means to trim away some of its perimeter. Cropping can often improve an image, as illustrated by Figure 12-8. When shooting this scene, I couldn't get close enough to fill the frame with the ducks, as shown on the left. So I cropped the image after the fact to achieve the composition on the right.

Figure 12-8: Cropping creates a better composition and eliminates background clutter.

The Trim tool enables you to crop right in the camera. However, always make this your last editing step because you can't alter the cropped version using any other Retouch menu tools.

After you select Trim from the Retouch menu, you see the screen shown in Figure 12-9. The yellow box represents the crop frame, which you can adjust as follows:

- **Set the crop aspect ratio:** You can crop to one of five aspect ratios: 3:2, 4:3, 5:4, 1:1, and 16:9. The current aspect ratio appears in the upper-right corner of the screen. To cycle through the other settings, rotate the Main command dial.
- Adjust the crop frame size: For each aspect ratio, you can choose from a variety of crop sizes, which depend on the size of the original. Sizes are stated in pixels, with the current size dis-

Crop size Aspect ratio ¥3600x2880 5:4 Aspect ☑:□ O3Save Crop box Enlarge crop frame Reduce crop frame

Figure 12-9: The yellow box indicates the cropping frame.

played in the upper-left corner of the screen.

If you're cropping in advance of printing the image, remember to aim for at least 200 pixels per linear inch of the print — 800 x 1200 pixels for a 4 x 6 print, for example.

Use these techniques to change the crop-frame size:

- Shrink the cropping frame. Press and release the Zoom Out button. Each press further reduces the crop size.
- Enlarge the cropping frame. Press the Zoom In button as many times as needed to get the frame size you want.
- Reposition the cropping frame. Press the Multi Selector up, down, right, or left.

When you view cropped images in Playback mode, a scissors symbol appears in the lower-right corner of the frame.

Three Ways to Play with Special Effects

In addition to practical photo-correction tools, the Retouch menu offers some special-effects tools. You also can add effects as you shoot by using the Effects exposure mode. The next three sections explain these two features plus one additional special effect that you can achieve through the Photo Shooting menu or Retouch menu.

Applying special effects via the Retouch menu

For after-the-shot effects, try these Retouch menu options:

✓ Cross Screen: This tool adds a starburst effect to the brightest part of the image, as shown in Figure 12-10.

To get to this tool, choose Retouch > Filter Effects > Cross Screen. You see a preview along with options that enable you to adjust the number of points on the star, the intensity of the effect, the length of the star's rays, and the angle of the effect. To update the preview after changing a setting, select Confirm. When you're happy with the effect, select Save.

✓ Soft: Another one of the Filter Effects options, the Soft tool blurs your photo to give it a dreamy, watercolor-like look. You can choose from three levels of blur: Low, Normal, and High.

Figure 12-10: The Cross Screen filter adds a starburst effect to the brightest parts of the photo.

- Color Outline: This tool turns your photo into a black-and-white line drawing. (Please don't ask me why this tool isn't called Black-and-White Outline. Nikon's Names of Things Committee sometimes veers a bit off course.)
- Color Sketch: This filter creates an image similar to a drawing done in colored pencils. You can modify the effect through two options: Vividness, which affects the boldness of the colors; and Outlines, which determines the thickness of outlines.
- Fisheye: This tool distorts your subject to make it appear that you took the photograph using a fisheye lens, which produces an ultra-wide, circular perspective (sort of like the view you see through a security-door peephole).
- Miniature Effect: Have you ever seen an architect's small-scale models of planned developments? The Miniature Effect filter attempts to create a photographic equivalent by applying a strong blur to all but one portion of an image, as shown in Figure 12-11. For this example, I set the focus point on the part of the street occupied by the cars.

Original

Miniature Effect filter

Figure 12-11: The Miniature Effect filter throws all but a small portion of a scene into very soft focus.

After you select the tool, a yellow box appears to indicate the area that will remain in focus, as shown in Figure 12-12. Adjust the box orientation, size, and position as follows:

- Rotate the box 90 degrees:
 Press the Zoom Out button.
- Position and resize the box: When the focus box is oriented horizontally, press the Multi Selector up/down to move it. Press right/left to resize it. If the box is oriented vertically, use the opposite maneuvers.

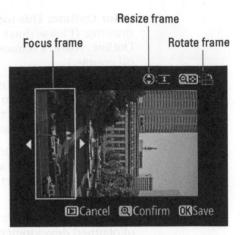

Figure 12-12: The area inside the yellow box will remain in focus.

This filter works best if you shoot your subject from a high angle; otherwise, you don't get much of a miniaturization result.

✓ **Selective Color:** This effect *desaturates* (removes color from) parts of a photo while leaving specific colors intact. For example, in Figure 12-13, I desaturated everything but the yellows and peaches in the rose.

ISO

Figure 12-13: I used the Selective Color filter to desaturate everything but the rose petals.

You can select up to three colors to retain and specify how much a color can vary from a selected one and still be retained. Make your wishes known as follows:

• *Select the first color to be retained.* Use the Multi Selector to move the yellow box, labeled *Color selection box* in Figure 12-14, over the color. Then press the AE-L/AF-L button. The chosen color appears in the first color swatch at the top of the screen.

Figure 12-14: To select a color you want to keep, move the yellow box over it and press the AE-L/AF-L button.

- Set the range of the selected color. Rotate the command dial to display a preview of the desaturated image and highlight the number box to the right of the color swatch, as shown on the right in Figure 12-14. Then press the Multi Selector up or down to choose a value from 1 to 7. The higher the number, the more a pixel can vary in color from the selected hue and still be retained. The display updates to show you the impact of the setting.
- Choose one or two additional colors. Rotate the Main command dial
 to highlight the second color swatch and then repeat the selection
 process. Walk the same path to retain a third color, if desired.
- Reset a color swatch box. To empty a selected swatch box, press
 the Delete button. To reset all swatch boxes, hold down the button
 until a message asks whether you want to get rid of all selected
 colors. Select yes to go forward.

Shooting in Effects mode

When you set the Mode dial to Effects, as shown in Figure 12-15, you can apply special effects on the fly — that is, the effect is added as the camera writes the picture to the memory card.

Using Effects mode involves a special setup routine. Start by setting the camera to the Live View still photography mode, as shown in Figure 12-16. You can't adjust effect settings unless you're in this mode. In Movie mode, you can't even select a different effect, let alone tweak its settings.

An icon representing the selected effect appears in the upper-left corner of the Information display, as shown in Figure 12-16. (The icon in the figure represents the Color Sketch effect.) Rotate the Main command dial to select a different effect.

An OK/Set symbol at the bottom of the display, as shown in Figure 12-16, indicates that you can fine-tune the effect. Press OK

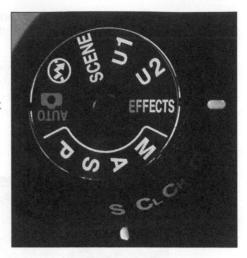

Figure 12-15: Effects mode applies special effects to movies and photos as you record them.

to access the settings. For example, Figure 12-17 shows settings available for the Color Sketch effect. Use the Multi Selector to adjust the settings and then press OK to return to the live preview. You can then exit Live View if you want and use the viewfinder to take the photo or, if you want to record a movie, rotate the Live View switch to the movie-camera position and press the movie-record button to start recording.

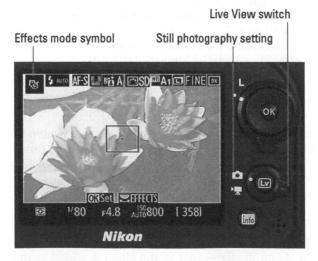

Figure 12-16: You must set the camera to the Live View still photography mode to adjust effect settings.

You can choose from these effects:

Night Vision: Use this setting in low-light situations to produce a grainy, black-and-white image.

Because the camera needs to use a slow shutter speed to record the image in dim lighting, use a tripod to avoid camera movement, which can blur your photo. Moving subjects may appear blurry even if the camera is on a tripod. Flash is disabled, and the image is recorded in the JPEG format. You can't record a Night Vision photo in the Raw (NEF) format.

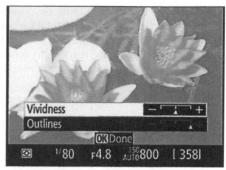

Figure 12-17: In Live View mode, you can preview and adjust Effects mode settings.

- Color Sketch: This setting produces an effect similar to what you see in Figures 12-16 and 12-17. As with the Night Vision mode, photos are recorded in the JPEG format. Movies play back as a series of still images rather than a standard movie. Autofocusing during movie recording is disabled.
- Miniature Effect: This one produces results similar to its counterpart on the Retouch menu. Figure 12-11 shows an example.

As with the Retouch menu version, this effect works by blurring everything but a small area of the image. To set up the shot, focus on the area that you want to remain sharp. Then press OK to display yellow bars that indicate the boundaries of the sharp-focus region. Press the Multi Selector up or down to adjust the size of the focus region; press right or left to change the orientation of the focus boundary. Press OK to exit the settings screen.

Flash is disabled, as is the AF-assist lamp. You can capture a still image in the JPEG mode only, and in Continuous Release mode, the frames per second rate is reduced.

For movies, sound recording is disabled, and autofocus isn't possible during recording. Perhaps most important, movie frames are compressed and play back at very high speed. Record about 45 minutes of footage, for example, and you end up with about a 3-minute clip.

✓ **Selective Color:** This effect creates an image in which all but one to three colors are desaturated, just like the Selective Color option on the Retouch menu. Figure 12-13 has an example.

In Effects mode, you see the same controls for selecting the colors you want to retain as when you use the Retouch menu tool. Three color swatches, each neighbored by a color-range adjustment setting, appear at the top of the screen, and a small color-selector box appears in the middle of the screen. The process of selecting colors is a little different, though:

- Choose a color to retain: Frame the image so that the selection box is over the color you want to preserve. Then press the Multi Selector up.
- Set the color range: After your selected color appears in the color box, the range value becomes active. Press the Multi Selector up and down to change the value. The higher the value, the more a pixel can vary in color from the one you chose and still be retained in the photo.
- Choose an additional color to retain: Rotate the Main command dial
 to select the second swatch box and repeat the process of choosing a color and setting its range value.
- Deselect a color: Change your mind about retaining one of your chosen colors? Rotate the Main command dial to highlight its color swatch and then press the Delete button. Or hold down the button for a few seconds to delete all your selected colors.

Press OK to lock in your decisions and hide the options. Press OK again to revisit the settings.

As with the preceding Effects settings, you're limited to using JPEG as the file type, and flash is disabled.

- ✓ Silhouette: Choosing this setting ensures that backlit subjects are captured in silhouette. To ensure that the subject is dark, flash is disabled.
- ✓ High Key: A high key photo is dominated by white or very light areas, such as a white china cup resting on a white doily in front of a sunny window. This setting is designed to produce a good exposure for this type of scene, which the camera otherwise tends to underexpose in response to all the high brightness values. Flash is disabled.

How does the name relate to the characteristics of the picture? Well, photographers refer to the dominant tones — or brightness values — as the *key tones*. In most photos, the *midtones*, or areas of medium brightness, are the key tones. In a high key image, the majority of tones are at the high end of the brightness scale.

Low Key: The opposite of a high key photo, a low key photo is dominated by shadows. Use this mode to prevent the camera from brightening the scene too much and thereby losing the dark and dramatic nature of the image. Flash is disabled.

Two roads to a multi-image exposure

Two camera features combine multiple photographs into one:

- Multiple Exposure (Photo Shooting menu): With this option, you can combine your next two to three shots. After you enable the option and take your shots, the camera merges them into one file. The shots used to create the composite aren't recorded and saved separately. The Multiple Exposure option isn't available in Live View mode.
- Image Overlay (Retouch menu): This option, available only through the regular Retouch menu (and not the Playback version of the *i* button menu), enables you to merge two existing Raw images to create a third Raw image. I used this option to combine a photo of a werewolf friend, shown on the left in Figure 12-18, with a nighttime garden scene, shown in the center. The result is the ghostly image shown on the right. Oooh, scary!

Figure 12-18: Image Overlay merges two Raw (NEF) photos into one.

On the surface, both options sound cool. The problem is that you can't control the opacity or positioning of the images in the combined photo. For example, my overlay picture would have been more successful if I could move the werewolf to the left in the combined image so that he and the lantern aren't blended. And I'd also prefer to keep the background of image 2 at full opacity in the overlay image rather than getting a 50/50 mix of that background and the one in image 1, which creates a fuzzy-looking background.

However, there is one useful effect that you can create with either option: a "two views" composite like the one in Figure 12-19. For this image, I used Image Overlay to combine the front and rear views of the antique match striker into the composite scene.

For this trick to work, the background in both images must be the same solid color (black seems to be best), and you must compose each photo so that the subjects don't overlap in the combined image, as shown here.

Figure 12-19: If you want each subject to appear solid, use a black background and position the subjects so that they don't overlap.

I don't recommend using Image Overlay or Multiple Exposure for serious photo compositing. Instead, do this work in your photo-editing software, where you have more control over the blend. In the interest of reserving space for features that I think you will find much more useful, I leave you to explore these two features on your own. The camera manual offers details on both options.

Using a Smart Device as a Wireless Shutter Release

Chapter 10 explains how to use the Nikon Wireless Mobile Utility (WMU) app to connect your camera wirelessly to an Android or iOS smart device. You can then use the device to view your photos and transfer low-resolution versions of your favorites so that you can share them online, using your device's Internet connection.

You can also use the app to trigger the camera's shutter release wirelessly. Unfortunately, you can't use this feature for movie recording. It's not that great for still photography, either, because you can't adjust any camera settings with the smart device. You can *only* trigger the shutter release. Still, if you need to position the camera in one part of the room and yourself in another, it's a workable option.

The steps for connecting the camera and smart device for this purpose are the same as outlined in Chapter 10, so I won't waste space repeating that information here. After the devices are connected and you launch the WMU app, your smart device displays a screen with two icons: Take Photos and View Photos, as shown on the left in Figure 12-20. The figure shows the screen as it appears on my Android tablet; the design may vary if you use a different device or operating system.

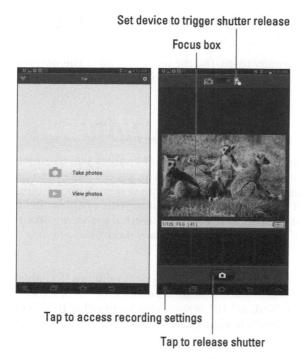

Figure 12-20: The Live View preview appears on the device screen; tap the camera icon to trigger the shutter.

Tap the Take Photos icon to display the screen shown on the right in the figure. (Again, this screen is the Android version; things look a little different in the iOS version of the app.) On an Android device, tap the icon at the top of the screen that looks like a finger on a tablet, which tells the device that you're going to use it as a camera remote control. The camera shifts to Live View mode, with the live preview appearing on the smart device. You also see some shooting data, such as shutter speed and f-stop — again, though, you can't adjust the settings from the smart device.

As in normal Live View, a focus box is used to indicate the area of the frame that will be used to establish focus if you use autofocusing. The exact focusing procedure depends on the current Live View autofocusing settings; Chapter 5 has details. To use the default autofocus settings, tap your subject on the device screen to move the focus box over it. The focus box turns green when focus is achieved, as shown in the figure.

Before taking the picture, you may want to investigate a few additional options available from the Take Photos screen. In Figure 12-20, I labeled the icon that brings up the options in the Android version of the app. You can choose to download the picture to the device automatically, and you can delay the shutter release by enabling the app's self-timer option. Leave

the other option, Live View, turned on to keep the live preview visible on your device.

When everything's ready to go, tap the camera icon at the bottom of the screen to take the picture. I labeled the icon in Figure 12-20.

Connecting Your Camera to an HDTV

Your camera is equipped with a feature that enables you to connect it to an HDMI television or monitor so that when you set the camera to playback mode, you can view your pictures on a large screen. Some photographers also use the HDMI connection during shooting; this enables clients and subjects to review each shot on the TV instead of gathering around the camera monitor. If the camera is in Live View mode, the preview appears on the TV.

To connect the two devices, you need a Type C mini-pin HD cable; prices start at about \$20. Nikon doesn't make its own cable, so just look for a quality third-party version. Next, set HD preferences by opening the Setup menu and choosing HDMI, as shown in Figure 12-21. You're offered these options:

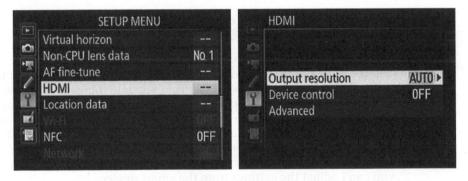

Figure 12-21: Select options for HD playback here.

- Output Resolution: By default, the camera decides the proper HD video resolution to send to the TV after you connect the two devices. But you can also choose a specific resolution through this option.
- Device Control: If your television is compatible with a technology named HDMI-CEC, you can use the buttons on the TV's remote control to perform the functions of the OK button and Multi Selector during fullframe picture playback. Set the Device Control option to On to enable this feature.

To use Live View when the camera is connected to your TV, you must turn off this option, however.

- Advanced: Settings in this group control a few more aspects of how the camera feeds the video signal to the TV.
 - Output Range and Output Display Size: Leave these two settings at their defaults unless your TV manual suggests otherwise. The Output Range setting controls the range of brightness levels in the video picture; the Output Display Size option determines whether the camera slightly reduces the dimensions of the display to ensure that everything is visible on your monitor. (Can't find your TV manual? Just experiment to see which options work best.)
 - Live View On-screen Display: Turn this option on to display the data that normally appears on the camera monitor during Live View shooting. (Press the Info button on the camera to change the type of data displayed.)
 - Dual Monitor: Enable this option to view the display both on the camera monitor and the HD screen. If you turn the option off, the preview appears only on the TV.

After you select the necessary Setup menu options, turn off the camera, and look for the HDMI-out port on the left side of the camera, as shown in Figure 12-22. The smaller of the two plugs on the HD cable goes into the camera port.

At this point, I need to rely on you (or your favorite media tech person) to figure out where to connect the other end of the HD cable. You may need to connect it directly to the TV or to another HD-input device that's part of your system. You may also need to change certain input settings on your TV or other HD device. When everything's good to go, turn on your camera to send the signal to the TV set. If you don't have the latest and greatest HDMI-CEC capability (or you lost your remote), control playback using the oncamera controls, as explained in Chapter 9.

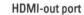

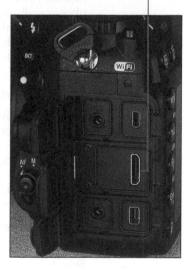

Figure 12-22: The HDMI-out port is located here.

Creating a Digital Slide Show

The Slide Show feature, found on the Playback menu, sets the camera to automatically display photos and movies one by one. You can view the show on

the camera monitor or, by connecting your camera to a TV as just outlined, enjoy it on an HDTV screen.

Which files are included in the show depend on the setting of the Playback Folder option on the Playback menu. Additionally, any pictures that you hid through the Hide Image function do not appear. Chapter 9 explains more about choosing which files and folders you want to view in playback mode; Chapter 10 details the Hide Image feature.

Follow these steps to present a slide show:

1. Display the Playback menu and select Slide Show.

You see the screen shown in Figure 12-23.

2. Set the Image Type and Frame Interval options and then press OK.

Select Image Type to specify whether you want the show to include photographs and movies, photos only, or movies only. The Frame Interval option determines how long each image will be displayed. (Movies always play in their entirety.)

Figure 12-23: Choose Slide Show to set up automatic playback of pictures and movies.

3. To begin playing the show, select Start.

When the show ends, you're given the option to restart the show, adjust the frame interval, or exit to the Playback menu.

During the show, control playback as follows:

- ✓ Pause/restart. Press OK to pause; to resume playback, select Restart. While the show is paused, you can adjust the frame interval if needed.
- ✓ Skip to the next/previous image. Press the Multi Selector right or left.
- Change the information displayed with the image. Press the Multi Selector up or down to cycle through the display modes. See Chapter 9 for details on the various modes.
- Adjust movie volume. Press the Zoom In button to increase volume; press the Zoom Out button to decrease it.
- Exit the show before it ends: Press the Playback button.

Index

• Symbols and Numerics •

* (asterisk), 121
1.3x Crop, compared with DX, 78–80
3D Color Matrix II, 115
3D Tracking (3d), 151
9-point Dynamic Area (d9), 150
21-point Dynamic Area (d21), 150
24 fps option, 216
25 fps option, 217
30 fps option, 217
50 fps option, 217
51-point Dynamic Area (d51), 150
60 fps option, 215

· A ·

A (aperture-priority autoexposure) about, 55, 110 aperture in, 120 flash and, 83 ISO in, 121 manipulating exposure in, 222 for scenic vistas, 204 speed in, 120 accessing movie-record button, 301 retouching tools, 305-306 accessory terminal, 32 action, shooting, 200-203 Active D-Lighting, 130–132 copyright notices, 293-294 hidden comments, 293-294 index markers, 215 special effects via Retouch menu, 314-317 Additional Photo Info option, 247 adjusting automatic shutoff timing, 239, 304 basic video settings, 215-218 data displays, 214

exposure, 118-121 Flash mode, 88-90 flash power through Flash Compensation. flash strength, 91-93 focus during recording, 214 Image Quality settings, 75-78 Image Size settings, 75-78 Main/Sub. 299 menu items, 292 menu options, 15-16 playback display modes, 246-247 playback timing, 239 playback volume, 229 purpose of OK button, 297-298 role of shutter button, 303-304 shutter speed, 118-121 tool settings, 307 viewfinder, 9-10 White Balance setting, 173-177 Adobe RGB, 188 advanced exposure modes, 109-111 advancing frame by frame, 229 AE-L/AF-L button, 25, 300-301 AF Activation, 157 AF-A (auto-servo autofocus), 148 AF-area mode, 149-153, 161-163 AF-assist lamp, 30, 31 AF-C (continuous-servo autofocus), 148 AF-F (full-time servo AF), 161 AF-mode button, 30 AF-S (single-servo autofocus), 146-148, 153–154, 161 Android, app features for, 281 aperture in A (aperture-priority autoexposure) mode in, 120 about, 102, 109 depth of field and, 104-105, 167-168 in M (manual exposure) mode, 119 manipulating exposure in, 223

Backup setting, 36

balancing exposure, 108-109 aperture (continued) barrel distortion, removing, 309 in P (programmed autoexposure) mode, batches, deleting for files, 262-263 120 - 121in S (shutter-priority autoexposure) battery about, 7 mode, 120 checking status of, 13-14 setting, 118-125, 299 saving power, 41 aperture-priority autoexposure (A) bit depth, 73-74 about, 55, 110 BKT (Bracket) button, 29, 30 aperture in, 120 blown highlights, 250 flash and, 83 blurry photos, shutter speed and, 147 ISO in, 121 bounce lighting, 94, 199-200 manipulating exposure in, 222 for scenic vistas, 204 bracketing defined, 140, 206 speed in, 120 for scenic vistas, 206 applying Active D-Lighting, 130-132 white balance, 185-188 Bracketing button, 29, 30 exposure compensation, 126-129 Flash Compensation, 91-93 Brightness histogram, 253 buffer, 59 aspect ratio, 313 Assign Shutter Button options/Depth-of-Built-In AF-Assist Illuminator, 157 Field Preview button, 215 built-in flash, 83, 98, 197 assigning tasks to buttons, 300-303 Bulb setting, 119 asterisk (*), 121 Burst-mode shooting, flash and, 82 buttons attaching lens, 8 AE-L/AF-L, 25, 300-301 audio, controlling, 218-221 AF-mode, 30 Auto Area (Aut), 151 Assign Shutter Button options/Depth-of-Auto Distortion Control, 80 Auto Flash mode, 44-50, 88 Field Preview, 215 BKT (Bracket), 29, 30 Auto+ Flash mode, 88 Bracketing, 29, 30 Auto Flash Off mode, 52 Delete, 24, 236 Auto focus, 33 Depth-of-Field Preview, 31, 301 Auto mode, 44-50, 52 Exposure Compensation, 28 autoexposure lock Flash, 30, 89 manipulating exposure in, 224 using, 139-140 Fn, 80, 300-301 Function (Fn), 31 autoexposure modes, flash and, 83 Help, 26-27, 302 autofocusing, 54-55, 153-154 i, 25, 232 automatic bracketing, 140-144 Info, 25 automatic picture rotation, enabling, 240 ISO Zoom Out, 26 automatic shutoff timing, adjusting, 239, 304 lens-release, 29, 30 auto-servo autofocus (AF-A), 148 Menu, 27 Metering Mode, 28 movie-record, 28, 301 OK, 25, 297-298 back-of-the-body controls, 23-27

On/Off switch and shutter, 27, 28

Playback, 24, 236
Protect, 26–27
Qual, 27, 75–76
shutter, 58, 111, 303–304
WB, 26–27, 174, 183
Zoom In/Out, 27, 236
buttons, assigning tasks to, 300–303. See also specific buttons
buying memory card(s), 38–39

· C ·

Calendar view, displaying photos in. 242-244 camera. See also specific topics connecting to computer, 265 connecting to HDTV, 324-325 connecting to smart devices, 281-283 Custom Setting menu, 42-43 customizing. See customizing displays, 19-23 external controls, 23-32 lens, 32–35 memory cards, 36-39 navigating menus, 15-19 preparing, 7-14 Setup menu, 40-41 shooting in Auto/Auto Flash modes, 44–50 camera files about, 257 copying between memory cards, 278-280 copying for online sharing, 275-277 deleting, 261-263 downloading pictures to computer, 265-269 editing, 306 hiding photos during playback, 259 Nikon Mobile Wireless Utility app. 280–283 processing Raw (NEF) files, 269-275 protecting photos, 258 ViewNX 2, 263-265 Camera menu selections, 3 camera-to-subject distance, depth of field and, 168 Capture NX-D, 270, 273-275 Card slot (File Information mode), 248

center-weighted mode, 90, 115 CH (Continuous Light) mode, 59 changing automatic shutoff timing, 239, 304 basic video settings, 215-218 data displays, 214 exposure, 118-121 Flash mode, 88-90 flash power through Flash Compensation. 200 flash strength, 91-93 focus during recording, 214 Image Quality settings, 75-78 Image Size settings, 75-78 Main/Sub. 299 menu items, 292 menu options, 15-16 playback display modes, 246-247 playback timing, 239 playback volume, 229 purpose of OK button, 297-298 role of shutter button, 303-304 shutter speed, 118-121 tool settings, 307 viewfinder, 9-10 White Balance setting, 173-177 Cheat Sheet (website), 4 check mark, 247 checking battery status, 13-14 space available, 10-13 choosing AF-area mode, 149-153, 161-163 batches of photos, 285-286 color spaces, 188 exposure metering mode, 115-117 exposure mode, 52-56 Flash mode, 84-90 Image Quality, 66-78 Image Size, 66-78 images to view, 237-238 items from Custom Setting menu, 17 Live View Focus mode, 161 menus, 15 photos for transfer, 284-286 presets, 183

CL (Continuous Low) mode, 59 Clean Image Sensor option (Setup menu), 40 color about, 171 bracketing white balance, 185-188 choosing color spaces, 188 creating custom white balance presets, 180-185 manipulating, 310-312 Picture Controls, 188-191 white balance, 171-180 Color Outline tool, 315 Color Sketch tool, 315, 319 color spaces, 188 color temperature, 171 command dials, 75-76, 80, 174, 183, 243-244, 298-300 Commander Mode, 98 comments, hidden, 293-294 comparing images, 307-308 computer, downloading pictures to, 265–269 Conformity Marking option (Setup menu), 41 connecting camera to computer, 265 camera to HDTV, 324-325 camera to smart devices, 281-283 via NFC, 284 Continuous Low (CL) mode, 59 Continuous (burst mode) shooting, 58–60 continuous-servo autofocus (AF-C), 148 Control panel, 19-20, 27, 28, 38 controlling audio, 218-221 depth of field. See depth of field focus. See focus ISO, 121-124 memory card(s), 39 white balance, 177-180 convergence, correcting, 310 "cool light," 172 copying files between memory cards, 278-280 files for online sharing, 275–277 copyright notices, 293-294 correcting convergence, 310 creating custom exposure modes, 289-291

custom white balance presets, 180–185 digital slide shows, 325-326 menus, 291-293 crop factor, 34-35 cropping photos, 312-313 Cross Screen tool, 314 custom exposure modes, 289-291 Custom Setting menu about, 15 options for, 42-43 selecting items from, 17 custom white balance presets, 177, 180-185 customizing about, 289 adding copyright notices, 293-294 adding hidden comments, 293-294 adjusting automatic shutdown timing, 304 assigning tasks to buttons, 300–303 changing purpose of OK button, 297–298 command dials, 298-300 creating custom exposure modes, 289-291 creating menus, 291–293 filenames, 294-295 filenames for still images, 295 folder names, 295-297 menus, 299-300 modifying role of shutter button, 303–304 playback, 299-300

D7200 camera. See also specific topics connecting to computer, 265 connecting to HDTV, 324-325 connecting to smart devices, 281-283 Custom Setting menu, 42–43 customizing. See customizing displays, 19-23 external controls, 23-32 lens, 32-35 memory cards, 36-39 navigating menus, 15-19 preparing, 7-14 Setup menu, 40–41 shooting in Auto/Auto Flash modes, 44–50 dampening noise, 125 data, changing displayed, 214

Data display mode, 254-255 date, setting, 9 Date and Time (File Information mode), 249 decibels (dB), 220 default settings restoring, 43 shooting using, 210-215 Delete button, 24, 236 deleting barrel distortion, 309 files, 262-263 frames, 230 items from Recent Settings menu, 17-18 lens, 34 memory card(s), 39 menu items, 292 pincushion distortion, 309 vignetting, 137-139 depth of field aperture and, 104–105, 167–168 camera-to-subject distance and, 168 defined, 55 for dynamic close-ups, 206–207 focal length and, 168 manipulating, 166–170 Depth-of-Field Preview button, 31, 301 desaturate, 316 diffuser, 94 Digital Print Order Format (DPOF), 286 digital slide shows, 325–326 diopters, 208 direct measurement, setting white balance with, 180-182 disabling built-in flash, 83 display modes, 246–247 displays and displaying about, 19 Control panel, 19–20 Information display, 21 Live View, 21–23 main menus, 15 Movie, 21-23 photos in Calendar view, 242-244 viewfinder, 20-21 Distortion Control filter, 80 D-Lighting tool, 311 downloading pictures to computer, 265-269 DPOF (Digital Print Order Format), 286

drag-and-drop transfer, 269 DX, compared with 1.3x Crop, 78–80 Dynamic Area option, 150 dynamic close-ups, shooting, 206–208

· E ·

editing

Easy ISO, enabling, 124

files, 306 presets, 183-185 Effects mode about, 53 flash and, 82 ISO in, 121 shooting in, 317-320 enabling automatic picture rotation, 240 built-in flash, 83 Easy ISO, 124 high-speed flash (Auto FP), 94-96 Image Review, 239 playback display modes, 246-247 Vibration Reduction, 34, 214 EV (exposure value), 127 **EV Steps for Exposure Cntrl** (Control), 114 expanding tonal range, 129-137 exposure about, 101-102 adjusting, 118-121 advanced modes, 109-111 aperture, 102-109 automatic bracketing, 140-144 balancing, 108–109 choosing exposure metering mode, 115-117 ISO, 102-109 locking, 303–304 manipulating, 222-225, 310-312 multi-image, 321-322 reading exposure meter, 111-114 for scenic vistas, 205 setting aperture, 118–125 setting ISO, 118-125 setting shutter speed, 118-125 shutter speed, 102-109 troubleshooting, 125-140

exposure compensation applying, 126–129 manipulating exposure in, 223 Exposure Compensation button, 28 Exposure Delay mode, 62 exposure meter, reading, 111-114 exposure metering modes choosing, 115-117 flash output and, 90 exposure modes advanced, 109-111 choosing, 52-56 custom, 289-291 for recording, 225 exposure stops, 114 exposure value (EV), 127 external controls back-of-the-body, 23-27 front-right, 30-31 hidden connections, 31–32 left-front, 29-30 topside, 27–29 Extras page (website), 190 Eye-Fi memory cards, 39

· F ·

Face Priority setting, 162 fast-forwarding playback, 228 features, recommended, 305-326 50 fps option, 217 51-point Dynamic Area (d51), 150 File Information mode, 248-250 file size, 68-70 Filename (File Information mode), 249 filenames, customizing, 294-295 files about, 257 copying between memory cards, 278–280 copying for online sharing, 275–277 deleting, 261-263 downloading pictures to computer, 265-269 editing, 306 hiding photos during playback, 259 Nikon Mobile Wireless Utility app, 280–283

processing Raw (NEF) files, 269-275 protecting photos, 258 ViewNX 2, 263-265 Fill Flash mode, 84-85 Filter Effects, 311–312 Firmware Version option (Setup menu), 41 Fisheye tool, 315 FL (Flat) setting, 190 flash about, 81 adjusting power through Flash Compensation, 200 adjusting strength of, 91-93 built-in, 83, 98, 197 choosing Flash mode, 84–90 for dynamic close-ups, 207 enabling high-speed flash (Auto FP), 94-96 exposure metering modes and, 90 Flash Value Lock (FV Lock), 94–96 limitations of, 82 shutter speed and timing of, 84 softening, 94 switching to manual flash-power control, 93 white balance and, 198 flash bracketing, 98 Flash button, 30, 89 Flash Compensation adjusting power through, 200 applying, 91–93 flash hot shoe, 29 Flash mode, 55, 84-90 Flash Off mode, 88 Flash Value Lock (FV Lock), 94–96 Flash/Flash Compensation, 29 Flat (FL) setting, 190 fluorescent bulb type, 176 Fn button, 80, 300-301 focal length, 34-35, 168, 204 focal plane indicator, 28, 29 focus adjusting during recording, 214 Live View, 159-166 manual, 157-159 methods for, 33 on moving subjects, 155–156

options for recording, 225-226 setting basic method, 145-146 standard focusing options, 147-159 Focus mode (AF lock or continuous AF), 147-149 focus point, 247, 248 Focus Point Illumination, 157 Focus Point Wrap-Around, 157 Focus Selector Lock switch, 24, 25 Focus-mode selector, 30 Folder (File Information mode), 248 folder names, customizing, 295-297 formatting memory card(s), 38, 258 fps (frames per second), 60 Frame Number/Total Pictures (File Information mode), 248 Frame Size/Frame Rate, 216-218 frames eliminating, 230 saving as still images, 231-232 size of, 313 frames per second (fps), 60 framing guides, 22 Frequency Response, 221 front infrared receiver, 30 front-curtain sync, 87 front-right controls, 30-31 f-stop numbers (f-stops), 102 full-time servo AF (AF-F), 161 fully automatic exposure modes, 52-55 Function (Fn) button, 31

· H ·

HDMI port, 32
HDR (high dynamic range) photography, 132–137
HDTV, connecting camera to, 324–325
headphone jack, 32
Help button, 302
hidden comments, adding, 293–294
hidden connections, 31–32
hiding photos during playback, 259
high dynamic range (HDR) photography, 132–137
High ISO NR (Noise Reduction), 226
High Key tool, 320

Highlight Display mode, 224–335 Highlights data, 253 Highlights Display mode, 250–252 high-speed flash (Auto FP), 94–96 Histogram Display, manipulating exposure in, 224 histograms, 23, 252 horizon, leveling, 308–309 hot shoe, 28, 29

0 | 0

i button, 25, 232 *i* button menus, 18–19, 76, 79, 131 icons, explained, 3 Image Area, 78-80, 249 Image Dust Off Ref Photo option (Setup menu), 40-41 image noise, ISO and, 106-108 Image Overlay, 321-322 Image Quality adjusting settings, 75–78 File Information mode, 249 selecting, 66-78 Image Review, enabling, 239 Image Size adjusting settings, 75-78 File Information mode, 249 selecting, 66–78 images. See also still images basic settings for, 193-194 choosing to view, 237-238 comparing, 307-308 cropping, 312-313 displaying in Calendar view, 242-244 downloading to computer, 265-269 hiding during playback, 259 magnifying during playback, 244–245 matching white balance to existing, 182-183 protecting, 258 scrolling with command dials, 243-244 selecting batches of, 285-286 selecting for transfer, 284-286 straightening, 308-310 tagging, 284-285 viewing. See Playback mode

images (continued) viewing data, 245-246 viewing on smart devices, 284 in-camera processing feature, 270–273 index markers, adding, 215 Info button, 25 Information display, 21, 37 inserting memory card(s), 8-9 Internet resources Cheat Sheet, 4 Extras page, 190 Nikon, 41, 208, 265 Nikon Cinema, 209 online articles, 4 Interval Timer shooting, 63–66 iOS, app features for, 281 ISO about, 102, 109 controlling, 121-124 image noise and, 106-108 manipulating exposure in, 222–223 setting, 118-125 ISO Sensitivity Step Value, 114 ISO Zoom Out button, 26

• 7 •

JPEG, 70–73, 75 JPEG Compression option, 77

. K .

Kelvin scale, 171, 176–177 key tones, 320

Landscape (LS) setting, 190

0/0

language, setting, 9
left-front controls, 29–30
lens
about, 8, 32
attaching, 8
distortion, 80
for dynamic close-ups, 206–207
enabling Vibration Reduction, 34

focusing method, 33 removing, 34 zooming, 34 lens-release button, 29, 30 leveling horizon, 308-309 light fall-off, 137 lighting, for scenic vistas, 206 Live View mode about, 21-23 Auto mode and, 47–50 changing purpose of OK button from, 298 checking space available in, 11–13 choosing, 161 exposure metering in, 113 focusing, 159-166 manual focusing during, 166 setting, 10 Live View switch, 24, 25 Location Data option (Setup menu), 41 Lock Mirror Up for Cleaning option (Setup menu), 40 locking exposure, 303-304 memory card(s), 39 Low Key tool, 320 LS (Landscape) setting, 190

· M ·

M (manual exposure) about, 56, 110 aperture in, 119 exposure metering and, 112-113 flash and, 83 ISO in, 121 manipulating exposure in, 222 speed in, 119 Mac Finder, 269 macro lens, for dynamic close-ups, 208 magnifying photos during playback, 244-245 Main command dial, 24, 25 Main/Sub, changing, 299 managing audio, 218–221 depth of field. See depth of field focus. See focus

ISO, 121-124 metadata, 293 memory card(s), 38-39 metering mode, manipulating exposure white balance, 177–180 in, 222 manipulating Metering Mode button, 28 color, 310–312 microphone, 28, 29, 219-221 depth of field, 166–170 microphone jack, 31, 32 exposure, 222–225, 310–312 Miniature Effect tool, 315–316, 319 manual exposure (M) mireds, 178 about, 56, 110 Mode dial, 28–29 aperture in, 119 modeling flash, 98 exposure metering and, 112-113 modes flash and, 83 AF-area, 149–153, 161–163 ISO in, 121 Auto, 44–50, 52 manipulating exposure in, 222 Auto Flash, 44–50, 88 speed in, 119 Auto+ Flash, 88 manual focus, 33, 157-159, 166 Auto Flash Off, 52 margin art, 3 autoexposure, flash and, 83 matching white balance to existing photos, center-weighted, 90, 115 182 - 183Commander Mode, 98 Matrix (whole frame) mode, 90, 115 Continuous Light (CH), 59 maximum recording time, 218 Continuous Low (CL), 59 MC (Monochrome) setting, 189–190 custom exposure, 289-291 memory card reader, 266 Data display, 254–255 memory card(s) display, 246–247 about, 8, 236 Effects, 53, 82, 121, 317–320 buying, 38-39 exposure, 52–56, 109–111, 225, 289–291 copying files between, 278–280 Exposure Delay, 62 formatting, 258 exposure metering, 90, 115–117 File Information, 248-250 inserting, 8–9 maintaining, 38-39 Fill Flash, 84–85 two-card system, 36-38 Flash, 55, 84–90 memory-card access light, 24, 25 Flash Off, 88 Menu button, 27 Focus (AF lock or continuous AF), menus 147-149 creating, 291–293 fully automatic exposure, 52-55 Custom Setting, 15, 17, 42–43 Highlights Display, 224–335, 250–252 customizing, 299-300 Live View, 10, 11–13, 21–23, 47–50, 113, i button, 18–19, 76, 79, 131 159–166, 298 Movie Shooting, 15, 175, 183 Matrix (whole frame), 90, 115 My Menu/Recent Settings, 15, 17–18 Metering, manipulating exposure in, 222 navigating, 15-19 Night Vision Effects, 121, 319 Photo Shooting, 15, 77, 80, 132, 175, 183, normal (viewfinder), 10, 11, 44-47 321 - 322Overview Data, 255-256 Playback, 15 Playback, 235-246, 297-300 Retouch, 15, 305-308, 314-317, 321-322 Quiet (Q), 58 Setup, 15, 40–41 Rear-Curtain Sync, 87

modes (continued) Red-Eye Reduction, 86 Release, 28, 29, 55 RGB Histogram, 252-254 Scene, 53-55, 82, 83, 121 semi-automatic (P, S, and A), 55-56 Shooting, 297 Shutter-Release, 56-66 Single Frame (S), 58 Slow Rear-Curtain Sync, 87–88 Slow-Sync Flash, 86–87, 198 Slow-Sync with Red-Eye Reduction, 87 Spot, 115-116 spot-metering, 90 Viewfinder, 11, 44-47 Monitor Brightness option (Setup menu), Monitor Color Balance option (Setup menu), 41 Monitor Off Delay, 304 Monochrome (MC) setting, 189-190 Monochrome tool, 312 motion blur, shutter speed and, 105–106 MOV format, 215 Movie displays, 21–23 Movie Quality, 217 Movie Shooting menu, 15, 175, 183 movie-record button, 28, 301 movies about, 209 adjusting basic settings, 215–218 adjusting basic video settings, 215–218 controlling audio, 218–221 customizing buttons for recording, 303 customizing filenames for, 295 manipulating exposure, 222-225 manual focusing during shooting of, 166 recording options, 225–227 recording with shutter button, 304 saving frames as still images, 231–232 screening, 227-229 shooting using default settings, 210-215 trimming, 229-231 moving subjects, focusing on, 155–156 Multi Selector, 24, 25, 236

multi-image exposure, 321–322 Multiple Exposure (Photo Shooting menu), 321–322 MUP (Mirror Lockup), 61–62 My Menu/Recent Settings menu, 15, 17–18

· N ·

navigating menus, 15-19 NEF (Raw) files about, 70-71, 73-74, 75 processing, 269–275 NEF (RAW) Recording option, 77–78 Neutral (NL) setting, 189 NFC (Near Field Communication) option (Setup menu), 41, 284 Night Vision Effects mode, 121, 319 Nikon ViewNX 2, 263-265 website, 41, 208, 265 Nikon Capture NX-D, 265 Nikon Cinema (website), 209 Nikon D7200 camera. See also specific topics connecting to computer, 265 connecting to HDTV, 324–325 connecting to smart devices, 281-283 Custom Setting menu, 42–43 customizing. See customizing displays, 19-23 external controls, 23–32 lens, 32–35 memory cards, 36–39 navigating menus, 15–19 preparing, 7–14 Setup menu, 40-41 shooting in Auto/Auto Flash modes, 44 - 50Nikon ML-43, wireless remote-control shooting with, 62–63 Nikon Mobile Wireless Utility app, 280–283 Nikon ViewNX-i, 263–265 9-point Dynamic Area (d9), 150 NL (Neutral) setting, 189

noise, dampening, 125

Non-CPU Lens Data option (Setup menu), 41 Normal Area setting, 162 normal (viewfinder) mode Auto modes and, 44–47 checking space available in, 11 setting, 10

. () .

off-camera flash, 94
off-the-dial shutter release features, 62–66
OK button, 25, 297–298
1.3x Crop, compared with DX, 78–80
online articles (website), 4
online sharing, copying files for, 275–277
On/Off switch and shutter button, 27, 28
options
for printing, 286
for recording, 225–227
Overflow setting, 36
Overview Data mode, 255–256

. p .

P (programmed autoexposure) about, 55, 109 aperture in, 120-121 flash and, 83 ISO in, 121 manipulating exposure in, 222 speed in, 120-121 pausing playback, 228 Photo Shooting menu, 15, 77, 80, 132, 175, 183, 321-322 photos. See also still images basic settings for, 193-194 choosing to view, 237-238 comparing, 307-308 cropping, 312-313 displaying in Calendar view, 242-244 downloading to computer, 265–269 hiding during playback, 259 magnifying during playback, 244–245 matching white balance to existing. 182 - 183

protecting, 258 scrolling with command dials, 243-244 selecting batches of, 285-286 selecting for transfer, 284-286 straightening, 308-310 tagging, 284-285 viewing. See Playback mode viewing data, 245–246 viewing on smart devices, 284 photo-upload feature, 275 PictBridge, 286 Picture Controls, 188-191, 226-227 pictures. See also still images basic settings for, 193-194 choosing to view, 237-238 comparing, 307-308 cropping, 312-313 displaying in Calendar view, 242-244 downloading to computer, 265-269 hiding during playback, 259 magnifying during playback, 244-245 matching white balance to existing. 182 - 183protecting, 258 scrolling with command dials, 243-244 selecting batches of, 285–286 selecting for transfer, 284-286 straightening, 308–310 tagging, 284-285 viewing. See Playback mode viewing data, 245-246 viewing on smart devices, 284 pincushion distortion, removing, 309 pixel dimension, 66 Playback button, 24, 236 Playback menu, 15 Playback mode about, 235-237 adjusting timing, 239 changing purpose of OK button from, 297-298 choosing images to view, 237–238 customizing playback, 299-300 displaying photos in Calendar view,

242-244

Playback mode (continued) enabling automatic picture rotation, 240 magnifying photos during playback, shifting from Single-Image to Thumbnail view, 241-242 viewing picture data, 245–246 Portrait (PT) setting, 190 preparing camera, 7-14 presets custom White Balance, 177 editing, 183-185 selecting, 183 print size, 67-68 printing, options for, 286 processing Raw (NEF) files, 269–275 programmed autoexposure (P) about, 55, 109 aperture in, 120-121 flash and, 83 ISO in, 121 manipulating exposure in, 222 speed in, 120-121 progressive video format, 217 Protected Symbol (File Information mode), 249 protecting photos, 258 PT (Portrait) setting, 190

• 0 •

Q (Quiet) mode, 58 Qual button, 27, 75–76 Quick Retouch filter, 311

. R .

[r24], 14 Raw converter, 73 Raw (NEF) files about, 70–71, 73–74, 75 processing, 269–275 Raw Shot 1 setting, 36 Raw+JPEG, 74–75 reading

brightness histogram, 253 exposure meter, 111-114 rear infrared receiver, 24, 25 Rear-Curtain Sync mode, 87 recalibrating meter, 114 recording times, maximum, 218 Red-Eye Correction tool, 311 Red-Eye Reduction mode, 86 reducing Image Area, 78-80 Release mode, 28, 29, 55 Remember icon, 3 removing barrel distortion, 309 files, 262-263 frames, 230 items from Recent Settings menu, 17-18 lens, 34 memory card(s), 39 menu items, 292 pincushion distortion, 309 vignetting, 137-139 Repeating Flash feature, 98 repositioning cropping frame, 313 resolution, 215. See also Image Size restoring default settings, 43 resuming playback, 228 Retouch menu about, 15, 305–308 adding special effects via, 314–317 Image Overlay, 321–322 Retouch Symbol (File Information mode), 250 retouching tools, accessing, 305-306 Reverse Rotation, 298 rewinding playback, 228 RGB histogram, 254 RGB Histogram mode, 252-254

S (shutter-priority autoexposure) about, 55, 109 aperture in, 120 flash and, 83 ISO in, 121

manipulating exposure in, 222	Live View mode, 10
speed in, 120	normal (viewfinder) mode, 10
S (Single Frame) mode, 58	for pictures, 193–194
saving	restoring default, 43
battery power, 41	shutter speed, 118–125
edited copy, 307	Shutter-Release mode, 56-66
frames as still images, 231–232	tool, 307
Scene modes, 53–55, 82, 83, 121	video, 215–218
scenic vistas, shooting, 203–206	white balance, 173–177
screen display size, 68	white balance with direct measurement,
screening movies, 227–229	180–182
scrolling pictures with command dials,	Setup menu, 15, 40-41
243–244	sharpening, 189
SD (Standard) setting, 189, 216	shooting
selecting	about, 51, 193
AF-area mode, 149–153, 161–163	action, 200–203
batches of photos, 285–286	in Auto/Auto Flash modes, 44-50
color spaces, 188	basic picture settings, 193–194
exposure metering mode, 115–117	choosing exposure modes, 52–56
exposure mode, 52–56	Data display mode, 254–255
Flash mode, 84–90	dynamic close-ups, 206–208
Image Quality, 66–78	in Effects mode, 317–320
Image Size, 66–78	movies using default settings, 210-215
images to view, 237–238	reducing Image Area, 78–80
items from Custom Setting menu, 17	scenic vistas, 203–206
Live View Focus mode, 161	selecting Image Size and Image Quality,
menus, 15	66–78
photos for transfer, 284–286	setting Shutter-Release mode, 56–66
presets, 183	still portraits, 194–200
Selective Color tool, 316–317, 319–320	time-lapse movies, 227
self-timer shooting, 60–61	shooting mode, 297
semi-automatic modes (P, S, and A),	shots available, determining, 38
55–56	shutter button
Send to Smart Device symbol (File	initiating exposure metering with, 111
Information mode), 250	modifying role of, 303–304
sensitivity, of microphone, 219–221	movie recording and, 304
setting(s)	troubleshooting, 58
aperture, 118–125, 299	shutter speed
basic focusing method, 145–146	about, 102, 109
default, 43, 210–215	adjusting, 118–121
Focus mode (AF lock or continuous AF),	blurry photos and, 147
147–149	built-in flash and, 197
Image Quality, 75–78	for dynamic close-ups, 207
Image Size, 75–78	flash timing and, 84
ISO, 118–125	manipulating exposure in, 223
language, time zone and date, 9	motion blur and, 105-106

shutter speed (continued) for scenic vistas, 204-205, 205-206 setting, 118-125 shutter-priority autoexposure (S) about, 55, 109 aperture in, 120 flash and, 83 ISO in, 121 manipulating exposure in, 222 speed in, 120 Shutter Release mode, 56-66 silent-wave autofocusing (AF-S), 146 Silhouette tool, 320 Single Point (S) option, 150, 153–154 Single-Image, shifting to Thumbnail view from, 241-242 single-servo autofocus (AF-S), 146–148, 147–148, 153–154, 161 60 fps option, 215 skipping playback, 229 Skylight filter, 311 Slow Rear-Curtain Sync mode, 87–88 Slow-Sync Flash mode, 86–87, 198 Slow-Sync with Red-Eye Reduction mode, 87 smart devices connecting camera to, 281–283 using as wireless shutter releases, 322-324 viewing photos on, 284 Soft tool, 314 softening flash, 94 software, free, 263-265 Software menu commands, 3 space available, checking, 10-13 speakers, 24, 25, 236 special effects, 314-322 specifying fluorescent bulb type, 176 Kelvin color temperature, 176–177 speed in A (aperture-priority autoexposure) mode in, 120 in M (manual exposure) mode, 119 in P (programmed autoexposure) mode, 120-121

in S (shutter-priority autoexposure) mode, 120 Spot mode, 115–116 spot-metering mode, 90 sRGB, 188 Standard (SD) setting, 189, 216 Standby Timer, 304 still images autofocusing for, 153-154 customizing buttons for, 300–303 customizing filenames for, 295 saving frames as, 231–232 shooting, 194-200 stopping playback, 228 Store Points by Orientation, 157 straightening photos, 308–310 Sub-command dial, 30, 31 sub-dialing frame advance, 300 Subject Tracking setting, 162–163 synchronizing flash, 84

• T •

tagging photos, 284-285 tasks, assigning to buttons, 300–303 Technical Stuff icon, 3 30 fps option, 217 3D Color Matrix II, 115 3D Tracking (3d), 151 through the lens (TTL), 89 Thumbnail view, shifting to Single-Image from, 241-242 Time setting, 119 time zone, setting, 9 time-lapse movies, shooting, 227 timing playback, 239 Tip icon, 3 tonal range, 129–137, 253 tool settings, adjusting, 307 topside controls, 27–29 Trim tool, 313 trimming movies, 229–231 troubleshooting exposure, 125-140 shutter button, 58 TTL (through the lens), 89

21-point Dynamic Area (d21), 150 24 fps option, 216 25 fps option, 2176 Type C mini-pin HD cable, 324

· 4 ·

U1/U2, 56 USB cable, 265 USB port, 32

• U •

VI (Vivid) setting, 189
Vibration Reduction, 34, 214
viewfinder, 9–10, 20–21
Viewfinder mode
Auto modes and, 44–47
checking space available in, 11
Viewfinder Virtual Horizon, 23
viewing
photos. See Playback mode
photos on smart devices, 284
picture data, 245–246
ViewNX 2 (Nikon), 263–265
vignetting, eliminating, 137–139
virtual horizon, 22–23
Vivid (VI) setting, 189

• W •

Warm filter, 312 Warning icon, 3 WB button, 174, 183 WB/Help/Protect button, 26-27 websites Cheat Sheet, 4 Extras page, 190 Nikon, 41, 208, 265 Nikon Cinema, 209 online articles, 4 white balance about, 171-173 bracketing, 185-188 changing setting, 173-177 fine-tuning, 177–180 flash and, 198 matching to existing photos, 182–183 Picture Control and, 226-227 setting with direct measurement, 180 - 182whole frame (matrix), 90 Wide Area setting, 161–162 Wi-Fi option (Setup menu), 41 Wi-Fi shutter-release feature, 281 Wi-Fi transfer feature, 280-283 Wind Noise Reduction, 221 Windows Explorer, 269 wireless remote-control shooting with Nikon ML-43, 62-63 wireless shutter releases, using smart devices as, 322-324

• Z •

Zoom In/Out button, 27, 236 zooming lens, 34 zooming the view, 253

Populi Dynamic Ace (21) [59 84 g.s. optlon [218 85 los prásmi [176]

91, 254, 13 232 - 334, 235 231, 331, 332

110

VI (vivid) setting 189
Vibration according 18, 214
Viewfleter mode
American modes and 44 according 18, 11
American a according to 11
Viewfleter Viewal Horizon 23
Viewfleter Viewal Horizon 23
Viewfleter Viewal Horizon 23

tend part est, willing be be to the first and the second s

Historia ya shi Kara i Hasa Walawa Wali Tili ya Kishi ƙasar

Manual From Outron 20-22
Cheat Sheet, 4
Extrapage 190
Nikon 41, 08, 205
Nikon Corna, 206
Inherhalon, corlina, outlos 4
Inherhalon, corna, 206
Inherhalon, corna, 206
Inherhalon, corna, 206
Inherhalon, corna, 206
Inherhalon, corna, 108
Inherhalon, corna, 208
Inherhalon, corna, 208
Inherhalon, corna, 208
Inherhalon, corna, 200
Inherhalon, corna,

whole brane (mairle), 90

Write Area setting; [b] [bit |
Write aption (Solice menu), 41

Write shufter veloace [cities 28]
Write shufter veloace [cities 28]
Write become setting to a shuffer with the shuffer [cities 28]

Amelies statemen [cities 28]

mun spesin som alse sumvik kantoniya sus sussen kantosi

and the first areas and path was the first and the first areas

About the Author

Julie Adair King is the author of many books about digital photography and imaging, including the best-selling Digital Photography For Dummies. Her most recent titles include a series of For Dummies guides to popular digital SLR cameras, including the Nikon D5500, D3300, D7100, and D600. Other works include Digital Photography Before & After Makeovers, Digital Photo Projects For Dummies, Julie King's Everyday Photoshop For Photographers, Julie King's Everyday Photoshop Elements, and Shoot Like a Pro!: Digital Photography Techniques. When not writing, King teaches digital photography at such locations as the Palm Beach Photographic Centre. A native of Ohio and graduate of Purdue University, she resides in West Palm Beach, Florida.

Author's Acknowledgments

I am deeply grateful for the chance to work once again with a wonderful publishing team, especially editor Kim Darosett. Many thanks also to technical editor Dave Hall and to Steve Hayes, Mary Corder, and everyone else at Wiley Publishing who helped make this book possible.

Publisher's Acknowledgments

Executive Editor: Steven Hayes
Project Editor: Kim Darosett
Technical Editor: David Hall
Editorial Assistant: Claire Brock

Sr. Editorial Assistant: Cherie Case

Project Coordinator: Kumar Chellappan
Front Cover Image: dookfish/shutterstock
Back Cover Images: Courtesy of Julie Adair King